The Photography Handbook

Second edition

Terence Wright

Routledge
Taylor & Francis Group

LONDON AND NEW YORK

First published 1999
This second edition first published 2004
by Routledge
11 New Fetter Lane, London EC4P 4EE

Simultaneously published in the USA and Canada
by Routledge
29 West 35th Street, New York NY 10001

Routledge is an imprint of the Taylor & Francis Group

© 2004 Terence Wright

Typeset in Times by
Florence Production Ltd, Stoodleigh, Devon
Printed and bound in Great Britain by
TJ International Ltd, Padstow, Cornwall

British Library Cataloguing in Publication Data
A catalogue record for this book is available from the British Library

Library of Congress Cataloging in Publication Data
Wright, Terence, 1952–
 The photography handbook/Terence Wright. – 2nd ed.
 p.cm.
Includes bibliographical references and index.
1. Photography. 2. Photography – Processing. I. Title.
 TR145.W785 2004
 771–dc22 2003020099

ISBN 0–415–25803–0 (hbk)
ISBN 0–415–25804–9 (pbk)

The Photography Handbook

'An ideal companion for students of photography, familiarizing them with current theoretical viewpoints and providing a framework for their own practice.'

The Art Book Review Quarterly

'A clear structure of concepts and debates.'

Mark Young, Richmond-upon-Thames College

The Photography Handbook provides an introduction to the principles of photographic practice and theory and offers guidelines for the systematic study of photographic media. It explores the history of lens-based picture-making and examines the medium's characteristics, scope and limitations.

The Photography Handbook equips the reader with the vocabulary for photographic phenomena and helps to develop visual awareness and visual literacy.

The Photography Handbook introduces practical photography as a series of processes from pre-production through to post-production editing, covering choice of camera format, camera angle, aperture, development, captions and editing contact sheets. Terence Wright analyses photographic theory so that the photographer is able to make an informed use of the medium to deliver the desired image, while reflecting on the social and cultural environment.

The Photography Handbook includes:

- a new chapter on the ethics of photojournalism;
- coverage of digital photography;
- a new section on research in photography;
- new case studies including a study of the war photographer James Nachtwey, photographic representations of Marilyn Monroe and Adolf Hitler, and the 'Bert is Evil' website.

Terence Wright is Reader in Critical, Historical and Theoretical Studies in Visual Art at the University of Ulster. As a freelance photographer his clients have included BBC Television News and Current Affairs; magazines *Campaign*, *Company*, *Cosmopolitan* and *Country Life*; The BOC Group, EMI, Health Education Authority, Kleinwort-Benson, Nat West Bank, Sense, Sport Aid and Thames Water.

Media Practice

Edited by James Curran, Goldsmiths College, University of London

The *Media Practice* handbooks are comprehensive resource books for students of media and journalism, and for anyone planning a career as a media professional. Each handbook combines a clear introduction to understanding how the media work with practical information about the structure, processes and skills involved in working in today's media industries, providing not only a guide on 'how to do it' but also a critical reflection on contemporary media practice.

The Advertising Handbook Second edition

Sean Brierley

The Radio Handbook Second edition

Carole Fleming

The Television Handbook Second edition

Patricia Holland

The Newspapers Handbook Third edition

Richard Keeble

The Magazines Handbook

Jenny McKay

The Public Relations Handbook Second edition

Alison Theaker

The Cyberspace Handbook

Jason Whittaker

Contents

...

Figures

...

Acknowledgements

I would like to thank my friends, students and colleagues in the fields of photography and visual studies for information and ideas: especially Charlie Meecham and Kate Mellor of Outsiders Photography; Amanda Harman, Paul Stanley and Blu Tirohl; Maureen Thomas of CUMIS (Cambridge University Moving Image Studio); Dominic Power and Helen McGregor of the National Film and Television School; Alastair Haines of the Eastern Arts Board; and more recently my friends and colleagues at Kunsthøgskolen in Bergen, Norway. Many of the basic insights of photographic practice were developed during my freelance work with BBC Television: I am indebted to the experience, professionalism and friendship of the News and Current Affairs staff. I would like to thank the staff of the *Guardian*, especially the picture editor Eamon McCabe and photographer Dave Sillitoe. I am also very grateful for the patience and attentiveness of my editor at Routledge, Rebecca Barden. Special thanks must go to my wife, Sandi Wilson, who provided moral support, advice and tolerance to see me through the trials and tribulations of writing the book.

Introduction

...

The alchemy involved in photography (in which packets of film are inserted into cameras, buttons are pressed and pictures of Aunt Edna emerge in due course) are regarded as uncanny, but as uncanny processes of a natural rather than a human order, like the metamorphosis of caterpillars into butterflies. The photographer, a lowly button presser, has no prestige, or not until the nature of his photographs is such as to make one start to have difficulties conceptualizing the process which made them achievable with the familiar apparatus of photography.

(Alfred Gell 1992: 50)

Over the past one and a half centuries, photography has been used to record all aspects of human life and activity. During this relatively short history, the medium has expanded its capabilities in the recording of time and space, thus allowing human vision to be able to view the fleeting moment or to visualise both the vast and the minuscule. It has brought us images from remote areas of the world, distant parts of the solar system, as well as the social complexities and crises of modern life. Indeed, the photographic medium has provided one of the most important and influential means of expressing the human condition. Nonetheless, the recording of events by means of the visual image has a much longer history. The earliest creations of pictorial recording go as far back as the Upper Palaeolithic period of about 35,000 years ago (some 25,000 years before the development of agriculture). And although we cannot be sure of the exact purposes of the early cave paintings – whether they record the 'actual' events of hunting, whether they functioned as sympathetic magic to encourage the increase of animals for hunting, whether they had a role as religious icons, or if they were made simply 'to enliven and brighten domestic activities' (Ucko and Rosenfeld 1967) – pictorial images seem to be inextricably linked to human culture as we understand it.

Throughout the history of visual representation, questions have been raised concerning the supposed accuracy (or otherwise) of the visual image, as well as its status in society. Ideas and debates concerning how we see the world and the status of its pictorial representations have been central political, philosophical and psychological issues from the time of Plato to the present-day technological revolution of the

new media communications. Vision and representation have pursued interdependent trajectories, counter-influencing each other throughout the history of Western culture. The popular notion that 'seeing is believing' had always afforded special status to the visual image. So when the technology was invented, in the form of photography, the social and cultural impact was immense. Not only did it hold out the promise of providing a record of vision but it was able to make such representation enduring.

In the mid-nineteenth century, the invention of photography appeared to offer the promise of 'automatically' providing a truthful visual record. It was seen not only as the culmination of Western visual representation but, quite simply, the camera, functioning in much the same way as the human eye, was regarded as a machine which could provide a fixed image. And this image was considered to be a very close approximation to that which we actually see. The chemical fixing of the image enabled the capture of what might be considered a natural phenomenon: the **camera obscura**'s image. At the same time, the photographic image was held to be an achievement of our sophisticated Western culture and produced the type of image that artists had struggled throughout the centuries to acquire the manual, visual and conceptual skills to create. In this developmental scheme of things, every form of picture-making that had gone before, including the visual arts of 'other' cultures, amounted to more or less approximate attempts at achieving the representational heights attained by the Western world. Just as children learned how to draw by starting with 'primitive' scribbling and developing into making more complex and skilful adult drawings, so the representations of 'others' were seen as mirrors of their cultural and racial development. According to this view, Western art had shown the way for the 'correct' ways of viewing the world and set the model for depiction to be executed as it should be, and the camera seemed to prove this.

It may seem a further irony that, because of the camera's perceived realism in its ability to replicate visual perception, it was assumed that all peoples would 'naturally' be able to understand photographs. This gave rise to the question whether photography constituted a 'universal language'. For example, in 1933 this view had been expressed in a series of radio broadcasts by photographer August Sander: 'Even the most isolated Bushman could understand a photograph of the heavens – whether it showed the sun and moon or the constellations' (Sander 1978: 674). However, in the face of the rapid increase in global communications which has characterised the latter part of the twentieth century, we do need at least to ask to what extent the photographic image can penetrate through cultural differences in understanding. Or is photography as bound by cultural conventions as any other form of communication, such as language? Yet despite such uncertainties we find that, 'Photography is nearly omnipresent, informing virtually every arena of human existence' (Ritchen 1990: 1).

Is it possible that our familiarity with the photographic image has bred our current contempt for the intricacies and subtle methods that characterise the medium's ability to transmit its vivid impressions of 'reality'? Photography is regarded quite naturally as offering such convincing forms of pictorial evidence that this process of communication often seems to render the medium totally transparent, blurring the distinction between our perception of the environment and its photographic representations. As Alan Sekula (1982: 86) has pointed out, it is the most natural thing in the world for someone to open their wallet and produce a photograph saying 'this is my dog'.

Reflections of culture

Since its invention, there has been a gradual widening in the viewing of the photograph from virtually secret perceptions to those of blatant public display; the first photographic images, in the form of **daguerreotypes**, were relatively difficult to see. They could not be looked at directly, so the viewing of small images contained in 'folders' was private and restricted. Over the intervening years, the techniques of photographic reproduction have increasingly made the image more public and open and have increased the scale of the image to the advertisement hoarding. There are other questions that arise concerning the role of photography in society that have aimed to determine whether the camera operates as a mute, passive recorder of events or whether it possesses the voice and power to instigate social change. We may further speculate whether the camera provides images that have a truly educational function by conveying information or if it operates primarily as a source of amusement and entertainment. In provoking such issues, the photographic debate reflects polarised arguments that traditionally have characterised much of Western thought.

Ever since its invention in 1839, photography has played a central role in representing the major changes that have taken place in society throughout the modern age. As a product of science, the photograph 'automatically' realised the existing canons of two-dimensional visual art, yet (perhaps above all) it provided such a popular means of entertainment that we can regard the photographic image as a typical product of its age. In addition to its social role, since this early period, the technology of photography and the attitudes towards the medium by its practitioners have changed radically. This may partly be attributed to photography gradually moving into what might be termed 'mythic time' – its initial role as a nineteenth-century record-keeper has now moved beyond the human scale and photographic images, once immediate and close to photographer and subject alike, have now passed out of living memory. The passage of time has transformed the photograph from the aide-memoire into the historical document, a document which often reveals as much (if not more) about the individuals and society which produced the image than it does about its subject(s) (see Figure I.1).

In order to locate the medium in the British political, philosophical and colonial *Weltanschauung* of the era, photography had emerged at the point in history when the Chartist riots were taking place. Charles Darwin had just published *The Voyage of the Beagle* (1839). Further afield, Britain had just taken possession of Hong Kong. Since that time, photographic images have recorded dramatic periods of political, social and cultural change, which include the decline of the colonial era, the introduction of mechanical warfare, as well as new world-views instigated by such scientific advances as space travel on the one hand, and the increased destruction of the natural environment on the other. However, this book hopes to show that photography, and other systems of representation, do not just passively reflect culture but can provide the vision and impetus that promote social and political change and development. For example, it is difficult to imagine the cultural changes of the Italian Renaissance of the fifteenth century without recognising the central role of the development of perspective in bringing about new visual means of representation (see Edgerton 1980). Similarly, photography has made a major contribution to the bringing about of the media culture that characterises our own era, while at the same time it has assumed the ironic role of bringing the harsh realities of the world to the coffee table.

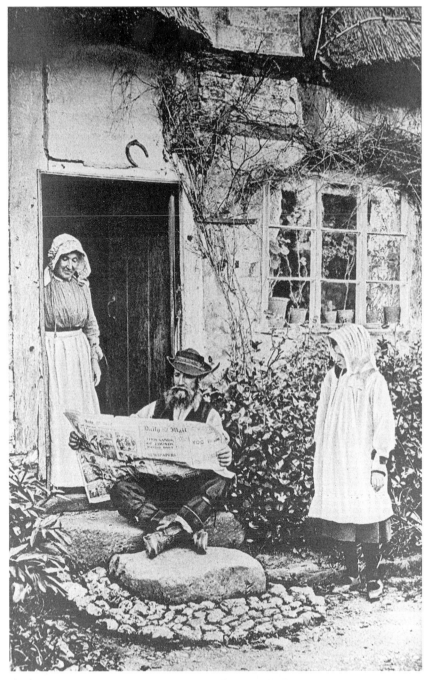

Figure I.1 A Shropshire Lad. The 1870s brought about the means to reproduce photographs on the printed page. This initiated photojournalism and contributed to social change by bringing images of current events to a wider audience.

Photograph by A.W. Cutler.

The relationship between a medium and its social environment is complex. For instance, photography has not simply acted as a passive reflector of change but has provided a system of visual representation that has both generated and promoted the social, political, economic, scientific and artistic developments of the past 160 years. The use of photography in advertising has evolved to perpetuate the very same consumer society to which photography owes its origins. But while the photograph can operate as a vehicle for mass communications and propaganda, it can also preserve personal memories as well as having the capability to express photographers' subjective responses to the world. Within twenty years of photography's invention the camera was ubiquitous and in extensive use. As Lady Elizabeth Eastlake put it in 1857:

> photography has become a household word and a household want; it is used alike by art and science, by love, business, and justice; is found in the most sumptuous saloon, and in the dingiest attic – in the solitude of the Highland cottage, and in the glare of the London gin-palace – in the pocket of the detective, in the cell of the convict, in the folio of the painter and architect, among the papers and patterns of the mill-owner and manufacturer, and on the cold brave breast on the battlefield. [See Figure I.2.]
>
> (Eastlake 1857, in Newhall 1981: 81–97)

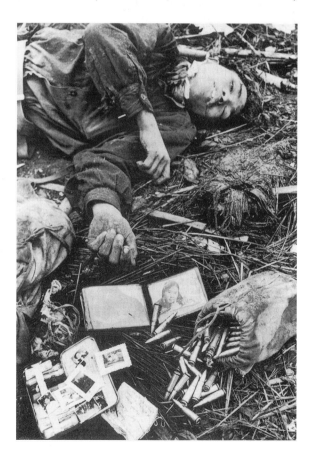

Figure I.2 Hue, Vietnam, 1968.

Photograph by Don McCullin. Courtesy of Don McCullin.

We can see from Eastlake's catalogue of applications that the photograph does not propose simply to record objectively the physical environment, nor just to express the human relationship to surroundings, but it also connects people to each other. In this role, it acts as a site for the meeting of ideas while it also serves as a stimulus for human social interaction. In later chapters we shall examine the photographer's active use of this characteristic of the medium.

The ubiquitous image

The last 160 years have witnessed an ever-increasing influence of the visual image, culminating in the global primacy of television. For photography, the new prospects and uncertainties posed by CD-ROM storage and digital manipulation present new challenges. Arguably, we stand at the point of the next leap forward in communications technology with the transmission of images via the 'Information Superhighway'. It has even been suggested that we now inhabit the 'post-photographic era' (see Mitchell 1992: 225), where technological and cultural change have devalued photography to such an extent that events have taken us beyond the photograph's use and value as a medium of communication. Furthermore, should we be asking if the advent of digital imagery means that photography, initially born from painting, has turned the full circle and has now returned to emulating painting – its progenitor?

Nonetheless, during its relatively short history, how do we account for the widespread influence and range of application of photography? In just a few years after its initial invention(s) the medium underwent a rapid succession of technological refinements. Its transformations and developments were accompanied by a widespread expansion of photographic practice carried around the world, for the most part, on the tide of colonialism. Perhaps the central reason put forward for the proliferation and dramatic uptake of photography is its ability to transcribe the world in a form that is readily portable from one location to another and that it preserves a visual record over the span of time. Support for this view rests on three related tenets:

1 The image is produced by mechanical means and therefore seems, not by necessity, to rely on human agency.

2 The camera forms images that appear to look real and, as such, they can be seen as both continuing and extending the general trajectory of Western art.

3 Physiological evidence would seem to suggest that the camera is constructed on, and functions by, the same optical principles as the human eye. This further reinforces the idea that the image produced by the camera has a very close correspondence to the images that we normally see.

In contrast to these points of view, it has been suggested that photographs are far from 'automatically realistic'. As products of a particular culture, they are only perceived as real by cultural convention: they only *appear* realistic because we have been taught to see them as such. This assumes that their representational relationship with the world is similar to that of language, i.e. by agreed social convention. As such they offer only one of numerous alternative means of providing a coded description of the world around us. We can therefore speak of photography as one example from a variety of visual languages. In this context, **interpretation** would seem to be the

closest term that can be used to account for our understanding of a photograph. This may lead us to question whether photography is purely a visual medium, or to take the further step of considering the value of limiting our analysis of the photograph to quasi-linguistic structures.

However convincing this latter theoretical viewpoint may be, it does imply a considerable shift of emphasis in the regard for the medium. It accentuates the viewer's response to a ubiquitous image which does not result from simplistic mechanistic procedures, but is produced by a complexity of cultural factors which perpetually relocate photographic images. Therefore it is the forces of culture that constantly alter our perception and understanding of photographs. As such, any image may have no fixed meaning at all and, although physically static, its message becomes subject to the fluctuations of shifting social patterns. In addition to this, we might consider that although the photograph yields its information all at once, this is not necessarily how we receive it. While we do not 'read' the photograph with the same prescribed linear progression involved, say, in reading a text, our perception of the image occurs over a period of time and necessitates a high degree of scrutiny. And, in contrast to movie film, it is the viewer who determines the duration of his or her engagement with the image. This means that the value of photography's representational powers lies as much in the image's historical and cultural contexts as in any inherent properties of the photographic medium itself. At the very least, our looking at a photograph, and our obtaining information from it, is not as straightforward as we might have first thought.

Outline of the book

It is the intention of this book to introduce the principles of photography which might enable the reader not only to gain a sound theoretical background, but also to develop a critical approach to the field of photographic practice. It aims to provide guidelines for the systematic study of photographic media. As such it is intended to be of interest to practitioners and theorists of the media and visual arts alike. The book is aimed at students and scholars of photography, media studies, communications and the visual arts. Through its comprehensive introduction to lens-based picture-making, it is anticipated that it will have additional value to those studying the 'time-based' visual media of film and video and will have further relevance to the role of the photograph in multimedia production. The book examines the importance and application of such theoretical positions to photography by establishing the medium's characteristics, scope and limitations. It aims to provide the reader with a vocabulary for photographic phenomena, to develop visual awareness and *visual literacy,* as well as enable students to familiarise themselves with current theoretical viewpoints and to evolve critical frameworks for their own photographic practice. The book examines the relationship between practice and theory, which may be summarised as follows:

- *Practice* Here photography is seen as a series of selection processes of **pre-production** selection and **post-production** editing. For example: choice of camera format, film stock, camera angle, viewpoint, shutter-speed, aperture, development, editing contact sheets, cropping, captions, etc. Information is selected from the environment through the activity of taking photographs, then that selection of information from the obtained visual array is gradually refined into that which will

appear in the final photographic print. Subsequently, the viewer's perception of the image can be directed by the general context of the display and the particular caption applied to the photograph.

- *Theory* The theoretical dimension examines the determinants of selection so that the photographer is able to make both an informed choice and efficient use of the medium to deliver the desired image while, at the same time, considering and reflecting upon his/her own social and cultural, temporal and spatial, location. Such choices may be determined by the type of assignment (high control/low control), institutional constraints (newspaper/corporate), in addition to the wider cultural and historical context.

Traditionally, the media context for photography is characterised by a desire to represent important events, having less concern for the intended artistic interpretation or the activity of investigating the scope and characteristics of the medium. However, this book aims to show that these approaches to photography can play an important role in visual communication. Furthermore, this work has been written in the belief that artistic practice – aimed to establish the scope and limitations of photography – can provide a valuable set of exemplars which can help us to understand the territory we are exploring.

The purpose of critical theory in photography

When a photographer takes a photograph, he or she makes a selection of visual information that is determined by his or her technical and aesthetic skills, personal views and experience, together with a set of social and cultural values. And in the course of this book we shall see how these determinants not only affect the style, content and expression of a photograph, but also how those images are perceived and responded to by the viewer. For example, we might consider that the casual reader of a newspaper will have an implicit understanding of the photographic images reproduced on the page. Rather than accepting the photograph at face value, we might question whether it accurately recorded the scene as it would have looked at the time. Or, in contrast, does it express the photographer's point of view? Is it the precise instant recorded that is of particular importance, or should the photograph on the page be understood as standing as a symbol to represent a state of affairs in the world?

Theory can operate by offering a degree of explanation of what is going on. It should not be taken as being all-embracing, nor necessarily offering ultimate truths. In fact, it can often be the deficiencies within a theoretical standpoint that offer the scope for the most promising and stimulating developments. In this context, there is an interesting relationship between critics and artists, where the critics aim to establish categories which artists then make it their business to extend or to subvert.[1]

The next issue we might consider is the extent to which an understanding of these theoretical positions is necessary for the photographic practitioner. Will they help to produce better photographers or do they merely exist as academic exercises? And to what degree of theoretical depth is it advisable, or indeed necessary, for the photographer to delve? It is unfortunate that in many instances one finds a polarised antagonism between photographers who do and theorists who think. For example, in

his book *Camera Lucida*, the French critic Roland Barthes offers the following commentary on a photograph:

> William Klein has photographed children of Little Italy in New York (1954); all very touching, amusing, but what I stubbornly see are one child's bad teeth . . . the detail which interests me is not, or at least is not strictly, intentional, and probably must not be so; it occurs in the field of the photographed thing like a supplement that is at once inevitable and delightful.
>
> (Barthes 1982: 43–7)

While this may seem all well and good, William Klein himself raises an objection to Barthes' analysis of his photograph:

> he's more interested in what he sees than in what the photographer sees. I saw other things when I took the picture . . . but Barthes isn't all that interested in what I see or what I've done. He's not listening to me – only to himself. Anyhow, Barthes and many critics, even Sontag, talk about photography, not about photographers.
>
> (Klein 1981: 18)

Immediately we are thrown into a debate between the photographer's intention in taking the photograph and the viewer's understanding and interpretation of the image. This said, it remains one of the essential problems of photography that, in comparison with other media, photographers seem exceedingly reluctant to theorise about their own practice. This leaves the impression that they photograph by instinct, that photography is an innate ability, and because photographers are born with photographic vision, they do not need to think about what they do. After all, it is considered that the photographs speak for themselves. I hope that this book will remedy such misconceptions. For example, by means of contrast, writing on the relative merits of painting and photography as far back as 1911, Alvin Langdon Coburn suggested:

> we shall find that the essential difference is not so much a mechanical one of brushes and pigments as compared with a lens and dry plates, but rather a mental one of a slow, gradual, usual building up, as compared with an instantaneous con-centrated mental impulse, followed by a longer period of fruition.
>
> (Coburn 1911: 72)

Working in this way, photographers may seem to take images instinctively, almost without thinking, yet later during the post-production process they reflect upon their practice and, on the basis of these reflections, go out and shoot again.

One of the most frequently voiced criticisms of the role of theory in photographic education is that it stifles spontaneity and creativity. In this regard, photographic education in Britain finds itself situated at a curious intersection between the art school tradition (with its philosophy of free expression and experimental exploration of the medium) and the socio-political inheritance from the old polytechnic sector proposing a new rationalism whereby all practice is the result of socially and culturally deter-mined forces. In worst-case scenarios, the resulting states of affairs engender a rigid dichotomy that leads either to a shallow, impressionistic and introspective approach which has little to do with the broader practice of photography, or to the student's

state of stagnation whereby he or she is unable to pick up the camera until all the theoretical formulae have been pre-established, fully understood and the interpretative strategies have been pre-empted.

Despite the wide range of subject matter that is committed to the camera, whether it be a portrait, landscape, studio set, street riot or a murder (notwithstanding the ethical and emotional factors), the photographic procedure is, in many important respects, the same. Essentially, the process entails the projection of a three-dimensional world onto a two-dimensional light-sensitive surface and the subsequent fixing of the image. It is a fundamental concern of this book that this phenomenon constitutes the foundations for critical practice in photography. Furthermore, it is proposed that theory and practice should develop hand in hand, with the practice of photography conducted in a climate of critical reflection and re-evaluation. Both the practice and theory of photography should be sites of discovery and experimentation, which aim to plot their developments in relation to the past traditions of photographic work at the same time as keeping their sights on the innovations of the future.

The book is based on the belief that anyone who uses a camera or who views a photograph will most probably be subscribing, albeit unwittingly, to some or other theory of representation. It can be argued that every photographer adopts some sort of theoretical standpoint almost as soon as they think of picking up the camera. Whether they have considered the further ramifications that arise from this prospect to the extent of adopting a theory of photography is another matter. In any case, all photographers will most likely have expectations that the camera will produce a certain sort of image that will fulfil their expectations to a greater or lesser degree.

For example, the parent, who perhaps becomes a photographer once a year, taking a snapshot of a child on holiday with an instamatic or throwaway camera, will have certain expectations with regard to the outcome of the image that is about to be produced. This is accompanied by a set of criteria for the evaluation of the success (or otherwise) of the endeavour and an idea of the intended audience. This may rely upon the pre-ordained standards for display to the restricted audience of the family album, to be viewed by close friends as well as present and future members of the family. These issues may not be conceived of in quite these terms, but there are criteria for the evaluation of photographs which are derived from an underlying theoretical standpoint – a situation which not only demands an implicit understanding of the camera's ability to provide a visual record, but which also determines the anticipated outcome which will be subject to certain traditions, codes and conventions of visual representation. The photograph may be intended to be realistic, a good likeness (if not flattering); will have formal qualities – it will be composed in a particular way, be colourful, etc.; it will express the socially acceptable image of a happy holiday. At the same time, it will be perpetuating a traditional photographic practice of the family snapshot accompanied by its hundred-year (or so) history, which includes the expansion of the railways that contributed to the development of the seaside tourist industry in the nineteenth century, in addition to the introduction of easy-to-use photographic equipment that enabled the rise of amateur photography. All such considerations will, in turn, engender further theoretical implications.

A knowledge of photographic critical theory will not provide the formula to enable the student to become a successful photographer. Photographs that are constructed from rigid theoretical frameworks can appear as reminiscent and as lifeless as the results of painting by numbers. Of course, it is not necessary to acquire any of this

theoretical background in order to take good photographs. However, for the student of photography, or for those intending to work with the medium or have greater understanding of his or her own practice and potential, photographic theory can offer a valuable insight into the medium's history, scope and characteristics. It is my belief that this will enable the student to take a broader and more innovative approach to the photographic medium, the practices of the future and the production of photographs that can contribute to extending the range of critical approaches to the medium.

In the chapters that follow, we will first examine the historical context and visual tradition that gave rise to the photographic phenomenon. Chapter 1 proposes a shift of emphasis away from the conventional 'history of photography'. Although it offers an historical outline of photography, it does not intend to be merely descriptive, but aims to provide both the historical background and the rationale for photographic representation. It introduces theories of vision, perception and representation which serve to indicate the characteristics of the photographic medium and the extent to which the photograph relates to the information gained through the activity of visual perception. This approach establishes a theoretical framework which can also be used to address the characteristics of digital photography.

Chapter 2 considers the pre-production factors in approaching the photographic shoot. It begins with a discussion of some of the conceptual skills necessary for using the camera and aims to understand photography through the *intentions* of the photographer, which are categorised in terms of realist, formalist and expressionist aesthetics. This is followed by a chapter dedicated to an investigation into the character and nature of the photographic image. Little attention is given to photographic techniques per se – specific details such as darkroom practice and how to use a camera are well covered in a number of introductory photographic textbooks.[2] In this volume it is considered that a more limited yet selective orientation to technical theory will suffice.

The scope and limitations of the post-production process become the subject of Chapter 4, which is followed by a discussion that deals more specifically with issues arising from notions of documentary practice in photography. Chapter 5 explores the use of the camera as a documentary tool and Chapter 6 looks at photography as a medium of expression. In paying special regard to contemporary photographic practice, a media-based photographic assignment is examined. The photographic assignment aims to enable students to see the entire process – from initial commission to reader's response – from a number of viewpoints. These are based upon interviews with those involved at various stages of the assignment: editor, photographer, picture editor and reader. Each of these stages will be accompanied by the photographs, contact prints, etc., which result from the actual assignment, as well as the various stages of the decision-making process. In addition to making decisions based on photographic criteria, there are social constraints on the photographer's activities. Consequently, ethical issues are discussed in Chapter 7. Lastly, Chapter 8 describes the current impact of new technologies on photographic practice. In this final chapter we shall turn to the transformations to photography made by computerisation resulting from the shift of emphasis from the analogue to the digital image. It aims to estimate the future significance of digital imaging for photography.

1 Historical outline of photographic representation

'Jeeves,' I said, 'have you ever pondered on Life?'
'From time to time, sir, in my leisure moments.'
'Grim, isn't it, what?'
'Grim, sir?'
'I mean to say, the difference between things as the way they look and things as they are.'

(P.G. Wodehouse 1930: 18)

The history of photography over the last 160 years traces the emergence of a practice that has revolutionised our understanding of visual communication. We can therefore propose that, in contrast to the conventional approach of describing the invention and development of the medium, we should study the medium's growth in social, cultural and psychological significance to offer an understanding of the photographic phenomenon. But in order to do this it becomes necessary to provide both the historical background and philosophical rationale for photographic representation. This can help us to understand some of the reasons and influences that might explain how the medium has attained such significance in contemporary society. Above all, photography can be seen as a product of its time, reflecting the intellectual climate of its origins, as well as operating as an instrument of social change. Nonetheless, perhaps the most basic and fundamental question that needs to be addressed is: why is it that photographs seem to appear so realistic? And is it this assumed realism that accounts for its widespread influence? Is the answer of a purely mechanical nature, arising from quite plausible demonstrations that the camera works in a similar way to the eye and thus provides the same sort of information we obtain in everyday perception? Or is it because we have been brought up in a culture that has developed a particular set of interpretative conventions and strategies that enable its members to perceive photographic codes as realistic images?

We shall see that the opposition of the realist view of photographic representation to the conventionalist theories has haunted photography from the first years of the medium's invention and seems to be surviving today's impact of digital imagery. While the accumulating evidence appears to suggest that the photograph cannot be so easily written off as presenting a simplistic window on the world, it may be neither

advantageous nor accurate to speak of photography constituting one of several visual languages. Instead, the photograph should be considered as a special kind of phenomenon which amounts to a complex system of representation drawing upon differing aspects of our cognitive processes and social interpretations.

Photographic realism

> Photography seems to record, rather than interpret, a piece of world in front of the camera . . . the camera and lens are often regarded simply as pieces of machinery which allow an image, a duplicate, of the world to be transferred onto film.
>
> (Annette Kuhn 1985: 26)

When we come to consider how a photograph is able to provide an accurate and detailed rendition of the subject, we find ourselves impressed by the realism of the image. In many people's view, a 'good' photograph is one that most accurately 'looks like' the thing it represents. If we hold up a photographic print and compare it to the subject, the image can appear to look more or less similar to the original (see Figure 1.1).

However, the argument for photographic realism goes beyond mere appearance, for our knowledge of the photographic apparatus (the camera) and its mechanism (the way it operates) provides sound reasons for believing the photograph records 'reality'. This *realist* view of photography is based on two central, and related, convictions:

1 The camera is similar in construction to the eye and forms an image in much the same way as our natural organ of visual perception.
2 We think of photographs as 'looking real' because they reflect the same pattern of light to our eye as the object itself would normally emit.

On face value, this would seem to offer a very straightforward and convincing argument. Both eyes and cameras are *chambered* in their construction and appear to operate by the same optical principles – those of the camera obscura. At one end of the chamber is an aperture where an *iris* controls the amount of light that enters and which is to be focused by means of the lens. This projection of light casts an inverted image of the 'world outside' onto the other end of the 'chamber'. In both cases it is a light-sensitive surface – the retina of the eye, the film in the camera – which records the visual image. Indeed, it has been these *instrumental* characteristics of the camera that have been used to explain the function of our eyes. For example, in the 1930s, the physiologist Sherrington (1937–8: 105) in describing the eye's construction went so far as to identify it with the camera: 'the likeness to an optical camera is plain beyond seeking. . . . The eye-ball is a little camera.' Such an approach appears to be relatively straightforward and non-problematic. It suggests that, when looking at a photograph, the viewer sees the same array of information that is normally picked up by the retina of the eye. The photograph is held literally to re-present what we would have seen had we been in the position of the photographer at the precise moment the shutter was released. While this form of explanation may seem an obvious fact of our visual perception, it had not always been thought to be so. Despite a general awareness of the phenomenon of the camera obscura, which had been noted as far back as

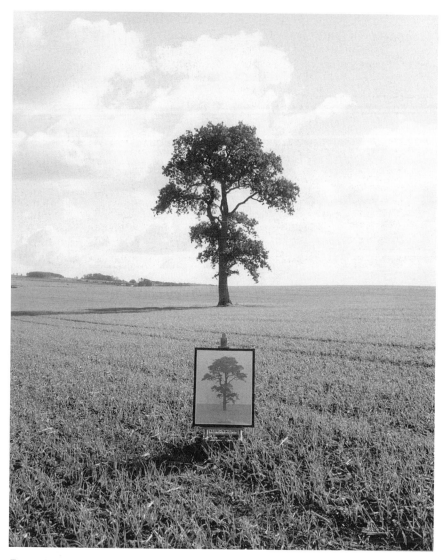

Figure 1.1 Tree at Upper Swell, Gloucestershire, 1997.
Photograph by Terence Wright.

the third century BC (Minnaert 1993), it was not until the seventeenth century, the age of **rationalism**, that a connection was made between the camera and the functioning principles of the eye (Lindberg 1976: 178–208). (See Figure 1.2.)

The camera obscura

Although photography itself has a relatively long history, camera-like devices had been in use by painters and draughtsmen over many centuries. The artist's camera

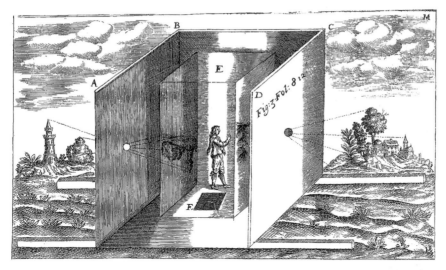

Figure 1.2 Camera Obscura: engraving from Athanasius Kircher (1671) *Ars Magna Lucis et Umbra*, p. 709.
Courtesy of the Science and Society Picture Library, Science Museum.

obscura, which was to become the ancestor of the modern photographic camera, was only one of many related optical devices that were employed to transcribe a three-dimensional world onto a two-dimensional picture-plane. The art historian Kenneth Clark (1949: 37), for example, points out that during the fifteenth century Piero della Francesca used the camera obscura for creating perspective images of three-dimensional scenes. Clark also mentions that Piero knew Alberti and it was Alberti (1435: 79) who is renowned for describing the picture as 'a window on the world', a metaphor which has had a lasting influence upon the visual arts. However, it was later recognised by Leonardo da Vinci, amongst others, that the pictorial representation of space posed a number of problems. One central concern was that an accurate impression of realism was obtainable only if the image was viewed at the centre of perspective and with only one eye. Otherwise, a variety of ambiguities and distortions could be encountered. For example, Leonardo had observed and analysed the perspective distortion which occurs at the edge of the picture when painting a wide field of view, and this phenomenon can continue to pose problems for the present-day photographer when using a wide-angle lens.

Vision and representation

The analogy between the eye and the camera was first proposed in 1604 by Johann Kepler. It then came to play a central role in the psychology and philosophy of perception for the next 350 years. It also had the added benefit of providing a scientific rationale for Western pictorial representation. Kepler's theory of vision had suggested there was a strong similarity between the way the eye functioned and the optical principles of the camera obscura. In particular, he felt that his analogy could overcome

the classical problem of how images of objects that were far away and much larger than the eye could find their way inside such a small organ of perception.

The term camera obscura was derived from the Latin for 'dark chamber' and it has been suggested that this principle was observed by Aristotle as far back as 32 BC.[1] Going a little further back, Plato's description of the cave bears a striking resemblance to the images (or shadows) projected on the interior wall of the camera obscura. It is no coincidence that Susan Sontag opens her account *On Photography* with 'In Plato's Cave', though nowadays, according to Sontag, 'this very insatiability of the photographing eye changes the terms of confinement in the cave, our world' (1977: 3). In the early eleventh century, the Arabian scholar Ibn Al-Haitham (usually known in the West as Alhazen) used a camera obscura in astronomical studies and went on to propose a theory of vision that relied upon a convergence of light rays. According to Schwarz (1985: 120), it was Kepler who, in 1611, was the first to invent the optical device known as the **camera lucida**. If this is correct, Kepler's stature in the history of photography is further enhanced. Not only would he have been the first to suggest that the eye operated on the same principles as the camera obscura but his invention of the camera lucida would have provided Talbot with a drawing device that would have had a profound influence on the invention of photography some 200 years later. Perhaps it was Talbot's (1844) association with this equipment that first led him to describe photography as 'photogenic drawing'. The difficulties that Talbot encountered in using the camera lucida forced him to return to his earlier experiments of using the camera obscura to project an image onto paper and then to make that image permanent.

However, the important point for photography is that a theory of pictorial representation evolved which had a firm basis in the current understanding of the optical and physical mechanisms of vision. In our present age of computer technology we have inherited this tradition of developing representational systems that aim to replicate our current understanding of visual processes. For example, the goals of 'simulation' or 'mimesis' remain central to the development of virtual reality technology, which also aims to use our current understanding of our perceptual processes to achieve its effect. As well as today's virtual reality systems, a further consequence of the analogy has been the introduction of a sequence of analogies, between our perceptual systems and the currently available technologies.[2] These analogies suggest that visual representations should present themselves to the viewer in a way that emulates the human perceptual apparatus. This is one way in which systems of representation reflect current thinking and become typical products of their historical period (see Penny 1994: 199–213).

The philosophical importance of Kepler's analogy was recognised by Descartes, and largely through his agency it came to have a lasting influence on the sciences and the arts alike. In 1637, Descartes, in his *Dioptrics*, described an experiment which demonstrated the analogy's validity and served to explain how the image is formed on the retina of the eye. The experiment (performed initially by Scheiner) claimed to demonstrate the camera-like principles of the mammalian eye. A dissected ox-eye was placed in the blind of a window, looking outside. Some of the membranes were gradually removed from the back of the eye until it was thin enough to be translucent without breaking. These were replaced by tissue paper which was held to have a similar function to the ground-glass screen of a plate camera. As the room was darkened an inverted image of the world outside became visible on the back of the eye;

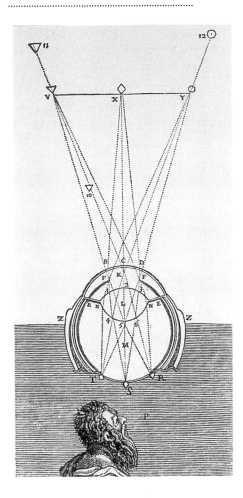

Figure 1.3 Scheiner's experiment, in Descartes' (1637) *La Dioptrique.*

as Descartes himself put it, 'not perhaps without wonder or pleasure'. This was held to demonstrate conclusively that the eye, operating on the same principles as the camera, produced a projected image which could, in turn, be detected by the brain (see Figure 1.3).

It was Descartes who played a leading role during a period of dramatic change in philosophical and scientific thinking. Although he wrote little on the arts, his principles and methods (as well as his general contribution to the prevailing intellectual climate) instigated the seventeenth-century revolution in cultural thought. For example, this period, which set in chain a sequence of scientific advances that led to the invention of photography, was marked by the formulation of aesthetic theories that came to terms with the new technology of the medium of print. Furthermore, it can be seen as a period of redefining communication and the role of the reader in the communicative process:

> From this moment on, gradually but increasingly there developed a race of authors who write to an indefinite body of readers, personally undifferentiated and unknown,

who accept this separation as a primary condition of their creative activity and address their public invisibly through the curtain, opaque and impersonal, of print.

(Bronson 1968: 302)

This aspect of communication is subject to current concern in view of the ascendancy of interactivity between the viewer and multimedia productions. However, the *dualism* between author and reader, implied by Bronson, can also be seen as characteristic of the Cartesian era. As with the **eye/camera analogy**, it reflected current thinking. In Descartes' scheme of things, the dichotomy of body and soul implied a conceptual separation of mind from eye. It was this mechanistic view of the human condition that underlaid his attraction to the analogy, thus reinforcing the analogy between the eye, as a discrete organ of perception, and the camera. The influence has been long lasting. **Cartesian co-ordinates** have become a central system to the rationalist method of understanding the world. The representation of space has relied upon the use of the Cartesian grid and lens-projection continues to be referred to in this context (Dubrey and Willats 1972: 15).

We might further reflect that the phenomenon of the camera obscura may well be architecturally dependent. It is an optical effect that is most likely to be observed by people belonging to those cultures that dwell in buildings.[3] Though we should remind ourselves that it is one thing to observe a phenomenon, it is quite another to decide to incorporate this natural optical phenomenon into a system of visual representation, let alone to give it a central role. Indeed, other cultures have adopted systems of representation employing a different range of criteria. Japanese painting, for example, may employ multi-viewpoints and an oblique projection system (see Figure 1.4).

In other systems, such as Palaeolithic cave art, other criteria become important, in particular that the image has indistinct boundaries and certainly nothing resembling a frame. So we can consider the tradition of representing the world through the boundary of a rectangle as being a peculiarly Western, urban phenomenon: 'Chinese painters like Chou Ch'en never considered that they should portray nature as if it were seen through a window, and they never felt bound to the consistency of the fixed viewpoint demanded of their Western counterparts' (Edgerton 1980: 187).

So in retrospect this may lead us to consider that, despite recognising that essential principles are shared between the eye and camera, this is not the essential factor in producing a successful picture and, on further reflection, we might consider it a mistake to base an entire theory of visual representation on such an analogy. However, such an identification has had a lasting influence upon the arts. The fact that the structure of the eye shares common physical and optical features with the camera – both employ a lens with an adjustable iris which focuses an inverted image onto a light-sensitive surface – offers a scheme that supports the construction and the final appearance of the 'realistic' picture; therefore this has remained a convincing argument for Western art systems that have retained 'mimesis' as their central purpose.

Nonetheless, the employment of such an analogy was not without its problems. Berkeley, in 1709, describing how 'external objects are painted on the *retina*' (section LXXXVIII), encountered the 'mighty difficulty' that the retinal images were inverted (and this is how the latent image is recorded on the film in the camera); but we are able to see the world 'the right way up'. As far as Berkeley saw it, the physiology of vision set up the dichotomy: that which we *see* ('visible ideas'), in contrast to that which we *know* ('tangible ideas'). Berkeley believed that the difficulty could be

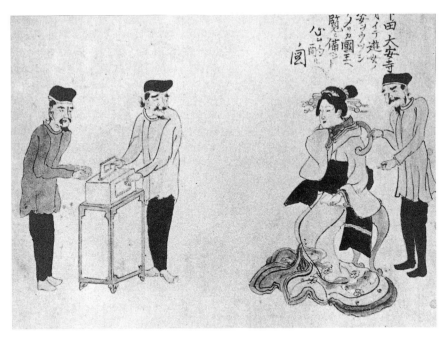

Figure 1.4 American photographers taking a daguerreotype of a courtesan, 1853–4.

overcome through a theory of association. This suggests that although we initially see the world upside-down, as we grow up we begin to feel objects in our environment. The information derived from this exploratory 'feeling' is used to convert our visual input to compensate for how things are in actuality. While this may seem to be of mere academic interest, Berkeley's theory, along with the eye/camera analogy, has survived the centuries to enter the photography textbooks. In his *Basic Photography*, in the section titled 'The Human Camera', Langford (1978: 123) muses: 'It is an intriguing thought that as newly born babies we had not only to learn to focus our lenses, but also grow used to the inverted images they form.' Recent developments in the theory of visual perception, as we shall see, are not necessarily in accord with this view. But Berkeley's dilemma between appearance and reality remains not only as a key issue in media reporting, but also as a central concern to the principles of photography.

At the time of its invention, photography was thought to realise the representational goals of Western art, just as Victorian culture was thought to be the acme of refinement, having developed from the 'primitive' social organisation of 'savages'. Charles Darwin sums up the theory of culture that prevailed during the year that the invention of photography was announced: 'One's mind hurries back over past centuries, and then asks, could our progenitors be men like these? – men, whose very signs and expressions are less intelligible to us than those of domesticated animals' (Darwin 1839: 474).

The developmental approach to the history of art which was characteristic of nineteenth-century theories of cultural evolution saw the developing trends towards realism as constituting art's evolution. It echoed the late Victorian theories of culture.

In this view, the early stirrings of primitive art could be seen as formative efforts in attempting to represent a world of confusion and magic.[4] In the late nineteenth century, this was equated with the drawings of children. With the rise of civilisation, the Greeks and Romans began to develop more or less correct means of picturing, employing depth cues and early forms of perspective. As Western culture descended into the dark ages, so visual representation degenerated, only to be rediscovered and reach new heights during the Renaissance, when perspective proper was developed. Finally, in the nineteenth century, photography was invented which, in accord with the contemporary views of cultural ascent,[5] provided the mechanical means of faithful representation. This view of cultural ascendancy does have contemporary significance in serving to demonstrate how camera representation became so deeply rooted in the social values of Western culture. For example, we might consider it is important to recognise the philosophical determinants of this particular sort of nineteenth-century representation, again marking an age when a considerable degree of faith was placed in current technology. A stereoscopic image produced by photographer and scientist Antoine François Jean Claudet not only features a number of his own inventions, but has resulted in a study that takes pride in the technological advancements of his era (see Figure 1.5). The daguerreotype includes a stereoscope and a treatise on photography amongst the array of optical instruments and chemical equipment.

The Constructivist Theory of perception

To return to theories of perception, the standpoint we have encountered thus far is known as the Constructivist Theory. To recapitulate, images of the world are focused onto the retina in a similar way that the camera focuses an image onto the surface of the film. This retinal image provides the basis of our visual perception from which the perceiver makes unconscious inferences. Learning by association[6] overcomes the problems of the image being inverted, reduced in size and flat. According to this theory, we associate the visual input with the tangible: that which we see with that which we know. If we were to update the theory we would suggest that the eye gathers signals from the world via a mechanism which shares basic features with the camera. Light is passed through a lens to be converted from energy into electrical impulses which are transmitted to the brain. However, some impulses (Berkeley's 'visible ideas') will conflict with other information (tangible ideas) causing a visual system conflict or illusion. **Constructivism**, with its roots in the philosophy of Descartes and Bishop Berkeley's scheme of things, leads to the 'argument from illusion' whereby we can never be sure whether our senses are deceiving us. This philosophical puzzle suggests that – as perception is *sometimes* fallible – we can never really be sure when our senses are acting faithfully or being wholly misleading. Therefore we are never sure if our perception is correct on any particular occasion. This is partly a consequence of an approach that depends upon the visual stimulation detected by the eye – the retinal image – being translated into perception by the brain. In this case it suggests that objects in the world outside are unknowable; we receive sensations and impose such secondary concepts as space and time upon them. For example, Helmholtz, who will be encountered in more detail later, firmly believed that we receive sensory input which only makes sense because of the associations we have

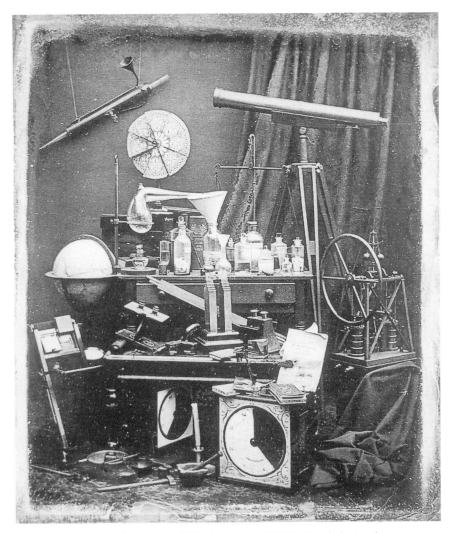

Figure 1.5 Laboratory Instruments, 1853: stereoscopic still-life of mid-nineteenth-century scientific instruments, and including a photographic treatise.

Photograph by Antoine François Jean Claudet.

developed through learning. On this point he is very close to Berkeley's theory of vision. Yet it led to his particular interest in visual illusions which suggested to him that perception is the result of 'unconscious inferences' made from sensory signals picked up by the organs of perception, such as the eye.

One of the problems with this theory is that it considers perception as being something of a spectator sport, in which the perceiver is cast in the relatively passive role of observing the image on the retina. More recent theories reject the notion of the retina as a simple location for recording pictures to consider it more of an information-gathering tool. We shall examine this shift of emphasis in detail later.

Of course one can see the attraction of such a theory, whereby photographs look realistic because the photographic image has been formed through a similar process to the ways we normally see the world. In semiotic terms, this argument supports the notion of the photograph as an *icon*: the photograph as 'looking like' its referent. C.S. Peirce uses the photograph as an example of the iconic sign in his theory of signs: **semiotics**. However, later theorists have suggested that because of its causal relationship with the photographed object, providing a trace of its existence, it should be classified in Peirce's scheme as an *index*. (This is discussed in greater detail in Chapter 3.)

The formulation of the recipe for success in producing a convincing picture has a long history in the visual arts. For example, in the eighteenth century, the painting should be produced

> to affect the eye of the beholder so that he should not be able to judge what he sees is only a few colours laid artificially on a cloth or the very objects there represented, seen through the frame of the picture as though through a window.
>
> (Taylor 1811)

In these instances, Taylor describes it as 'light … [travelling] from the picture to the spectator's eye in the very same manner as it would from the objects themselves'. Psychologist James Gibson provides a more contemporary description of this phenomenon:

> A faithful picture is a delimited physical surface processed in such a way that it reflects or transmits a sheaf of light-rays to a given point which is the same as would the sheaf of rays from the original to that point.
>
> (Gibson 1954: 14)

So, in adapting this to photography, the theory suggests that the camera records a pattern of light onto the film plane. This pattern is transferred (via photographic processing) to the photographic print which re-presents the same pattern of light (as produced by the original object or scene) to the viewer. A fundamental difference here is that the pattern of light is now dislocated in time and space from the original event.

There are certain conditions where the similarity between the 'artificial' image and our 'everyday' perception is so close that we can be fooled into believing that an image is a real scene. This is known as ***trompe l'œil*** [1] – a term which suggests that the visual display causes the eye to be mistaken in its perception. It presents the viewer with such a strong illusion that he or she is fooled into confusing the painting with an actual scene. In these instances, much depends upon reducing the pick-up of information concerning the surface of the image: its flatness or texture, for example. Indeed, it invariably involves the artist's attempt to suppress, as much as possible, the formal qualities of the medium. Throughout the history of painting a variety of methods have been employed and some are still employed today in the creation of virtual realties, for example the flight simulator where the 'user and the screen display are well shielded from reality by the simulated cockpit of a jumbo jet or interior of a space ship' (Loeffler and Anderson 1994: xv). Traditionally, they have included the following techniques:

- presenting the picture at a distance from the spectator so that the surface texture, brush strokes or canvas fabric cannot be seen;
- painting or projecting the image onto an unusually shaped surface;
- making the image appear to be part of the space occupied by the spectator (as in the above flight simulator example), such as creating a visual continuation of tangible objects into the depicted space;
- restricting the viewer's position to the centre of perspective of the image.

All these techniques can be found in Andrea Pozzo's painting *St Ignatius Entering Heaven* (see Figure 1.6) and have been discussed at length by Pirenne (1974).

We can find a contemporary continuation of the *trompe l'œil* tradition in the work of Callum Colvin, whose photographs create contradictions between that which we see and that which we know to be the case. In Colvin's photograph (see Figure 1.7), illusory information dominates the image. However, we can detect subsidiary information that leads us to conclude that if the exposure had been made from a point away from the painting's centre of perspective, the illusory image would lose its effect and impact.

These images can be seen as contemporary visual demonstrations of Berkeley's theory of vision. However, it should be stressed that they remain so only as pictorial

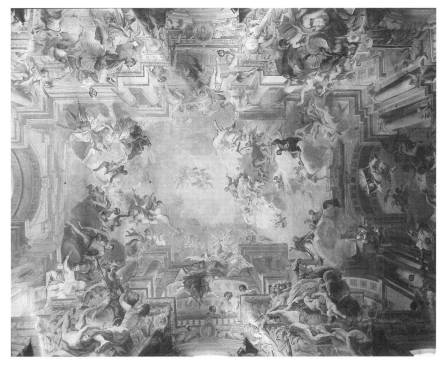

Figure 1.6 Saint Ignatius Entering Heaven, Andrea Pozzo, *c.*1707: an eighteenth-century example of virtual reality.

Photograph by Terence Wright.

phenomena and should not be taken as examples or model demonstrations of how we actually perceive the world. These, as with other illusions employed in the psychology of perception, are consequences of making pictures. Difficulties arise when the properties of visual representations are confused with the characteristics of our everyday perception.

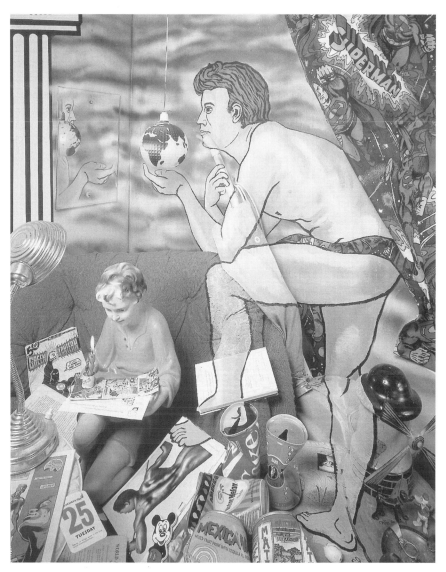

Figure 1.7 Heroes 1, 1986. Illusory information dominates the image. However, we can detect subsidiary information that leads us to conclude that if the exposure had been made from a point away from the painting's centre of perspective, the illusory image would lose its effect and impact.

Photograph by Callum Colvin.

Evolution and the camera

> I think the Old Masters weren't artists, they were just good photographers
> before the camera was invented.
>
> (Man Ray 1992: 20)

As we have already seen, the camera obscura and other related gadgets became useful tools for the Western artist some five hundred years before the invention of photography. For example, Giovanni Battista della Porta describes the value of camera devices when used as drawing aids for the artist. This influence was later to be regretted by Kenneth Clark:

> By the end of the seventeenth century the painting of light had ceased to be an act of love and had become a trick. The *camera lucida* was no longer an object of wonder, but an habitual artist's companion.
>
> (Clark 1949: 47)

Nonetheless, it was this device that had inspired Fox Talbot:

> amusing myself on the lovely shores of Lake Como in Italy, taking sketches with Wollaston's *camera lucida*. . . . After various fruitless attempts I laid aside the instrument. . . . I then thought of trying again a method which I had tried many years before . . . to take a camera obscura and to throw the image of the objects on a piece of paper in its focus. . . . It was during these thoughts that the idea occurred to me – how charming it would be if it were possible to cause these natural images to imprint themselves durably, and remain fixed upon the paper.
>
> (Talbot 1839)

With the notion of the images 'imprinting themselves', the 'automatic' characteristic of photography has tended to have the result of diminishing the skills of the photographer. Described by Gell (1992) as a 'lowly button presser' (see Introduction), all the photographer has to do is point and click. But even the use of the camera as an aid to painting proper has been looked down upon and deliberately obscured: 'the literature on Vermeer of Delft has included first hints, then suggestions and, finally, all but direct statements that Vermeer used . . . the *camera obscura* as an aid in making his paintings' (Seymour 1964: 232).

Although it had been long known that artists had used 'drawing machines', Seymour points to a conspiracy of silence among art historians, who were probably concerned that the skill and stature of great artists would be diminished if it were publicly known that they had 'cheated' by using artificial means for their picture-making. It may also be interesting to note in this context that Gombrich in his *The Story of Art* concludes his chapter 'The Mirror of Nature' with a discussion on Vermeer. Although Gombrich too makes no reference to the camera, he maintains, 'Like a photographer who deliberately softens the strong contrasts of the picture without blurring the forms, Vermeer mellowed the outlines and yet retained the effect of solidity and firmness' (1950: 324). Additionally, this epitomises the regard for photography that has traditionally been held by art historians who have found it difficult to come to terms with the attributes and qualities of the photographic medium and the skills of vision and selection it demands.

Apart from all this, it is important to remember that although the use and princi-ples of the camera obscura exerted a strong influence over photography by producing a similar system of projection, it was not the photographic camera as we know it. The medium of photography combines two sets of phenomena. As Roland Barthes (1982) reminds us: '[it] is at the intersection of two quite distinct procedures; one of a chem-ical order: the action of light on certain substances; the other of a physical order: the formation of an image through an optical device' (p. 10). He goes on to propose that 'the painter's camera obscura is only one of the causes of Photography; the essential one, perhaps was the chemical discovery' (p. 31).

We can take it that the convergence of these two procedures resulted in the medium of photography which, though related to painting and drawing, amounts to an entirely new representational system with its own particular attributes. In addition, photog-raphy came to prove itself capable of transforming the culture from which it sprang and was also a quintessential product of its own empirical era. Any examination of the development and proliferation of photography would not be complete without accounting for the medium's location in intellectual history. Some of the major histor-ical events surrounding photography's inventions were outlined in the Introduction of this book. The eighteenth century was a period characterised by scientific rationality. Although Darwin's *Origin of Species* was not published until photography had been around some twenty years, it was the 1850s that saw the beginning of the rapid expan-sion and proliferation of the medium. For example, we shall see later on that the stereoscope of this period not only boomed in its popularity but offered further support for the eye/camera analogy. In the meantime, in its process of revolutionising the Western intellectual tradition, Darwinism proposed a new rationality for the latter part of the nineteenth century. While the popular practice of photography was rapidly expanding (in 1851 there were fifty-two photographers in Britain, in 1861 this number had risen to 2,534[8]), the writer Charles Kingsley is reported to have remarked in 1863, 'Darwinism is conquering everywhere and rushing in like a flood' (Bibby 1959: 83). Naturally, photography was held to provide an objectivity that was most appropriate to this intellectual climate. Darwin himself had even employed the 'objective records' of the photographer Oscar Rejlander to illustrate his *The Expression of the Emotions in Man and Animals* of 1872 – a volume which also contained the photographs of the mechanistic demonstrations of Duchenne which used electrodes to stimulate facial expressions in mental patients (see Figure 1.8). Indeed, it can be argued that in the face of anti-Darwinian arguments, based upon the divine origins of species, the more Darwinism moved towards the sort of extreme demonstrations of socio-cultural evolu-tionism that have been outlined by Alan Sekula (1986).

In England, debates continued with regard to the purity of the photograph in conflict with artistic practice. In 1900, for example, the photographer Benjamin Stone alerted the Royal Photographic Society to 'process reproduction' – 'a lamentable custom resorted to of tampering with photographs either in the negative or in the process of reproduction, so as to correct partial failures in the original negative, and oftentimes embodying distinctly fraudulent effects' (Stone 1900). As far as the photographic world was concerned, Stone had entered the fray of an ongoing debate at the turn of the century concerning the relative attributes and deficiencies of straight and artistic photography. An example of the opposing view was outlined during this period by Robert Demarchy (1899) in 'What difference is there between a good photograph and an artistic photograph?'. In contrast, Frederick Evans (1900) – in putting forward the

Figure 1.8 Self-portrait of Oscar Rejlander, from Darwin (1872) *The Expression of the Emotions in Man and Animals*. Rejlander's illustrations were compared to those from an experiment by Duchenne, whose subjects were stimulated by electrodes into forming expressions of horror.

Photograph by Oscar Rejlander.

argument for 'Pure Photography' (one month after Stone's statement) – supported the National Photographic Record Association which had exhibited at the Royal Photographic Society that year. It was to prove to be an argument that was not (nor still is) likely to go away quietly. 'Photography has been, and is still, tormented by the ghost of Painting' (Barthes 1982: 30).

Twentieth-century theoretical standpoints

In the 1920s, the **Gestalt** psychologists attempted to shift the emphasis from the Constructivist point of view and in doing so revolutionised perceptual theory. Their reaction to the 'classical' view of perception as posited by Herman von Helmholtz was marked by the suggestion that the most important qualities for perception are not individual sensations, but the organisation and structure of perceptual information. That they believed the overall pattern of stimulation to be more important than the isolated stimulus is expressed in the catchphrase 'the whole is more than the sum of the parts.' Or, as later revised by Koffka (1935: 176), 'It is more correct to say that the whole is something else than the sum of the parts'. The important point to remember is that they considered perception to be holistic, and not restricted to making sense of a mosaic of independent sensations. The Gestalt approach overcame some of the problems posed by the classical theories – for example the perception of such qualities as transparency and glossiness. These cannot be perceived as individual sensations: the entire patterns of perceptual information have to be taken into account. They depend upon the relative attributes of the objects of perception.

In the visual arts, one of the most significant outcomes of the Gestalt revolution occurred in the history of the cinema. It was Eisenstein's indebtedness to Koffka that led to Eisenstein's notion of the third meaning in his theory of film montage, and a similar theoretical viewpoint was applied to photography by Barthes in his description of the 'third effect'. Meanwhile, in some respects this tendency was reflected in the photography of the period placing emphasis on the overall context of the photographed object:

'neo-realist' photography discovered a world of industrial products, and showed itself as a component of the aesthetic of commodities in a double sense, affecting

production and distribution ... an industrial product develops its own particular aesthetic only when the serial principle, as the general basis of manufacture, becomes pronouncedly visible.

(Molderlings 1978: 92)

Once more, we find that perceptual theory is closely related to photography movements of the period – accompanied by a revision of accepted notions of photography. For example, the 'New Realism' (Benjamin 1929) of the 1920s and 1930s is closely related to Köhler's psychology based on 'the world as I find it, naively and uncritically' (Köhler 1929: 1). Furthermore, the Gestalt psychologist Wertheimer propounded the Law of *Prägnanz* (Organisation) which stated that given a range of geometric organisations 'one will actually occur which possesses the best, simplest and most acceptable shape' (Koffka 1935: 114). That Wertheimer had suggested this in 1923 places his thoughts reasonably close to the thinking of Bell's (1914) notion of 'significant form'. Bell's search for a denominator, common to the art of all cultures and historical periods, led him to propose a formalist aesthetic in which the elements of colour and line generated particular emotions (see p. 42 of this volume). For the moment, it can be seen that a close association was maintained between theoretical perspectives derived from the contemporary intellectual climate and those of photographic and artistic practice.

The ecological approach

Gestalt psychology of the 1920s provided the impetus for further theoretical developments in the psychology of visual perception (Gibson 1979: 138). This most significant shift in perceptual theory occurred some forty years later in the work of the psychologist James J. Gibson. In his *The Senses Considered as Perceptual Systems* (1966), he expanded upon the Gestalt position. He states that 'it is a mistake to conceive each persisting pattern as a separate stimulus'. This pattern might be the retinal image conceived of as a photograph. In contrast, it is the ways in which the patterns of stimulation *transform* that are most significant for perception. 'Transformations of pattern are just as stimulating as patterns are' (Gibson 1966: 40).

For Gibson, it was his encounter with the problem of landing aeroplanes on a moving aircraft-carrier during the Second World War that led to his development of a new theory of visual perception. It almost goes without saying that such an approach to perception, derived from problems encountered in providing flight simulation, has gained particular relevance in the creation of virtual environments. This is perhaps most succinctly outlined in his *The Ecological Approach to Visual Perception* (1979). According to Gibson, the existing theories of perception could not provide an adequate account of how organisms could find their way around their environments. His reappraisal of perceptual theory was also partly motivated by evolutionary theory, for Gibson maintained that the basic elements of perception should be biologically significant. This takes us back to the origins of our perceptual systems.

In Gibson's view, the classical theories of perception were over-preoccupied with visual illusions and dwelt too much on the failures of perception. In addition, they were too concerned with taking a mechanistic approach, that is, involved with the physics of perception (as was Helmholtz). Instead, Gibson proposed that perceptual

processes had evolved alongside the organism's adaption to its natural environment and therefore should be biologically significant. Perception was now considered in evolutionary terms. In contradiction to the views of Berkeley (and Langford), it has been suggested that humans have evolved with neural structures that are genetically programmed to interact with early perceptual experience to create systems that function specifically for the perception of depth (Banks *et al.* 1975). One such example is binocular disparity, the perception of depth derived from the differences of information detected by each retina. In Gibson's scheme, this system has evolved because this method of perceiving depth information is ecologically valid. During the evolution of the species, the different combinations of retinal disparity and convergence have become associated with relative depth. Yet this input of depth information is achieved without recourse to a single stereoscope-type image located in the brain. These perceptual systems had evolved with the human organism to furnish us with the most appropriate information to enable us to cope with the environment we inhabit. Theories that emphasised the illusory nature of perception were heavily criticised for not providing an adequate explanation that was rational from this ecological point of view. Indeed, we would be right in supposing that any organism that was consistently deceived by its senses would be unlikely to survive. Needless to say, the epistemological ramifications of this debate are extensive. However, three central conclusions can be drawn:

1 Perception has to be studied with the subject operating in its natural environment.
2 Any organism has evolved a perceptual process to cope with the problems posed by its natural environment.
3 Natural selection operates on the whole organism, not just the eye but all the organs of perception in conjunction with the whole body.

The most significant point of all this is signalled by a move out of the psychology laboratory into the natural environment. As for its relevance to photography, Gibson's theory of perception, based upon ecological consideration, amounts to a strong objection to the eye/camera analogy. In doing so, it shifts the emphasis from the *passive registration* of retinal images to perception based upon the whole organism's *active engagement* with the environment. The close comparison between the eye (integrated into a dynamic exploratory organism) and the camera (operating as an impartial recording instrument) begins to fall away. Such an approach amounts to a radical challenge to those theories of perception which owed their ancestry to Descartes' mind and body dichotomy:

> One sees the environment not with the eyes but with the eyes-in-the-head-on-the-body-resting-on-the-ground. Vision does not have a *seat* in the body in the way the mind has been thought to be seated in the brain.
>
> (Gibson 1979: 205)

Gibson places increased attention on the perceiver's activity and exploration. We no longer consider that we capture the world by retinal pictures, but we gather visual information about the world that is contained in the ambient light and is already structured by the environment. It should be added that this 'free-floating' information is not constructed in the form of a picture,[9] though it is the camera's action of sampling

light which is projected onto a two-dimensional image plane that has the ability of structuring this information into pictorial form. In addition, Gibson points out that the chambered eye of the vertebrate is only one method of perception. For example, with their compound eyes, insects pick up visual information without relying on a mechanism that resembles a photographic camera. We might also consider that bats are able to perceive the features of the environment that are significant to their existence in their usual habitats without recourse to optical information. Such thoughts provided the basis for Gibson to develop his **ecological** approach to visual perception.

For photography, the general upshot of Gibson's contribution to perceptual theory is that it places a new relevance on the differences rather than the similarities between perceiving the world and its putative visual representations. So if photographic/retinal images do not form the basis of visual representation, it means that photographs become rather special objects, posing a particular set of problems when we begin to consider how they provide us with information. In this context, it is not so much the perception of the world that is important, but the question of how we perceive photographs that becomes especially relevant. In deposing pictorial images from their central position in perceptual theory, Gibson has drawn attention to the peculiar nature of photographs and has increased awareness of the problems specific to visual representation.

As soon as we adopt Gibson's theoretical standpoint, most of the illusions that suggest the fallibility of perception have to be disregarded. They depend on the cramped style of the perceiver as the psychological subject – for example, head fixed looking through a peephole – or they rely on abstractions or pictures which are not characteristic of our everyday perception of the world. As we saw with Pozzo's painted ceiling (Figure 1.6), the success of the realistic illusion depends upon the viewer's fixed position at the centre of perspective. In the church of Sant'Ignazio in Rome this is indicated by a yellow marble disc fixed into the centre of the floor. Similarly, information regarding visual illusions is more often obtained from the psychology laboratory where

> the subject's perception is limited to one viewpoint and the ground of the perception has been made indeterminate. Either limitation is sufficient to destroy natural perception as such and hence my grasp of the situation is subject to error because my capabilities as a perceiver are severely cramped.
>
> (Fahrmeier 1973: 268)

Gibson's approach to visual perception amounted to a strong reaction to a general cultural tendency of a narrowing of the disciplines in an aim to establish their exclusive areas. While in art and photography this had come to manifest itself in **modernism**, in the theory of visual perception it meant that psycho-physiological explanations of visual illusions had been in ascendance.

So, in the early 1960s, art critic Clement Greenberg in his 'Modernist Painting' was advocating that painting should reduce its activities to its 'unique and proper area of competence' (Greenberg 1960: 103), whereby 'painting has had above all to divest itself of everything it might share with sculpture'. This reflected his earlier views when he felt that photographers were intruding upon the territory held by painting. For instance, he considered that the photographer Edward Weston displayed 'a lack of interest in subject-matter and an exclusive concentration on the medium ... a confusion of photography with painting' (Greenberg 1946: 295). Similarly,

attempts have been made to define the role and characteristics of photography. In his *The Photographer's Eye* (1966), John Szarkowski distinguishes paintings that are 'made' from photographs that are 'taken'. Furthermore, in the 1950s other photographers, such as Aaron Siskind and Harry Callahan, were producing images that aimed to maintain 'a special equilibrium between the world of ordinary objects in familiar time and space and the intensely-felt subjective image' (Smith 1961: 102).

In the meantime, Gibson was shifting the site for the study of perception from the laboratory into the environment, as visual artists were also beginning to move out of the gallery into the landscape to produce **Land Art**. Both these changes reflect a general cultural trend that characterised the 1960s: abandoning the restriction of Greenberg's modernism by moving from areas of narrow specialism to the wider exploration of accepted confines of practice. In both areas of activity, increased demand was placed upon the role of the perceiver/viewer.

Not only were some artists constructing work, or mark-making, in the landscape (Richard Long), but some were rejecting the notion of an art-object altogether (Joseph Kosuth). In order to communicate this inaccessible or ephemeral work, the camera became an increasingly important tool of documentation. Richard Long established a new tradition in English landscape art, whereby the photograph was displayed in the gallery and came to stand in as visual evidence of a piece of sculpture.[10] Perhaps the final irony, in this context, was that however radical the art in attempting to reject the art establishment, the gallery wall retained its status as a prime site and location for exhibition. And it was the photograph that could provide a static permanent display in the gallery or be included in limited edition publications. The camera was considered to be an objective mechanical means of recording sculptural ideas. Initially its neutrality went unchallenged: 'The aspect of documentation has become increasingly important for **Conceptual Art**. The camera as well as the Xerox machine can be used as dumb recording devices' (Meyer 1972: xvii).[11] It was not long before these artists discovered that photography did have its own intrinsic properties which could not be left unexplored. Investigating the medium of photography through both written and visual work soon became the respectable pursuit of a number of artists. The work of Victor Burgin and John Hilliard are two such examples.

At this point we might reflect that the nineteenth-century invention of photography had the result of removing the necessity for painters to pursue representational goals. They began to question issues of visual representation and to explore the nature of the medium: 'Impressionist paintings may be seen as *mirrors* of nature, but above all they convey the idea that they are *paintings* of nature' (Scharf 1968: 179). So it would seem that the very same artistic practices launched by the camera in the late nineteenth century were catching up with photographic practice some eighty years later. Aaron Scharf had also noted that with the spread of the camera's influence the 'awareness of the need for personal expression in art increased in proportion to the growth of photography and a photographic style in art' (ibid.: 179).

Avant-garde practice

Like any other visual art, photography is a dynamic practice which is subject to change and innovation over time. A quick review of any field of photography will reveal how the photographic image in advertising, fashion, journalism and even the family album

has undergone dramatic stylistic and contextual changes over the past thirty years. While some of these changes may be due to technical innovation, most innovations in approach have been determined by the dynamics of photography operating in a changing society. Both factors interact to contribute to cultural change. The relationship between systems of representation and the culture in which they operate is rarely a matter of passive reflection. In this context, photography has provided new visions which have enabled, for better or worse, the transitions from the nineteenth to the late twentieth century. Science and technology, as well as culture in general, demand representational systems to promote and facilitate change. As an example, writing on the role of the visual arts in the broader context of the technical and social change that took place during the Renaissance, Samuel Edgerton predicts that: 'Scientists and historians of the future . . . will study the visual arts not as mere passive reflectors of great ideas, but as active promulgators of those ideas' (Edgerton 1980: 211).

Photography that can be considered avant-garde, meaning that it is in advance of its time,[12] has the sole aim of creating new styles, techniques and the expression of new ideas. Poggioli (1968) sees this as a product of the contemporary artist's alienation from society and similarly, within photography, it is generally regarded as a marginal pursuit, separate from mainstream photographic practice. This is not to say that an image that held good thirty years ago could not do so today, or that some photographic qualities are now out of date, but that there has been a rapid expansion in what might be called 'acceptable styles' of images. And new styles both reflect and create new ideas. This is partly Bloom's (1975) point – that the artist is trapped by the dilemma of either extending his or her tradition inherited from artistic forerunners or by creating work that is, at the same time, new and innovative. In taking a retrospective glance, we often find that yesterday's avant-garde artworks trickle down through a process whereby today's avant-garde becomes tomorrow's popular culture (see Figure 1.9).

In preference to industrial, fashion, advertising and scientific photography, why is the art photograph given so much prominence in the history of photography? Reading through the standard histories of photography one detects distinct favouritism for coverage of those who are on the art side of the medium, i.e. those photographers whose work is most frequently displayed in the gallery. As such it seems to characterise the distinction between pure and applied arts, which separates the efforts of the artist from those of the craftsman. This is exemplified in the nineteenth-century writings of Baudelaire who found 'utility' hostile to 'beauty', which should be independent and superior to any other consideration in the production of art.[13] Nonetheless, the ability to produce innovative work that can radically revise the photographer's traditions of practice has been criticised. According to some critics, the avant-garde and modernist approaches have become part of the art establishment: 'There is no tension, the creative impulses have gone slack. It has become an empty vessel. The impulse to rebellion has become institutionalised . . . its experimental forms have become the syntax and semiotics of advertising' (Bell 1976: 145).

In the 1970s, some critics such as Rosalind Krauss began to move away from the modernist tradition. In breaking the tradition of the artist striving towards originality, she cites the artist Sherrie Levine who 'seems most radically to question the concept of origin with its notion of originality'. Levine was considered to have infringed the copyright of Edward Weston by rephotographing a print by Weston of his son Neil, signing her own name and exhibiting the result.

Figure 1.9 Oxford Street, London, 1998. An advertisement derived from the artist Christo's *Running Fence* appears on the side of a bus.

Photograph by Terence Wright.

Photography as an entertainment medium

It is seldom recognised in the standard volume on 'the history of photography' that photography functioned as a medium of popular entertainment as much as an art or a science (by the photographer Muybridge, for example). One popular curiosity of the mid-nineteenth century was the stereoscope. The stereo photography 'fad' lasted for the fifteen years from 1852–67, though the device had been invented by Wheatstone as far back as 1833, six years before photography's invention was announced. The stereoscope received a significant boost in popularity after its appearance at the Great Exhibition of 1851. While Baudelaire in 1859 complained about the 'thousands of greedy eyes [which] were glued to the peepholes of the stereoscope, as though they were the skylights of the infinite', this development in photographic technology had strong associations with the latest findings in human physiology. In the same year as Baudelaire was expressing his trepidation, the physiological rationale for the stereo-scope was described by the physician Oliver Wendell Holmes on the other side of the Atlantic: 'our two eyes see somewhat different pictures, which our perception combines to form one picture, representing objects in all their dimensions, and not merely on surfaces'. Possibly by coincidence, approaching the decline of the stere-ography craze, Helmholtz published his *Treatise of Physiological Optics* (1866), where he describes the invention, and later (1884) he points out that there is no evidence of

a physiological fusion occurring in the brain whereby the two retinal images form a single stereo image. Returning to Descartes (1637), he had already remarked that there is not another set of eyes in the brain that look at the image derived from the retinae.

This physiological analogy is criticised by Pirenne in *Vision and the Eye* (1967). He cites stereography as another example of misconceptions arising from identifying the instruments of perception with the psychology of perception. In principle, the stereoscope would seem to explain *binocular disparity* (see p. 29) and to extend the visual system, suggesting that two diverse pictures are transferred to the retinae – are received as retinal images – and transferred in turn to the brain where the images of minimal difference are fused or matched together to create a three-dimensional percept: 'the supposition that the information has two parts, one to each eye, and that these parts require fusion' (Michaels and Carello 1981: 119). We might adopt yet another analogy proposed this time by Pirenne (1967: 196): 'if one touches a marble with two fingers, one does not normally feel two marbles'. These views would seem to concur with James Gibson's theory of visual perception.

This chapter has aimed to examine some of the theoretical standpoints that have determined how pictorial representation has been regarded and how it has come to play such a central part in Western culture. A view prevails that we are relying less on literacy: we are becoming more of a visual culture. But the term is not one that can be used lightly: the conditions under which visual images in general have come to operate throughout history, and how photography in particular has contributed to the formation of the modern era, are indebted to the complexity of changing theories of vision and visual representation.

We have moved from considering simple theories of replication, through those that proposed that photography is subject to the same complexities as linguistics, finding that neither extreme offered an entirely satisfactory theoretical model upon which to base photographic practice. Nonetheless, we find that visual images have a complex dynamic relationship with the culture in which they serve. Over the last 160 years, photographs have acquired a unique range of **cognitive** and social functions. They play a central role in extending our perception and widening our understanding of the world, as well as preserving personal records of our interactions and customs. It has been a changing picture and has not settled at any clear or concise theoretical standpoint. Quite how the photograph operates in relation to human psychology is yet to be determined by areas of study outside the remit of this book. To what degree a child is pre-programmed to have an inherent understanding of photographic imagery, or whether he or she relies upon the application of more general learning strategies to make sense of a photograph, remains an open question.

It could be argued that for the photographic practitioner such questions do not need to arise as it makes little difference to taking photographs, although in an environment of rapid social and technological change, the photographic medium is being subjected to shifting emphases regarding its supposed truth and ability to provide an accurate record. Consequently, this will have an effect on its use and function in an increasingly global culture. The photographer of the future may not be able to survive by simply emulating existing codes of practice. The future will prove that some of the issues outlined in this chapter will recur in different guises, accruing increased or diminished significance. Nevertheless, the digital era is creating and revealing complex and diverse systems of operation that photographers and theorists alike may find increasingly difficult to keep abreast with and understand.

Summary

- Issues of photographic realism and whether these accounted for the widespread influence of photography were examined.

- We considered whether the argument that the eye has a similar structure to the camera (and consequently functions in a similar manner) might account for the perceived realism of photographs. They look 'real' because they are formed in a similar way to the way our eyes see the world.

- We examined how, before the invention of photography (in the first part of the nineteenth century), artists had used the camera obscura as an aid to producing 'realistic' images. And we considered the emergence of photography in the context of its historical, cultural and artistic setting.

- Twentieth-century theories of perception that cast doubt upon the supposed relationship between human vision and photographic images pointed to the differences between perception and representation focusing on the unique characteristics of photography.

- Central to this move is James Gibson's *ecological* approach to visual perception, which shared similar sensibilities to the emergence of Land Art and a reappraisal of the modernist agenda in the visual arts.

- The chapter concluded with a recommendation for photographers to experiment with the medium: not to copy existing practice, but actively explore the medium's potential.

2 Pre-production

The aesthetics of photography

> Every time we look at a photograph, we are aware, however slightly, of the
> photographer selecting that sight from an infinity of other sights.
>
> (John Berger 1972: 10)

Despite its original derivation from the Greek verb 'to perceive', the primary aim of aesthetics from the eighteenth century onwards had evolved to include the study of ideas concerning beauty or taste. For example, Baumgarten, in 1735, began to apply Cartesian principles to the arts and, at the same time, coined the term **aesthetics** (Beardsley 1966: 156). More recently, since the beginning of the twentieth century, this field of study has been characterised by a concern for the principles (or rules) of art as well as the broader concerns of artistic practice. In this context, it is the aim of this chapter to establish a theoretical framework that is appropriate to the practice of photography. Nonetheless, it would be very unwise to suggest that successful photographs could be produced by applying appropriate formulae: tastes in photographic representation vary from individual to individual and are subject to change over time. But while concepts of beauty are culture-bound or can be partly determined by the individual's subjective experience, there may be some universal principles which apply to all aesthetic systems. Symmetry, proportion and balance are three such examples. In the art of the Yolngu, the Australian people of north-east Arnhem Land, the Aboriginal word *miny'tji* approximates to the English terms 'design' and 'colour': it 'can also be used to refer to any regularly occurring pattern or design, whether it is natural or cultural in origin' (Morphy 1992: 184). As we saw in the previous chapters, the early practitioners and commentators on photography were led to think of the camera as providing an automatic record of the truth. And here the film theorist André Bazin has been frequently quoted from his paper 'The Ontology of the Photographic Image', where he refers to the 'objective' nature of photography: 'Originality in photography as distinct from originality in painting lies in the essentially objective character of photography ... between the originating object and its reproduction there intervenes only the instrumentality of a nonliving agent' (Bazin 1967: 13).

This is a (characteristically French) play on words: for the word *objectif* has a double meaning with its English translation being equivalent to either 'objective' or 'lens'. Bazin uses this analogy to suggest the automatic objectivity of lens-based representational systems. While the critical theory of photography can appear incredibly complex, seeming to comprise a confusing web of competing perspectives: psychoanalytic, phenomenological, feminist, semiotic, etc., the triangle of realism, formalism and expressionism provides a basis that is appropriate to lens-based media and offers an easily comprehensible structure that enables the student to address the others.

As mentioned earlier, it often appears that theories are mutually exclusive and dogmatic. While sometimes theoretical perspectives are established in strong reaction to the existing theoretical canon, with the benefit of hindsight they seem to blend into each other, cross-breed and develop from each other – appearing as variations on a theme. The intended use of these categories is not to pigeon-hole photographic practice. Rather, they assume that the act of photography usually involves a subject – which is more or less realistically represented; a photographer (or operator) – who expresses something of his or her personality and/or cultural situation; and the formal properties of the photographic medium – which will be more or less evident in the final photograph. For example, if we look at an historical photograph, rather than considering it exclusively in terms of *realism* we would be wise to examine the *expressive* aspects of the image – what were the personal and social constraints on the photographer; as well as the *formal* aspects – the technological limitations and the prevalent styles of photography of the particular period (see Figure 2.1).

As a brief summary, the 'aesthetic intentions' can be described as the photographer intending the viewer to look:

Figure 2.1 Mr and Mrs Edwin and Emily Wilde, early twentieth century, photographed by their daughter (the author's grandmother). Not only has a likeness of the subjects been recorded by the camera (realism), but the image expresses security, assuredness and domesticity. This is aided by the formal elements of the image: the triangular pose of the subjects, the framing with the curtain and the inclusion of domestic artefacts, conforming to the style of the Victorian carte-de-visite.

Photograph by Betty Viner.

- *through* the photograph – as if it were a window: **realism**;
- *at* the photograph – as if it were an aesthetic object: **formalism**;
- *behind* the photograph – to consider what might have motivated it: **expressionism**.

These can be considered the basic aesthetic concerns of photography which centre around recording the subject (realist) through photography (formalist) by a photographer (expressionist). In retrospect, these concerns can be seen to be present in the art of all eras and cultures. However, the intention of artists to pursue these representational goals is very much a late nineteenth-century/early twentieth-century phenomenon. The invention of photography had played a significant role in initiating these tendencies: 'personal expression in art increased in proportion to the growth of photography and a photographic style in art. . . . Impressionist paintings may be seen as *mirrors* of nature, but above all they convey the idea that they are *paintings* of nature' (Scharf 1968: 179). So as photography evolved and its usage proliferated, artists became more concerned with the pursuit of *realism*, that is, to produce paintings that represented 'real life', and they began to consider *formalist* matters or exhibited a greater tendency for personal *expression*. Some painters combined two or all of these characteristics. While this scheme may be considered something of a generalisation, it does have the virtue of providing the building blocks for a theory of photography. It does not pretend to be exhaustive but forms a basic conceptual framework that can aid the student's understanding of photography[1] and encourage the development of his or her own practice.

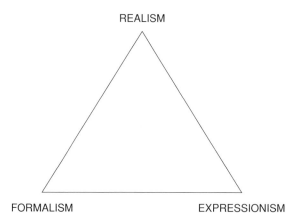

REALISM

FORMALISM EXPRESSIONISM

The diagram represents the ideal notions of realism, formalism and expressionism; they remain outside the triangle as, in mainstream photographic practice at least, they can be considered unattainable. In other art-forms, painting for example, it may be possible to produce work that is non-representational in that it claims to make no reference to the representation of depth, nor any real or otherwise perceived world (this matter is discussed at length by Greenberg (1960)). But with photography, assuming that the image is 'taken' with a camera, the image's source of information, despite any subsequent manipulation, is derived from the physical world. Thus all photographs will contain information about the subject (realism), the medium (formalism) and will contain clues to the intentions behind the production of the image (expressionism).

The author recognises that Expressionism, Realism and Formalism refer to specific movements at particular periods within the history of art. This photographic use of the scheme should not be confused with nor identified with them. For the purposes of this volume the terms have been derived from more general cultural tendencies, as follows:

- *realism*: the 'willed tendency of art to approximate to reality' (Levin 1963: 68);
- *formalism*: 'Any school or doctrine that emphasises, any emphasis on or preoccupation with, form or forms or formal elements in any sphere: of thought, conduct, religion, art, literature, drama, music, etc.' (Bullock and Stallybrass 1977: 240);
- *expressionism*: 'A quality of expressive emphasis or distortion, to be found in the works of any period, country, or medium' (ibid.: 223).

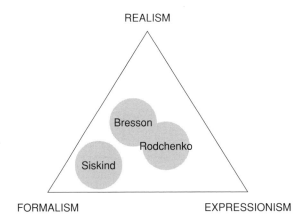

So when these terms are applied to photography, they can be summarised as representing three interrelated viewpoints: *realism* – which prioritises the photographed object or scene; *formalism* – concerned with the qualities of the photographic medium or the photograph as an object itself; and *expressionism* – the viewpoint of the photographer. For example, in the 1920s the 'f-64' group founded in California aimed for 'straight photography' – addressing the image in terms of both realist and formalist issues. Rather than interpret the subject matter, they used photography to present the subject to the viewer, relying on the medium's characteristics of detail, focus and clarity. This theoretical framework for the photograph applies more to the pre-production of photography and may be linked to the intention of the photographer or the characteristics of the photograph that may be sought by the viewer. The diagram above gives an indication of how the work of three photographers might fit into the scheme.

Realism

The arguments for photographic realism were addressed in the last chapter. To summarise, they rested on the mechanical automatic operation of the camera, the perceived similarity between the camera and the eye (identifying photographic representation

with our usual visual perception) and the fact that photographs (to the naive observer at least) tend to look like the subject. As we saw earlier, the film-theorist André Bazin in proposing his theory of realist cinema believed in the objective nature of the camera. It could automatically achieve objectivity because it was a mechanical device that could produce an imprint with little recourse to the human agency. This replication of reality had been the initial goal of the painter in classical times, and the ideal of the representation that is true to life has remained an important consideration in contemporary media and the new technologies. For example, the notion of virtual reality is characterised by more and more detailed attempts to fulfil most of the conditions that create verisimilitude. Certainly, at the time of photography's invention, it was thought that the trace produced by the camera automatically fulfilled the representational goals of Western art. The painter Delaroche, responsible for the notorious pronouncement 'from today painting is dead', had reported:

> The painter finds in this process an easy way of making collections for after-study and use which otherwise are obtainable only at great expense of time and labour, and yet perfect in quality, no matter how great his talent may be.
>
> (quoted by Arago 1839, in Trachtenberg 1980: 18)

At this point we encounter a further philosophical problem as, inevitably, we must ask what is this reality against which photographic images should be judged? At its extreme, photographic realism is marked by attempts to suppress any evidence of the photographer's role or the viewer's perception of the medium of photography.[2] The intention is to produce a *trompe l'œil*, fooling the viewer into believing that they have access to unmediated perception of the scene. Perhaps this accounts for most of our common uses of photography as proof or evidence and for identification in passports, mug shots, forensic photographs, etc. The historical photograph can provide evidence about how things once were (though should be approached with caution and not be taken at face value). Nonetheless, the use of photography for forensic purposes is perhaps at the extreme of realist practice. The camera is used to provide quantifiable information. This was also the intention of the early use of the camera by anthropologists (Wright 1992a), where the assumed objectivity of the photograph could provide information for what was considered to be a **positivist** discipline. In **ethnographic photography**, the nineteenth-century anthropologists were concerned to produce photographic work in the context of positivism,[3] relying upon information that was scientifically valid and quantifiable. But, used in this way, the camera proved itself unable to record the social facts as were later demanded by British social anthropology, which emerged in the early twentieth century supplanting the evolutionary approach to the development of culture.

However, in the positivist context, the photograph is intended to function as a *record* rather than an *interpretation* in order to represent what an observer-on-the-spot would have seen. Its ability to provide evidence is governed by the photographer adhering to certain rigid requirements and criteria. The image should contain no distortion and the photographic method should aim to be straightforward and accurate. Naturally this may still be open to interpretation but, in order to try to achieve these goals, the forensic image would be photographed whenever possible with a standard lens yielding normal perspective and depiction of the objects at the same relative size to achieve optimum clarity in the photograph.

Although this attempt to bring about a neutral objective image is usually regarded as the province of science, some photographers working in the genre of fine art have attempted to minimise aspects of projection by producing a frontal image (see Figure 2.2), or have reduced the amount of minification or magnification so as to provide more of a direct transfer of the object onto the picture-plane. For example, Edward Weston referred to himself as a 'straight' photographer, and looked for the 'basic reality' of the things he photographed recorded by the camera's 'innate honesty'. We might even cite the Russian photographer Alexander Rodchenko who took to an exploratory investigative approach which involved examining the subject 'in the round rather than looked through the same key-hole again and again'. However, as we shall see later, there can be quite different opinions regarding the exact terms of the reality that the photographer considers him or herself to be recording.

As we have already seen in Chapter 1, the history of photography has closely shadowed that of mainstream art and over the years their paths have frequently crossed. In one such period, during the late 1960s/early 1970s, a number of artists adopted the camera as a means of documenting transient artworks that were often sited in obscure locations – Richard Long for example, who established a particular landscape tradition that has since been adopted by other artists such as Andy Goldsworthy. Although the site for the construction of the work had moved from the gallery into the landscape,[4] photography became an essential means of displaying artworks to a wider public.

However, despite their intentions towards photographic realism in which the photograph would serve as a 'transparent' record, it soon became apparent that the photograph was altering the viewer's appreciation of the artwork. Photography had its own unique characteristics and formal qualities which led sculptor Walter de Maria

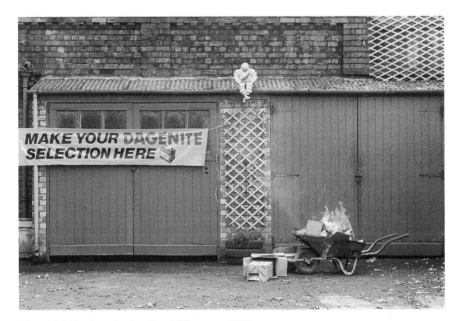

Figure 2.2 Incubus, London Road, Worcester, 1989.

Photograph by Terence Wright.

to state: 'this sculpture was not made with the intention of creating a situation for a photograph. The photograph, through repeated use, throughout the years, has inadvertently come to be a work in its own right' (de Maria 1980: 44).

The problem remains that, despite the photographer's intentions towards realism, the photograph is an object with an arrangement of surface elements which can have only a limited correspondence to the three-dimensional world. This can be described as the dual nature of the photograph: the photograph as representation and the photograph as a two-dimensional object.

As we have seen, the camera has the ability to record a limited amount of the information that is available in the environment. However, in doing so, the process will add its own qualities and is well able to distort this information. Some photographers, however, have become exclusively concerned with the medium of photography itself and have made the scope and limitations of the medium the sole objective of their visual investigations. As art critic Richard Cork put it in 1975:

> All too often, the camera tends to be employed as a useful technological convenience rather than as a visual recording device with its own uniquely circumscribed set of capabilities and limitations. . . . Photography does entail a material entity in its own right, whether the artist likes it or not.
>
> (Cork 1975: 60)

Formalism
...................................

> Whether . . . art has pretensions towards 'realism' or not, it remains as 'bound' by conventions which act as rules as much as a game of chess does.
>
> (Terence Hawkes 1977: 73)

Whatever intentions the photographer may have with regard to recording reality in a photograph, it nonetheless remains that photography is a medium and the characteristics of that medium act as both vehicle and obstacle to the scene recorded. Even if the photograph is intended to act as a window on the world, the viewer cannot help but perceive the window at the same time as viewing the world. So the photographic representation of a three-dimensional scene depends upon the camera's projection of an image on a two-dimensional flat surface. Once an experience is mediated it becomes subject to the scope and limitations of the particular medium employed. And, as we shall see later on, it also remains bound to the social and cultural conventions which provide the broader context of the mediated experience.

The tendency for artists to acknowledge openly the form of a painting emerged during the late 1860s. During this period the full social impact of photography was becoming clear. While Scharf (1968: 179) notes that these changes can be attributed to the 'encroachments of photography on naturalistic art', Malraux had proposed that 'modern art began when what the painters called "execution" took the place of "rendering" . . . for Manet the drawing, the rendering of skin, came second; his sole object was to make a picture' (Malraux 1954: 116). This idea of 'making a picture' is particularly characteristic of modernism where concern with the process or the medium is foremost (Greenberg 1960).

While photographs are not made up of brush strokes as is a painting, the fixing of a two-dimensional pattern upon the pressing of a button is a fact of life for the photographer. In painting, the two-dimensional pattern was referred to by Delacroix as the 'music' of the painting and furthermore it is clear that Delacroix made use of photography (Scharf 1968: 119–25) as a sketchbook to make preliminary studies for his paintings. 'In most painting, this canvas pattern does provide the "music" of the painting . . . This "visual music" does somehow get mentally integrated with the perception of the scene depicted in depth' (Pirenne 1972: 95).

The dual awareness of the scene in depth and the surface pattern of the image – as in the rabbit/duck illusion – may be an *either/or* phenomenon. Sir Kenneth Clark (1949) describes his attempts to 'creep-up' on a painting, trying to catch the moment when the brush strokes became a picture: the point at which the representation transforms into the art-object. Once again, it seems that one or the other perception has to predominate.

Cartier-Bresson (1952: 47) seems to suggest that the surface 'pattern' may be perceived at a subconscious level; he nonetheless considers it to be a key feature of photography and integral to perceiving the photographic image: 'if the shutter was released at the decisive moment, you have instinctively fixed a geometric pattern without which the photograph would have been both formless and lifeless'.

While Cartier-Bresson's approach relies upon the underlying *formal* properties of the photograph, Aaron Siskind (1956: 98) maintains their priority emphasising form over content: 'I accept the flat plane of the picture surface as the primary frame of reference of the picture . . . the object serves only a personal need and the requirements of the picture'.

Despite the rationale for the photograph's replication of physical reality, Siskind has shifted his emphasis to the pictorial characteristics of the image whereby form is considered to be an end in itself, maintaining its own justification. This concern with the form of the picture is very close to Bell's notion of the 'significant form' which stirs the emotions. Again, picking up on Delacroix's musical analogy, in the 1950s Suzanne Langer maintained that 'music is a tonal analogue of emotive life' bearing 'close logical similarity to forms of human feeling' (Langer 1953: 27).

As we saw in the last chapter these sentiments are characteristic of their era, with the formalist agenda culminating in Greenberg's notion of *modernist painting* of 1960. The alternative view of this tendency in photography has considered that this approach is forcing photography into an aesthetic straitjacket borrowed from painting. The Russian literary critic Viktor Shklovsky (1917) believed that the purpose of poetry was 'to make objects "unfamiliar", to make forms difficult, to increase the difficulty and length of perception because the process of perception is an aesthetic end in itself and must be prolonged. *Art is a way of experiencing the artfulness of an object; the object itself is not important*' (Shklovsky in Lemon and Reiss 1965: 12).[5] This approach, with certain similarities to James Gibson's active perception (see p. 28 of this volume), suggests that the photographer's formalist use of the medium can deliberately create an obstacle between the viewer and the object, so that the viewer, involved in making efforts to overcome the medium, is forced into adopting a new perceptual standpoint with regard to the object – that of seeing a familiar object in a new way. I think we can assume that in such instances the medium must not be so impenetrable that the viewer loses interest in engaging with the photograph. According to the Russian formalist critics, images in poetry have never really changed; what has

changed is the form of the poem. And if we are to apply this view to photography we might suggest that, despite technical innovations in photographic equipment and materials, the subject matter of photographs has changed relatively little – portraits, landscapes, war, etc. Yet the style of these images has changed over the years, as has the photographer's approach to a rapidly acquired repertoire of subject matter.

An extreme brand of formalism is **self-reflexive photography**; this is characterised by the photographs which have an overall concern with informing the viewer about the ways that the medium of photography operates – photographs about photography. This type of work has often been criticised as being introspective as it does not tell us about the world as normally expected of the medium; rather, it only informs us about photography. Nonetheless, this approach can have the virtue of drawing renewed attention to the scope and limitations of the photographic medium, to make unfamiliar those characteristics to which, because of our everyday encounter with photographs, we may have become blind. For example, it may remind us that the photograph is only an image imprinted on a flat piece of paper, or it may reveal certain anomalies in photographic representation.

This form of practice may become an important aspect of the photographer's work in an attempt to push the boundaries of the medium to find the ways that photography can best work in order to widen the photographer's own repertoire of photographic effects, vocabulary and style and to establish an individual way of seeing. Essentially, it involves a conscious activity of experimentation with the photographic medium.

What is the significance of this for the wider practice of photography? This approach can provide valuable explorations into the capabilities of the medium, readjusting its scope in the contexts of social and cultural change. It can enable the practitioner to understand the character of photography. This might be considered particularly useful in contrast to the early years of photography, where innovation in photographic work can appear to have been somewhat limited by the accepted canon of art and by the employment of metaphors with current technologies.[6]

Expressionism

Traditionally, this approach has been characterised by the photographer choosing and photographing a subject not on its own merits, but because it has qualities that express the photographer's innermost feelings. One might say that the photographer finds something in the world he or she can identify with and can photograph it in such a way that it expresses a feeling or thought process. It aims to present a subjective reality by means of transforming what the photographer sees in the physical world into a photographic image which projects the photographer's inner self. In this context, the symbolic value of the image may be more important than straightforward denotation. Although it depends on a photographed object, the final image is not so much concerned with recording what is out there nor with the medium of photography but with the photographer's own way of seeing. On the one hand, it could display the unique vision of an individual, on the other, the type of society to which we belong, or it could include expressing the need for social change.

For example, the surveillance image produced by the automatic, photographerless camera, as Kember (1995) has pointed out, played an important role in solving

the crime of the abduction and murder of the toddler James Bulger, and the post-production images were important in the reporting of the crime. The same images were used in a number of papers, in a variety of contexts. Although the stills which had been grabbed from the video footage derived from security cameras were fuzzy and nearly useless, it returns us to the assumed value of the photograph, no matter how out of focus. Its value is that it is *a photograph*. We have an image that owes its existence to a non-living agency which nonetheless still has the power to create a wide range of speculation and potential meanings. For example, the impersonal images from the all-seeing eye of the surveillance camera can in themselves express horror or dismay in our society.

In contrast to the other two categories, expressionism in photography has less to do with presenting a realistic representation or producing an interesting formal picture and is more concerned with the photographer expressing his or her own point of view. It could be the unique expression of the artist's inner self – the subjective world; or the expression of the artist's social, cultural and historical situation. So expression can be of an extremely personal, perhaps even of a spiritual nature, or it can express a strong political opinion. It may intend to instil in the viewers empathic contemplation or it may aim to change their opinion or even stimulate them into taking some form of social action. In some feminist photography, for example, the objective of the photographer can be to arouse the viewer's empathy with a social situation, with the longer-term aim of creating social change or promoting social responsibility (see Figures 2.3a and 2.3b).

Photographs in this category do not need to be so concerned with recording the perceived world. Examples are the constructed images of Valie Export in which she mimics the poses of classical painting: 'I am trying to whittle out the expression and to give it independence. ... I am dealing mainly with female postures from a feminist viewpoint' (Export 1977: 168). Or, depending more upon the formal manipulation of photographic material, there is the photomontage work of Peter Kennard (see Figure 2.4).

Extending the tradition of political commentary established by John Heartfield (Evans and Gohl 1986) and to stimulate social action is: 'political photomontage in the service of the proletarian movement' (Klingender 1935). As for the photographic tradition, this attitude can be traced back to C. Jabez Hughes' (1861: 260–3) **pictorialism** whereby a photographer, 'like an artist, is at liberty to employ what means he thinks necessary to carry out his ideas. If a picture cannot be produced by one negative, let him have two or ten.' Here, realism becomes subservient to the photographer's expression as do the formal aspects of the image whereby 'the picture when finished must stand or fall entirely by the effects produced, and not by the means employed'. This sentiment has been subject to something of a revival with the increased use of digital photography.

With the advent of postmodernism, photographers have aimed to shift the emphasis of expression away from the genius of the individual artist's unique and privileged viewpoint to that of cultural expression which recognises little distinction between the connoisseur and mass culture: 'original and reproduction, high and low art, entertainment and information, art and advertising' (Jan Zita Grover, quoted in *The New York Times Magazine*, 9 October 1988).

If we look for the origins of expressionism in photography we find that the medium had inherited some of its attributes from the attitudes and theories of painting. For

Figure 2.3a Industrialisation (1), 1982.
Photograph by Jo Spence. Courtesy of The Jo Spence Memorial Archive.

instance, styles of expression in nineteenth-century British landscape photography can be traced to the expressionism of the paintings of Turner. In this regard, there is a sense of idealism which retains some of the characteristics of Berkeley's argument: between appearance and reality, but now introducing emotion. Indeed, E.H. Gombrich (1950: 373), in his viewing of a Turner, is prepared to direct his attention away from realism in favour of expressionist criteria: 'I do not know whether Turner ever saw a storm of this kind, nor even whether a blizzard at sea really looks like this. . . . In Turner nature always reflects and expresses man's emotions.' Furthermore, Ruskin

Figure 2.3b Industrialisation (2), 1982.

Photograph by Jo Spence. Courtesy of The Jo Spence Memorial Archive.

(1860: 366) had found obvious connections with the work of the early photography: 'A delicately taken photograph of a truly Turnerian subject is far more like a Turner in drawing than it is to the work of any other artist.'

The 1920s witnessed a renewed influence of expressionism over the mechanical arts of film[7] and photography. Artists such as Caspar David Friedrich (a German contemporary of Turner) came to be cited as occupying the same line of descent as the photography of the 1920s. Heise, describing the work of photographer Renger-Patzsch, finds:

Figure 2.4 Crushed Cruise, 1981.
Photomontage by Peter Kennard.

These are pictures of the life of the earth in the sense of Caspar David Friedrich. In this way a relationship between the painter and the photographer is both possible and fruitful – not because of the style of the image, but because of the similarity of conception.

(Heise 1928: 11)

A more contemporary example is the work of Cindy Sherman, whose self-portraits show her in a series of fictional stereotypical roles which reflect the ways in which the mass media have traditionally portrayed women (see Figure 2.5). Her work contains aspects of performance art and photo-narrative. Of course, in the situation of making a self-portrait, one is at the same time photographer and subject. In this case one is able to develop the idea of self-projection. In Sherman's case she presents the viewer with a series of Jungian-style archetypes that might have contributed to the make-up of her own personality and fantasies. She has photographed herself in a number of guises or identities which have been derived from film and media images:

There is a stereotype of a girl who dreams all her life of being a movie-star. She tries to make it on the stage, in films and either succeeds or fails. I was more interested in the types of characters that fail. Maybe I related to that. But why should I try to do it myself? I'd rather look at the reality of these kinds of fantasies.

(Sherman 1982: 8)

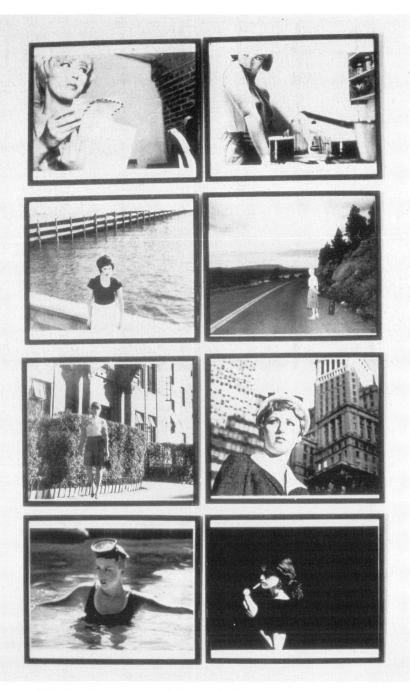

Figure 2.5 Untitled film still, no. 48 (Hitchhiker), 1979.

Photograph by Cindy Sherman. Courtesy of the Saatchi Gallery, London, and Metro Pictures.

At base, Sherman's portraits seem to be asking the question 'Who am I?' by examining and presenting possible influences on her life drawn from popular culture. In this way, she is dissecting her own personality into those constituent parts that have been created by impressions and images which she has subconsciously combined and incorporated into her own character formation.

The shoot
.........................

Having considered the balance between the photographer's approach to recording the subject of the photograph(s): realism; the way the characteristics of the medium are to be used and featured in the representation: formalism; and the photographer's own personality and cultural milieu evident in the photograph: expressionism, we can now move to consider how this is put into practice. One of the central difficulties for photographers upon approaching a subject is estimating how the final photographs will measure up to their perception of the event in real life. It becomes necessary for the photographer to visualise the event in photographic form.

Figure 2.6 Nat West Tower, London (1), 1997.

Photograph by Terence Wright.

Figure 2.7 Nat West Tower, London (2), 1997.

Photograph by Terence Wright.

What does all the aforesaid mean to the photographer on a photojournalist assignment? The context of the event may determine the type of image and approach expected of the photographer in photographing the National Westminster Bank building in the City of London, for example. The photographer may be asked to produce an image in the context of *realism*. The commissioning media organisation would be expecting a realistic likeness with even lighting, minimal perspective distortion – a **stock-shot** that would be suitable for a variety of contexts in a broad range of applications. It would have the basic demand of showing what the building looks like (see Figure 2.6).

In contrast, a *formalist* emphatic image may be required to appear on a front cover, possibly with the purpose of enticing the reader to purchase the journal. Here the requirement could be for an interesting photograph, perhaps with dramatic colour or lighting, or a small section of the facade, or possibly something of a puzzle picture. The photograph may not need to be recognised as being of the particular building (see Figure 2.7). If a caption were used to locate the image, it could aim in Shklovsky's

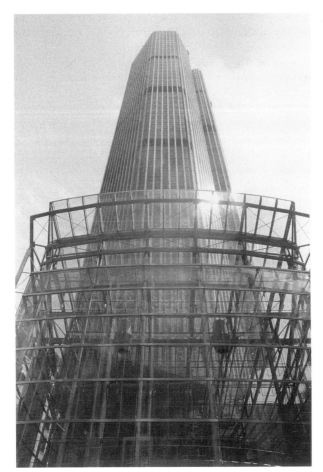

Figure 2.8 Nat West Tower, London (3), 1997.

Photograph by Terence Wright.

words (see p. 43 of this volume) 'to make objects "unfamiliar", to make forms diffi-cult, to increase the difficulty and length of perception'.

Yet again in the *expressionist* context, the photographer could be sent to photo-graph the building in such a way that expresses the power (and possibly the corruption and menace) of the city institutions. The photograph may show the building as domi-nating or menacing, possibly using a wide-angle lens that exaggerates the normal perspective of the building (see Figure 2.8).

Visualisation

you can visualize any final image that your imagination and your technical mastery make possible. Visualization also includes the effects of camera position, the focal length of the lens, and your personal approach and orientation as a photographer.

(Ansel Adams 1973: 228)

The central concern of **visualisation** is that of accounting for the relationship between the photographer's everyday perception when compared with how the scene or event will appear as a flat, still, visual image, divorced from its original context. Rather than recording the scene that you see, the camera records the pattern of light that the scene reflects or emits. In contrast to making an image of a three-dimensional physical world, the camera makes its image from the light that the physical world reflects. Ernst Gombrich (1975), for example in his paper 'Mirror and Map', in pointing out some of the consequences for visual representation, distinguishes between these two modes of recording. The photograph records visual phenomena that alter as the light changes, in contrast to a map which plots more permanent features of the terrestrial layout. For example, shadows do not cause us problems as we walk around the environment, but when we take a photograph such intangible and ephemeral phenomena appear as solid and permanent elements of the photograph. As we have already discussed, our systems of visual perception have developed to account for the stable features of the environment with less concern for the illusory or impermanent characteristics. So, seeing photographically involves imagining the scene from the unnatural static viewpoint of the camera. It means that the photographer must become especially aware of the light and other visual qualities of the scene. 'Seeing photographically', according to Edward Weston,

> is [the photographer] learning to see his subject matter in terms of the capabilities of his tools and processes, so that he can instantaneously translate the elements and values in a scene before him into the photograph he wants to make.
>
> (Weston 1943: 173)

At the same time, photographers often need to distance themselves from events. Of course, it is essential to be aware of events that are going on around them but the final images resulting from photography will appear divorced from the context of the event. Also, it goes without saying that they will not record the perceptual cues of sound, nor will they automatically convey atmosphere. This will depend on the photographer's skill and ability in expressing such qualities in visual form. This is most commonly experienced in photographs of rock concerts, where the images seen in the cold light of day without the music can appear stilted and lifeless.

However, this ability of photographers to distance themselves from the events they photograph has generated criticism. Placing the camera between the operator and the event can render the photographer as disregarding human suffering, creating the illusion that he or she can adopt the role of the detached recorder of events, fulfilling a function with no requirement for emotional involvement. For example, Malcolm Browne, who photographed the burning monk in Saigon, believed 'I had no point of view. I was concerned that the [photograph] be properly exposed, since the subject was self-illuminated that wasn't much of a problem' (quoted in Moeller 1987: 355).

Similarly, Harold Evans (1981: 80–1) reproduces a photograph of the massacre in the Bangladeshi polo field, photographed by Michael Laurent in 1971. Seemingly, the photographer, among other onlookers, continued to photograph while people were being bayoneted in front of him. This not only raises the question of the detached photographer but the possibility that the presence of the camera acts as a stimulus or audience for people's actions and actively encourages events that otherwise might not have happened. The purist approach to photographic realism can suggest that the

photographer does nothing to intervene on the scene. The image is taken with the aim of being strictly observational (or fly-on-the-wall), with not the slightest stage direction, not even removing one blade of grass. All the photographer can do is respond to events by selecting the appropriate camera angle and viewpoint, etc.

One way of avoiding the tricks of the light and other unpredictable elements is to set up the image. This more careful approach to photography involves staging the photograph where the image is planned in advance – an example of high-control photography. In these instances the image is preconceived, then the conditions and arrangements for the image are established, organised and executed. Rather than responding to events it becomes a matter of art direction, with much less dependence on the photographer's spontaneity. The concept for the photograph may be the idea of a journalist or picture editor and can reduce the photographer's role to that of a mere functionary who may be brought in at the last minute to make a photographic record of a predetermined scene. In ideal conditions, for this type of shoot, the photographer is involved at the outset and is expected to contribute his or her expertise to a photograph that depends more on teamwork than on the vision of the individual.

Another consideration for the photographer is whether to shoot in colour or black and white. In most commercial instances this choice will be prescribed by the journal, and some clients may ask for both. In this case it is useful to be able to establish which film-stock is to be given priority, as in a spontaneous situation it is not always possible to replicate shots. The shooting becomes more straightforward if you can shoot with the prioritised film-stock in one camera, using another camera body loaded with the other as a back-up.

While in monochromatic photography an image lacking in colour will appear very different from the real world, it can have the added benefit (or hindrance) of romanticising the subject or of accentuating the graphic elements of the picture. At the same time it can radically alter the significant elements of the image. Bright, vibrant, coloured objects in the distance can be reduced to total insignificance in the monochromatic photograph. However, in colour photography the reverse is often the case, whereby the intentional nature of perception can direct the photographer's attention away from insignificant but very colourful features which later can dominate the photograph. Whatever the standpoint of the photographer, the success or failure to communicate to the viewer depends upon the ability to control the medium to produce the desired effect.

Composition

.......................................

> Composition is an essential part of a good photograph; photography as an art has no meaning without it. But composition, like technical craftsmanship, is a means and not an end. Expression is the end. If composition is made the end, the result will be self-conscious, artificial and lifeless. Expression and composition are like life and body – a unity. Body by itself is a corpse.
>
> (Eric Samuel de Mare 1972: 64)

The idea of composition is a complex one. At the outset photography had adopted the compositional rules of painting. These were laid down by Henry Peach Robinson (1869) and became the bible of the amateur photographer. In painting, the placing and

formal arrangement of pigment on the painted surface is an essential part of the process. With photography, however, composition depends more upon changing the spatial relationships within the picture by selecting lines of sight and lens projections. By 1911 new styles of photographic composition were beginning to emerge. Photography, having released painting from representational goals, was now becoming subject to the abstract trends of painting, though with a distinctive photographic style. We have already seen the formalist aspects in the work of Aaron Siskind and Cartier-Bresson: how a two-dimensional pattern is imprinted on the picture-plane upon releasing the shutter and that, according to Pirenne, our subsidiary awareness of this pattern forms an essential part of our perceiving depth in the image. However, this view has been countered by moves towards an anti-aesthetic which has aimed to repress the formalist elements of the image in order to prevent them from detracting from the importance of the subject-matter. If the image is to convey a serious political message or if it aims to portray human suffering, for example, its impact may be weakened if its beauty as an image is perceived first and foremost. Whichever approach the photographer may aim to take, he or she cannot prevent the creation of a two-dimensional surface design and decisions must be made to accentuate, use or diminish the print's aesthetic qualities. Like composition in music, there are certain principles that characterise an artistic tradition but to compose by pre-established formulae invariably produces a dull and lifeless work. And innovative work often depends upon deviating from, rather than adhering to, the rules (or fixed patterns) to extend the boundaries of photographic practice.

Framing

Framing is the process of 'lining up' the camera with the subject at the time of taking the photograph. Adjusting the camera angle and its distance from the subject enables the image to be composed through the viewfinder. Essentially it involves adopting the appropriate camera angle and viewpoint to fit into the picture all the information that the photographer considers to be significant. It can aim to give a clear, contained, accurate picture of the subject, or it can aim to hint at the subject and/or tantalise the viewer by **cropping** the subject with the edge(s) of the photograph. From a formalist point of view, it can mean positioning the camera to allow the projection of the required elements onto the surface of the film. This might aim at composing a pleasing or emphatic arrangement of shapes and/or patterns that will appear in the final print.

While it may seem an obvious statement, at the moment before pressing the shutter all that is seen through the viewfinder is in its natural context. The photographer's normal perception is operating on the whole environment both before and after taking the photograph. At the moment of pressing the shutter everything in the line of sight in the selected piece of the environment collapses onto the two-dimensional picture-plane and is cut from its original context. The image will subsequently appear in an entirely new context.[8] Here it may depend upon (or even play upon) the viewer's speculations or imaginings with regard to what took place before, after or outside the photograph. In this way context, as much as content, determines the photograph's meaning.

If, as Susan Sontag (1977: 14) suggests, the camera is like a gun, it is like a shotgun in that it is fairly indiscriminate. Everything within the broad range of the camera's

Figure 2.9 An example of false attachment, 1982.
Photograph by Terence Wright.

format, from foreground to far distance, as long as it is in the camera's line of sight, will appear in the photograph. As the photographer changes position the alignment between close, near and distant objects changes, creating different pictorial effects in the images. This can result in the classic photographic illusion of **false attachment** through the photographic compression of space. Objects in the distance are compressed in the camera's projection onto the picture-plane and appear attached to objects in the foreground (see Figure 2.9).

As an example of how minute changes in camera position can result in dramatic consequences in composition, one can adopt the artist's technique of holding out your arm in front of you. Keeping your head in the same position, close one eye, view the scene, then view with the other eye. In terms of the picture, your hand will appear to have moved significantly in relation to the background, despite the small distance involved in looking first through one eye and then the other.

Because of the relatively small negative size of the 35 mm camera system it becomes important to make optimum use of the negative area. This means that while the photographer can afford to waste little of the picture format, he or she can afford to experiment with a wide range of *framings* and take many more photographs to achieve the desired effect than would be feasible for the photographer with a larger format camera. In the case of medium or large format cameras, there is a little more flexibility in pictorial composition. Framing is established at the time of shooting, but can be subsequently modified when printing the image without losing too much image quality. With 35 mm, aim for greater economy, because if one wants to obtain the best possible image quality one cannot afford to lose much of the picture area through cropping. However, the most minute changes in camera position can result in the most dramatic changes in the photograph's appearance.

Figure 2.10 Vue en haute, Paris, 1988.

Photograph by Terence Wright.

The frame itself acts as the primary boundary of the image, forming a physical and conceptual barrier between the illusory world of the picture and the world of reality. It can be used to contain information or to suggest the existence of objects (or of formal elements) beyond the confines of the picture. The idea of cutting off the subject with the edge of the frame is a particularly photographic compositional phenomenon. After the invention of photography it influenced such artists as Caillebotte and, as a compositional device, appears in his paintings (see Scharf 1968: 176). Photography not only introduced new styles of framing, but also gave rise to a special interest in the view from above (see Figure 2.10).

Size and type of frame can act as signifiers as to how the image is to be regarded and the relationship the viewer has to the photograph. The width of the frame can act as more or less of a barrier setting the image apart from the spectator's space, or an ornate frame can suggest that the image is to be considered a special (or art) object. One might contrast this approach to early cave paintings where the boundary of the image is determined by the natural shape and form of the surface (see pp. 1 and 18 of this volume). The photographed scene or object sets up a dynamic relationship within the frame of the image. It can act as a stabilising factor, can set up tensions inside or imply an extension of these factors outside its boundary. It will be affected by the chosen format of the camera – for example either:

Rudolf Arnheim (1956) has shown how the dynamics of composition depend upon the relationship of the depicted forms to the frame. For photographs this is partly true but Arnheim's scheme, if applied to photography, begins to reveal the inadequacy of basing photographic composition on abstract principles. Photographic composition is more to do with vistas and lines of sight than with the physical arrangement of elements within the picture. There is no recipe or formula for producing a successful photograph; rather, the photographer must take into consideration a set of variables. Rather than providing a set of finite principles of composition, it is safer to assume that the motivating force behind any photograph is the photographer's ability to fit the subject into the frame with the greatest efficiency. So the compositional variables will be governed by the subject and its context, the message to be conveyed by the photographer, as well as the final context of the print.

Camera angle

One must take several different photographs of an object, from different places and positions as though looking it over.

(Alexander Rodchenko in Lavrentiev 1979: 31)

Rodchenko's active exploratory use of the camera not only amounts to wise practical advice for the photographer, it also had political motivation. He believed that his unusual views could present a new reality. In line with the political thinking of the new Soviet state, it was considered that a new social order should demand a new mode of representation:

> We must seek and find, and (rest assured) we shall find, a new aesthetic, together with the enthusiasm and pathos necessary to express our new reality, the Soviet reality, through the medium of photography. . . . It is our duty to experiment.
>
> (Rodchenko in Shudakov 1983: 18)

The type of exploratory approach advocated by Rodchenko can create dramatic changes in the way the image appears. In contrast, many photographers display the unfortunate tendency of taking all their photographs at eye-height. This in itself restricts the many possibilities of points of view which they could adopt. So out of all the possible positions for the camera, most photographs are taken from within the height range of 4′ 9″ to 5′ 9″. All too often this results in a dull or ordinary photograph. However, in adopting Rodchenko's recommendation and taking up a variety of viewpoints, the photographer is enabled to express a variety of meanings and can suggest his or her personal point of view or interpretation of the subject. For example, while a ground-level viewpoint or an elevated position can add impact or drama to the image, it sometimes requires only the slightest change in camera position for all the dynamics of the photograph to alter. It can be demonstrated that all the spatial relationships within the image change.

A different lens cannot only magnify the field of vision, but can also alter the spatial relationships and relative size within the picture (see Figures 2.11 and 2.12). The change of lens and camera viewpoint alters the relationship between the constituent parts of the image. The longer lens projection compresses the space with the effect of enlarging the trailer, while in both images the size of the tree remains relatively unchanged.

To help ensure accurate exposure or to acquire the desired effect with regard to colour saturation, etc., in some situations it may be desirable to **bracket** the exposures. This technique aims to make sure that at least one exposure of several will be correct or to achieve a range of variations. The intention is to reduce all variables within the image (except for the exposure), so that the images will be identical in composition but not in tonality. Usually it is achieved by taking a photograph at what is estimated to be the correct exposure reading then following this shot with two more shots, one below and one above the first reading. While this can be accomplished by changing either the aperture or the shutter-speed, it should be noted that if the aperture is used the photographer may experience slight variations in the depth of field in the image. Of course, this should not be taken to suggest that this recommendation in any way lessens the need for correct light metering in the first instance. Rather, it offers an additional safety measure in situations of rapidly changing or unpredictable lighting.

Figure 2.11 Wooton, Oxfordshire, 1997, taken with a long lens.

Photograph by Terence Wright.

Figure 2.12 Wooton, Oxfordshire, 1997, taken with a wide lens.

Photograph by Terence Wright.

The camera

We are beginning to see that the medium of photography depends upon a series of selections. The photographer not only makes the choice of camera format and film-stock, but also of the camera angle, viewpoint, shutter-speed and aperture, then chooses the appropriate development and selects images from the contact sheets and the final prints with the necessary cropping, captions, etc. As there is a wide range of camera types and formats available for the photographer to choose, the selection of the right appliance for the job is not necessarily straightforward. Each will offer and determine different approaches which the photographer will make towards the subject. Primarily, they will differ in their manoeuvrability and image quality as well as dictating the ratio of the frame which will influence the overall composition of the image. It should be remembered that though there is greater flexibility afforded to the photographer using a 35 mm camera in terms of images to choose from, manoeuvra-bility, ease of shooting, etc., these gains may be at the cost of relative image quality. Different camera systems also alter the way the photographer views the subject: some have separate viewfinders, or they (SLRs) offer virtually the same scene (give or take a fraction of a second) as will be recorded on film, while others employ a coupled rangefinder system that approximates to the 'scene' yet is very quick to use. Yet again, a camera with a waist-level viewfinder 'automatically' presents a different camera-angle and offers the photographer a mirror image view of the scene which can facilitate pre-visualisation. On balance, the auto-focus single lens reflex camera is most likely to be used in photojournalism, given its ease of use and the image quality now avail-able from modern emulsions coupled with the image quality of most publications. The choice of camera format and film-stock determines the selection priorities and the shooting style of the photographer. In general, this relationship can be summed up in the following diagram:

	Format		
	Large	*Medium*	*Small*
Control	high	>>>>>>>>	low
Image quality	high	>>>>>>>>	low
Spontaneity	low	>>>>>>>>	high
Shots	few	>>>>>>>>	many

Whichever type of camera is chosen, it is important that the photographer learns to use it well so that taking photographs becomes second nature. Total familiarity with one's photographic equipment is essential. For example, on a portrait shoot the photog-rapher has to do at least three things at once: engaging in conversation with a subject who may feel uneasy about having his or her photograph taken (see quote by Roland Barthes, p. 136 of this volume), keeping in mind how the photograph will *appear* as an image, and at the same time coping with the technical aspects of the shoot. The photographer should be able to perform automatically such operations as taking light readings, changing the film and adjusting the levels of artificial light sources. It should be noted that from a psychological point of view a photographer who appears to know what he or she is doing instils confidence in the sitter and helps the subject to feel at ease and more comfortable with the shoot.

Some unphotographic practicalities

Before setting out, research is essential. The photographer needs to know as much as possible about the shoot. It is most important to know who, or what, you are photographing and why. Although with press or current affairs photography it is not always possible to research an item thoroughly beforehand, it is still vital to maintain a knowledge of current news items as well as to possess a good general awareness of social and cultural issues. Without this background information, at worst the photograph can be uninspired and uninformative, at best it can lead to the photographer's embarrassment. For example, if at short notice you are sent on an assignment, say, to photograph Beryl Bainbridge, it is not in the photographer's best interests to reply 'Who's she?'.

So while an assignment may involve the photographer in such practicalities as booking hotel rooms, buying maps, etc., there is also the need to have a good understanding about the subject in order to produce images that are relevant to the context and contain the appropriate information. If possible, it can be very worthwhile checking out, prior to the shoot, the location and positions that will provide the best viewpoint. This has the advantage of perhaps predicting the shots before the event and having the appropriate cameras and lenses ready to be prepared to respond quickly to the event. For example, the black-coloured door of 10 Downing Street is notorious among press photographers for giving misleading light readings and it is desirable to take a hand-held light reading before the event takes place. Also, it is useful to know that if the Prime Minister is receiving a head of state, he or she will be greeted by the Prime Minister outside the door (see Figure 2.13), whereas lowlier dignitaries will be greeted inside in the lobby. So if a 'two-shot' is required the photographer can make arrangements to be in the appropriate location.

So aside from concerns that are essentially photographic ones there are some unphotographic practicalities, which will have an important, albeit indirect, influence on the success of the photographic assignment. These can include:

- *Being in communication* It is not only essential to be able to be contacted in order to be commissioned for an assignment, but the use of pagers, bleepers, mobile phones, answerphones, faxes and e-mail enable you to report back or receive important updates on events while away from your base. Much time can be wasted looking for a functioning phone box.

- *Being informed* It is essential to read the morning's papers, watch breakfast television and/or listen to Radio 4's *Today* programme to keep abreast of current affairs. (This programme has an uncanny ability to set the agenda for the day's news stories.) So when the telephone rings you should be aware of the broader political and social context of any assignment that awaits.

- *Getting there (and back)* It is essential to have an efficient transport set-up: a car (or in the case of one Central London photographer – a bicycle), appropriate insurance for equipment, maps, money for parking meters and an ability to estimate realistic journey times and a map-reading ability. Disproportionate amounts of time can be spent travelling and parking: for example, 1 hour to get there, ½ hour to park, ¼ hour photography is not uncommon. An account with a reliable courier service may also be important. Some photographers ride their own motorbikes which can avoid traffic congestion, yet they are limited in the amount of photo-

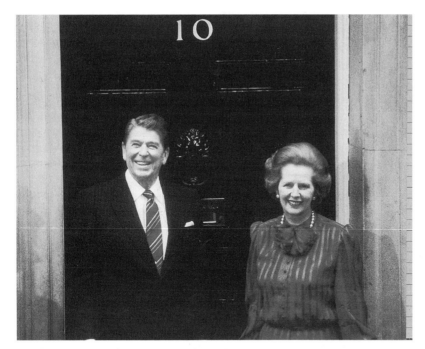

Figure 2.13 President Reagan and Prime Minister Thatcher, 1984.
Photograph by Terence Wright.

graphic equipment they can carry and encumbered by the amount of motorcycle gear they need to stow somewhere on arrival.

- *Documentation* One always needs a pen and paper to jot down the names of those in the photograph, travel directions, labels and envelopes (sometimes pre-printed) for dispatching the film and so on.

- *Weather forecasts* Knowing the forecast will enable you to be prepared not only for the day's lighting conditions and film-stock, but also with appropriate clothing. A dripping photographer at a photo-call does not operate at his or her most efficient.

- *Appropriate dress* This should be flexible, adaptable, appropriate – at the same time of a style that reflects confidence. Sometimes it will need to be acceptable to both sides of the industrial divide of management/shop floor. You may be asked to climb a church steeple in the morning, then photograph a formal lunch, then find yourself photographing a tree in a muddy field in the afternoon. It may be important to dress in a manner that is appropriate for the client, for example working for a fashion magazine or for a business journal implies different styles of dress.

- *Understanding jargon* Different organisations develop their own unique codes of communication which can appear confusing to an outsider: 'The DG is going to be at BH at 4. We need some TJs so use RDP but, if you can, also take a roll of C41 for the files. The DR will get there at 4.30 to get the film back to the Centre for the 4.45 E6 to make the 6.' This piece of BBC speak can be translated as 'The

Director General [of the BBC] is going to be at Broadcasting House [in Portland Square, London] at four o'clock. We need colour slides to broadcast, but some colour prints would also be useful for publicity purposes. A dispatch rider will meet you there at half past four to take the film back to Television Centre [in White City] for the 4.45 p.m. colour-slide process, so that the photographs will be processed ready to appear on the "Six O'Clock News".'

- *Cooperation with other photographers* Photography is a competitive business but, in the press pack, although tempers can become frayed there is normally an atmosphere of camaraderie and cooperation while waiting for the photo-opportunity, buying tea, keeping your place and so on. But when it comes to getting the actual shot, photographers are most likely to display their characteristic independence.
- *Press cards and passes* The NUJ may or may not be recognised; a Scotland Yard press card or a Royal Rota pass are not necessarily passports to access.
- *Use of darkroom (or studio?)* This may be a requirement depending on the photographer's area of practice and the clientele. Some photographers may have a small darkroom in their home (for use in emergency), while the majority of the processing and printing may be sent to a commercial photo-lab. While some are content to hire a studio, if/when necessary, you can find groups of three or four photographers who share a permanent rent on a studio. This may also depend upon whether the photographer is more or less of a specialist or a general practitioner.

The freelance photographer may have to consider other more general business matters. These might include:

- printing headed stationery and business cards;
- finding an accountant for dealing with Income Tax and advice on VAT registration. Arranging a business account and/or use of credit cards. Setting up accounts with suppliers, labs, etc.;
- equipment purchase/hire, car, computer and printer and digital manipulation program as well as the associated upkeep, repairs, etc.;
- office space, communications (mentioned above), filing facilities for accounts, correspondence and photographs.

A standard photographic kit

Each photographer will have different preferences but the following equipment will enable the photographer to cope with most situations:

- 35 mm camera body with TTL light meter
- 24 mm lens
- 35 mm lens
- 50 mm lens
- 85 mm lens
- flash gun
- tripod or monopod.

This said, much can be achieved with just a camera body and a standard lens. Instead of loading up with equipment it might be advisable to spend a month or two using this simple set-up. Once the scope and limitations of the single standard lens are understood the photographer will have a greater understanding of the characteristics of other lenses and which of them will be used only when necessary. One also needs to have a good stock of film, to cover most eventualities. There are few tasks more miserable than trying to find a chemist that may, if you are lucky, have one roll of out-of-date amateur film-stock. At the photographer's base, a refrigerator may be necessary for storing film (and paper) at the correct temperature. And, finally, you may need a small light aluminium ladder with a padlock and chain. This has the dual function of providing height to see over crowds and it can be chained to a security barrier to stake one's claim on a particular vantage point during a tea-break or rainstorm.

Whose opportunity? Organised or unorganised types of shoot

Organisations often arrange photo-calls, which are intended to present the press with an organised opportunity to photograph an event. For example, the Foreign Office may set up a photo-call in order that news organisations can obtain stock-shots of a new ambassador due to be sent to Mozambique. Similarly, football clubs arrange for all their footballers to be photographed (usually positioned sitting as if on a production line). On other occasions (such as the royal family on holiday) a photo-call is arranged in the hope that, having obtained some photographs in a controlled situation, the press will be satisfied. The disadvantage of this arrangement is that the photo-call can aim to control the event – and the photographic images that result from it – more than providing the photographer with an 'opportunity'. It may leave the photographer wondering 'Whose opportunity is it?'. The stage management of the photo-opportunity displays an increasing tendency for a public relations control of photo-calls (see Carol Squiers (1990), 'Picturing Scandal'). Not only are they preplanned but they can limit the scope for the attendant photographers, so that the control of determining the outcome of the photographs is balanced in favour of the organisers:

> Pictures are one of the most important ways of communicating and are the basis on which a number of people form their opinions of the President. So we're naturally concerned about and interested in generating the most favorable and policy-goal consistent pictures we can. They don't always read the story, but they always see the pictures.
>
> (Mark Weinberg, assistant press secretary to Ronald Reagan, quoted in Squiers 1990: 124)

At its worst, the photo-op can amount to presenting to the press a *tableau vivant* which those invited to the shoot are then obliged to photograph. Nonetheless, photo-calls do go wrong and photographers can take the opportunity to seek out the cracks in the facade and exploit them. One famous example is when during the BSE scare John Selwyn Gummer attempted to use the photo-call to demonstrate that eating beef was safe. He offered his daughter a hamburger to show that he would even feed beef to his own child. In front of the assembled press she refused to eat.

One alternative strategy for the photographer is to go **door-stepping**. This, as the name implies, can involve literally waiting on the doorstep to snatch a shot of the subject when they return home or attempt to leave for work. Door-stepping has the implications at one extreme of investigative journalism and, at the other, harassment. For example, it may involve waiting outside the Old Bailey to take photographs of defendants or key witnesses in a case. It usually implies some aspect of invasion of privacy in which, ideally, the photographer should satisfy him- or herself that they are taking on a course of action that is fully justified. This is not always easy to do. Sometimes it involves placing one's faith in the integrity of the journalist or the news organisation, which is possible if they happen to be a working partner or a regular client. However, door-stepping can be subject to false information, boredom and, on rare occasions, violence.

An extreme and notorious example of 'doorstepping' preceded the death of the Princess of Wales. The candid photographs taken of her in the gym drew wide attention to the issue of whether press photographers have the right to invade the privacy of public figures. While a democratic society depends on having an informed electorate and public figures have some degree of public accountability, we have to be clear about the distinction between informing the public and voyeurism. Harassment of the subject can rarely be described as 'observational' recording.

When it all goes wrong

Given the nature of the photographic medium and the unpredictable nature of the subject, in photojournalism there is always a high probability (if not inevitability) that sooner or later something will go disastrously wrong. This may be due to technical failure: an equipment fault, a processing error or an oversight on the part of the photographer. Almost every professional photographer has made the classic fundamental mistake of forgetting to put a film in the camera. Nevertheless, this mistake is usually only ever made once!

When a major disaster has occurred there is very often little that can be done about it. At best the photographer should try to be aware of the most common mistakes. In many cases, these are most likely to happen when the photographer is distracted, or the unexpected occurs or anything happens that disrupts the methodical necessities of the photographic process. Whereas a writer can return to the keyboard and produce a revised version, the photographic moment is usually lost and gone forever. Some of the most common disasters include:

- equipment failure: when this happens, often you do not find out until the film is processed;
- forgetting to check: light-reading, which film is in the camera, if there is a film in the camera, the film-speed setting, the shot list, equipment, batteries, or even the time of day or the date of the assignment;
- missing the shot: through traffic congestion, for example;
- unexpected access problems: crowds or security restrictions;
- losing the film: through one's own lapse of competence, lab disasters, in transit.

When (or if) any of these situations arise, it is advisable to be straightforward with the client, owning up to any idiocy on the part of the photographer and negotiating

(without confrontation) a solution that does not jeopardise the likelihood of getting further work. Most experienced picture editors will be sympathetic and understand how such problems can arise, though obviously it is not good for the photographer to gain a reputation as a disaster area. It is advisable to remain reasonable and remember that if the film has been lost by the courier or ruined by the processing, it is still the photographer's overall responsibility. However, it is a responsibility that may have to be taken up by the picture editor who may be required to justify, to the journalist and/or the editor, commissioning such an incompetent photographer in the first place. However, assuming all goes to plan, the event is attended, the shutter is pressed and the photographs are taken. And the photographic image is imprinted on the film in the camera.

Research for photography

One of the ways of reducing the probability of things going wrong on assignment is to thoroughly research the subject. This section aims to provide some ideas and factors that need to be taken into account in research for photography. As for the student's approach to research, it makes little difference whether you are writing about photography or embarking on a photojournalism assignment, the research methodology remains pretty much the same. In planning a dissertation on photography, many research principles relate directly to the sort of knowledge and approach to the subject that the practising photographer might take. Of course it is unlikely that practising photographers will be expected to write essays about photographs. However, taking a methodical approach to one's own work, as well as that of other photographers, is useful in positioning your practice in the wider theoretical context. As a photojournalist, the ability to comprehend the intricacies of the subject will enable more informed photographs to be taken and can engender more of an enquiring approach to photography. As a photographic artist, the ability to produce an 'artist's statement' to accompany an exhibition of work is a valuable asset. In either case, occasions arise when photographers are asked to lecture on their work, or more generally to provide clear and succinct accounts of their work and its broader implications when presenting their folios to potential clients.

In some instances, news photography for example, there may not be the time to conduct any sort of extensive research on the subject before setting off. In such cases it may be enough for the photographer to keep generally well informed on matters of news and current affairs. However, in the case of a long-term photographic assignment, it is important to have a simple, straightforward starting point that enables you quickly to get to grips with the subject. One aid to achieving this is to establish a 'working title'. This will probably be descriptive. It can act as a guide or reminder of the aim of the project. Often the project will change or outgrow its working title and (if necessary) it can be abandoned at a later stage. Having a 'working title' at the very beginning of the dissertation gives the project a name and consequently an identity. It makes it easy to refer to and gives it an element of tangibility. It also gives the project focus: that of demarking the amount of research and reading you will need to do.

Setting the limits

At the same time as emphasizing the importance of research, there can be a danger in over-researching the subject. This often happens in undergraduate dissertations

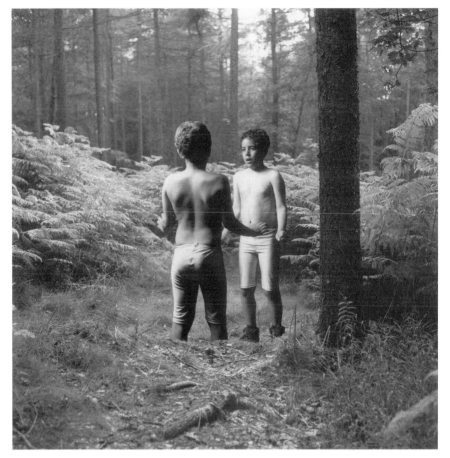

Figure 2.14 In a Shaded Place, 1995.
Copyright Wendy MacMurdo.

where the student feels under pressure to know everything to do with the subject. For example, if writing about the digital photographs of Wendy McMurdo (see Figure 2.14) the concept of the *doppelgänger* – the double that shadows the self – is especially pertinent. This relates to notions of the 'unconscious' and Freud's work on the uncanny, which involves the subject's fascination/revulsion in the notion of encountering their double. McMurdo herself refers to the films *Metropolis* and *Blade Runner* in the context of her work – films that feature the substitutions: human/machine; human/alien; dream/reality; and the mythical character Medusa, who looks both forward and back. These contrasting characteristics have additional relevance to Lévi-Strauss' *binary opposites* that we shall encounter in Chapter 3. So already, from one single image as a starting point, one can see the theoretical ramifications are mounting up. Having introduced Freud and Lévi-Strauss, we might be tempted to extend our research to Jacques Lacan who refers to the 'mirror-stage' of the child's development. Apart from the child's age McMurdo's photograph could almost act as an illustration for Lacan's theoretical standpoint on the importance of self-recognition/realisation.

To introduce a more up-to-date point of view, we might look to Julia Kristeva (who also happened to be a student of Roland Barthes) and so on. We already have a vast amount of complex theoretical material to get through, in addition to viewing a couple of classic movies. And most likely we will be only expected to write 20,000 words. So our getting a familiarity with the relevant material, yet not being able to read all the works of Freud and the others, is essential to keep the research manageable.

Assignment example

The photojournalism assignment might be documenting 'Life on the River Thames'. The photographer, unlike the writer who can give an account of historical events, is limited to documenting the present so our assignment might imply that we are concerned solely with the contemporary picture. However, we may be inspired by the nineteenth-century photographer Henry Taunt's obsession with the river and could be interested in preparing a photographic survey that compares the locations, changes over time, in addition to reflecting changes in photo-documentary style that have taken place over the intervening 140 years.[9] If this were the case, it would be wise also to consider the logistics. Not only did Taunt make the river his lifelong work (his intense interest in the river lasted for a period of some sixty years), but the river itself extends for some 346 km or 215 miles (see Figure 2.15). It is possible to start at the source and work downstream, but how long will this take? A more focused approach might be to take one particular building, perhaps photographed by Taunt in the dockland area, and see how its use has changed from a working building to dereliction to luxury homes. This could open up social and political issues regarding the changing

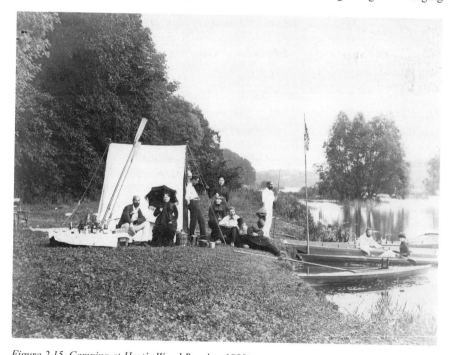

Figure 2.15 Camping at Hart's Wood Reach, c.1880.

Photograph by Henry Taunt. Copyright Oxfordshire County Council Photographic Archive.

community. Perhaps the photographer could start with (and remain with?) one group of people who have been affected by the historical changes that have occurred since Taunt's time.

This type of *diachronic* approach was adopted in the 1970s by photographer Homer Sykes who retrod the path taken by Sir Benjamin Stone some 75 years earlier (see Figure 2.16). In one such instance, Sykes produced a (then) contemporary photograph of the Abbot's Bromley Horn Dance (1977) which can be compared with Stone's original of 1899 (see Figure 3.5). While the essential ingredients of the ancient custom have remained, it is clear how technological change as well as changes in the general expectations of the photographic record have occurred over the years. However, nowadays for a photographer revisiting the subject, Sykes' photograph itself is already twenty-five years old and can be seen as characteristic of the British documentary photography of its own era. One of the challenges is to take a fresh approach to the subject that reflects current attitudes to traditional British customs while taking advantage of and exploring the attributes of contemporary media. This might facilitate a more focused in-depth study of a social, cultural and ethnic issue that becomes truly investigative and goes beyond making numerous comparisons which might be based upon the superficial appearances of photographic images. As a general point, while there is usually no difficulty, to begin from simple beginnings and then to make one's project more complex, it is extremely difficult to take a wide-ranging complex subject and channel it into a manageable starting point.

As a starting point, whatever the subject, there are some essential questions that need to be asked – some basic research questions (which also apply to journalism) that you need to establish at the outset: Who? When? Where? What? Why? and How? They will be useful for you and whoever comes to read the dissertation. Similarly the photographer needs to know the answer to such questions before setting out on an assignment. If we take the example of a press release announcing a photo-call, we not only find all the relevant details, but also notification of any potential hazards for photographers (see facing page).

Photographing a bear?

> An unusually high percentage of people mauled by bears are photographers . . . they see a bear and try to get closer for a better photo. Such behavior is counter to all rules of safety for hiking in bear country.
>
> (Bill Schneider 1996: 33)

Not only is it advisable to note the safety recommendations of photo-call organisers, but also some research may be necessary for purposes of survival. For example, photographing a bear in the wild may seem, if not a rather unusual assignment, reasonably straightforward, presuming the photographer has fairly easy access to 'bear country'. However, according to Schneider (1996: 7), not only do deaths by bear get undue publicity (far more people are killed by domestic dogs, bees, bulls and lightning), but a relatively high number of photographers have been mauled or killed trying to get a good photograph of a bear. There are a number of basic precautions that should be taken. While some might be considered 'common sense', others may not have occurred to the photographer. For example, over short distances, a bear can run at a speed of 30–40 mph: 'Bears can run as fast as horses, uphill or downhill' (Piven and Borgenicht 1999: 53). Consequently in his section, 'Special Precautions

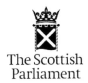

The Scottish Parliament

Parliamentary News Release

001/2001

Tuesday 22 January, 2001

'TOPPING OUT' OF MSP OFFICE BLOCK ON WEDNESDAY MORNING (10am)
HOLYROOD PHOTO OPPORTUNITY

A significant milestone in the construction of the new Parliament building at Holyrood will be reached on Wednesday (January 24) with the completion of the main superstructure of the MSP's office accommodation.

To mark this occasion, a traditional 'topping out' ceremony will be held on the roof of the building at the west end of the Holyrood site.

Performing the topping out will be the Parliament's Presiding Officer Sir David Steel, the Convenor of the Holyrood Progress Group, Lewis Macdonald MSP, and John Spanswick, Managing Director of Bovis Lend Lease Europe, construction managers of the new Parliament building.

A photo-call will be held on Wednesday morning. **As this will take place on the roof of a multi-storey building, there are particular health and safety requirements which must be adhered to. These are outlined below:**

Media wishing to attend should contact ourselves (number below) or Bovis Lend Lease (Marie Guthrie - 0131 472 7100) in advance.

Those attending should report at **10.00am** to the Bovis Lend Lease site office at the foot of Holyrood Road (to the east of Our Dynamic Earth and across the road from the Parliament building site). **Latecomers risk not gaining access to the site in time for the ceremony.** Some parking may be available.

Protective clothing MUST be worn by all those going on site. This will be provided by Bovis. It should also be noted that the photo-call will take place on the roof of a building **reached only by an external staircase.**

The platform party will be welcomed by a lone piper on the roof of the MSP office block. After the ceremony, Sir David Steel will be presented with a silver-plated engraved trowel for the Parliament by Mr Spanswick.

BACKGROUND NOTE

The 'topping out' of a building during the construction process is an ancient tradition which evolved, not only to celebrate the completion of the main superstructure, but also to recognise the accomplishment of the construction workers.

For further information, the media contact is:
Andrew Slorance: 0131 348 5389
E-mail: andrew.slorance@scottish.parliament.uk

For factual Holyrood Progress Group information contact:
Sarah Davidson, Secretary to the HPG: 0131 348 6509
e-mail: sarah.davidson@scottish.parliament.uk

For public information enquiries, contact: 0131 34 85000
For general enquiries, contact: 0845 278 1999 (local call rate)
email: sp.info@scottish.parliament.uk
Visit our website at: www.scottish.parliament.uk

Figure 2.16 The Abbots Bromley Horn Dance, 1977.

Photograph by Homer Sykes. From *Once a Year*, copyright Gordon Fraser.

for Photographers', Schneider recommends that a telephoto lens should be used with a minimum focal length of 500 mm and that the photographer maintains a distance of 1,000 feet or more. This not only provides distance if escape is necessary, but recognises that the bear may interpret direct eye contact as an act of aggression. If possible, situate yourself near a climbable tree (that can get you 10 feet off the ground) and do not try to creep up on the animal. The photographer should not try to attract bears with food or to make 'any unusual sounds or throw anything at the bear to prompt it into a better pose' (Schneider 1996: 85–6).[10] While this constitutes an exaggerated and outlandish example, it does serve as a useful reminder that when approaching unfamiliar subject matter nothing should be taken for granted and, at the very least, some basic research should be carried out. As in all photographic assignments make use of any local knowledge that is available. This should be combined with common sense as an essential ingredient to any decision-making process.

Setting up as a freelance

The ability to set up as a freelance photographer is partly a matter of personal circumstances and partly a matter of luck. The type of photography that you wish to undertake also has a bearing on your route to freelance photography. For instance, in the case of studio advertising photography – because of the high cost of equipment, the need for premises and a demand for specialist skills – it is easier to acquire such expertise by first becoming apprenticed to a specialist studio photographer. Although one may at first be required to undertake the more menial tasks (some of which may not be particularly photographic – making tea, doing a sandwich run, etc.), skills that can normally take months to acquire can be learned and performed automatically in a few weeks. If the 'master photographer' is generous he or she may allow apprentices to acquire clients in their own time and use some of the studio facilities when available. In recent years however, with so many young people wanting to get into the media industries, many photographers will only take on apprentices who require no wages but who are willing to work free, just for the experience. This is an unfortunate trend because it can have the result of abnegating the normal employment responsibilities of both parties: employer and employee. Some photographers, at the early stage of their careers, acquired a studio and photographic equipment that they shared.

In my own case, when I left college after an MA degree in Fine Art, I was fortunate to be offered two days a week part-time lecturing on the photography course at the Surrey Institute of Art and Design.[11] This provided enough money for the rent and enough time to set up as a photojournalist. In addition, being in a position of teaching photography concentrates the mind on acquiring a thorough knowledge of the medium, having the additional benefit of learning from one's colleagues. During the vacation, the college money stopped so I took another part-time job printing black-and-white electron microscope photographs for the Institute of Dental Surgery at the Eastman Dental Hospital in London. After about two years, when the business was reasonably well established, it provided the financial basis that enabled me to pursue my Ph.D. research. Although it may sound somewhat idealistic, it was not without its risks – a contemporary and colleague, David Hodge (also freelancing and doing his Ph.D.) was

tragically killed during the Brixton riots in 1986 at the age of 29. The *Observer* newspaper set up the Observer Hodge Award in his memory to promote documentary photography for photographers under the age of thirty.

Starting up can be an uphill task. For example, there are considerable disadvantages in taking your folio around to different magazines and picture agencies when you have no previous commercial experience. Many will want to see the photographs that you have had in print. Again there is no formula for success. My own first assignment came about after trailing around London visiting magazines and getting numerous rejections because of lack of experience. I visited a film production company in Wardour Street. They looked through my collection of 'independent' art photography and told me it didn't bear the slightest resemblance to their requirements. Despite that, I started to try to convince them of my photographic skills. At this point I was asked to take a roll of 35 mm 400 ASA positive film and get some shots of people working; if the results were any good I might get an assignment. After some thought, I went to Liberty's fabric hall – because of its colour and available light. I gained permission from their Press Office to photograph customers selecting fabrics, and the staff cutting to length, folding, wrapping and selling the material – thirty-six photographs that told a short story. I dropped the film back to the film production company and two weeks later they called me – would I go to Paris for them to shoot stills for an audio-visual production for training workers how to clean aircraft at Charles de Gaulle airport. The successful outcome of that assignment led to other assignments for the same company and to a meeting with a colleague who suggested approaching the BBC Photographic Unit at Lime Grove, London. This led to other assignments in other departments within the BBC and assignments for ITN (Independent Television News). Many of the stills were broadcast as story sequences or as illustrative images in programmes. For example, when a general election comes around, it is necessary for television companies to have photographic portraits of all the candidates in all constituencies. However, the irony remained that I had few photographs to show that were actually in print. But continuing to visit picture editors, showing the portfolio and talking about assignments eventually led to assignments with *Company* magazine and (also part of National Magazines) *Cosmopolitan*.

On the technical side of things, employ the services of an accountant. In my own case, I asked an ex-fellow student who had just set up a graphic design business and took her recommendation of an accountant who specialised in the art and music industries and in people at the early stages of their businesses who had potential. In turn, a few months later, I gave his number to one of my friends who was a lighting designer for rock concerts. However, the accountant is essential for establishing the photographer's relationship with the Inland Revenue, advising on business purchases and tax exemption, preparing accounts and general financial advice – creating a business plan, for example.

However, when discussing setting up in photography it is equipment that most commonly springs to mind. A standard photographic kit is mentioned on p. 64. If you don't quite have all on this list, this may be one of the first jobs for your accountant: advising on how to finance the equipment purchase. Buying second-hand is good, but you need to be careful that the equipment is reliable. From the photographic point of view, whichever brand of equipment is selected, it is important that you can hire compatible lenses, camera bodies and other extras. For some jobs you might need

expensive specialist equipment, so you may need to hire a 1,200 mm lens that fits your camera (see p. 64). Some hire charges you can pass on to the client, but most equipment will be just what a photographer is expected to have. At the same time, hiring equipment is a nuisance. You will have to leave a deposit to the equipment's value (this can be done by credit card if you have a high enough credit rating) and the equipment has to be collected and returned. You may need to try it out first if you are not used to handling it – a shift lens for example. On the other hand, you will need to assess whether a piece of equipment is going to be used frequently enough to justify buying it. Of course, in the process of amassing equipment, it is wise to make sure it is all insured. If your equipment goes, so does your livelihood.

One particular job may be a 'black tie' event requiring evening dress. Do you hire it? Buy it? Can you claim for it against income tax? – ask your accountant. Other essentials may be a car – again your accountant will tell you the percentage of car expenses that can be claimed against tax. Other essentials include a mobile phone, business cards and other stationery. Similarly, a personal computer is increasingly becoming an essential part of the photographer's equipment. Hours of tedious book-keeping time can be reduced with a simple spreadsheet program. Professional invoices can be printed, images can be transmitted over the Internet and the photographer can keep in touch with events as they happen in the 'photographic community'. With the increasing importance of digital imaging, the computer has a central role in scanning (and perhaps manipulating) images, as well as in cataloguing and keeping general tabs on photographic collections.

Summary

- The chapter examined some of the characteristics that are unique to photographic/lens-based systems of representation and introduced the aesthetic concerns of *realism, formalism* and *expressionism*.

- *Realism* is the notion that the photograph offers a straightforward 'transparent' view of the world, subscribing to a tradition that considered pictures to offer 'a window on the world': close to what we would have seen had we been there at the time the photograph was taken.

- *Formalism* considered the photograph as an aesthetic object. This view holds that while the photograph may offer a limited view of the world, it is primarily a flat surface that supports a pattern of light, shade and colours. In this context when we look at a photograph we are always aware of the properties of the photographic medium.

- *Expressionism* implies the use of the photograph to express the feelings or ideas of the photographer that may go beyond the initial appearance of the image and its material qualities. In this context the photograph may express the photographer's emotional feelings or a strongly held political viewpoint or social comment.

- We then looked at some of the factors involved in the photographer's pre-visualisation of the photograph: to be able to predict how the scene, as viewed in real life, will later appear as a flat two-dimensional image. Composition, framing and camera angle were considered as comprising a series of *selections* that are open

to the photographer. The type of camera the photographer chooses to use determines some of these choices.

- The chapter concluded with some of the practical requirements for the photographer embarking on an assignment, as well as some general recommendations for setting up in business. It also took into consideration some instances where the assignment can go wrong and pointed to how the photographer can deal with this.

3 The photographic image

··

Technically photography is at the intersection of two distinct procedures; one of a chemical order: the action of light on certain substances; the other of a physical order: the formation of the image through an optical device.

(Roland Barthes 1982: 10)

the painter's *camera obscura* is only one of the causes of Photography; the essential one, perhaps, was the chemical discovery.

(ibid.: 31)

The photographic image itself relies upon two essential ingredients: the camera's projection of an image and the subsequent chemical development of the image. In this context it would be wise to heed the words of the Gestalt psychologists and remember that the whole is more than the sum of the parts, for the medium of photography amounts to much more than the chemical development of a camera image. And this would seem to account for many of the conceptual limitations of the early theorists of photography who had proposed that photography was a form of auto-mated drawing.[1]

This chapter aims to establish the central characteristics of photography. It aims to answer the following questions:

- What is a photograph?
- Does it tell the truth?
- What information does it transmit?

The instant the shutter of the camera is released, an image is recorded on the light-sensitive surface at the back of the camera. It should be remembered that in normal conditions light is falling onto all objects in the environment; the light is reflected from the surfaces of these objects and bounces around the environment in all directions at an incredibly high speed (186,000 miles per second). It can be described as a complex web of visual information. The camera 'samples' an extremely small segment of the light reflected from the environment and by the objects in it, while the camera's

shutter is open with the lens directing and focusing (or projecting) the light onto the back of the camera. As we saw in earlier chapters, the optical principles of the camera have been cited as similar to those of the eye – but that is only as far as it goes.

It is important now to note that this is where the paths diverge between **analogue** and **digital** cameras. Up to this point, the technical principles of both lens-based systems are essentially the same. The main difference from this point on is in the imprinting, recording, storage and transmission of the image. The analogue photograph records the information by means of chemical change on the surface of the film. The pattern of light falling on the film instigates different responses from the silver **halides**. This initial process is the same with the digital camera as far as the lens projection is concerned. However, in the digital camera a charge-coupled device (**CCD**) 'translates' the light's pattern into a series of digital codes – made up of 0s and 1s. (See Chapter 8 on digital photography.)

Returning to analogue (or chemical) photography, the action of the light hitting the surface of the film in the back of the camera creates invisible chemical changes to the film's emulsion. Across the surface of the film the degree of change created is relative to the intensity of the light: thus the light reflected through the lens forms a chemical pattern which is determined by the pattern of light sampled from the environment. This process is referred to as the formation of the **latent image**. If it doesn't sound like a contradiction in terms, it is an invisible image but one that can be revealed by development (see Sowerby 1951: 377). Any correctly exposed but undeveloped film or print bears a latent image. The processing or developing of the film reveals and makes permanent this image, usually in the form of a negative.[2]

The photographic image begins with the transfer of a three-dimensional scene onto a two-dimensional light-sensitive surface by means of a lens and camera. After the processing of the negative and subsequent transfer of the pattern of light onto the print, via the enlarger, the photographic print can re-present to the viewer a similar pattern of light to that initially recorded by the camera at the time of the exposure. It is these processes of transfer of the pattern of light that have been used to stress the *indexical* nature of the photograph. The photograph is a 'trace' of the scene recorded. As such, it has been considered similar to fingerprints or footprints whereby the camera acts as the agent that enables the (distant) subject or scene to become imprinted on the film surface. In principle, the photographer should be advised to strive for the optimum recording and processing of the information recorded by the film as this image can be considered the fundamental building block of the entire photographic process. This should not necessarily be seen to preclude the accidental or experimental in photography, but if the best possible image is obtained it offers the widest range of printing and post-production possibilities for the photographer.

So, in summary, the camera provides the viewer with a flat visual pattern which is perceived as an image. However, a closer look at the photograph reveals that the image provides not just a simple record of what once appeared before the lens but it can also be regarded and evaluated as an industrial product situated in a broader historical and cultural context. The viewer's understanding and familiarity with this context can be as important (if not more so) as making sense of the image. In some instances we may think of the photograph as a visual catalyst that provokes a sequence of thoughts in the viewer's mind. But, however speculative that might be, we can certainly introduce the influential notion of 'photographic encoding', which points to a position from which photography can be considered as a representational system.

In doing so, we shall propose a theory of natural correspondences between the photograph and the perceived environment; this retains something of Bazin's realist basis for the photographic image. However, I suggest that these correspondences operate only as approximations to that which we see. They achieve their communicative function in collaboration with pictorial conventions – some of which emanate from the medium itself and others which are determined by the culture in which we live. These are in part indebted to our inherited tradition of the visual arts as well as to the broader array of images that we encounter every day from popular culture. Indeed, Sprague (1978) in his study of Yoruba studio portraits from West Africa has shown how photographic style has become entwined with specific traditions of cultural presentation and Gutman (1982) found that Indian photographers produce photographs that are in keeping with the principles of Indian painting (these are referred to later in this chapter, p. 84). The point has been succinctly expressed by Rudolf Arnheim that 'in order to make sense of photographs, one must look at them as encounters between physical reality and the creative mind of man' (Arnheim 1986: 112). This sentiment sets the agenda for this chapter which examines the photograph's ability to transmit information: in its ability to operate as a medium of communication, photography is examined in terms of its social and cognitive functions, as a site of social interaction and a source of knowledge about the world and the human condition.

Structuralism/semiotics/semiology

If we follow Arnheim's line of enquiry, we are left with the puzzle that examining the nature of physical reality in itself is complex enough, especially the task of examining the 'creative mind of man'. The French anthropologist Claude Lévi-Strauss made one attempt to engage with this problem, that has had a lasting influence on theories of culture throughout the second half of the twentieth century. Lévi-Strauss developed his Structural Anthropology in the belief that it was the discipline of anthropology that held the key to the way the human mind worked (Lévi-Strauss 1968). He considered that the unique characteristic of the human mind is its ability to think. And thinking results from the interaction between humans and their environment: the interaction between *nature*, on the one hand, and *culture*, on the other.

In anthropology it had been generally recognised that the so-called 'primitive' peoples adopted *totems* or symbols from nature – e.g. the North American totem pole. This was not only found in the Americas, but also as far away as Australia. It appears that the adoption of totems was a 'universal' characteristic and that it provided a systematic approach to the ways people lived their lives. Accordingly Lévi-Strauss maintained that this was not primitive superstition but a basic example of logical thinking. It provided a scheme of things that would specify what could be eaten and who could be married. The system can be simplified into a series of *binary oppositions*, which Lévi-Strauss considered to be universal elements in the cultural vocabulary. Binary classification divides:

- Us from Them (our group from other groups)
- Men from Women
- Adults from Children

- Vegetables from Animals
- Animals from Gods.

Of course as universal characteristics binary oppositions are not limited to tribal societies. Some have speculated that they were also a reflection of their time – the 1950s – which included the establishment of the cold war and the development of cybernetics, digital computers and binary codes – the on/off switch. In recent times the cold war separated *them* from *us*, expressed by the East/West divide, and was taken to imply Good/Evil as indicated by US president Ronald Reagan's reference to the former Soviet Union as the 'evil empire'. Even though Lévi-Strauss developed his theory during this period he would not have considered it to be historically determined – these were 'universal' characteristics – because it reflects the way the human mind works. Accordingly, no individual element can be understood in isolation, but only as part of a contrasting system:

- Noise/Silence
- Raw/Cooked (also the title of a book by Lévi-Strauss)
- Naked/Clothed (Adam and Eve eat from the 'Tree of Knowledge of Good and Evil')
- Light/Darkness
- Heaven/Hell.

This enables us to begin to see how binary oppositions operate not only in our own culture, but also in our cultural mythology. For example, see the section on the 'Looking-glass war' on p. 115.

The Swiss linguist Ferdinand de Saussure (1857–1913) is the common ancestor of both semiology and **structuralism**. Saussure formalised semiology as a science of signs to include the studies of linguistic and non-linguistic communication alike. Semiology attempts to interpret human cultural activities through the identification of common principles and forms of signification. As Geertz puts it: 'man is an animal suspended in webs of significance he himself has spun, I take culture to be those webs, and the analysis of it to be therefore not an experimental science in search of law but an interpretive one in search of meaning' (Geertz 1973: 5). Semiology has aimed to examine the constituent elements of any sign system or signifying practices, of which photography can be included. And during the 1980s and 1990s semiotics appeared to dominate critical writing on photography. This may seem strange, as Saussure himself had written very little on the application of his theories to visual images. Saussure's influence reached photography through the application of semiology to culture in general (similar to the influence of Marxism on the visual arts) and through the agency of Roland Barthes. In the 1960s Barthes began to investigate how meaning was created in a variety of visual image media. For example, in his *Image – Music – Text* (Barthes 1977) not only does he analyse an advertisement for Italian food products ('Rhetoric of the Image'), but also feature films ('The Third Meaning') and, of course, photography ('The Photographic Message').

C.S. Peirce's scheme

The North American philosopher, C.S. Peirce (1839–1914) introduced a branch of study which he termed semiotics. In the 1970s, semiotics theory was adopted as a central critical strategy in a number of academic disciplines and, mainly due to the writings on photography of Roland Barthes, became particularly influential in providing a theoretical framework for photography. Whether it is useful as a functional tool of photographic criticism is questionable. Semiotics, claiming to be a science of signs, has aimed to examine the constituent elements of any sign system (of which photography can be included as one such system). Peirce's *semiotics* – as distinct from *semiology* (Iversen 1986) – like Saussure's contribution to theory, made little connection between his perspectives and the visual arts, though Peirce's scheme of things does seem to have a little more appropriate application to visual images. According to Peirce, any sign can be summarised as an **icon**, **index** or **symbol** (or indeed it may embody a combination of these elements). An *iconic* sign is one which in some way looks like its referent (or the subject). With the *index*, we should expect some type of causal connection with the referent. In the case of the *symbol*, it achieves its communicative function through convention or agreement between the sender and receiver of the message. The scheme, as summarised by literary critic Terry Eagleton, is as follows:

> the 'iconic', where the sign somehow resembled what it stood for (a photograph of a person, for example); the 'indexical', in which the sign is somehow associated with what it is a sign of (smoke with fire, spots with measles), and the 'symbolic' . . . only arbitrarily or conventionally linked with its referent.
>
> (Eagleton 1983: 101)

In this last instance, we might consider how the crown has come to *symbolise* the power and authority of the British monarch (or the eagle to stand for the United States of America).

The iconic

> Nothing could be more natural than . . . a man pulling a snapshot from his wallet and saying, 'This is my dog.'
>
> (Alan Sekula 1982: 86)

This is a variation of the realist view that proposes that the photograph basically looks like its referent – a theory of representation based upon the resemblance or perceived similarity between the photograph and the photographed. In common parlance, people tend to refer to a photograph as being 'a good likeness', thus evaluating the photograph in terms of its iconic relationship to the subject.

The indexical

> it is a direct physical imprint, like a fingerprint left at the scene of a crime or lipstick traces on your collar.
>
> (William Mitchell 1992: 24)

Based on the *causal connection* between the photograph and the subject, the light reflected from the subject imprints itself on the surface of the film. This is perhaps most noticeable when a photograph is taken with a slow shutter-speed and the trace of a passing car or moving figure is marked across the surface of the negative. As in the case of puzzle pictures, it may not be that it possesses an immediately recognisable likeness (as does an *icon*) to the subject yet, perhaps because of an unfamiliar angle of view, the subject has left a trace and our recognition may depend more on our powers of deduction than on immediate perception.

The symbolic

> yet photography, despite its apparent simplicity, constitutes a rich and
> variegated language, capable like other languages of subtlety, ambiguity,
> revelation and distortion.
>
> (Fred Ritchen 1990: 1)

This we encountered earlier: the view that our understanding of a photograph depends on our interpreting the image, and our ability to interpret the photographic message has to be learned.

Throughout its history photography has been subjected to two opposing polarised theories of representation: those of realism and convention (Wright 1992a). While some theorists, subscribing to the realist view, have regarded the photograph as bearing a close correspondence to its referent, others, the conventionalists, have considered its representational powers to be arbitrary. Either the photograph looks realistic because it is directly transcribed from nature, or the photograph looks realistic because we have been taught to see it that way. In holding the extreme conventionalist position, the value of the photograph as a form of documentation at all would seem to be called into question. With regard to the issue of photography as language, we might question the extent to which the linguistic model is appropriate to understanding photographic meaning. Attempts to apply such theories become over-semantic or too heavily burdened with theoretical standpoints that are unsuited to photographic practice (Burgin 1975). The photographic image may not be simply reducible to cognitive or semantic explanations and the separation of linguistic and visual communication may owe more to the legacy of Cartesian dualism than it does to visual representation.

Some theorists have provided simple definitions regarding the documentary nature of the photograph. For example, psychologist Rudolf Arnheim (1986: 109) has looked for authenticity, accuracy and truth in evaluating the documentary qualities of a photograph, though how the casual observer of a photograph can assess the presence of these qualities remains open to question. Meanwhile, the photographic historian Beaumont Newhall (1982: 235) believes that '*any* photograph can be considered a document if it is found to contain useful information about the special subject under study'.

On face value, this too appears to be a useful definition in that Newhall shifts the balance to the context of study: he does not aim to address the issue of truth, which is, at the best of times, a slippery term – let alone when applied to photography. Nonetheless, arguments regarding photographic truth are all-pervasive and have proved long-lasting.

To what extent can a photograph tell the truth? Or, perhaps more important, what do we mean by 'truth' in the context of visual representation? 'In every photomontage was the implicit message that photography alone cannot "tell the truth" . . . the truth value of photography is often overrated or mislocated' (Rosler 1991: 59).

It seems that even with a manipulated photograph there remain strong suggestions of veracity. For example, in the case of the composite photographs of Henry Peach Robinson in the nineteenth century, the images remained highly plausible: 'the very fact it was a *photograph* implied it was a truthful representation, and so the scene was viewed literally' (Newhall 1964: 61). Thus, it may be due to our very knowledge that our knowing an image to be a photograph in itself gives the picture special status with regard to its truth value. This faith in the image, based upon our cultural knowledge of the image's photographic derivation, has been the cause of numerous problems concerning people's innate (or otherwise) abilities to perceive the information in photographs (Wright 1983). For example, writing in 1859, Francis Frith maintained that photography's popularity was due to its '*essential* truthfulness' (Frith 1859: 71). Other, more recent, writers have assumed that if the photograph can be shown not to tell the truth on some occasions, we must regard all photographs as essentially suspect:

> the mythology that the 'camera never lies' is evidently being replaced by a sense that it often does . . . readers should be suspicious of photographs for a variety of reasons, not least of which is the fact that each image is an interpretation of a situation, not its objective representation.
>
> (Wombell 1991: 1)

This proposition, reminiscent of the 'argument from illusion' in the psychology of perception (see pp. 20–2), has led some theorists to take a position which maintains 'the truly conventional nature of photographic representation' (Sekula 1982: 87). But this point aside, I would argue that the very issue of the truth of the photograph at best leads to questionable anecdotes concerning 'primitive' people looking at photographs, and, at worst, leads to no conclusive view as to the nature of photography. In fact, we might consider if questions regarding the truth of photography have been wrongly phrased in the first place. So it is with regard to the 160-year-old debate concerning the familiar adage 'the camera never lies'. New questions should be asked as to whether the photograph remains faithful to its referent. For example, the issue of truth or untruth is reminiscent of the philosopher J.L. Austin (1962: 142) who aims to confront the statement 'France is hexagonal' with the facts. Is it true or false that France has six sides? He concludes: 'it is a rough description; it is not a true or false one'. Austin's is a problem which has much in common with the issues arising from visual representation. We could add that the photograph can be considered similarly to provide a rough description of the world by displaying a limited array of visual information sampled from the environment (Gibson 1979). Like any other rough description, or approximation, it will contain information that both corresponds and deviates from the original. Indeed, we need to enquire further to ascertain the specific photograph's scope and limitations. In drawing closer analogies with computer technology, the photograph considered as a provider of information rather than the *locus* of an image might offer a straightforward, common-sense approach to the perception of photographic images, and avoid many of the theoretical pitfalls associated with such terms as 'looking like' or the 'truth' of the image. It is interesting to note that

(ex-)picture editor Harold Evans (1978: 227) coyly mentions 'infelicities' in referring to the deliberate post-production cropping of an image to remove information that does not suit the editor's standpoint.

Furthermore, photography is not a static medium; as culture changes, the perspectives of the image alter. The process of representation can never be considered totally complete. This brings us back to the notion of photography as a system of representation – that the photograph offers a visual display of a particular set of information that has been chosen for historical and cultural reasons. We might consider that other systems, which may not rely upon perspective projection, can however display the same sorts of information but subject to different orders of organisational priority. Engineering or architectural drawings are less concerned with showing how an object looks, but are concerned with providing information in such a way that enables measurements to be taken from the drawing.[3] In this context it is worth noting that Peirce referred to two types of icon: the *image* and the *diagram*. This distinction is central to Gombrich's (1975) paper 'Mirror and Map', where he considers photographic systems which provide optical information: how the environment *appears* at a particular moment in time, in contrast to structural systems (maps and diagrams) which represent the more permanent features of the subject and environment. Gombrich expresses his observation rather poetically: 'there are no maps of Vienna in moonlight' (p. 127). He thus makes the point that, irrespective of changes in lighting that would radically alter the appearance of a photograph (a system which supplies only transitory information), the map provides us with visual information regarding the terrestrial layout that is not affected by the time of day. And looking to the representational traditions of other cultures, we find that it is rarely considered significant or necessary to show how something looked on one particular occasion and from the single viewpoint as shown by the photographic system.

To summarise, we have developed a view whereby practitioners choose the best representational system for a particular task. However, there will be strong cultural factors that determine an aesthetic framework. For example, while Western photographers can be considered to have been extending the traditions of Western art in their photographic style, Indian photographers have followed another pictorial tradition, which has retained the organisational space of Indian painting (see Figure 3.1). Indeed, they have 'compressed space, used unique patterns of composition and radically altered uses of light' (Gutman 1982: 15).

And looking to another cultural tradition, the anthropologist Stephen Sprague in his study of commercial studio photography in West Africa noted that 'the Yoruba have developed unstated but clearly discernible conventions regarding appropriate subject matter; those governing posing and presentation of subject matter have also developed' (Sprague 1978: 52).

In both cases, photographers have selected from the photographic medium those characteristics and visual qualities that enable them to conform to their own cultural traditions, rather than those imposed or demanded by the West. However, here we might distinguish between cultural change that has arisen to fulfil the demands of that culture, in contrast to cultural change that has been introduced (or imposed) from elsewhere, particularly those changes arising from the introduction of new technologies. Returning to Peirce, the question now posed is, what does the photograph give us in its information? In this context it seems that Peirce's scheme, when applied to photography, rather than providing a simple answer does run us through a range of

Figure 3.1 An Indian studio photograph from the *Sweet Dreams* project, *c.*1995.
Courtesy of Satish Sharma.

possibilities and suggestions that might account for the way the image is perceived. So it becomes apparent that the photograph considered as an icon which shares the appearance of the world as normally perceived needs further qualification.

As mentioned in Chapter 1, the evidence seems to suggest that the photograph does present enough information to look like its referent as if viewed under restricted conditions. We might consider that the light as structured by the subject is channelled through the camera to become imprinted on the emulsion of the film. Yet, at the same time, we do need to resort to a considerable amount of cultural knowledge to gain the wider and deeper understanding of the image. So although Peirce's scheme might be useful in helping us to consider how visual images gain their power to communicate, it becomes difficult to pigeonhole photography into his conceptual framework. For example, it might become apparent that indexical characteristics of the photograph can in fact generate some symbolic understanding. Using the simple example of the

case of a blurred part of the image seen to be representing movement, we have already seen how this is created through a sort of remote smudging of the picture-plane during a relatively long exposure. It does require knowledge of the conventions of the photographic system of representation to understand this effect, so some elements of symbolic representation come into play. So in order to understand the blur as representing movement we either have to be in possession of knowledge arising from the cause and effect of the photographic process, or we simply learn the rule that such a phenomenon as a blur, for example, *symbolises* movement.

The nature of the photograph

In the popular imagination, the photograph may be considered less real than a video sequence which presents the continuity of events, has the added quality of movement and contains much more information. Nonetheless, there is a considerable psychological impact to be gained from the still, or arrested, image. Furthermore, capturing the isolated moment affords the viewer reflection and contemplation. Sontag places the still photograph in relation to movie film, offering the viewer the opportunity to 'linger over a single moment as long as one likes' (1977: 81). This point is taken up by Annette Kuhn (1985: 27): 'The spectator's look at a photograph is not limited in time, however: she or he may merely glance at the image, may study it at length, or come back to it again and again'. According to Kuhn, this sets photography aside from other forms of media such as film and television. She considers the still nature of the photographic image, in contrast to the movie, whereby the spectators can themselves determine the length of initial viewing time and that of any subsequent viewings they may wish to make. This affords the viewer the activities of contemplation or perhaps encourages voyeurism. (We refer to this issue on p. 66 of this volume.)

In addition, the historical tradition of the *tableau vivant* in the theatre (where a scene or historical event would be represented by a group of performers frozen in position, silent and motionless) and the importance of the depicted 'moment' in narrative painting create the precedence for the image with this type of impact which, at the same time, has been chosen to represent the longer-term chronology of the event. For example, in Western religious painting, the moment when, during the last supper, Christ put his hand into the bowl at the same time as Judas Iscariot became the significant moment for the representation of *The Last Supper*. Yet, in Leonardo da Vinci's version, he shifts the emphasis to the moment when they are just about to put their hands in the bowl, which has the greater dramatic effect of stimulating the viewer's imagination as to what happens next. A similar device is used in the depiction of the hand of God in Michelangelo's creation of Adam. The fact that the hands do not quite touch increases the drama within the image.

The story-telling moment

This is the rationale for the **decisive moment** in the Cartier-Bresson scheme of things, with the photographer selecting, as Eisenstadt put it, 'the story-telling moment' (Evans 1978: 20). The historical precedent of this in painting of the *peripateia* (or 'pregnant

moment') has been discussed at greater length by Burgin (1986a: 99), who describes the phenomenon as 'an instant arrested within, abstracted from, a narrative flow'. Although there is little psychological research on the subject, empirical evidence suggests that despite the relative technical advancements of film and television it is the still image that becomes the memorable image. The arrest of time, a temporal and spatial slice of the past, is frozen into a permanent state of presence. The camera has fixed the moment in the continuous present which enables the viewer, at his or her leisure, to take time to speculate on (or fantasise over) an event which could not be perceived in the same way in the normal course of events. Yet it can only give the briefest indication of the cause and effect of what we see. The captured moment which can never be repeated has been secured by the camera for reproduction and repeated viewing. The camera enables aspects of our perception to endure over time. It presents the opportunity to the viewer which goes beyond the bounds of everyday perception, offering the time and space to imagine, examine or analyse in a way that would not normally be possible. This places the camera in the company of other scientific devices such as telescopes, microscopes, etc. that have extended the range of human perception.

As we have seen, the moment the shutter is pressed an optical projection is imprinted on the film. The information derived from the moment becomes dislocated from its context and fixed in time, enabling the viewer to scrutinise one aspect of the event which would not be feasible in the normal course of events. As Barthes (1977: 44) has put it, the photograph has the ability to shift the 'there – then' to 'here – now'.

This is part of the attraction of historical photographs. The image displays these once-living people and is preserved in its minute detail: a moment has been frozen and fixed and then the continuum of life progresses along the course of time (see Figure 3.2). Until the 1860s, fast shutter-speeds and film speeds were not available to capture the arrested moment. When they did arrive, the images they produced seemed to take *Photo News* (18 October 1861) by surprise: 'Here is a lad transfixed in the act of falling, flying forward, as something has tripped him up; he remains on the slide doomed neither to fall farther or rise again.'

Barthes suggests that the photograph is always situated as 'historical', as 'arrested time'. As an example Barthes points to the apparent paradox of Alexander Gardner's photograph of Lewis Payne who had attempted to assisante US Secretary of State W.H. Seward in 1865. When we look at the image of the condemned man we see the face of someone who, from our present perspective, is dead and yet the photograph shows him about to die: 'He is dead and he is going to die . . .' (Barthes 1977: 96).

As soon as the shutter is pressed, the image becomes dislocated from its temporal and spatial context. This constitutes the photographic paradox: that the image automatically belongs to the past, and continues to exist for us in the present. In common with the museum artefact, it preserves a fragment of the past and maintains a causal link with the event that instigated the image. In this context, it is tempting to propose an analogy between the photograph and the freeze-frame button on a video recorder, which allows the viewer to arrest the normal continuum of events to make a detailed inspection of the image at their own leisure, as has been suggested by Sontag. However, as indicated in previous chapters, it would be a mistake to suggest that our perception of the world is more like looking at a video than it is to viewing a photograph – this point of view would simply amount to updating the eye/camera analogy.

......................................

It becomes yet another attempt to straitjacket perceptual theory into a scheme derived from current technology and does not account for the active exploratory role of the perceiver. According to Roland Barthes (1977: 44), it is immediacy and realism, 'an awareness of its *having been there*', that set photography apart from past media. In his opinion, this has resulted in a significant mental shift: 'The type of conscious-ness the photograph involves is indeed truly unprecedented' (ibid.).

The isolated moment we have described enables reflection upon past events, as well as contemplation of both the detailed contents of the depiction and consideration of their broader significance. This places considerable responsibility on and demands the special skill of the photographer. Here it is the ability to select a particular moment, camera angle and composition that represents the longer-term course of events which is of prime importance.

As we saw in earlier chapters, the consideration of the photograph as a document providing an objective record of events is only one approach to the medium. For the photograph does not supply evidence in a straightforward manner: it provides a **lateral message** signalling evidence of its own nature and making. For example, the moral opinions as to what can or should be photographed and the technical possibilities available to photographers have altered throughout the course of the medium's history.

Figure 3.2 The Old School, 1904 and 1997: a digital photograph. Superimposed on the contemporary photograph are the 'ghost' images of children in the playground. The children have been placed in their original positions in the same field of view as in Percy Elford's 1904 photograph.

Photograph by Percy Elford, 1904. Photograph by Terence Wright, 1997.

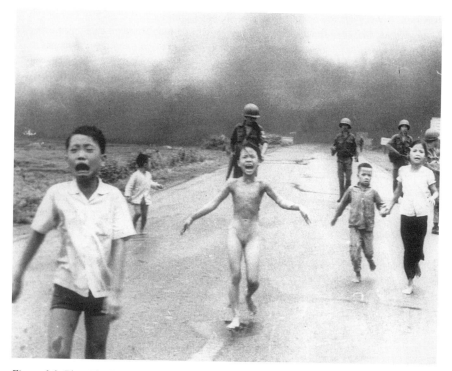

Figure 3.3 Phan Thi Kim Phuc in Napalm Attack, Vietnam, 1972: voted 'Picture of the Year, 1972'.

Photograph by Huynh Cong Ut or Nick Ut. Courtesy of Associated Press.

We not only find that the nature of the photograph is determined by its social and historical context, but it is also influenced by the personal vision and circumstances of the photographer. These determinants of the photographer's choice are crucial to the understanding and resulting communication of the image. The specific slice of time and space chosen by the photographer comes to stand for the general totality of the event recorded, perhaps becoming a symbol for it. The well-known photograph of Phan Thi Kim Phuc, the naked Vietnamese girl running away from a napalm attack, became a symbol for the whole of the Vietnam War, even creating a widely accepted stereotype (see Figure 3.3).

Information outside

The emphasis is now shifting from the information within the photograph to the information without. Although the image recorded by the camera is fixed onto the paper, it will not significantly change as will the course of events and the interpretation of the image alter over time. From the photographer's point of view, he or she occupies a pivotal position between the real-life event and the photograph's future appearance as it might be seen by the viewer. We could expect that if the photographer is taking photographs with the possibility of these new contexts in mind, it may

require a certain distancing from what is happening before the lens. Does the photographer aim to become the impartial observer, responding to and recording events, or does he or she reach the point where something has to be done to physically help the situation? We looked at such questions in Chapter 2, p. 54. As the anthropologist Malinowski (1922: 21) noticed, it is impossible to be the observing photographer and a social participant at the same time. It is 'good for the Ethnographer sometimes to put aside camera, notebook and pencil, and join in himself in what is going on'. So the photograph itself can be seen as being in the position of a relatively static fulcrum between the happening of the event on the one side and its subsequent representation on the other. The values and techniques of perception of the photographer and those of the viewer shift at either side of the image. This said, we would be mistaken if we were to consider the photograph as totally passive. The image should be viewed as being surrounded by and subject to a mass of information we already have about the world and about photography itself, and of the ways photography works and our knowledge of the uses that society makes of photographs. Photographs suggest meanings, partly in the ways they are structured themselves, and parts of the image can set in motion trains of thought which have as one of their objectives that of stimulating the viewer's imagination.

We have already discussed the limitations of considering the photograph as a recording of 'physical reality' – as a primary source of information. According to this approach, we might consider that meaning is subsequently assigned to the image as a secondary mode of perception: the viewer's interpretation. This two-stage approach creates perceptual problems, as Burgin (1986b: 53) has pointed out in his paper 'Seeing Sense'. Although we can think of the signifier and signified as separate entities, when it comes to viewing a photograph there is a tendency for perception and interpretation to take place at the same time (though this should not restrict or rule out imaginings and reflections that may take place when the image is not present). As we have seen, we should not see the photograph as being associated with any physical reality: we might consider it as a record of visual experience (this is closer to Gibson's point of view). As society changes and history moves on, the relationship between the associations of different parts of the image shifts around. This is subject to our own anticipations and retrospections which we experience in our encounter with the image: expectations that may or may not be fulfilled and preconceptions that may be confirmed or denied. These perceptions run close to ideas of narrative discourse, though we should remember that the photograph does not release its information in the same linear fashion as does movie film or literature. Like a painting, its information is presented all at once.

With a documentary photograph we are invited to make inferences and connections with regard to the subject matter. The photographer might expect that the assumptions made by the viewer will, in a variety of ways, conform to the circumstances surrounding the moment of taking the photograph. In this context, we are able to surmise the course of events before the photograph was taken as well as imagine the probable outcomes or effects of events that led up to the photographic moment. As such, the photograph will have an implied history. This history is partly derived from the social context in which the image was made. As Tagg (1988: 187) has pointed out: 'The photographer turns his or her camera on a world of objects already constructed as a world of uses, values and meanings.'

Nonetheless, this history can be manipulated: enhanced or distorted by the context and other information accompanying the photograph. It would be fair to say that good practice in photojournalism consists of showing pictures in such a context that it enables the viewer to arrive at the correct assumptions as to the causes and effects of the actual circumstances that have generated the image. The photographer may have these worthy intentions in mind as exemplified by Cartier-Bresson's *decisive moment*, aiming to sum up in one photograph the essence of the event.

In his discussion of the photographic genres – documentary, photojournalism and visual sociology – Howard Becker has pointed out: 'Photographs get meaning . . . from their context' (Becker 1998: 88). He suggests that a lack of context places the onus on the viewer to resort to 'their own resources' (p. 89). While the newspaper photograph exists in a context prescribed by the media institutions, it also reaches out to its broader social and historical location. In the wider arena of the 'new visual culture', alongside 'the growing tendency to visualize things that are not in themselves visual' (Mirzoeff 1999: 5) there exists the construction of a 'world picture' that 'does not depend on pictures themselves but the modern tendency to picture or visualize existence' (ibid.). The photograph not only provides a visual record of events but, through its ability to function as a metaphor, it also attracts a complexity of cultural connotations. For the field of visual cultural studies this demands an interdisciplinary approach. As van Leeuwen and Jewit (2001: 2) point out, this consists not so much in a specific research methodology, but more in setting 'an agenda of questions and issues for addressing specific images'.

Interpretive frameworks

From a philosophical point of view, Warburton (1988: 177) refers to the 'implied narrative' of the photograph. Lartigue's photograph of his sister jumping down stairs implies that she has launched herself and, presumably will have landed, after the exposure was made (see Figure 3.4).

This may seem a fairly basic and somewhat obvious point. Nevertheless, Warburton's description of the photograph of the Vietnamese girl in the napalm attack (photograph cited by Sontag 1977: 18) gives a clear indication of how this implied narrative operates in the single image and is worthy of quoting at length:

> the expression on her face is unambiguous – it is terror. Something had obviously terrified her before the exposure was made. If we recognize the emotion as terror then we appreciate a fact about the girl's beliefs, since emotions have a certain cognitive element. The smoke behind her suggests an explosion of some sort. Something must have led to her running naked down a road, to her holding her injured arm so awkwardly: in the context in which it was presented, accompanying an article about the Vietnam war in the *New York Times*, many more specific inferences could be made. In whatever context it is presented, however, certain minimal inferences about the subject matter are possible. Once we appreciate that we are in the documentary mode, then we can be more certain about the connection between perceived resemblances to supposed subject matter and the causal history of production of the photograph.
>
> (Warburton 1988: 177)

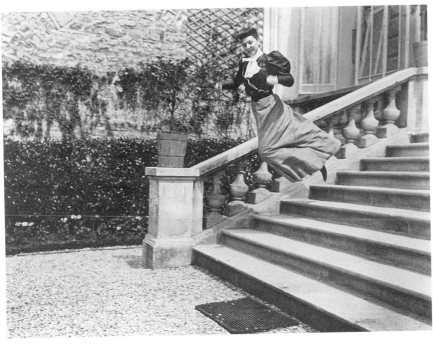

*Figure 3.4 Bichonnade in Flight, c.*1904.

Photograph by J.H. Lartigue. Copyright Ministère de la Culture, France/Association des Amis de J.H. Lartigue.

The photograph is able to give us information about the world, therefore we assume various details about the world purely through our encounter with photographic images and the ways that the camera defines the world.

This reflects back to the early days of photography: the photograph considered as part of the visual tradition, a significant part and continuation of the trajectory of Western representation. However, photography went on to develop its own characteristics and attributes at the same time as sharing some of those with the former arts (painting or theatre, in the case of the *tableau vivant*). Again, these images cannot be seen as separate from the culture in which they were produced, nor from the cultural viewpoint with which we see them today and that from which future generations might perceive them.

The static image is subject to different strategies of interpretation. As we have seen, it already operates within a visual tradition. It relates to Western notions of art: a particular way of transcribing the world and a particular mode of visual communication. It also relates to the world: the realist aspect of photography that we have already discussed whereby the image itself is derived from the optical array obtained from the light reflected from the objects that surround us (this provides the scientific rationale for understanding photography) – the positivist image. Not totally unrelated to this is the documentary aspect of photography. In this mode the image is used to make social and political comment about states of affairs in the world. The image is organised to have a particular impact or effect upon the viewer (or to encourage him or her to view an aspect of the world in concurrence with the photographer). We might further

consider that photographs do not only imply their history, but they also become part of history itself. The definition of history supplied by the American historian Frederick Jackson Turner is particularly apt at this point if applied to the photograph: 'History is all the remains that have come down to us from the past, studied with all the critical and interpretative power that the present can bring to the past' (1891: 201).

While we can create frameworks of categories for critical analysis, when we come to deal with practical aspects of the medium it is far more difficult to separate these issues. This seems to comprise the essential problem of relating theory to practice: creating categories that enable reflection and contextualisation that do not rigidly bind the practical activity. Besides, it would be a mistake to think that one particular image is linked to one particular mode of interpretation – whatever the photographer may say is the intention. In this context, Edwards has pointed out that early ethnographers derived image styles from classical painting, even though they were intended to be used in scientific discourse. She illustrates this by referring to the style of *The Three Graces* of Botticelli: this painting provided the model for representing three partic-ular Aboriginal women from Australia. She includes this classical source of the image with 'the extensive range of photographic images derived from the exotic conventions of orientalist painting and Western male erotic fantasy' (Edwards 1992: 9).

Nonetheless, such observations do not undermine or invalidate the documentary nature of the image. We can look at an image as a limited record of what happened in one interpretative framework and in another as related to the traditions of Western art but neither should preclude the alternative interpretation. A photographer may decide to produce an image with a realist intention; that does not prevent the viewer deciding to look at it from the point of view of a formalist aesthetic. The photog-rapher may be adopting an artistic approach unconsciously. Benjamin Stone, for example, may have had firm documentary intentions for the purpose of education (see Figure 3.5). Now we are more likely to see his images from a primarily nostalgic point of view, as symbols of a particular view of the past, perhaps one that does not allow us to penetrate the surface but to view them as Romantic images which have been removed from their historical realities – this again depends on our previous know-ledge and preconceptions. This is not limited to sepia-tinted, nineteenth-century photographs: images from the 1960s or 1970s are viewed with ever-increasing nostalgia. However, the immediate context of the image can give rise to different inter-pretations. Although the information in the image does not change itself, it can be accentuated, contradicted or guided by the text accompanying the photograph.

In his *Pictures on a Page*, Harold Evans (1978) outlines examples of 'the decisive moment', 'creative cropping' and 'words and pictures'. The latter two will be dealt with in greater detail in the next chapter on post-production issues. In traditional news-paper practice, these might refer respectively to the selection made by the photographer at the time of shooting, to the selection by the picture editor from the existing photo-graph(s), in addition to the editorial role of putting the journalist's words and the pho-tographer's images together in the final copy. Each of these activities will serve to refine or to deviate from the implied narrative of the photograph. The artist John Hilliard's *Cause of Death* provides a good example of this and is discussed in detail on p. 113. While Evans uses three criteria in deciding which photographs to print – ani-mation, relevant context and depth of meaning – his overall intention would seem to be that of realism. The journalistic photograph should aid the viewer's interpretation

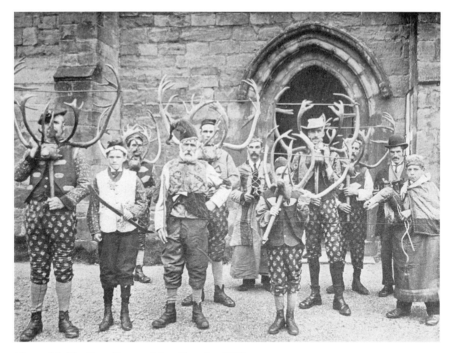

Figure 3.5 The Horn Dance, Abbots Bromley, 1899.
Photograph by Benjamin Stone.

of what happened before the lens rather than hinder it – what 'really happened' as opposed to 'artistic interpretation' of events. As Warburton (1988: 78) has put it: 'What Evans's criteria amount to are practical guidelines about how to encourage an interpretation of a photograph which is consistent with what it is actually a photograph of. This almost always involves some sort of implied history.'

By itself, the image has a variety of possible interpretations whereby different aspects of it will spark off particular trains of thought in the viewer. The ways that the viewer proceeds to construct the narrative are determined by the context in which the image appears. We might consider that we are already set up as to how to view the image: whether it appears on an advertisement hoarding, in a newspaper or family album we will have certain expectations of the image and will begin to employ a particular critical framework that will be appropriate to that context. The context will imply a certain range of possible interpretations and the text will aim to anchor the wide range of potential connotations that can be triggered by the photograph. In the art photograph, it may be the photographer's intention to let aspects of the image be ambiguous, leaving it open to a wider spectrum of imaginative possibilities on the part of the viewer. Here the skill and ability of the photographer in this context lie in creating images that evade direct meaning and provoke conflicting interpretations as well as stimulating subsequent controversy and debate. As an example the photograph which was awarded the *Guardian* Stop Press Award, 1995, was described by the judges as follows:

Much of its power comes from its ambiguity, offering so many different ways one can decode it. A child of uncertain gender stares at the photographer with uncertain eyes. Is it a look of reproach? If so, is it directed at the photographer or at a world which has failed to stem his/her misery? Or is the child pleading for help, for food? Or is it, perhaps, a look of simple curiosity? The strength of the photograph is that it rewards sustained viewing: the collage of faces, expressions and eyes giving rise to innumerable meanings.

(*The Media Guide* 1996: 98)

Another point of view is that the photographic image acts as a surrogate for the object(s) it represents. The example of Elizabeth Eastlake's implied photograph of a loved one 'on the cold brave breast on the battlefield' is used in place of the person who is absent. In this case, the photograph is considered to be a stand-in or an inferior replacement for a person, location or indeed Alan Sekula's dog (see p. 81). While this seems relatively straightforward, the ambiguity of the visual image has been noted by the philosopher Wittgenstein, who asks us to:

Imagine a picture representing a boxer in a particular stance. Now, this picture can be used to tell someone how he should stand, should hold himself; or not how he should hold himself; or how a particular man did stand in such and such a place; and so on.

(Wittgenstein 1953: sec. 22)

The photograph demands further detail or a more specific context to help us derive the full meaning of the image.

Case study: I. Russell Sorgi's photograph of a suicide

The chance that every news photographer dreams of – to be in the right spot at the right time – fell right into my lap.

Under the circumstances, this rather unfortunate choice of words was written in 1942 by Buffalo's *Courier Express* staff photographer I. Russell Sorgi (see Figure 3.6). On his return from a regular shoot, Sorgi by chance decided not to drive along his usual route back to the office. He noticed a speeding police car and decided to follow. The trail led to the Genesee Hotel where a woman was sitting on an eighth-storey ledge:

I snatched my camera from the car and took two quick shots as she seemed to hesitate. . . . As quickly as possible, I shoved the exposed film into the case and reached for a fresh holder. I no sooner had pulled the slide out and got set for another shot than she waved to the crowd below and pushed herself into space. Screams and shouts burst from the horrified onlookers as her body plummeted toward the street. I took a firm grip on myself, waited until the woman passed the second or third story, and then shot.

(Sorgi 1942)

Figure 3.6 Suicide, Buffalo, 1942.

Photograph by I. Russell Sorgi, *Buffalo Courier Express*, 8 May 1942. Courtesy of E.H. Butler Library, Buffalo State College.

Earlier that day Mary Miller, according to the following day's *New York Times* (8 May 1942), had checked in to the hotel registering as 'M. Miller, Chicago'. She 'entered a woman's restroom, locked the door from the inside and crept out onto the ledge'. Two days after the suicide the police confirmed this identification. She had lived with her sister in Buffalo but had left saying that she was going to visit relatives in Indiana. Her sister could suggest no motive for the suicide (*Courier Express*, 8 May 1942). It was Sorgi's photograph that made the front page of the *Courier Express* captioned 'Camera Catches Death Leap in Mid-air'.

It is most probable that Sorgi was using a Graflex Speed Graphic camera which was in almost universal use in US news photography by the Second World War. They were of a single-lens reflex design with a fixed lens offering a relatively wide angle of view. It took 5 × 4-inch sheet film, which meant that despite the wide field of view the photographer could crop the photograph in the darkroom without significant loss of image quality. In contrast to the 35 mm camera with thirty-six exposures, the Graflex user would have to remove the exposed slide and insert another before a second shot could be taken. This is apparent in Sorgi's account and adds further emphasis to his cool approach in waiting for the right moment – he would not have had another chance. This style of shooting can be compared to the present-day news photography as featured in the *Guardian* case study (see p. 147).

A critical interpretation

The story behind the photograph closely conforms to the movie stereotype of newspaper journalism, for example in the films *The Naked City* (1948) and *Public Eye* (1992); both had been inspired by the news photographer Arthur Fellig (or Weegee) who worked in New York in the 1930s and 1940s. At face value, Sorgi's photograph appears to be a classic press photograph. In this context the image is a good example of **spot news**, probably designed to appear only once – a sensational picture aimed at having immediate dramatic effect. This aim for an image with impact is close to the classical notion of the sublime: the sense of putting the viewer/listener in the picture (this is addressed in greater detail in the next chapter). With the photographer acting as eyewitness, a moment has been caught, due to his being on the spot at the right moment part by chance and part by opportunism: a 'scoop'. However, the photographer did display particular photographic skills. He took a couple of establishing shots (under the circumstances, taking a risk with a plate camera). When the woman jumped he did not shoot immediately, as might a less experienced photographer, but exercised his self-control in waiting for the falling woman to reach the most dramatic position. This sense of detachment poses some of the moral dilemmas we encountered earlier. Could Sorgi have done anything to prevent the tragedy? Or should we have expected him to continue to do his job and leave the woman's plight to the appropriate authorities? If we follow Arnheim's line of argument, the detached role of the photographer is considered to be a necessary precondition for the newspaper photographer: 'the news photographer . . . has no substitute for going to the place that will give shape to his dream. But precisely this intimate involvement with the subject-matter necessitates . . . detachment' (Arnheim 1986: 103).

Although, from today's viewpoint, the passage of time has increased the detachment of the viewer of the photograph, we might question whether Sorgi's photograph amounts to an unnecessary intrusion into personal suffering. However, there almost seems to be an inverse relation between the story's sensationalism and its subsequent depreciation in news value. Following the immediate aftermath of the event, the image may accumulate a different set of values arising from its new historical or social context. It is in these contexts that the photograph begins to pose more questions about its own value or status. For instance, the newspaper's attitude remains characteristic of the single viewpoint – displaying while controlling, delimiting and packaging the event.

It may transpire that the photograph has less significance for the individuals involved and takes on a symbolic role expressing the difficulties and frustrations of urban living for a 35-year-old white woman living in the eastern United States. Nonetheless, the action she has taken is not necessarily typical of American women of the 1940s. We should remind ourselves that we are limited in our ability to consider her action, having been presented with only a representation of her action. As such, we are left with the image representing the conventions of sexual stereotyping: a man, I. Russell Sorgi, the photographer; a woman, anonymous, the victim.

Small, hitherto insignificant, details begin to take on special relevance. The sign reading 'Give till it hurts Hitler' reminds us of the historical setting yet at the same time, with other street signs, the words create an impression of estrangement. As for the implied history of the image, it could be that our familiarity with popular fiction or cinematic conventions may lead us to speculate that the man leaving the hotel could

have walked out on the victim, or to suppose from the date, 1942 (the United States had just entered the Second World War), that perhaps a lover may have been lost. Apart from these suppositions, the viewer is placed in a privileged position of access to information that is unavailable to the actors in the scene. The men seated in the restaurant and the policeman entering the hotel seem unaware of the tragedy about to happen. Yet the photograph can only give the briefest indication of the cause and effect of what seems to appear before us.

If we decide to engage in further depths of interpretation we might find an irony emanating from the sign 'Coffee Shop Fountain', as we find that in Western art the fountain features as a symbol of eternal life and salvation. This point may be considered to be a little far-fetched, but if we are considering the photograph as an image operating within a pictorial tradition as part of a broader historical trajectory, we might cite Brueghel's *Landscape with the Fall of Icarus* as a predecessor.

If we forget, for a moment, that we are comparing a painting from the mid-sixteenth century with a photograph from the mid-twentieth century, we find that both images share a number of common features: an everyday setting; a lack of awareness on the part of passers-by; and a moment of death through falling. As for the broader cultural setting, two years before the suicide, W.H. Auden (1940) had published his poem 'Musée de Beaux Arts', which points to the contemporary (if not endless) significance of Breughel's painting of the fall of Icarus. In particular, Auden notes the lack of concern for the dramatic and tragic event on the part of the ploughman and the passing ship. In general, he points out that human suffering usually occurs while others, unaware, are casually pursuing their normal everyday activities.

What might be the purpose of this juxtaposing of the photograph with the painting and quoting the poem? It can widen the possibilities of interpretation and place it in the context of conventional Western allegories of individual destiny. For example, it could be given a moral signification, suggesting the suicide victim has metaphorically 'flown too close to the sun'. In fact, Dante's (*c.*1314, Canto XVII: 109) version of the Icarus myth implies that Icarus fell because he disobeyed his father. Indeed, we find that the extremes and follies of youth contesting the wisdom of the elder is a common theme in myths which serve to reinforce patriarchy. Further consideration of the Icarus myth would lead us to discover that it was the patriarch who had constructed the labyrinth from which escape became necessary, a detail which might contribute to a contemporary feminist reading of the photograph. This interpretation would also have common characteristics with André Gide's Icarus – the image of human disquiet and impulse to discovery – who did not realise the labyrinth was within himself. 'He thought that he could only escape by way of the heavens, all terrestrial routes being blocked' (Gide 1948: 30).

Naturally, the direction and lengths to which such connections can (or should) be pursued is one of the viewer's (in this case my) subjective choice. On the other hand, such interpretation may offer a deeper understanding of why such images continue to retain an attraction and fascination in contemporary culture. In fact, the story continues to be published. The quotation accompanying a similar image published in 1988 (in which the victim was fortunate enough to survive the incident) read: 'I thought everything was over. I was alone. No one wanted to know and I couldn't explain my feelings to anyone. . . . The next thing I knew I was on the roof preparing to jump' (Raif 1988: 19).

This brings us to the point where the increased emphasis on interpretation of the image and the role of the viewer make it necessary to make a further examination of the post-production aspects of the image:

> The photographer tries to bring into existence something new that 'preserves' something that already has concrete existence but will cease to exist in just that way in the next moment or day or year. Uniting these thoughts, it seems to me that the documentary photograph particularly is suited to preserving appearances and that the photograph, as document, gives us *retrospective accessibility* to preserved appearances that are time specific. What is important for the purposes of documentary work or the documentary use of images is that the retrospective accessibility of the images is conditional to their being subject to interrogatory examination.
>
> (Harbutt 1973, in Suchar 1989: 52)

We can consider our perception of the photograph to be in the form of a *virtual image*. This does not mean we internalise a little picture or replica of the photograph in our minds, but the information derived from the image becomes incorporated with other information derived from our life experiences. As Jean-Paul Sartre put it:

> The photograph forms but a vague object, and the persons depicted in it are well constituted as persons, but simply because of their resemblance to human beings, without any particular intentionality. They float between the banks of perception, between sign and image, without ever bordering on either of them.
>
> (Sartre 1940: 26)

We find another contradictory position for the photograph: for Sartre would seem to be flying in the face of those theorists who marvelled at the accuracy and precision of the photograph. It may be precise in producing an *effect* of realism, yet vague in the production of *meaning* unless anchored or directed by other factors determining its context. 'Thus can be seen the special status of the photographic image: *it is a message without a code*' (Barthes 1977: 17). This is bringing us to a position where we can regard the photograph as containing information which amounts to incomplete meaning, that requires the context to complete the message.

Summary

- The chapter examined the nature of the photographic image and suggested some of the ways that enable photography to act as a medium of communication.
- C.S. Peirce's theory of semiotics (the science of signs) was introduced. Three types of sign – *icon*, *index* and *symbol* – were put forward as possible ways in which the viewer gathers information from the photograph.
- This opened up the issue of the 'truth value' of the photograph and the consideration of some cultural determinants on ways that photographers can use the camera. Examples from Indian and Yoruban photography were cited in this context.

- We looked at the ability of the camera to catch the 'frozen moment' and some of the standpoints that some photographers (for example, the anthropologist Malinowski and photographer Cartier-Bresson) have taken in regard to their decision-making processes.

- We began to consider how the photograph might be 'interpreted' by the viewer and that the photographic image can carry with it an 'implied history'.

- As an example of interpretation, the chapter concluded with the case study of I. Russell Sorgi's photograph of a suicide. We examined some of the possible interpretative strategies that can be applied to this particular image and some of the ethical issues arising from the conditions under which the photograph had been taken.

4 Post-production

..

[F]ew people realise that the meaning of a photograph can be changed
completely by the accompanying caption, by its juxtaposition with other
photographs, or by the manner in which people and events are
photographed.

(Gisèle Freund 1980: 149)

The post-production aspects of photographic communication are concerned with
things that can be done to the photograph once it has been taken and processed
to change or enhance its meaning. As mentioned in earlier chapters, photo-
graphs are taken in a particular context and there is a strong dependency on the
knowledge of this context which determines how the final image is understood by the
viewer. In the case of the documentary photograph we find ourselves looking at a
visual display from which we are able to make inferences regarding the subject matter.
We make assumptions about the events that we see in the photograph and draw (hope-
fully the appropriate) conclusions from the image. We assume that our conclusions,
derived from our retrospection and anticipations which have been engendered by the
photograph, in some way concur with the factual circumstances that brought about
the moment of the photograph. We place faith in the image itself and its subsequent
editorial context that it conforms to the natural or original course of events. And this
is what we described in the last chapter as the implied history of the photograph.

This implication of the photograph can be shifted by the context in which the image
is displayed. However, we might consider that good practice in photojournalism
requires the editorial skill to place the photograph in such a context that the viewer
makes the appropriate assumptions regarding the context of the event itself – the casual
antecedents of the event. This is the essence of Cartier-Bresson's notion of the deci-
sive moment – that it directs the viewer's drawing of conclusions or invokes the
intended sentiment. But this belief is not without its problems. As we saw in the
William Klein example (pp. 8–9 of this volume), the photographer may be acting with
the best of intentions but be unable to predict or determine the viewer's response. His
or her concerns, responses and understanding may be entirely different:

why should our understanding of . . . photographs be prefaced by knowing the
intentions of the photographer? No reading of a picture can be unambiguous, or

completely objective. Even knowing a photographer's intentions should not prevent
the viewer of the photograph from contributing to the information that the photo-
graph emits.

<div align="right">(Kuhn 1985: 16)</div>

What we find in a photograph and our response to the image are governed by our
own beliefs, expectations and values. Our beliefs derived from our experience of life
lead us to draw a particular set of conclusions from the image. It is the context of the
image (and indeed our experience and familiarity with photography) which may lead
us to expect particular information from the photograph. Additionally, our evaluation
of the image is determined by our own set of social and cultural values. This may
lead us to conclude that it is impossible for us to see beyond our own mindsets;
that we cannot perceive the image with any unattached objectivity that stands outside
our own historical, political, cultural and biographical standpoint. This is particularly
noticeable with historical photographs, where the viewer has privileged knowledge (of
the outcome of events, for example) which would not have been available to the
photographer or subject(s). This, in itself, gives added intrigue to the photograph (see
Figure 4.1).

Figure 4.1 Maurice Bishop, 1983. This photograph was taken at a poorly attended press
conference in London. Bishop made an impassioned plea for assistance, claiming his country
Grenada was to be invaded. A few months later Bishop was dead and US (and Allied
Caribbean troops) moved in to Grenada.

Photograph by Terence Wright.

Indeed, I can view the same optical information that was perceived and recorded by Julia Margaret Cameron. However, my understanding of her appreciation of the photograph extends only as far as I can find out further information that enables me to imagine her point of view. There is a 130-year historical, social and biographical distance. That said, although we are unable to view the image with detached objectivity, the photograph may be able to offer new perspectives on life in order to provide the means through which we can achieve a degree of detachment that may enable us to obtain a new way of perceiving our immediate social environment. The issue becomes more complicated when we discover that the role demanded of the viewer is by no means universal. The response to an image in itself is also culturally conditioned: we find that different cultures place differing demands on the expected contribution of the viewer to the process of communication. And this can be integral to the traditions of other systems of representation:

> Throughout the history of Chinese and Japanese drawing, examples appear that are very close to perspective, but the system was never consistently developed as it was in the West. The need to involve the spectator in the painting is peculiar to the West.
>
> (Dubrey and Willats 1972: 19)

The context of the image

So we have reached a conclusion where, in the realist media context, we can see the photographer's role as one of selecting, from the natural flow of events, a static image that best points the viewer in the right direction for reaching the appropriate conclusions regarding the broader context of the event. The connotations implied by the image may be further refined by adding a text or caption. However, just as the information in the photograph can support – or anchor – the information to a wider range of signifiers, so the photograph can support the assertions made in a written statement. In contrast, we should see this as a two-way process and we shall see, on p. 128, how John Hilliard's *Ash on Crag Lough* presents a simple example of how the photograph can resolve ambiguity in the caption. In this example, the image and its caption are mutually supporting. Nonetheless, photographs are unable to assert in the same way that a written or verbal statement can. The Greek philosopher Cratylus, whose actions and approach to the world are in many ways similar to those of the photographer, considered that as he could not be certain about anything in the world, he was unable to make a statement about anything. He therefore decided that the only way to communicate with others was not to speak but simply to point at things. In photography, the camera is pointed at a particular subject or phenomenon and the documentary photographer's intention is to draw attention to that which has appeared before the lens. In this instance, the photographer's function is that of a post-dated 'pointing-at'.

Of course, the problem with Cratylus was that by limiting his communicative activities to pointing, he was unable to put forward any proposition or state a point of view. Similarly, the photographer is required to contextualise the image in order to communicate to the viewer. As we shall see later, this contextualisation does not have to be written: a series of photographs can be composed into a narrative sequence, or can

represent an abstract concept by virtue of their juxtapositioning. As for the single photograph, it is a matter for speculation whether the new technologies will empower the photographer with greater abilities to determine the viewer's perception. If, as some have suggested, digital photography has brought about a radical change of direction from existing photographic practice, we may be persuaded to accept Wombell's view that 'Now the photograph is as malleable as a paragraph, able to illustrate whatever one wants it to' (1991: 12). This would seem to imply a limited similarity with language in that a statement can mean one thing in one context, yet something entirely different in another. So we must address the specificity of the photograph in terms of the particular subject as well as the levels of ambiguity brought about by the processes of representation. There will be some common principles with the use of verbal or written language but, at the same time, substantial differences.

Roland Barthes, while referring to the press photograph as a 'message', proposes that the message is also formed by the 'source of emission', the 'channel of transmission' and the 'point of reception'. These are, respectively: the staff of the newspaper; the group of technicians who choose, compose and treat (title and caption) the image; and the public who read the paper. So it is the entire newspaper, as a vehicle of communication, that transmits a series of lateral messages that contribute to the understanding of any photograph that may appear in it. And we would have different expectations of the same photograph in different papers. If it is in the *Daily Telegraph* for example, our perception of the image will be already coloured by what we know of that paper. Indeed, in common parlance people often refer to themselves as 'a *Telegraph* reader' or 'a *Guardian* reader', not only suggesting a preconceived allegiance to the paper, but also anticipating certain expectations to be fulfilled during reading. In addition, the circumstances in which the image appears may also direct the spectator towards meaning. This extends the point made earlier that if a photograph appears on an advertisement hoarding, in a newspaper, on a gallery wall or in a family album, the viewer will require certain expectations to be fulfilled and will be prepared to respond accordingly.

In this book, the concept of this post-production chapter is one of tracing the editing process of the photograph (from contact print to the printed page) and, in addition, it aims to account for the viewer's response to the image. It hopes to offer guidance in the editorial reading of the contact sheets and practical advice for resourceful decision-making. Additionally, it examines the sensational in contrast to the thought-provoking image, in terms of response to the visual effects of the photograph or in terms of the viewer's construction of meaning.

The post-production processes may seem fairly limited in that once the photographer has committed finger to button, captured the image(s) and the course of events has moved on with the passing of time, there is little else that can be done. And while it is true to say that once things have changed it is not always possible to go back and rephotograph if a mistake has been made, so also you cannot photograph an aspect of an event once it has been carried away by the flow of time. Nonetheless, it will become apparent that the photograph can have new life breathed into it and new contexts can create new meanings. Photographic meaning is constructed retroactively from the present viewpoint and new meanings are developed for past events. All photographs are by nature historical and the representation of the frozen moment will alter as time passes into the future. We may be able to rewrite history, but rephotographing it is quite another matter.

Reading contact sheets

Once the film has been shot and processed, the photographer may take a quick look at the negatives to check that they are satisfactory (to see if they have been correctly exposed, etc.). But it is not until the contact sheet has been printed that the photographer experiences his or her first engagement with the photographs. With a 35 mm camera, when the film has been exposed and processed he or she will confront the thirty-six negative-sized images that display in their correct sequence all the photographs that have been taken. Each image has its unique set of dormant and potential meanings which will, more or less, conform to the actuality of events and/or the photographer's impressions of, and conclusions drawn from, the situation. The contact sheets not only enable the photographer to choose the most appropriate print(s) but they provide a visual record of the shoot: the images will contain and display the decision-making processes (on the part of the photographer) that took place as events unfolded before the camera's lens (see the contact sheet, Figure 5.7, reproduced in the *Guardian* case study on p. 150). So even if the sheet does not bear an image that the photographer can use on that occasion, it will still retain a value in enabling reflection and revision as to how future shoots might be conducted.

Contact prints are produced by bringing the film into *contact* with a sheet of photographic paper and exposing this arrangement to light. The prints are produced without an enlarger, thus without any magnification from the original. They overcome the problems involved in viewing the image in negative, as the process transforms the images into positives so that the tones of the photograph form a closer approximation to those perceived in the environment. This has an impact on the theory of photographic representation. According to a strict **conventionalist** position, this process should be unnecessary. If our understanding of photographs is a learned ability, we could just as easily learn to read a negative as we could a positive. However, even the most experienced photographers have difficulty in gaining the full picture from the negative image. For example, in viewing a negative of a portrait photograph, the art historian Gombrich finds it extremely difficult to decipher the direction of the sitter's gaze, 'where the highlights . . . appear black while the black pupils appear white and elicit the false response' (1975: 130). Indeed, Gombrich uses this example to make a point regarding the nature of photographic representation which adds to the theoretical issues we discussed on p. 30 that 'if it were just a conventional notation the inventors of photography would not have evolved the process of turning a negative into a positive' (p. 129). If it were simply a matter of learning to read photographs, reading negatives should be as easy a skill to acquire as learning to read a positive.

As the contact prints are negative sized (24 × 36 mm), they have the drawback of being so small that it still remains fairly difficult to make a selection from the images or to appreciate them for their full quality. In addition, their appearance as a six-image by six-image block makes it very hard to evaluate any individual image in isolation. As we have already noted, the context can determine meaning and the accompanying images on the contact sheet, even if taken on the same shoot, have a tendency to cross-influence each other. Inexperienced photographers can often encounter problems in reading thirty-six images, which are displayed in competition with each other. Unable to view individual images in isolation, some of the most interesting of photographs can go unnoticed. It is often the case that a day or two or a week or so later (if one is working on a longer-term project and can afford the time), with the benefit of more

distance from the event, other images become more or less significant. One tip is to use an old 35 mm slide mount to frame each image so that it can be viewed out of context with the others. In addition to this, a small magnifying glass designed for the purpose, a *lupe*, enables the photographer to magnify and inspect the image for detail. It often happens that, during the post-production phase, the photographer is the worst judge of his or her own work. Despite attempts to remain distant from the event, the photographer often remains psychologically attached to or involved in the shoot. Advice and a further degree of objectivity from a third party are required in the selection of images. For example, it can often be the case that the photographer becomes attached to the photograph that took the most amount of effort to achieve, and fails to notice the attributes of an image that was relatively easily shot until they are pointed out by someone who was not present at the shoot. In addition, one of the most difficult aspects of the editing process is having to reject good pictures. Images may have been taken that are striking in having dramatic impact, yet on reflection they may not be considered central to the story.

Contact prints are normally produced on glossy paper. This not only provides greater clarity in terms of the negative's tonal range, but it is a surface which enables frames to be marked with a chinagraph (wax) pencil. This leaves a mark that can be clearly identified and easily wiped off upon a change of mind. Some photographers use a colour-coding system, for instance to mark out first impressions in one colour, subsequent revisions and reassessments in others. In summary, three tips are suggested that can aid the 'reading' of contact prints (see Figures 4.2, 4.3 and 4.4).

As mentioned in the last chapter, artistic licence aside, the greater technical skill the photographer possesses in ensuring that the negative contains as much visual information as possible (maximum tonal range, for example), the more latitude there

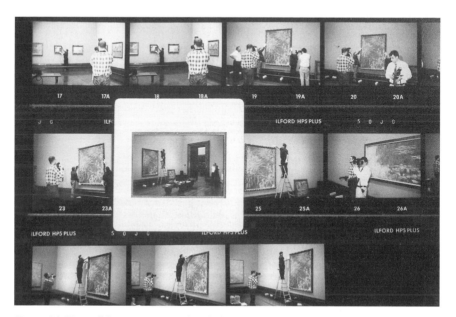

Figure 4.2 Use a slide mount as a mask to isolate each image in turn.

Photograph by Terence Wright.

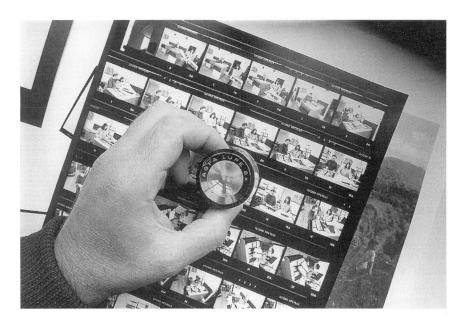

Figure 4.3 Use a lupe to magnify the image.

Photograph by Terence Wright.

Figure 4.4 Mark up contacts with a chinagraph pencil.

Photograph by Terence Wright.

is for the widest choice in post-production selection. If the film has been correctly exposed and developed, advantage will have been taken of the film's optimum capability for the recording of information. The photographer also needs to be aware that the contact prints are unlikely to have the tonal latitude to reproduce all the information contained in the negative. With some subjects (containing important detail in both shadows and highlights), it may be necessary to produce two sets of contacts subject to different exposures. Or sometimes it is necessary to view the contacts in conjunction with the negatives to check for additional information. One of the skills in reading contact prints is to be able to look beyond the obvious in the image and find unexpected information that may appear in the background. Small details can make dramatic differences. One of the earliest observations of a characteristic of photography, noted by W.H.F. Talbot, was that:

> the operator himself discovers on examination, perhaps long afterwards, that he had depicted many things he had no notion of at the time. Sometimes inscriptions and dates are found upon the buildings, or printed placards more irrelevant, are discovered upon their walls.
>
> (Talbot 1844)

The contact sheet editing process is another stage in the longer procedure of photographic selection. The photographer's choice of images may be purely subjective and there is always the potential for disagreement over those chosen by the photographer opposing those chosen by the picture editor. The impressions of the photographer who was at the actual scene may be different from the view of the editor who may be seeing the image from the more or less detached view that may be experienced by the reading public. Quite apart from that, personal life experiences will make a difference as to how two individuals might perceive the same photograph. What they happen to find interesting, their psychological make-up and their prejudices will all be determining factors. However, the next step is to select a frame (or number of frames) that can be printed into work prints, to check for quality and detail and to assess the printing strategy for the final finished print(s).

The photographic one-liner

This can be considered a simple photographic message with the purpose of entertaining or interesting the viewer, which can be presented with little or no comment (see Figure 4.5). It usually takes the form of an observation on life or a visual comment on the human condition. It is the photographic equivalent of saying 'Look at that!' (or telling a joke). It can be an observation on an ironic aspect of life. It relies upon the characteristic of photography expressed by Vicki Goldberg (1991: 7) as 'a swifter more succinct impact than words, an impact that is instantaneous and intense'. In the context of the debate regarding photography as a conventional system, as is language, we should note that photographs do not reveal their information in the same way as does the written text. Such images can present a problem for the theorist as they may not warrant any further elucidation, elaboration or exegesis and to add further explanation becomes rather like trying to explain a joke. You either get it or you don't. Either it appeals to the individual sensibility of the viewer or it does not.

Figure 4.5 Rainstorm, Paris, 1988.
Photograph by Terence Wright.

The role of the editor

> What we should demand of the photographer is the ability to place his
> picture in such a context that it cannot be read as a fashionable pictorial
> cliché but is given some new, some revolutionary meaning.
>
> (Walter Benjamin 1929: 107)

This is perhaps how photographic practice should be conducted in an ideal world: that
the photographer is always able to bring something new and revolutionary both to the
subject and to the medium of photography; that the image may have the effect of
jolting or shocking the viewers into a sudden change of opinion or of causing them
to challenge their own preconceptions. However, the mainstream traditional practice
of press photography or photojournalism does not always allow the photographer such
scope and only in rare instances is the printed image endowed with this power.
However, the new technologies may allow the photographer more (or too much)
editorial control, or none at all! (See Chapter 8.)

As discussed above, we should expect the first line of editorial control to be that
of the photographer upon viewing the contact sheets. In practice, it does not always
work that way. For example with news photography, where there is a high degree of
urgency, the photographer might hand the film to a dispatch rider who takes it directly
to the client or to a processing lab. When this happens, the photographer may not have
the opportunity to view the images before they reach the picture-desk, and in some
instances may never see what has been recorded on film. Of course, it is important
that the practising photographer is able constantly to reflect upon his or her practice.

The immediate and critical viewing of imagery not only facilitates feedback and enables the photographer to re-evaluate shooting strategies, but it also provides a means of fault-finding in the checking of the day-to-day performance of photographic equipment.

Indeed, with the proliferation of the new technologies, photographs are processed, printed, sent down the line and can appear on a television screen (or even on the printed page in the case of such publications as London's *Evening Standard*), before the photographer has left the location of the assignment. However, in complete contrast, technological developments have created situations offering the possibility of the photographer having greater involvement in the editorial process. A photographer with a digital camera is able to photograph an event, plug the camera into a laptop computer and transfer the captured digital image into an image file. The photograph can then be cropped, using an image-processing program like Photoshop, and transmitted to the newspaper via a cellular telephone. While this process may restore some of the photographer's autonomy, it goes without saying that this new system is open to abuse. In this example, the digital image has not been derived from a negative, so the image may be in print and circulated without the journal being able to check the authenticity of the photograph, that is, the extent to which the image may have been *enhanced* or *distorted*. Also, at the final judgement of any dispute that may arise as to whether the photograph is an authentic record of a genuine occurrence, there can be no recourse to an original image that might settle the issue. We shall return to this topic in the penultimate chapter.

However, in the traditional course of events, it is the role of the picture editor to make the selection from the photographer's proofs, with or without the photographer's permission or agreement. The picture editor is concerned with the cropping, captioning and layout of the image as well as how it fits in and interacts with the editorial material and the overall context of the publication. The picture editor acts as mediator between the photographer's vision and the aims and objectives of the publication. At the same time, the editors can make up for what they feel are the inadequacies of the photographer. In this regard, Fred Ritchen's *In Our Own Image* quotes the man who moved the pyramids: the editor of the *National Geographic*. He felt he had achieved 'an establishment of a new point of view by the retroactive repositioning of the photographer a few feet to one side' (1990: 7). This is a relatively new post-production phenomenon. Earlier, I had suggested the limitations of fixing the optic array as an imprint as the shutter is pressed and that the photographer's ability to alter the image after this moment was relatively restricted. The issues of the post-production change of camera position, video-grabbing and the like will be considered later.

Cropping the photograph

> Cropping can often improve and occasionally transform. It can also create an untruth and ransack a photographer's perception. Much of the art of picture editing lies between these two sentences.
>
> (Harold Evans 1978: 223)

Cropping at its most basic allows the photographer to make further attempts at composing the picture after the photograph has been taken, processed and printed (see

Figure 4.6a
A photograph
taken from a
'conventional'
angle.

Photograph by
Terence Wright.

Figure 4.6b Post-production cropping can be employed to suggest that
a different camera angle has been used from that of the original.

Photograph by Terence Wright.

Figures 4.6a and 4.6b). In effect, it enables the photographer or picture editor to zoom in, from the viewpoint fixed by the camera, to select one part of the image and discard the rest of the photograph. Sometimes an image may be cropped so that the photograph does not have to be presented in the **aspect ratio** (to use the cinematographic term) prescribed by the camera's format. In fact, when shooting stills for television, the photographer has to keep in mind the automatic cropping of the television screen cut-off, as well as having to remember (in most circumstances) always to shoot in the horizontal (or landscape) format. Again, cropping may enable the editor to focus on a key part of the image. Or it may create a new point of interest that may be determined by such factors as new evidence or information that may have come to light since the photograph was taken, or the imposition of a different political point of view or implication demanded by the editor or newspaper. Yet, at another level, this selecting of a chosen part of the image can further remove an image from its original context. The photographer's choice of framing and selection of the precise moment may provide one level of abstraction removed from the original event. But the editor's cropping of the image can amount to creating a new meaning by someone who may not have had firsthand experience of the subject. Or, arguably, it may be done by someone who has a greater understanding of the broader issues and significance of what has been photographed. Harold Evans, for example, draws the distinction between

> cropping which accepts the main subject as presented in the print, and cropping which creates a new focus of interest. The first is concerned mainly with excluding extraneous detail; the second is the recognition that a portion within the picture is really its main story.
>
> (Evans 1978: 207)

John Hilliard's *Cause of Death* provides a useful textbook example of the ways the meaning of a single image can be altered by its cropping and caption (see Figure 4.7). This piece of work demonstrates how meaning in the photograph is achieved by selecting the appropriate information. From a single negative, Hilliard has selected and titled four possible 'causes of death' that might explain the situation of a body shown lying on a beach. These 'explanations' have been captioned *crushed, drowned, fell* and *burned* and gain their effect purely through the way Hilliard has decided to present the facts. The spatial relationship between each fragment and its frame indicates that each image has been cropped from a larger image, which (if ever shown in its entirety) would prove to be ambiguous. Upon viewing Hilliard's work, we cannot only discover that we may have been deceived by the four possible interpretations, but the way that they have been displayed provides us with the means to find out exactly how we might have been misled.

This is a *formalist* piece, in which the process is on display. The *realist* aspect of the image is suppressed in favour of a high-control set-up in which the focus of attention is on characteristics of photography itself – in particular how the meaning of the image can be shifted by selective cropping. Hilliard, working primarily as an artist who uses photographs to comment on the nature of photography, has provided us with a precise yet isolated observation of the ways photography can be made to work. John Fiske, on the other hand, in his *Introduction to Communication Studies* (1990: 105)

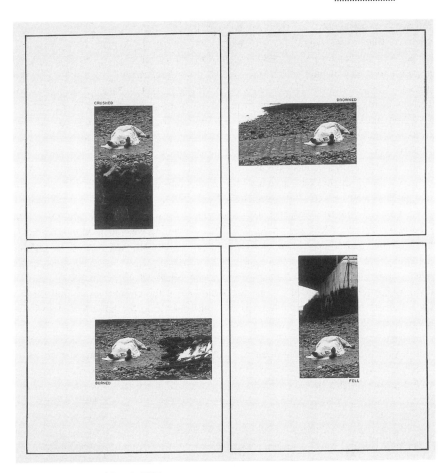

Figure 4.7 Cause of Death, 1974.

Photograph by John Hilliard. Courtesy of John Hilliard.

shows a photograph before and after cropping. He points out how a confrontation has been reinforced by reformatting the image into a long, narrow shape, thus giving more direction to the viewer's gaze, so that it becomes an 'iconic representation of an exchange between the two sides'. The caption, printed in a heavy black font under-lined and positioned between the two sides of the photograph, increases the connotations of conflict. He suggests that such devices direct the viewer in such a way that there are few other possible interpretations or readings of the image. New contexts suggest new meanings and, as long-running stories unfold over the weeks, the same image may appear in a vast array of formats and contexts, especially if only one or two photographs are available (the photograph of Fred West for example). If there is only one photograph which has been syndicated through an agency to a number of newspapers, there can be intense competition as each picture editor crops their own version of the original in his or her attempt to re-present the image to arrive at a maximum impact.

Angled cropping

Apart from the conventional method of cropping the image (as initially discussed on pp. 110–13), another method of cropping is that of 'angled cropping'. This changes the photograph's reference away from the horizontal to create a more dramatic picture (see Figure 4.8). Arnheim describes how, in both photography and painting, a visual effect can be achieved through confronting the viewer with an 'indeterminate orientation':

> Photographers sometimes tilt their pictures relative to the frame in order to add an element of heightened excitement. The cubists and expressionists gave violent action to their landscapes by rendering the vertical dimension of buildings, mountains, or trees as piles of oblique units.
>
> (Arnheim 1956: 85)

This not only emphasises how some of the fundamental principles of pictorial composition remain common to a variety of media, but also how the orientation of the picture can create an impression of movement and instability in static objects. Of course this technique, which can be found in the photographs of A. Rodchenko for example, is not only limited to post-production cropping but can be achieved through taking up an exaggerated camera angle during the shoot. In fact, among practising photographers, there is a broad range of opinion extending from purists who refuse to allow one millimetre to be cropped from their photographs, to those

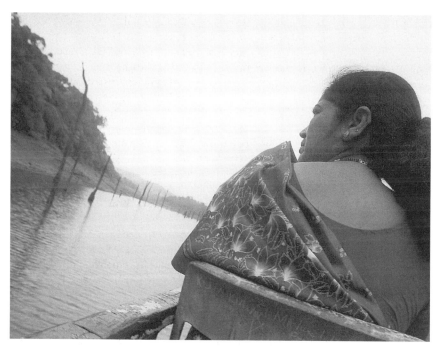

Figure 4.8 Periyar, India, 1996: an example of angled cropping.
Photograph by Terence Wright.

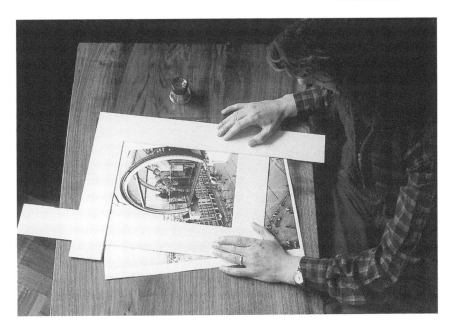

Figure 4.9 The use of L-shaped off-cut cards facilitates post-production cropping.
Photograph by Terence Wright.

who have little concern for what might be done to their original photograph. According to Sir Tom Hopkinson,[1] Bill Brandt would spend hours in the darkroom cropping and printing his photographs, benefiting from the relative luxury of the abundant detail afforded by his medium format negatives. As mentioned earlier, the 35 mm photographer cannot afford to indulge in extensive cropping without suffering image deterioration through loss of detail. However, it can be a useful post-production exercise for the photographer to try out different compositional strategies which may offer reflection on photographic practice and which can determine his or her approach to shooting other subjects on future occasions. Photographers can experiment with different types of framing by using two off-cut cards in an 'L' shape (see Figure 4.9).

Extended case study: 'Looking-glass war'

The photographs taken from the front pages of *The Times* and the *Guardian* not only illustrate how the same syndicated image may appear on the same day in two different national newspapers, but demonstrate the different contexts, cropping and captioning styles employed by the editors. *The Times* (see Figure 4.10) has cropped the image so as to reduce the photographer's artistic interpretation of the event and show a more straightforward documentary image. It may have been considered that the soldier's reflection was a non-essential detail, perhaps detracting from the impact required of a front-page headline photograph. In contrast, the *Guardian* (see Figure 4.11) decided to use more of the photographer's interpretation to the extent of using the contents of the photograph to fashion the caption 'Looking-glass war'. Having exploited the

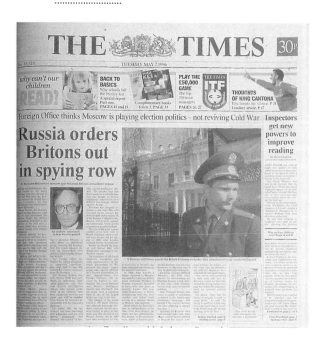

Figure 4.10 Photograph published in *The Times*, 7 May 1996.

Photograph by Grigory Dukor. Courtesy of *The Times*.

inclusion of the reflection of the soldier in a window, this headline suggests the mirroring of the tit-for-tat exchange that immediately follows diplomatic expulsion. Perhaps it also suggests a certain absurdity of the situation which is not dissimilar to Lewis Carroll's *Through the Looking-glass* (1872). In Carroll's book the world becomes inverted and it contains many references to left and right reversals and, in similar representational style to that of the photograph in the *Guardian*, Carroll's ridiculous characters Tweedledum and Tweedledee are, in fact, mirror images of each other. Whether these details had occurred to the *Guardian*'s caption writer is a matter for speculation. It may be of further conjecture (or of mere academic interest) that as Carroll (Charles Dodgson) was a keen photographer, his writings may have been influenced by his firsthand experience of the formation of the photographic image, the negative of which is also inverted and displays left and right reversals.

While *The Times* is using the image to fulfil a simple narrative function, providing us with a quick and easy way of telling a story, the *Guardian* seems to be regarding the photograph as more complex phenomenon, whereby it serves as a carrier or prompt for an conscious or subliminal thought trains. In support of this line of argument, Mathews (1993: 11) claims, 'no matter how limited their projected use, they burn indelible outlines into the mind . . . [they can] overwhelm the ideas they are supposed to be carrying. . . . Images not only express convictions, they alter feelings and end up justifying convictions.'

Following this movement away from the naive realist position we may consider that the photograph offers more than appears at face value. In our everyday encounters with photographs as they appear in newspapers, we may assume that the formal characteristics of this type of pictorial image, which are unique to the photographic medium, may be able to provide a particular insight into aspects of events that are beyond the scope of the editorial. For example, a single photograph can deliver the

Figure 4.11 Photograph published in the *Guardian*, 7 May 1996.

Photograph by Grigory Dukor. Courtesy of the *Guardian*.

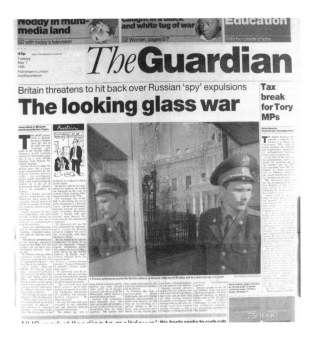

immediacy of a facial expression, say, or it may have the power to imbue a mundane occurrence with special significance by creating an image of dramatic visual impact. Furthermore, it may be able to represent the event in a way that adds new meaning to the subject, perhaps stimulating the viewer's interpretative or imaginary 'reading' of the image, functioning in a poetic mode that not only can express opinion but can also convey atmosphere. The anthropologist Clifford Geertz (1980: 135) suggests that any object or practice 'that somehow or other signifies' becomes a 'vehicle' for ideas. He continues: 'Arguments, melodies, formulas, maps, and pictures are not idealities to be stared at but are texts to be read; so are rituals, palaces, technologies, and social formations.' The notion that the understanding of culture, or of cultural practices, is to be achieved through 'interpretation' and 're-interpretation' is central to the work of Geertz. For the photograph it means we should look to image's wider context. If we do treat visual representations as fully integrated into a broader cultural pattern and a lineage of artistic practice, we must accept a certain degree of free play in the signifiers and flexibility in the perceived connotations of the image. Irrespective of the intentions of the photographer or the editor of the journal, the viewer is most likely to draw upon his or her wider experience of understanding visual images. We can examine the newspaper photograph to show how the addition of a caption has extended the interpretative possibilities of the image. In this particular instance, literary allusion undermines the documentary value of the photograph, taking us into a area of visual representation which blurs the distinction of fact and fiction. Furthermore, the paper proposes to show how photographic practice can be fully integrated into aspects of Western cultural performance, including that of political posturing. An analysis of the photograph's historical, political and literary location aims to reveal greater significance of the image's metaphorical function than may have been initially realised by the photographer. For instance the photographs reproduced in *The Times* and the

Guardian, at the same time as providing a straightforward illustration for the story of British/Russian espionage, also take us into a shadowy mythologised world of James Bond and, of course, John le Carré:

'Drop a hint to the London newspapers. Stimulate publicity. Print the photographs.'
'And?'
'Watch them. Watch the East German and Soviet diplomacy, watch their communications. Throw a stone into the nest and see what comes out.'

(le Carré 1965: 86)

However, we might be wise firstly to consider the historical and political context in which the images have appeared.

Historical and political context

On May 1996 a spying row erupted between Britain and Russia. It was described by *The Times* as 'the worst espionage row since the end of the Cold War' (7 May 1996: 1). The timing of the announcement that nine British diplomats were to be expelled from Moscow, just prior to the Russian presidential elections, led to speculation that the incident may have been politically motivated. Observers in both countries thought that Russian officials might have timed the incident to give Boris Yeltsin the opportunity to be seen to 'act tough' in order to aid his re-election chances in July of that year.[2] During his campaign, Yeltsin had warned repeatedly of a return to cold war rivalry with the West if he lost to Gennady Zyuganov, the Communist Party candidate. Nonetheless, *The Times* editorial (7 May 1996), propounded the view that 'obsessive secrecy still shrouds the decision-making in the Kremlin' and, despite the end of the cold war, Russians remained suspicious of Western intentions. Alexander Zdanovich of the Federal Security Bureau (FSB – the Russian Federation successor to the Soviet KGB) had made a 'stern protest' that Britain was using its embassy for 'illegal spying activities'. They had caught 'red-handed' and arrested a Russian government employee who had confessed to passing on information 'of a political, defence and strategic nature' to British agents. The Russian Foreign Ministry was quoted as saying: 'A number of English intelligence agents, working under cover of the embassy, have been declared "persona non grata" and are being expelled from Russia for activities incompatible with diplomatic status.' As for London's reaction, the Foreign Office claimed that the allegations were unjustified and would be met with 'an adequate response'. In cold war-speak, the phrase 'activities incompatible with diplomatic status' meant spying and the suggestion of the 'adequate response' implied that London would carry out 'tit-for-tat' expulsions if Moscow went through with its threat. According to Russia's *Segodnya* newspaper, 'This is an unprecedented scandal in the new post-Soviet history of Russia.'[3] Now the cold war was over, these more recent events raised the question for *The Independent* 'What is the purpose of spying on Russia?' The newspaper put forward three possible reasons: Russia still possessed considerable military strength; its relationship with China and certain Middle Eastern states caused concern; and it had become a prolific source of organised crime.

The incident of May 1996 made the front pages of newspapers in both countries. Britain's *Daily Mail* announced 'Russia Set To Expel Nine Britons', while *The Times* featured the headline 'Russia Orders Britons Out In Spying Row'. The following day

Vladimir Simonov of *Nezavisimaya Gazeta* (8 May) asked 'Will the unpleasant incident lead again to a vicious circle of mirror spy scandals which were typical of the Cold War?' This 'mirror' metaphor reflects the approach taken by the *Guardian* where, on the front page of the 7 May issue, a photograph was displayed with a caption which declared the outbreak of the 'Looking-glass war' (see Figure 4.11).

The photograph as illustration

'Covert activity can . . . be concealed using a rolled-up newspaper or hollowed out loaf of bread to hide a camera, but such gambits are used more often in adventure movies than in reality.'

(William L. Broecker 1984: 502)

'Looking-glass war' must have been thought to be a rather good title because, in a later edition that day, the paper had promoted it from a caption to the front-page headline. This more unusual headline adopted by the *Guardian* was partly stimulated by the traditional approach that Russia and Britain have taken to such states of affairs: each country 'mirroring' each other's actions. However, the origin of the 'looking-glass war' was primarily derived from the photograph taken by Grigory Dukor, a photographer working for Reuter's in Moscow. The image features a Russian soldier on guard outside the British Embassy. The photograph of the soldier provides us with one arrangement of visual information, but the inclusion of the reflection has enabled the headline writer to extend its metaphorical meaning, not only of the photograph, but of the wider political state of affairs. Of course the caption's literary connotations have been derived from Lewis Carroll's account of Alice's adventures through the looking glass; or, from this century, John le Carré's novel *The Looking-glass War* (1965). Indeed this 'mirror' analogy is often employed in the context of espionage; for example, R.V. Jones' *Reflections on Intelligence* (1989) and Anthony Verrier's *Through the Looking-glass* (1983), which is described as a book on British foreign policy in the 'age of illusions'. We shall return to these considerations.

From my own experience working as a freelance photographer, the spying quarrel would have been considered a 'big story' – after all it did make the front pages of the majority of the British national daily papers – and the photographer may well have been dispatched to the embassy to find something that could illustrate the story. While the decision of an agency or picture editor to send out a photographer to the embassy in question may be considered something of a poor fall-back position, the opportunity of the soldier's presence with his tall-fronted peaked military hat signifying authority and totalitarianism (i.e. a conventional pictorial representation of the Russian state), appears to have provided the appropriate analogy for the political state of affairs. Of course a spying row, almost by its nature, is a difficult phenomenon to illustrate – particularly by means of a photograph. And this is perhaps the central point of the argument – that although the subject under discussion cannot be photographed directly, it can be illustrated by exploiting the metaphorical potential of the photographic image.

While the photograph contains all the ingredients of a stereotypical cold war image of Russia – the guard, his uniform, Fedor Shekhtel's neo-Gothic architectural design of the British Embassy building, the iron railings and security kiosk – the militiaman on duty does not appear to possess much authority. He has a rather weak expression, and his gaze, directed out of the frame, seems to suggest his distraction or lack of

interest for the matter in hand. Curiously, the three-dimensional representation shows the gate of the embassy to be open, but in compositional terms the railings block our view leading towards the embassy building situated at the centre of perspective.

When looking at the photograph I find myself wondering why I personally found it so compelling. It is not necessarily what one would describe as a 'striking' photograph. It could have been that the soldier's face reminded me of an old colleague. Or, from a sense of nostalgia, I found the image reminiscent of my visits to the former Soviet Union. On arrival at Leningrad airport in 1983, looking out of the plane window it was dark and snow was falling. Across the floodlit runway two soldiers with tall, peaked caps, enormous greatcoats and carrying Kalashnikovs stepped out of the darkness to meet the plane. This type of self-analysis involved in looking at the image is perhaps what Sartre meant in describing the spontaneous imaginative consciousness which we bring to the photograph: 'We become aware of *animating* the photograph, of lending it life, in order to make an image of it.' (1940: 26)

The duality of the photograph

In Soviet intelligence the word 'double' is a dirty word.

(Ismail Akhmedov[4])

In his *The Psychology of the Imagination*, Sartre commented that photographs 'float between the banks of perception, between sign and image, without ever bordering on either of them' (1940: 26). Not only has the camera become closely associated with espionage activities, but both the photograph and the secret agent maintain a certain cultural mystique, sustaining a marginal existence between two worlds.[5] There is a common element of marginality in the subject (spies), the medium (photography) and that of the photographer (as observer).

In his *Studies in Iconology*, Panofsky distinguishes between 'motives' and 'stories'. 'Motives' account for the immediate recognition of things in the picture; 'stories' require the viewer's comprehension of a broader contextual/literary discourse. And, in shifting our viewpoint to take in an anthropological perspective, we can broaden the 'story' in an attempt to make sense of certain characteristics which pervade a wider cultural setting – this is true of a variety of systems of visual representation. In addition to the close relationship between a visual representation and its social message, more general patterns of visual culture can be identified. For example, in his discussion of symmetry in Maori art, Hanson (1983) finds that such compositional strategies resound in the wider patterns of Maori cultural dualism, referred to by Hanson as 'Maori Cartesianism' (pp. 86–7).[6] While he finds no direct reference or representational correspondence between symmetry in Maori art and Maori cultural practices, he notes similarities in the formal characteristics of the symmetrical composition in art and more general recurring manifestations in the wider social context: 'The frequency and variety of its concrete instantiations, both in art and in other institutions, indicates that dualism is an ordering principle of pervasive importance in Maori culture' (Hanson 1983: 81). At face value this would seem an ideal hypothesis. Hanson continues to explain that the symmetrical designs in Maori Art are associated with 'escalating reciprocal competitive exchange and/or warfare and revenge'. This could also prove a fitting description of the cold war state of affairs. It bears strong resemblance to the bilaterally symmetrical image reproduced in the *Guardian* and to the

past political reality that the photograph has been employed to represent. Indeed our case is made all the stronger by the fact that the 'looking-glass' photograph is not exactly symmetrical but *nearly* symmetrical, for according to Hanson, 'just as reciprocity in social life was never "perfect" but always marginally unbalanced, giving rise to the outward momentum of competitive striving, so Maori bilateral symmetry is always marginally disturbed by contradicting elements of wilful asymmetry'. Nonetheless, Gell (1998: 161) rightly questions so grandiose a claim. He asks if we are supposed to assume that all cultures that consistently employ symmetrical designs are supposed to be reflecting that culture's patterning? However, I would argue that for the specific instance, rather than proposing a general cultural rule, the compositional device of symmetry does reflect the political situation – as such it becomes one possibility in the photographer's/picture editor's repertoire. And it is the nature of the photograph to offer a specific representational image and not a purely abstract pattern. Of course the photograph does possess a formal patterning, giving the image compositional coherence, and we always maintain a subsidiary awareness of this (see Pirenne (1972: 95) and pp. 42–4 of this volume). It is part of the photographer's repertoire to diminish or accentuate the formal elements of the medium as may be required.

East–West duality

> Anyone resident in the West since the 1950s . . . will have lived through an era of extraordinary turbulence in the relations of East and West. No one will have failed to note how 'East' has always signified danger and threat during this period, even as it has meant the traditional Orient as well as Russia.
>
> (Edward Said 1978: 26)

Should we expect the signification of the looking-glass metaphor to be limited to casual literary allusion or does it have deeper connotations in Western duality: of the divide between East and West, 'us' and 'them' or 'we' and 'they'? From this general view, not only are we reduced to a scheme of binary categories, but it also suggests 'a single breaking point, a Great Divide, though whether this jump occurred in Western Europe in the sixteenth century, or Greece in the fifth century BC, or in Mesopotamia in the fourth millennium, is never very clear' (Goody 1976: 3). More specifically, we might consider the relationship between Britain and Russia. There was the so-called 'Eastern Question' of the nineteenth century which was concerned with preserving the Ottoman Empire, 'the sick man of Europe', in order to curtail a feared Russian expansion that might threaten British interests in India. The Crimean War (1853–6) was one outcome of this rivalry.[7] In a popular anthropology book written in 1908, A.H. Keane is concerned by 'a very real "Panslav terror"' (1908: 388). He goes on to suggest that the world's future depends upon maintaining an equilibrium between the Russians and the English. The Russians:

> in recent historic times displayed a prodigious power of expansion second only to that of the British peoples.

> being, next to the English, the most numerous of civilised peoples . . . special attention may be claimed for the national temperament, on which the future of humanity itself so largely depends.

> (ibid.)

Keane develops his argument with a blatantly racist tone, providing a character sketch of the mental characteristics of the Russian people. But the essential point I wish to address here is the issue of balance, power, equality and rivalry between East and West. Since the end of the cold war it has become more difficult to determine Russia's ideo-geographical position. According to Haslam, some commentators hold the belief that:

> Russia is not properly part of Europe; yet ironically, the insistence in Warsaw – accepted by the West – that Poland is a central European and not an east European state does not lend much credence to this line of approach: if the Poles are in central Europe, what exactly constitutes eastern Europe?

> (Haslam 1998: 121)

On the Eastern side of the Iron Curtain in Poland during the 1950s, for instance, there was a conscious attempt to 'mirror' the West through popular culture. Fashion and entertainment took on a 'principle role in [a] bizarre war' (Dzięgiel, 1998: 159) between the authorities and a youth culture that sought to imitate Western style. In this context 'Jazz, chewing gum, Coca Cola' were branded as 'symbols of the alleged corruption of the non-communist world and at the same time elements of an extremely naively construed mythology of the West' (p. 160). In the wider field of popular imagery, West and East are characterised in terms of ideological differences, yet possessing qualities of sameness (as in most cultures men are classed as different to women, but the qualities of sameness are cited when the contrast is made between human and animal). In our scheme of symbolic dualisms, East and West appear as *enantiomorphs* – mirror images of each other. In structuralist terms (see Lévi-Strauss (1969: chs 3–4 and Chapter 3 of this volume) it is characterised by a binary opposition where a contrast occurs between *our group* and *outsiders*. In this sense the 'mirror' analogy is extremely pertinent, for the image not only has a metaphorical relationship (association through perceived likeness) to the 'original', but – through its reversal – there is a metonymic relationship (association through juxtaposition of dissimilarity). This dual notion is central to the concept of reciprocity – the relationship which both unites and separates. It unites through the relationship of exchange, while at the same time it divides the participants as separate members of the exchange relationship. True reciprocity can only function if the parties are engaged in a symmetrical relationship. In anthropological terms the tit-for-tat exchange of diplomats would be referred to as 'symmetrical reciprocity'.[8]

In her book *Varieties of Realism*, Hagen (1986: 211) refers to reflective symmetry – based on the mirror image, in contrast to iterative symmetry which results from the repetition of elements. And, in terms of pictorial composition, the effect of the 'looking-glass' photograph is achieved by 'reflective' or 'bilateral' symmetry from the mirror-imaging of elements within the picture. It is the juxtaposition of the 'original' and the reflected image that creates the bilateral symmetry which can be seen in the *Guardian* photograph – the reflection is achieved optically by 'flipping a figure over in a plane, through a line or a point' (Hagen 1986: 33). And, as we saw, the *Guardian* photograph had been cropped so as to increase this appearance. As the mirror's reflection creates an image with this underlying symmetry, an effect is achieved where the parts are identical in shape, yet they remain opposite in their spatial orientation. It results in an East–West reversal either side of the metaphorical divide of the Iron Curtain, which stretched from the Baltic to the Adriatic, according to Churchill.[9]

Through the looking-glass

> 'There were times when he confronted his own image as a man confronts an empty valley, and the vision propelled him forward again to experience, as despair compels us to extinction'.
>
> (John le Carré 1965: 124)

We might well be led to question the newspaper's analogy between news of present-day Russia and its reference to the novels of le Carré. I would propose that it has been partly motivated by what Rosaldo (1989) would term 'Imperialist nostalgia'. This occurs when the agents of social change display nostalgia for the passing of an era, the destruction of which they themselves have engineered, and we could justifiably claim that the press had been party to bringing about the end of the cold war era.[10] However, the photograph under discussion could be criticised for not fulfilling the expected journalistic role of supplying information about actual events. Rather, it is aiming to express more of a 'poetic' feeling or attitude towards events. One could argue that placing the photograph in this context amounts to an act of 'fabulation' by selecting facts from reality and using them as the basis for creating a story. This embroidering of the truth can compensate for a lack of knowledge in the area, or act as a replacement for facts that cannot be accepted. In the context of Soviet intelligence, fabulation was a common practice. According to Colonel Mikhail Luibimov of the KGB Foreign Intelligence:

> When we drew up reports, of course we dramatised those bits which pointed out the threat to the Soviet Union. By emphasising the right things, I'd ensure that my report would go straight to the top – to the Politburo; if the report was dull and boring, it would just get filed away.[11]

The metaphor functions through presenting things in the guise of something else. It thus enables us to understand a concept through similarity. This distinction has been succinctly expressed by Geertz (1973: 81): 'The use of a road map enables us to make our way from San Francisco to New York with precision; the reading of Kafka's novels enables us to form a distinct and well-defined attitude towards modern bureaucracy.' Even so, things are not quite as clear-cut as Geertz makes out. Our consultation of the road map triggers a host of mental associations drawn from popular culture.[12] For instance, we find that Kerouac's map-reading (though travelling in the opposite direction to Geertz's proposed journey) was not only associated with the early American pioneers and 'dreams of what I'd do in Chicago, in Denver, and then finally in San Fran' (1957: 15); it also represented 'the dividing line between the East of my youth and the West of my future' (p. 20). By similar means I would suggest that it becomes impossible to apprehend such a phenomenon as the cold war without recourse to our own cultural mythology, which can include the cinema as well as literary works of fiction and aspects of popular culture in general.

That the 'cold war' is replaced by the 'looking-glass war' signifies a change of state from a long-term stand-off to current conditions of absurdity. We might be reminded of Karl Marx's revision of Hegel's notion of history repeating itself. According to Marx, the first time is enacted through tragedy, the second time through farce. Equally, it suggests that the political situation is not dissimilar in character to

Lewis Carroll's (Charles Dodgson's) *Through the Looking-glass* (1872) with its central narrative based upon a game of chess.[13] According to Alice, 'It's a great huge game of chess that's being played – all over the world – if this is the world at all, you know' (p. 208). From the caption, we might take it that the soldier depicted in the *Guardian* photograph appears as a chess piece who cannot tell if he is moving by his own volition; nor does he have any overall concept of the game plan. He could be said to function as a character in Kafka's *Castle* or Rabelais' *Gargantua*. The extraordinary game of chess has proved a useful literary device. For example, H.G. Wells in *The Underlying Fire* describes a game of chess being played between God and the devil. Here too, a literary precedent provides an appropriate metaphor for the cold war stalemate: 'the adversary cannot win, but also he cannot lose so long as he can keep the game going'. Indeed the most likely outcome of cold war escalation was considered to be *Mutually Assured Destruction*.[14] This is something of a 'universal' political theme, recognised by Clifford Geertz in the Balinese cockfight, which also has a strong resemblance to the issue at hand:

> Men go on allegorically humiliating one another and being allegorically humiliated by one another day after day, glorying quietly in the experience if they have triumphed, crushed only slightly more openly by it if they have not. *But no one's status really changes.* You cannot ascend the ladder by winning cockfights; you cannot, as an individual ascend it at all. Nor can you descend it in that way. All you can do is enjoy and savour, or suffer and withstand, the concocted sensation of drastic and momentary movement along with the aesthetic semblance of that ladder, a kind of behind-the-mirror status jump which has the look of mobility without its actuality.
>
> (Geertz 1973: 443)

Similarly, le Carré (1965: 223) expresses the world as perceived by a participant in the cold war espionage game: 'he was witnessing an insane relay race in which each contestant ran faster and longer than the last, arriving nowhere but at his own destruction'.

Conclusion to the spying episode

> In the spy's world, as in dreams, the terrain is always uncertain. You put your foot on what looks like solid ground and it gives way under you and you go into a kind of free fall, turning slowly tail over tip and clutching on to things that are themselves falling. This instability . . . is both the attraction and the terror of being a spy. Attraction, because in the midst of such uncertainty you are never required to *be yourself*; whatever you do, there is another, alternative you standing invisibly to one side, observing, evaluating, remembering.
>
> (John Banville 1997: 143)

The mirror image has played a significant role in the development of Western art. From the technical point of view, Brunelleschi's painting of the Florence baptistery was achieved by the use of the mirror (White 1957: 114) and Alberti had used

mirror images to aid his development of perspective. Contemporaneous technological advances were responsible for a new vision. In the fourteenth century, newly available flat glass mirrors replaced the flat metal and glass hemispherical ones. These reflected a clearer image and encouraged a closer association between the field of vision and a two-dimensional flat surface. At the same time there has developed a general integration of the formal properties of reflection and mirroring into systems of representation.[15] The physical attributes of glass act as a pertinent metaphor for the cold war. Its hardness, yet extreme fragility, is complemented by its optical qualities which (depending on how the surface has been treated) can offer transparency, opacity or reflection. From the symbolic interpretation, the reflected image may be considered to have sinister implications, with the reflection bearing witness to the split or doubled self – the tradition of the *doppelgänger*. Knightley proposes that the successful spy depends upon having a split personality which entails doing all the things that a 'decent' person would not do: intercepting mail, reading other people's letters, listening in to phone conversations, exploiting the weaknesses in people's personalities, as well as manipulating others for his or her own ends. The adoption of false names, identities and ways of life would result in a schizophrenic 'maze of mirrors' (Knightley 1999).

This case study has attempted to show how the *incomplete* 'looking-glass' photograph is part of the *larger* metaphorical political and cultural picture. This part/whole relationship leaves us with the proposition that it becomes impossible to separate the fact from the fiction and that we cannot even begin to address (or photograph) such a phenomenon as the cold war without our becoming entangled with its fictive manifestations.[16] Further, the cold war phenomenon itself maintained an underlying fictitious structure with its clearly defined roles of 'us' and 'them' which served to mask the details and intricate nature of world politics. Now the 'war' is over we can begin to perceive these divisions more clearly. Returning to Rosaldo's 'imperialist nostalgia', the loss of the cold war bilateral partition of the world – leaving the two sides without a clearly defined enemy – creates an atmosphere of instability and insecurity. Once again this is not limited to the sphere of political realities since the spy film is also characterised by its tendency for political oversimplification.[17] The spy film genre (along with the country of Russia[18] and the 'Western Alliance') has yet to renegotiate its place in a new world of increasing complexity, and has found difficulties representing states of affairs that more and more seem to evade binary categorisation.

As for the conclusion of this particular episode of the 'looking-glass war', ten days after the story appeared in the papers (on 17 May 1996), Russia ordered four British diplomats, instead of the proposed nine, to be expelled from Moscow as spies. Britain retaliated by expelling four diplomats from London. The Russian Foreign Ministry told the British ambassador Sir Andrew Wood 'to withdraw four members of the embassy staff within the next few days'. In London the British Foreign Office summoned the Russian ambassador, Anatoly Adamishin, and handed over the names of four Russian embassy staff who were to be withdrawn in the next two weeks. This relatively relaxed time-frame for the exchange not only suggested a compromise, but also that it would be to the benefit of both parties to play down the affair. According to Maureen Johnson, writer for the Associated Press, 'British [government] sources said privately that the arrangement was "very satisfactory"'.

Image/text relationship

> The camera is getting smaller and smaller, ever ready to capture the fleeting
> and secret moment whose images paralyse the associative mechanisms in
> the beholder. This is where the caption comes in, whereby photography turns
> all life's relationships into literature, and without which all Constructivist
> photography must remain arrested in the approximate.
>
> (Walter Benjamin 1929: 107)

As mentioned in the John Hilliard example (p. 113), the image depends upon the anchoring function of the caption or text, in this instance the photograph placed in a context by use of language. The caption can have two main functions: supplying either what we might call 'supporting information' or 'extending information':

• supporting information can refer to information and detail that is already contained within the photograph by drawing attention to certain features. In this context, it acts as a guide which tells the viewer how to view the image.

• extending information can add facts or information derived from a different source to the photograph. This may be of a nature that is beyond the scope of the photographic system of representation and may serve to broaden the restrictions of the single image.

In both these cases the image/caption relationship creates a **third meaning**, though perhaps the second instance produces the more powerful effect. For here the viewer derives the meaning from neither image nor caption: it is achieved by the combination of the two. As described by Nancy Newhall, the caption 'combines its own connotation with those in the photograph to produce a new image in the mind of the spectator – sometimes an image totally unexpected and unforeseen, which exists in neither words nor photographs but only in their juxtaposition' (1952: 22). This is a similar state of affairs to that in our earlier discussion of Gestalt psychology. For this idea is reminiscent of the Gestalt psychologist Koffka's statement in 1935 that 'the whole is something else than the sum of the parts', which may have reached Newhall via film theory. For example, Eisenstein refers to Koffka in support of his theory of film montage where 'two film pieces of any kind, placed together, inevitably combine into a new concept, a new quality, arising out of that juxtaposition' (1943: 14). 'In such cases the whole emerges perfectly as 'a third something'.' (ibid.: 19).

Further influences upon the individual image can be derived from accompanying photographs, which can change emphasis through their sequencing, layout, etc. This can mean achieving a balance between powerful images and more passive photographs. In a layout of very strong images they tend to compete with each other, and in such a way that dilutes their individual and overall effect. This effect generated by a collection of photographs can have another 'third something' as described in the literary critic George Poulet's (1972: 48) account of a collection of paintings. We might consider that Poulet takes the third meaning a stage further and he suggests this when looking at a series of images, in this instance the paintings by Tintoretto assembled together at the Scuola di San Rocco in Rome. He gains the impression of an overall 'essence' of the collection by 'emptying my mind of all the particular

images'. Whether we wholeheartedly subscribe to such a view may be another matter; nevertheless we might reflect upon how we do obtain meaning or the appreciation of style when confronted with a large collection of photographs, in an exhibition for example, though Poulet's suggestion might help to explain how we can identify an image as having been taken by Tina Mondotti or Sebastio Salgado (for example), even though we may have never seen that particular photograph before. We might propose that in an exhibition we begin to identify elements (perhaps signifiers or logical connections) that are common factors shared by two or more images. Thus we can begin to abstract an overall impression of that photographer's work or, arguably, those photographers' aesthetic movements. For example, one cannot only identify a similarity of style in the photographs of Rodchenko, but also in those of his close associates who were working with him at the time (Shudakov 1983).

We can assume from the above that the photograph and the caption are mutually supportive in their functions. In contrast, John Hilliard produced another piece of work which in some ways reverses the interdependence of image and caption. In his *Ash in Crag Lough* he presents us with three identically titled photographs, all photographed from the same camera position (see Figure 4.12). However, Hilliard, using a very narrow depth of field, has altered the focusing of the camera to provide the viewer with three different planes of focus of the same scene. The use of differential focus shifts the emphases of the captions to dictate the terms under which the ash tree is said to be *in* the water. It now appears that the caption is ambiguous until qualified by the photograph's information which indicates 'reflected in', 'floating in' and 'submerged in'. Photographically the result might be considered fairly clinical, illustrating a technical detail of photography, but the series sheds light on a particular subtlety of the image/text relationship and, as Hilliard himself points out, aptly draws attention to visual characteristics of the environment:

> the structure of camera procedure (i.e. three focusing) is echoed/revealed by the structure of the picture content – each change in focus affecting a different reading within a triad of possibilities. . . . Both glass and water lend themselves in a peculiarly apt way. Because of their physical structure, each embodies an imagery at three optical levels – being simultaneously transparent, opaque and reflective.
>
> (Hilliard 1980: 19)

This further self-reflexive example can be seen as a development of the basic point of the differences between the permanent terrestrial layout and that of the landscape's optical appearance made in Gombrich's 'Mirror and Map' paper, cited earlier.

Sequences

We have already seen in the combination of image and text how the third meaning is created by the viewer. This is equally true for two or more images – described by Wilson Hicks (sometime executive editor of *Life*) as the 'third effect': 'when two selected pictures are brought together, their individual effects are combined and enhanced by the reader's interpretative and evaluative reaction' (1952: 34). The juxtapositioning of images enables/forces the viewer to make temporal and/or spatial comparisons. It could be before-and-after shots which enable the viewer to make a

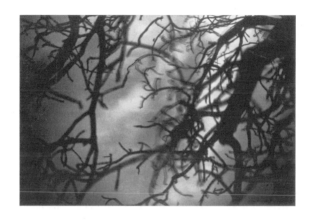

Figure 4.12 Ash in Crag Lough, 1976.

Photographs by John Hilliard. Courtesy of John Hilliard.

factual comparison by analysing, contrasting or matching the images to reach a conclusion as to how the scene or subject has changed over the passage of time.

In most circumstances the photographer only has the opportunity for one image to sum up the whole event or story. On occasion, there is the possibility of a series of images which may eventually be displayed spatially, as part of a page layout, or sequentially, in a prescribed order – on following pages or on television. The opportunity of using more than one photograph can increase the possibility for the photographer to pursue the development of an idea. As soon as photographs are incorporated into a series this puts forward a very different type of narrative sequence to the implied history of the single image. It places the photographer in a different mode of shooting and delivery, with new opportunities to create ideas, and can offer a greater degree of control over the interpretation of the signifiers of the images. This is not to say that this form of presentation is better or more significant than the single image (for example, the single image can stand out for its power of impact which can be lost among competing images); rather, that it opens up a different scope and range of possibilities. In a series the perception of the changes, the contrasts and comparisons can take over from any particular information that we would normally expect an individual image to deliver.

The creation of a sequence is a skill in itself. The photographer has to deal with issues of continuity and coherence throughout the series. Apart from developing a flow of images, we could expect the classic sequence to have a beginning, a middle and an end and that those elements have a logical connection. To a certain extent, it will need to be orchestrated, with points of impact and relaxation throughout the sequence. The shooting and the editing processes are different. The central concept(s) should be spread across images yet also displayed with efficiency. Too many images can weaken the effective communication of the concept. In a series, each photograph cannot be considered on its own merits: it must be thought of in the context of the other images that will accompany it so that it can function as part of a chronological rationale. This may imply a shift of emphasis from the decisive moment of the single image to the critical instants of a structured narrative. These instants will determine when the photographer presses the camera's shutter. The photo-sequence, to use Roland Barthes' term, should consist in selecting a series of *nuclei*, which 'constitute the real hinge points of the narrative' (Barthes 1977: 93) yet with each image containing *catalysers*, whose purpose is to 'merely "fill in" the narrative space separating the hinge functions' (ibid.). While Barthes is primarily referring to the literary narrative with its linear mode of delivery, the photo-sequence tends to concentrate on the *nuclei*, with the *catalysers* 'nested' in each photograph. These are not so much 'delivered' to the viewer, rather they 'lie in wait' for the viewer's discovery and attention to detail. In adopting Barthes' terminology, this 'non-intentional' point of detail is referred to as a *punctum*. We encountered one such example in Barthes' description of the William Klein photograph (p. 9), where Barthes felt himself drawn to 'one child's bad teeth'. For Barthes the *punctum* 'is an addition: it is what I add to the photograph and *what is nonetheless already there*'.

In addition to the implied narrative of the single photograph, the arrangement of a series of photographs in sequential order can enable the photographer to have greater control over determining the viewer's perception of the image(s). Here we must distinguish between a *sequence*, which has a prescribed order of viewing, and a *series* which leaves the narrative order to the viewer. The sequence often implies a temporal

ordering, while the series may not be linear in its arrangement but may be composed in some form of spatial layout. Perhaps the most common occurrence of a sequence of photographic images is to be found in the rapid (twenty-four frames a second) sequencing of movie film. There are important similarities as well as distinctions from this form of presentation to the static sequence of still photographs. Some of the basic narrative principles may be the same, but we should be respectful of important differences expected of the viewer. Similarly, the sequence of photographs suggests to the viewer the connotations of the individual images that they should pick up on. With the inclusion of an accompanying text, the different juxtapositions of image and text combined with the relationship between a series of images can enable the unfolding of a story or the development of an idea. This process is similar to the unfolding of a story-line in the photo-romance sequencing of images. A classic example of the photo-story in British photojournalism was 'Unemployed' which appeared in *Picture Post* in 1939 (see p. 175 of this volume).

It was the French literary critic Gérard Genette (1980) who aimed for a systematic organisation of the complex relation between narrative and the actuality of a story. He describes three categories of narrative:

* *recit*: the order of events in the text;
* *histoire:* the 'actual' sequence of events, as they happened;
* *narration*: the act of narrating itself.

Although his scheme was initially developed to be applied to literary criticism, he adopts terminology that has been derived from the lens-based media: Genette's terms include 'point of view' and 'focalisation'. However, the practical relevance of this consideration is that images designed to appear in sequence not only need to be carefully composed as individual photographs but there is the additional composition of the sequence to be taken into account. We should consider each image in relation to the preceding and following (antecedent and successional) images. As the viewer can determine the duration of viewing of a photo-sequence, the entire effect of the piece is achieved and completed by the photographer playing on the role of the viewer. When looking at a sequence, the viewer's response is one of mentally moving backwards and forwards between states of anticipation and retrospection. In making sequences of photographs for television broadcasts, it is this characteristic that is usually exploited. The still sequence was often preferred for its ability to give a subject a dynamic quality that was not so easily achieved in video footage.

The viewer's response to the image

> The photograph is in no way animated . . . but it animates me.
>
> (Roland Barthes 1982: 20)

In the discussion of Barthes' *punctum* there was a gradual shift of emphasis away from what may have been the photographer's intention or the direct point of the photograph, to the viewer's interpretation of the image. We have also gained from the notion of the implied history of the photograph that the viewer is placed in the position of having to create meaning from the photographs, dependent upon what they can believe

and feel is plausible from the image. It should be noted that the photograph's implied history is not a fixed commodity: it is subject to changes in time (as time moves on, perspectives change) and it is subject to interpretation from different standpoints. This is most noticeable in ethnographic photographs, where the intentions of those who had used the camera from the colonial viewpoint produced images which appear in stark contrast to the ways those images are perceived by the members of those cultures that had been photographed. So as times, locations and political and cultural points of view change, so the perspectives on the information displayed in those photographed shift in emphasis. This can be quite extreme, affecting the status of the photograph in different cultural locations. For example, according to Hall (Collier and Collier 1986: xv), 'western people . . . perceive the written word as reality and the visual image as impression. Navajo observers . . . see photographs as literal information and language as coded interpretation.' Whether or not we are in full accord with Hall's point of view, his statement does serve to suggest distinct cultural differences in regard to the photograph. This is placing more emphasis on the role of the viewer, who is involved in actively constructing his or her own context for the image rather than acting as the passive recipient of visual information. The photograph can be now considered as a point of visual stimulation or as a trigger to set thought trains and the imagination in motion. Its unique power to do this lies in its ability to re-present *some* of the information that is (or could be) normally available for us to access during our visual perception of the environment. Needless to say, the thought trains will be determined by our own life-experiences and naturally will include the knowledge we may have of the photographed subject, as well as what we know about the medium of photography.

We saw in Chapter 1 that Gibson's theory involved the active exploratory role of the perceiver. It follows that the viewer of a photograph might also adopt an active exploratory role. Naturally, the degrees of action and exploration will be limited by the static two-dimensional display of information of the photograph and should not be identified with everyday perception. Now my perception, or what I see in a particular image, may not be the same as someone else's perception. And, upon a later viewing, I may find the image appears differently from my first encounter with it. The photograph itself has not changed, but what has changed is the nature of my engagement with the image. And my engagement with the photograph will not be exactly the same as another person's. It should be emphasised that any one of these viewings is not truer or more accurate than another, but they have triggered different thought trains. Depending upon the success of the photograph in its particular context, subsequent viewings will enable more or less innovative viewings.

Gunther, in a discussion of literary criticism, distinguishes the *artefact* (for our purposes *photograph*) from the *aesthetic object* (which we might consider to be the viewer's interaction with the photograph):

> The artefact [photograph], unchanging in its structure, is of course the source of the meaning from which the reader [viewer] must constitute, the point of departure for all concretization [perception or understanding] of the work by its recipients; and yet the work in its totality cannot be reduced to the artefact [photograph]. Since it is concretized against a background of fluctuating systems of aesthetic norms, the structure of the aesthetic object is continually shifting as well.
>
> (Gunther 1971: 143)

This has brought us a long way from the early days of photography, when opinions regarding the effect on the viewer were derived from classical art. Frith believed that photography was not only 'truthful' by nature, but that photography's 'truth' in itself would have a beneficial effect on the public:

its essential truthfulness of outline . . . of perspective and light and shade . . .

Since truth is a divine quality it is, we argue, quite impossible that this quality can so obviously and largely pervade a popular art, *without exercising the happiest and most important influence, both upon the tastes and morals of the people.*

(Frith 1859: 71; emphasis in original)

Although this may sound rather quaint in its sentiment, it is a problem that remains with contemporary media. For example, should films portray sexual or violent acts because they are reflecting life as it is lived, or should they present examples of how life should be? To act so as to exert a good influence upon the cinema-goer, or to portray suitable role models for members of society? It is clear that Frith's belief that photography had the innate capacity to do this automatically meant that he was not able to conceive of the subject matter encountered by the contemporary photo-journalist.

The issue of the viewer responding to effect or meaning

As we saw in Chapter 2, one of the most important goals for the arts since the classical period has been realism, and this idea of realism was one that was to be achieved by imitation. Herodotus (the fifth-century BC historian) was acclaimed for his ability to achieve vivid descriptions in his writings: 'he takes you in imagination through places in question, he transforms hearing into sight. All such passages, by their direct personal form of address, bring the hearer right into the middle of the action being described' (Longinus 1953: xxvi). We find, in the ancient world, the existence of legends concerning painters who are able to create convincing illusions that could fool people, animals or even artists themselves into mistaking works of art (painted surfaces) for reality. For example, there was the work of Zeuxis, the painter whose picture of grapes reputedly was pecked by birds. Pliny later continues the story in which Parrhasios, a rival of Zeuxis, tried to raise a curtain which in fact happened to be a painting. In the history of philosophy where Plato condemned imitation, Aristotle in his *Poetics* (IV) (in Else 1957: 124) considered it to be a characteristic of human instinct: 'The instinct for imitation is inherent in man from his earliest days; he differs from other animals in that he is the most imitative of creatures, and he learns his earliest lessons by imitation.'

This quotation serves to emphasise that the notions of copying or imitating have been considered to occupy a central and influential role in Western culture. They not only had a lasting influence upon theories of education, but also a lasting impact on aesthetics and the role of visual representation. For example, the Victorian/Edwardian photographer Sir Benjamin Stone, between 1868 and his death in 1914, created a unique photographic archive of 22,000 images and wrote extensively about the value of the photographic archive for education. As Stone put it: 'I look on photography as

being a most valuable aid in education, because pictorial illustration is by far the earliest mode and pleasantest manner in obtaining instruction' (*Tit-Bits*, 16 April 1898). Stone's view would appear to be continuing this tradition that the photograph could provide a replica from which the student could gain part of their education by proxy. Stone is further placed in the classical tradition in that it was Aristotle's conviction that humans also have an inherent desire to obtain pleasure from viewing other people's imitations. In the sixteenth century (bringing us closer to the period of Kepler's eye/camera analogy and Descartes' experiment) Ludovico Dolce (1557: 176) extended the classical line of argument: 'the painter must labour hard not only to imitate but also to surpass nature'. According to Dolce, nature itself cannot be improved upon, though human nature can be. Here imitation has the ability to inspire people to betterment and to noble acts.

The social impact of technological change

This brief diversion has the purpose of reviewing some aspects of the aesthetic context from which photography emerged. The reader will recall from Chapter 2 that such theories formed the prevailing influence over the early photographers (Rejlander and Jabez-Hughes for example) as did Frith's ideas concerning photography's inherent ability and potential to improve the general public. The intention of the artist to imitate nature (through painting or poetry) had continued until photography was invented. According to Scharf (1968: 179), 'the increased emphasis on *matière* can well be attributed to the encroachments of photography on naturalistic art'. Photography had removed from the painter the role of mechanistic replication. It may be oversimplistic to state that it was owing to the invention of photography that painters felt that the imitation of nature had been forcibly removed from their province and that they had to pursue other aims in order to justify their existence. This type of view was expressed by Renger-Patzsch who believed that:

> there's not the slightest doubt that graphic art has been obliged to surrender to the camera much territory in which it was previously absolutely sovereign, and not only for reasons of economy, but because in many instances photography worked faster, and with greater precision and greater objectivity than the hand of the artist. . . . Modern art can no longer pursue representational goals.
>
> (Renger-Patzsch 1929: 15)

And from the point of view of the painter, photography had initiated new freedoms. On this point it was Pablo Picasso's belief that 'Photography has arrived at a point where it is capable of liberating painting from all literature, the anecdote, and even from the subject. In any case certain aspects of the subject now belong to photography' (Brassai 1966: 46–7).

However, the invention of photography may have contributed to creating the social climate in which painters felt the need to question the canons of representation. In fact, it may have been social conditions that created the climate for the need for a representational system such as photography. In Giselle Freund's view, it was the change in the social structure of the nineteenth century, such as the machine age and modern capitalism, that altered the nature of subject matter and artists' techniques.

For example, both the styles and techniques of portraiture had changed, accompanied by a new democratisation of the visual image:

> Technological progress outside the art world led to the invention of a series of processes that were to have considerable bearing on future developments in art. ... The most decisive factor in making art accessible to everyone was the invention of photography.
>
> (Freund 1980: 3)

So perhaps the overriding achievement of photography was not the automatic recording of reality as it was so understood, but a process that makes this form of recording potentially open to everyone.[19] Freund (ibid.: 28) points out that the almost simultaneous inventions of photography by a range of individuals is a clear indication that the photographic process was very much a product of its time. This seems something of a one-way process – that of a culture demanding a particular system of representation. But we should not view the invention as a matter of simple passive response. In practice, one does not encounter a cultural pattern or environment to which a technological development is simply added. The inclusion of a new technology results in a completely new environment, which can change the forms of communication and the economic organisation as well as the political power relationships of a given society.

In the eighteenth century, the full impact of the invention of the printing press was being felt by writers who were accepting a distancing from their readership: 'who accept this separation as a primary condition of their creative activity and address their public invisibly through the curtain, opaque and impersonal, of print' (Bronson 1968: 302). Mechanical and mass reproduction had created a separation from the personal address that had characterised the classic style as exemplified by Herodotus.

This section has aimed to consider the change in response theory from that of the viewer responding to the effect of the personal address to one of a distance, imposed by technology, that involves collaboration between the viewer and the photographer in creating meaning. Later we shall be looking at the collaboration between the photographer and the subject (p. 136). As we have seen in earlier chapters, some theorists have stated that photographs should be understood by the viewer's recourse to linguistic abilities and not by means of the photograph's ability to replicate the subject. James Agee aimed to overcome this polarisation in his description of photography as the 'language of reality':

> [It] may be the most beautiful and powerful but certainly it must in any case be the heaviest of all languages. That it should have and impart the deftness, keenness, immediacy, speed and subtlety of the 'reality' it tries to produce, would require incredible skill on the part of the handler, and would perhaps also require an audience ... equally well trained in catching what is thrown.
>
> (Agee and Evans 1941: 236)

In addition, Agee seems to be suggesting that photographic communication is similar to a game. The photograph not only tests our conception of the plausible but it invites us to engage with the image. Charles Suchar (1989: 52) has described this as the 'interrogatory principle': 'all photographs can *equally* be considered as

documentary photographs if they can be seen as providing answers to questions that we have about them; that is, if they fulfil the *interrogatory principle*'.

If we adhere to Suchar's *interrogatory principle*, our interrogation of the photograph might lead us to ask the following questions:

- Can we analyse the 'internal' content of the image – ask what information has been selected by the photographer and what we find interesting in the photograph?
- Can we make a comparison of the particular photographer with other photographs – placing the photograph in the context of comparative photographic practice?
- What value does it have as an example of an image of its kind?
- What were the intentions of the photographer?
- What use has been made of the image?
- What do we know about the subject of the photograph?
- How does the photograph relate to other historical evidence?
- How does the image relate to theoretical perspectives of photography in particular, and visual representation in general?

Of course, such questions are more applicable to viewing a photograph taken by someone other than the enquirer. For our own photographs we might shift the emphasis of the questions:

- What information do we find *within* the photograph?
- What additional *external* information do we need to supply to direct the meaning of the image?
- What is the range of potential meanings and interpretations that the viewer might construct from the photograph?
- Can we make a value judgement on how the image relates to others of its kind?
- How does the image fit in to the broader historical and theoretical spectrum of photography, visual imagery, the arts and the general cultural milieu?

For an example of how this might work in practice I recommend the reader returns to look at the possible descriptions and interpretations in the case study of I. Russell Sorgi's photograph of a suicide (Figure 3.6) and in the 'Looking-glass war' case study (Figures 4.8 and 4.9).

Photo-elicitation

Photo-elicitation can be described as the deliberate exploitation of the viewer's response to the photograph. It is a method often employed by visual anthropologists, and is a significant aspect of photo-therapy, for example where family photographs can be used to trigger hidden memories (Spence 1987, 1995). It enables the researcher to gain access to subjective responses to the photograph. If one is studying a social or cultural group, showing their members photographs that may have been taken of them, by them or by other people, or of particular locations and events, etc., facilitates

a response to the photograph by asking for comments upon the significance of the image. The method enables the researcher to understand how the subjects:

- view their group from the inside;
- perceive their own role and sense of self;
- examine the meanings of their own behaviour and engagement in cultural processes.

This can be viewed as exploiting a characteristic of the family album in its mnemonic function. In addition to providing a record of memorable events, the image can operate as a stimulant to the memory (see Collier and Collier 1986).

It should be emphasised that in the normal practice of commercial photography there is the expectation of fairly rapid results. The chances of the photographer having familiarity with the subjects, and the possibility of finding out much about them or how they themselves wish to be represented are limited. So it becomes difficult to think how community-based projects and cooperation with the subjects will fit into the framework of current commercial practice. With community photographs, the subjects are usually expected to suggest ways that will enable the photographer to become a catalyst or facilitator to help members of the community achieve their own aims and aspirations. So in this context, consultation does not consist of a one-off interview, but will be a sustained process throughout the duration of the project and of a nature whereby community members are able to see the whole process through and be involved at each stage. If they wish to withdraw their involvement at any time, the photographer may need to compromise between carrying through the project and respecting the wishes of the subjects. If this happens, it might be seen as part of the practice of documentation.

Case study: the Australian *After 200 Years* project

> In front of the lens, I am at the same time: the one I think I am, the one I want others to think I am, the one the photographer thinks I am, and the one he makes use of to exhibit his art. . . . I am neither subject nor object but a subject who feels he is becoming an object.
>
> (Roland Barthes 1982: 13)

If, as Susan Sontag maintains, 'to photograph people is to violate them' (1977: 14), the Australian Aborigines could well claim to be victims of the camera. The proliferation of photography went hand-in-hand with colonial expansion and has left a sad record of the subjugation of Australia's indigenous culture. From the viewpoint of a more (though by no means wholly) enlightened time, it is possible to rewrite colonial history: shifting the emphasis to redress the balance and show new perspectives on events. Of course, photography is not quite so accommodating (or flexible) in this regard. Once events have passed we can alter written accounts as attitudes and circumstances change, but the fixed image of the photograph can only be recontextualised (although this does not account for the issues that arise from digital photography –

these will be addressed in another chapter). It was Australia's Bicentenary that was chosen to provide an opportunity to amend the photographic record. Even though from the Aboriginal perspective it 'symbolises destruction and loss of life, land and culture', it was felt it could offer a new, more positive opportunity. With this in mind, over twenty photographers from both the Aboriginal and the non-Aboriginal community were engaged to live and work in communities throughout Australia to document Aboriginal life. The general purpose of the project was to collate images that represented the variety of situations and lifestyles experienced by contemporary Aboriginal Australia. It was proposed that the photographs should act as an antidote to the exotic, or supposedly authentic and traditional, images of Aboriginals that were the products of the colonial viewfinder. The photographs aimed to show those aspects of Aboriginal culture, conditions and activities that were less familiar to an international audience. For example, there were images of urban and rural life that could show the continuity from old to new – including the depressing images of a prison community. As for the means of achieving this, the project 'attempted to develop a long-term model of co-operation between an institution and its Aboriginal constituents, between an archive and the people whose images would fill it, between photographers and their subjects' (Taylor 1988: xv).

The representation of one group of people by another can raise sensitive issues, so the success of the project hinged on this philosophy of cooperation and participation between photographer and subject(s). Initially, the project was announced to Aboriginal communities through their local newsletters. Contacts were made with Aboriginal organisations to propose the aims and objectives of the project and to collate suggestions and feedback as to how the project might be conducted from the subjects' point of view. Old photographs of the area and communities were printed and made available for return and absorption into the community. This had the bonus effect of stimulating discussions as to how the Aborigines had been represented in the past, and could help people to consider how they might wish to be represented in the present and what record of their lives and culture they would like preserved for the future. Once the project was under way, new collaborating communities were shown what had been achieved from earlier collaborations. So to begin with, much discussion took place about general issues of photography and, more specifically, about the public image and perceptions of Aboriginal life. This included their own family albums and the process of matching those and discussing them in comparison and contrast with archive photographs. For example, a stark contrast was noted between photographs taken by outsiders and the family photographs which showed the Aborigines looking relaxed and interacting with each other. In particular, from schoolchildren there was criticism of those photographs

> which depicted only life in remote areas, illustrated by dark-skinned people catching kangaroos or eating witchetty grubs. These narrow images, they felt, only encouraged their non-aboriginal classmates to believe that people who lived differently were not 'real' aborigines.
>
> (Taylor 1988: xix)

From the discussions there also arose the issue of the narrowness of media representations which concentrated on the poorest areas of a town. They were not interested

in Aboriginals who had jobs, but served to reinforce the stereotype of the unemployed, drunken and lazy Aborigine. As the media had concentrated on such negative representations, it was felt that the *After 200 Years* project could assist in the production of a positive image of aboriginal life.

Nonetheless, the project was not without its problems. There were issues concerning visual representation that arose from specific cultural factors. For example, there were cultural restrictions on seeing photographs of recently deceased persons, which meant that the photographic strategy of distributing photographs and subsequently publishing them could have upset and offended certain groups. The introduction to the book that resulted from the project had to include a warning that readers might feel that some aspects of the book could infringe a particular cultural taboo: a taboo which did not necessarily apply to those who had been deceased for two or so generations but only to those whose mortuary rites were still continuing. Similar restrictions applied to certain ceremonies:

> one photographer took photos of parts of a ceremony that was privileged to initi-
> ated men only. He did so at the request of older men present and on condition that
> no women or government people would see them. The photographer processed the
> film himself, made copies of 50 photographs which were returned to the appro-
> priate person, and then the negatives were destroyed.
>
> (Taylor 1988: xxi)

Another feature of the project involved the production of the third meaning, created by the combination of image and caption. The community members were invited to provide the text for the photographs as well as assisting in the selection of the images.

The general conclusion that we can reach from the example of the *After 200 Years* project is that there is no absolute formula for success in providing a photographic record of any particular cultural group. The best procedure for the photographer is to establish all the possible relevant factors, and devise a course of action that, although it will not necessarily be perfect or foolproof, will at least be the result of informed decision-making.

Case study: photography in the search for identity

Camilla Sune is a Norwegian photographer living in Oslo. Born in Korea, at the age of fourteen months she was adopted and brought up in Norwegian culture and speaking the language. It was during her studies in England in 1995, that people would ask her where she was from and, when she replied 'Norway', they wanted to know where she was *really* from. This led her to search for her Korean identity and to use photographs to aid her in her quest. In common with other ethnic groups she has used photography as a means of re-establishing her identity (for example, Black photographers, or the Australian Aboriginal *After 200 Years* project), but Sune finds it difficult to connect with their work. She has in common some of the general issues of race, ethnic and cultural identity, but not the specifics of her own cultural and personal experience.

Feeling that circumstances have denied her an important aspect of her past, she began to place her childhood photographs into items of traditional Korean clothing – literally to re-dress parts of her missing history. In other images she has produced self-portraits that compare and contrast her own Korean appearance, her clothing (which can be either Western or Korean) and the Norwegian landscape. Using photography in this way, her connection to Korea is made through symbols of *Koreanness*: the sorts of images and artefacts that one finds in picture postcards and other tourist imagery. On the one hand the photographs seem to come to terms with the two cultures; on the other hand they can display her difficulties in coming to terms with an aspect of her life that is something of an academic point, as she cannot remember any of her life in Korea and is unable to speak the language. Thus she faces a personal dilemma: in some senses she is attempting to come to terms with her 'real' identity, but it is an identity that is largely based upon her own physical characteristics and 'circumstantial' evidence. She also faces the cultural contradiction of Korea itself. Since the end of the Korean War (1950–3) the country has been divided into two separate states – North and South Korea – and until recently this political divide has

Figure 4.13 Vinter, 1997.

split many families. For the past half-century, the notion of *being Korean* has implied a divided sense of self – a situation which continues to be the subject of protracted negotiation (Ward 2002).

Although Camilla does not personally identify with the divided notion of Korea, the issue is by no means fully resolved, but this is the strength of her work. As an ongoing search for her 'true' identity, can an adequate conclusion ever be reached? Simultaneously as photographer, subject and viewer, she is balancing her subjective experience with her objective knowledge, using the medium of photography to juggle with some of the contradictions of human existence. James Clifford in his *The Predicament of Culture* writes of 'ethnography in alliance with avant-garde art and cultural criticism, activities with which it shares modernist procedures of collage, juxtaposition, and estrangement. The "exotic" is now nearby' (1988: 10). Similarly, using the camera as a means of self-projection, Camilla Sune's photographs raise questions about the relationships between personal history, cultural stereotypes and photographic genres such as documentary, ethnographic, family snapshot and self-portrait (see Figures 4.13 and 4.14).

Figure 4.14 Vinterterien, 1998.

Summary

- We considered the post-production of the photograph, in particular how the context of the photograph can influence the meaning of the image.

- As a practical example, the ability to 'read' contact sheets was addressed, and this was followed by looking at examples of the different ways the photograph can be 'cropped'. Sometimes this can dramatically change the ways the image is to be understood.

- The extended case study of the 'Looking-glass war' offered a detailed discussion of the relationship between the image, its title and the potential range and depth of interpretation that this relationship can yield.

- The image/text relationship was explored further in the creation of the 'third meaning' that resides in neither photograph nor caption but arises out of their juxta-positioning. This discussion was extended to take into account the use of photographs in sequence.

- The chapter concluded by considering the 'interrogatory principle': the unconscious questions we might apply to the photograph and how such lines of questioning can lead to photo-elicitation – the use of images to instigate a response from people as part of a structured research method.

5 The documentary photograph

The photograph as a document

In view of the argument regarding the nature of photographic representation developed in earlier chapters – that the photograph is subject to the photographer's selection of subject, framing, lens and personal regard for the subject, as well as the institutional and broader historical or cultural context – what do we mean if we describe the photographic record as 'documentary'?

According to the *Oxford English Dictionary*, the term 'document' suggests an artefact that has educational value or has value as evidence: intended primarily for instruction or record purposes. We can extend this definition to include those photographs that are 'didactic', 'observational' or 'polemic'. We might consider that it is the **didactic** intention that fulfils documentary's educational role. Its approach aims to embellish the straightforward activity of recording by informing the viewer about the subject. Here an accompanying caption or text may act as a narration, whereby a mediator (whether the photographer or a third party) might provide specialised knowledge or expertise, adding to that which we perceive in the photograph. The observational mode (in the broader definition of documentary) aims to provide evidence by means of a document that acts as a channel, in the naive realist sense, whereby the unobtrusive camera allows the viewer a relatively unmediated view of the scene. The overall aim here may be to provide a record of events for the future – to create something that will later have historic value. However, we may also add the polemic approach, which can aim to put forward a particular point of view about the subject. In this instance, the photographer takes issue with the overall aim of expressing what he or she thinks, believes or feels about the subject. But we do need to try (at least) to be clear where the idea 'to document' ends and when the photographer aiming 'to persuade' or 'to promote' becomes involved in producing propaganda. Perhaps we should ask if communication, or indeed information, can be neutral or is there always some underlying hidden agenda? This may depend on who is providing the information, and for what purpose, as well as on the broader context of the communicative process.

Again, the categories of the observational, didactic and polemic are not mutually exclusive but can serve to indicate some of the intentional strategies that have been

proposed by those photographers who claim to operate in the documentary mode. We should note that, to greater or lesser degrees, all three categories imply different levels of authenticity (that they provide evidence of 'real' events) and authority (that the producer(s) consider it is important that they should be brought to our attention). As Bill Nichols (1991: 7) has put it: 'Documentary offers access to shared historical construct.'

It was the documentary film-maker John Grierson who coined the contemporary use of the term 'documentary', which he described as 'the creative treatment of actuality'. As we have seen in previous chapters the idea of realism is a rather slippery commodity and this equally applies to actuality. Not only is actuality a very loose term, but we might recognise a sliding scale which runs from actuality through to fantasy (encountering such terms as opinion, viewpoint and impression along the way). Nonetheless, in taking a retrospective glance at Grierson's films with reference to the categories established above, we find they conform to a strongly didactic approach, characterised by an overriding objective of educating and informing the viewer.

So when we look at a photograph it can supply information regarding the culture by which and from which the image was taken. It conveys information regarding its own formation – the aesthetic and technical criteria that have come into play in the production of the image. This information has been referred to in literature as the 'lateral message' by Jameson: 'at the same time that they speak the language of reference, [they] also emit a kind of lateral message about their own process of formation' (1972: 89). And taking this further, according to Bourdieu at least, representations only really represent themselves and not at all any external reality: 'In stamping photography with the patent of realism, society does nothing but to confirm itself in the tautological certainty that an image of reality that conforms to its own representation of objectivity is truly objective' (quoted in Krauss 1984: 57).

In this case, it seems that Bourdieu is suggesting that the photographic system of representation happens to fulfil those criteria that Western society has already decided upon to depict the world, whereby representations relate more to other representations than they do to reality. Such a position seems somewhat indebted to the Russian formalist view of poetry.

In any photograph of the human subject, we find that the subject displays expressions and that their style of clothing carries a message, as does the location of the photograph, all of which may indicate a particular social role and aspects of character. The photograph can supply visual evidence of some thing or an event that has occurred before the camera. Of course, as time moves on, so the information in the photograph can be put to different uses. And, despite the intentions of the photographer (or the subjects), the intended purpose of the image can backfire, a famous example being the photograph taken during the siege of Paris in 1871 (see Figure 5.1). The Communards, having rebelled against the French government, not only stood by the barricades posing before the camera but, having demolished a statue of Napoleon Bonaparte dressed as a Roman Emperor, stood around the remains in triumph. Some weeks later when the Commune finally fell, the photograph provided the French government with the necessary evidence to identify the perpetrators and to round them up for execution. It may appear ironic that the French realist painter Gustave Courbet, who was counted among the rebels, not only appeared in the photographs but managed to escape with his life, having agreed to pay for the repair of the statue. This gives the photograph an additional historical dimension and places the image in a broader narrative context.

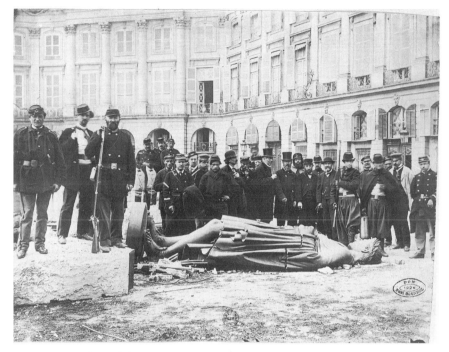

Figure 5.1 Courbet and the Communards, Paris, c.1871.
Courtesy of the Bibliothèque Nationale de France.

Photojournalism

The broad aim of photojournalism is to produce photographs of quality that become the primary means of telling a story or portraying an event. It is the main purpose of the photojournalist to bring visual information to the attention of the public. Apart from dealing with the photographic mechanics of the shoot, photojournalism depends on the photographer's skills of observation. It may rely upon the skills of recognising a potential for showing the familiar in a novel way, or on the photographer's ability to highlight detail or new aspects of the subject and its overall environment. Above all, it is most likely expected to display a power of conviction that might supply the viewer with evidence to support or change an opinion regarding a particular issue. It will often require that the photographer's photographic skills become automatic, so taking the photographs becomes second nature, leaving the photographer free to concentrate, not so much on the subject, but on the *representation* of the subject. Sometimes this may involve engaging the subject in conversation whilst simultaneously carrying out the activity of taking photographs. So complete familiarity with the photographic equipment in this context becomes essential. As put by photographer Robert Doisneau (1948: 1), 'His technique should be like an animal function . . . he should act automatically'.

It may seem obvious, but a central characteristic is being there. Where, arguably, a news reporter could arrive after the event and still piece together a story from eye

witnesses or the police for example, it is not quite so plausible for photography. Once the event has happened the photo-opportunity is lost. The photographer also needs the appropriate equipment to carry out the job and to know the background details so as to be able to take informed photographs that can tell the story, back up or complement the written word. Another skill (that depends much upon the foregoing) is being able to anticipate what is about to happen, and being able to respond effectively to an unexpected turn of events so that one can be in the optimum position to draw out the visual elements of the event for the ideal photographic moment. Often a news event will develop its own choreography and will unfold like a speeded-up game of chess. It is therefore up to the photographer to predict the possible moves and responses to obtain the best possible viewpoint and position.

We need to consider the purpose of the photograph in the context of photojournalism and what information the image is intending to convey. As far as it is possible to say what makes a good photograph in this context, it is one that does more than simply illustrate the event or the story: it should reinforce information that is already on the page. It is part of the photographer's skill to be able to assess the subject, isolate its visual qualities and predict how these will appear in pictorial form. Sometimes the skill lies in the ability to take a written idea or one that is issued verbally and convert it into pictorial form. The photograph needs to arouse interest both in its factual content and visual appeal. Often it is intended to refer to a much wider context, effects and significance of the event than the immediacy of the event itself. In order to achieve this, research and preparation are of key importance. It is not simply a matter of gaining as much familiarity with the story as possible; it also involves being aware of the balance between words and images as they will appear in the final copy.

Almost immediately upon arrival, irrespective of the subject or event, it is important to secure a number of establishing shots. Or, in this context, safety shots as a form of insurance against any unexpected occurrence, whether this is in the form of an unusual turn of events or some unpredictable technical problem. At the very least, these lay the foundation for the assignment and can always be improved or elaborated on later. We will recall that this technique was adopted by I. Russell Sorgi's 'I snatched my camera from the car and took two quick shots'. Then he waited for the moment which, for him, made the story.

Working arrangements

There are a number of ways in which photographers can come to be working on an assignment. They may be on the staff of a media organisation, in which case they may be asked (or told) to cover a particular event. On the other hand, they may be operating in a freelance capacity, or as photographers who may be taken on for a fixed-term contract or be commissioned on a more or less regular basis. If the latter is the case, there are some dangers in becoming too dependent upon one organisation as changes beyond the photographer's control (in policy or personnel, for example) can result in work suddenly drying up. At the same time, working for too many organisations can gain the photographer a reputation for never being available – a state of affairs which can have the equally surprising result of all work ceasing for a month or two with no immediately apparent cause or reason. The photographer, whether staff

or freelance, may be able to propose an idea for a feature, particularly if they are on location and another event or story comes to their attention (see Figure 5.2).

Another way of operating as a freelancer is to work 'on spec.' whereby the photographer carries out the research to find events with commercial potential. If it is considered worthwhile, the attempt can then be made to sell the photographs to journals. In many cases, it depends upon being better informed than the picture-desk or better located than any of their staff (or regular freelancers). While this mode of operation proves more risky in providing a livelihood, the financial returns for a successful assignment can be considerably higher than for a commissioned assignment. It also places greater emphasis on the photographer's research, marketing skills and nose for a story.

There are some individuals who are able to combine the skill of both photographer and writer to provide the photograph, and the text to go with it, as a complete feature. At any fast moving event it does become difficult to maintain attention for both methods of delivering information: there is the added complexity of, in effect, trying to do two jobs at once. In the long run, either the writing or the photography may appear to suffer.

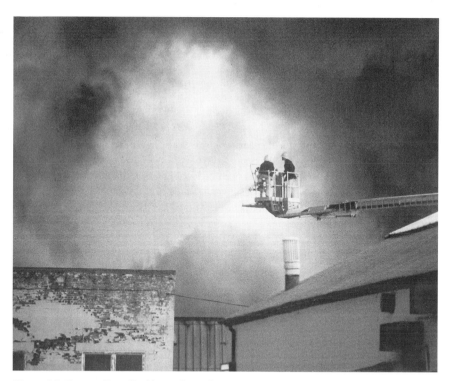

Figure 5.2 Factory Fire, Cricklewood, London, 1985.
Photograph by Terence Wright.

Case study: the *Guardian* assignment

The day begins with the photographers and picture-desk staff arriving in the office and reviewing the previous day's issue of the paper. Potential stories are being identified and preliminary enquiries are being made. At 10.30 the first conference of the day begins. Attended by the different heads of department and leader writers, the round-table discussion lasts for approximately thirty-five minutes. It begins with a summary of the day's edition and those attending go through the paper page by page. Editorial decisions are explained and, if necessary, defended, problems are discussed and the general critique session follows.

This is drawn to a conclusion which provides the basis for seeing which stories will carry over into the listing of the day's current issues and a consideration of their news potential. For example, possible stories for Wednesday, 5 March 1997, included: government changes in SERPS (which could be simplified into a Q and A chart), asbestos compensation claims, the German nuclear train protest and an item on the Cairngorm railway (which someone had picked up on from Radio Four's *Today* programme). When it comes to the picture editor's contribution, Eamon McCabe identifies which stories offer the greatest scope for pictures.

Another aim of the conference is to identify any areas of overlap between departments. For example, *G2*, the *Guardian*'s feature section, may be covering the same item as the broadsheet, so to avoid duplication of effort it is important for all concerned to be aware of this.

Returning to the picture-desk, photographs appear on-screen sent by different agencies – Associated Press, Reuters and Fast News[1] who use digital cameras – and from a variety of freelance photographers.[2] The photographs are thumbnail images, all captioned with descriptive detail. They are selected and placed into desktop files of images that may be suitable for the day's news (see Figure 5.3).

At any point, to aid the decision-making process the images can be enlarged on-screen and/or printed as hard copy. For example, in the case of the German nuclear train, two potential images are identified and evaluated for their image quality, that is, the amount of detail they contain, the directions of light, their effectiveness if reproduced in monochrome and so on.

At 12.30, the second conference takes place (see Figure 5.4). By this point a news list has been prepared and (in comparison with the 10.30 meeting) the day's stories are now consolidated. It is part of picture editor Eamon McCabe's contribution to identify which stories are picture-led. For example, the German nuclear train protest has an ongoing picture potential, Milan fashion pictures could provide strong but relatively straightforward visuals, while the SERPS story is considered to be relatively barren in terms of its visual potential.

Two press releases are taken up: the hanging of paintings by Monet at the National Gallery and the Egyptian opera company at the British Museum. It is decided that both have strong visual potential, particularly the opera members who would be in costume in the Egyptian Galleries of the British Museum. Photographer David Sillitoe is dispatched to cover the stories.

At the hanging of the Monet show, the main problem is to draw out an interesting image from what could come across as a fairly ordinary scene. It would have been possible to have simply reproduced one of the paintings and not sent a photographer

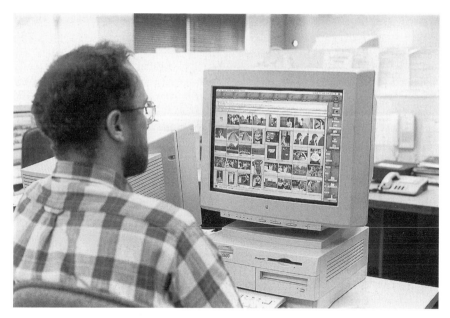

Figure 5.3 The picture-desk, with thumbnail images on-screen.

Photograph by Terence Wright.

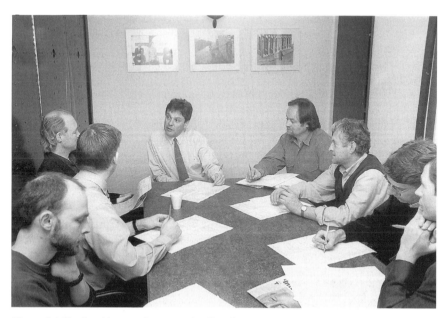

Figure 5.4 Twelve-thirty conference at the *Guardian*.

Photograph by Terence Wright.

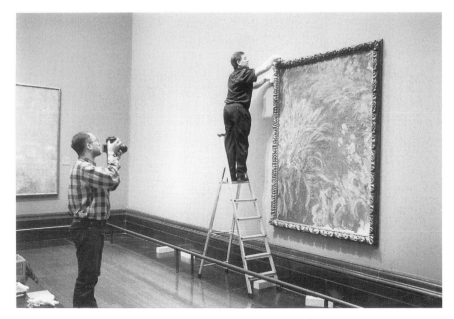

Figure 5.5 Photo-call at the National Gallery.

Photograph by Terence Wright.

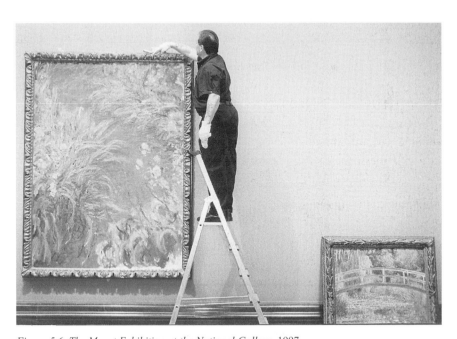

Figure 5.6 The Monet Exhibition at the National Gallery, 1997.

Photograph by David Sillitoe. Courtesy of David Sillitoe and the *Guardian*.

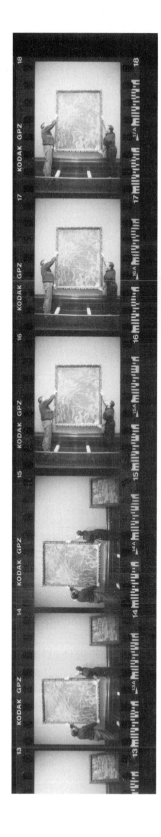

Figure 5.7 Contact sheets of photographs taken at the Monet Exhibition, 1997.

Photographs by David Sillitoe. Courtesy of David Sillitoe and the *Guardian*.

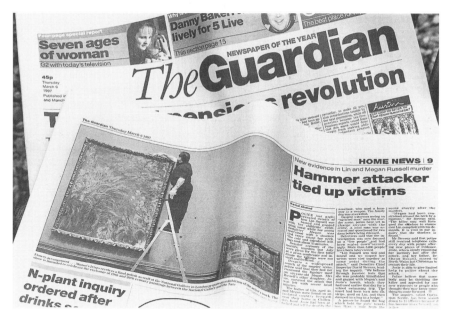

Figure 5.8 The photograph as it appeared in the *Guardian*, 6 March 1997.
Courtesy of David Sillitoe and the *Guardian*.

at all. But despite the reputation of the artist it is unlikely that his more retinal and ephemeral images would reproduce well enough (particularly in black and white) or have the impact required for the newspaper context.

After taking a number of shots of different paintings and a variety of activities, a picture is set up, quickly improvised from the people and objects that happen to be there at the time. One of the gallery technicians is asked by Dave to climb a ladder and go through the unlikely procedure of dusting the frame of one of the newly hung paintings (see Figure 5.5). It is one of the images taken of this situation that is finally selected from the shoot.

Although constructed from available elements, the image conveys an impression of last-minute attention to detail, preparation and readiness for public show. The subject is eye-catching and has strong formal qualities and, although the painting is not one of Monet's most well known, a more familiar image featured in the corner of the photograph provides easy recognition and an element of compositional balance for the photograph (see Figure 5.6). The image was shot on colour negative and the film had been uprated to 800 ASA to compensate for the subdued lighting in the gallery. The image had been selected from the contact sheets (see Figure 5.7) and had been printed full-frame. This is particularly appreciated by photographers, most of whom like the paper to respect their compositional selection. The image was reproduced on page 9, seemingly out of context: apart from a short caption the image was left to speak for itself (see Figure 5.8).

The assignment

Without being too categorical, there are different demands placed upon the news photographer and the features photographer. In the case of the former, there can often be greater emphasis on getting to the location on time than on the act of taking photographs. Of course, the popular image of the photojournalist is that of someone who just happens to be in the right place at the right time. But it is research and experience that enable the photographer to predict where the right place is most likely to be, and when the right time is to be there. Nonetheless, news photography can be risky and the profession has a long casualty list. And it is always worth remembering that no photograph is worth losing one's life for. Below, two situations are contrasted: a news assignment and a features assignment, with the example of a portrait shoot.

News photography

For a photo-call I had in Central London, a 10.00 a.m. appointment at the Foreign Office to photograph a new ambassador about to be posted abroad, it was necessary to set out for the assignment immediately upon receiving the phone call from the agency. This meant that everything had to be ready – photographic equipment, *A to Z*, petrol in car, etc. Then the breakdown of time ran as follows:

45 minutes driving to Whitehall

15 minutes to find a parking space

10 minutes waiting around

10 minutes shooting

30 minutes to deliver the film to BBC Television Centre

25 minutes to return to base in West Hampstead.

In this case, the skills of time management, catching up on the latest relevant news, map-reading and route-planning, driving swiftly yet safely, accurate reporting to the office from the scene of the event, etc. were in greater demand than pure photographic skills. The actual taking of photographs involved a short time allowance in a given location. (Sometimes the subject would have been pulled out of a meeting into the only available room, in which case the photographer would have to make do.) Engagement with the subject was hurried, polite and extremely short – just enough time to take a roll of film and exchange a few pleasantries. In this instance, the purpose of a photographer being at the photo-call was to capture an image that would convey a recognisable likeness suitable for a broad range of applications. At the same time, I had to be prepared for the eventuality of the next assignment, which often involves carrying in the car a stepladder, wellington boots, passport, pen and paper, parking meter money, etc.

The news picture usually needs to have an impact and the ability to portray the character of a particular event or personality. In the news context, it is not unusual for the photographer to be sent out on an assignment in the company of a reporter. As the action unfolds, the two will work in close collaboration. For example, when covering a court case the reporter will be inside the court, taking notes of the

proceedings, while the photographer (unable to take cameras into the precincts of the court) will be waiting outside. When the trial is over the reporter will brief the photographer as to the significant people to photograph and will, if necessary, identify them so they can be photographed upon leaving the building.

However, in many cases the photograph is predictable, in that the photo-opportunity has been preplanned or created by a public relations agency or department. The image may have been already thought out and a PR representative will usually be on hand to ensure that the subject(s) appear in the best possible light for the story they are promoting.

Feature photography

In contrast, the feature assignment 'A day in the life of a woman bus driver' was planned a week in advance, allowing time for background research regarding the subject and discussion on the angle to be taken with the journalist. The idea for a story may be proposed by the photographer, a journalist or an editor. Who proposes the story determines the point in the proceedings where the photographer becomes involved and therefore the amount of influence he or she may be able to exert over the final outcome. In this case, a journalist had seen a woman driving a London double-decker bus and recognised the potential for a story. As the photographer, it was important that I was aware of the style of the journal, *Company* magazine. Nadia Marks, the picture editor, considered it important that the readership should be able to identify with the subject and that the bus driver should conform to *Company*'s image: she should look young and attractive. As it was an assignment for a publication that was new to me, I found it particularly beneficial to consult some back issues to see the journal's treatment of the image and the type of image the picture editor might be looking for: the journal's **house style**. This is important for the freelance photographer, as one would expect that the staff photographer would already be producing images that were considered acceptable by the journal. The freelancer may need to be able to adapt his or her technique to cope with the variety of expectations posed by the range of journals to which he or she contributes.

One good example of a distinctive house style is that of *Campaign* magazine. Its style of photography is derived from the art-school documentary style of the 1970s: stark, black and white portraits, set against a strongly composed background, usually with the subject displaying a forceful eye contact with the camera and an earnest expression (see Figure 5.9). However, it should be added that it is not the best advice simply to emulate the existing house style. If you want to gain a reputation as a photographer of note, it is sometimes possible to supply the journal with images you know they will be pleased with as well as evidencing your own individual photographic interpretation, in the eventual hope of being able to convince the editor of the value of your own particular approach and style. So the photograph to some extent could be planned in advance, possibly choosing the location to photograph the subject, and a relatively relaxed journey could be taken there. Photography would take about an hour and a half, during which time one would to some extent negotiate the photograph. The photographer's skills of negotiation depend upon being able to reach agreement with the subject to gain their full cooperation. It is important to be subtly persuasive, to give a clear idea of what is required for the photograph, and to be direct,

Figure 5.9 David Hay, 1980.
Photograph by Terence Wright.

to ensure the subject is posed appropriately before the camera without taking advantage of them. As for directing the subject of the portrait or altering or rearranging objects in the field of view, the photographer should question the extent to which this may alter the accuracy of the photographic report.

The photography itself takes place whilst conversing with the subject, taking time to ensure they are feeling relaxed and comfortable before the camera. The process of conversation can often fuel more ideas for photographs. The films are then taken to a regular photographic laboratory, where the photographer is able to oversee processing and printing. The normal delivery time for the contact prints to arrive at the journal is one or two days. Then the shoot is discussed with the picture editor and/or journalist to consider the selection of image(s), and possibly the layout of the photographs, at the picture-desk. The photographer's role in this part of the process is useful but not necessarily essential, but it often has the added bonus of picking up more work while in the office: another aspect of being in the right place at the right time.

In contrast to the news photograph, the feature photograph is usually expected to be of a subject that is held to be of more lasting significance. Its documentary role consists in a shift of emphasis from the purpose of conveying information to that of creating atmosphere and/or opinion. Most likely the event will be timely, but not subject to the same degree of urgency as up-to-the-minute news. However, it is important for the photographer to be able to select and frame the information that makes the significant photograph. This is where research comes in. It is necessary to gain a knowledge of the subject and to develop the ability to extract the important elements from the point of view of the subject and from the angle that the medium of communication (journal or television programme) wishes to take. For some features,

the magazine will not call upon a general practitioner photojournalist, for example, for architectural shots, food or fashion; instead, a specialist with expertise in this type of photography may be commissioned.

The feature allows the photographer to take a more premeditated approach, with more time to obtain more information about the subject and to give greater consideration to the aesthetic issues of the photograph. With the feature photograph, we move from the relatives low control of the news photograph to more of a situation of high control. Either assignment has its advantages, though each may be suited to photographers with different personalities. The feature photograph may allow the photographer to have more artistic (formalist) influence on, or subjective (expressionist) interpretation of, the image – for example, to compose the subject to create meaning through mood and atmosphere. On the other hand, the news image may have the excitement and drama entailed in having to respond quickly to an unexpected turn of events to get the significant information into the frame. For example, the photographer on assignment to photograph New Year's Eve in Trafalgar Square could be on the lookout for a news event, a particular 'incident', or, in the case of a feature, might look away from the central action to the periphery to produce a picture taken 'backstage' which summarises more the photographer's personal choice of subject and view of events. (See Figure 5.10.)

In most instances it is advisable to take photographs in both *landscape* (horizontal) and *portrait* (vertical) formats. This gives the picture editor and/or designer plenty of material to work from and more room to manoeuvre when adapting the image to fit the page layout. In more specialised areas of photojournalism, for example photography for television broadcasts, it is very unusual to be required to provide a

Figure 5.10 New Year's Eve, Trafalgar Square, London, 1979–80.
Photograph by Terence Wright.

photograph in the portrait format: it is important that the format of the image corresponds as closely as possible to the format of the television screen. This would seem to be easy to remember but is frustrating with some subjects. Once, having gone to photograph the tallest flagpole in Britain, I found that in adopting the horizontal format the viewpoint had to be so distant that there was a danger that the pole became lost amongst other information in the photograph. The photographer needs to adopt an exploratory role to obtain a photograph that will provide any recognisable image at all.

The television photographer also has to be prepared for the television cut-off which alters the aspect ratio of the frame, reducing the size of the picture. In effect, it crops a margin from around the edge of the picture. So as a rough guide in shooting for television to allow for the cut-off, the photographer needs to use a 35 mm lens where a 50 mm would normally do, and a 28 mm or 24 mm where a 35 mm would be expected. However, in the case of photographs required for television picture publicity, these restrictions are unlikely to apply.

One can also encounter difficulties in moving from one media organisation to another (particularly in the above example of television to print). The photographer has to switch from one set of shooting practices to another, which may not be quite so easy after spending a month or two following a particular mode of operation or on moving from colour to black and white or vice versa.

Case study: the Libyan People's Bureau siege

On 17 April 1984 during a peaceful protest outside the Libyan People's Bureau in St James' Square, a gunman opened fire on the crowd killing WPC Yvonne Fletcher. The police cordoned off the area and a siege developed which lasted for several days. Having received a call from the BBC Stills Library, I arrived at the scene within thirty minutes of the shooting and took establishing shots (see Figure 5.11) of the scene of confusion as the police checked and searched the surrounding streets.

Later, having managed to secure a position on the top of a building in Carlton House Terrace, I hired a 1,200 mm lens that gave me a view of the front door of the building (see Figure 5.12). On the last day of the siege I was able to take clear shots of the embassy staff leaving the building (see Figure 5.13).

Despite the effort involved, the images that were most used for TV broadcasting were those taken in the first few minutes after my arrival at the scene (see Figure 5.14). Notwithstanding the patience and lens power used to achieve the final photographs, they lacked the impact of the earlier, less considered images.

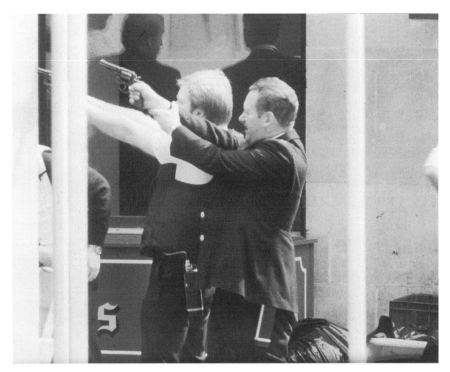

Figure 5.11 Police with guns at the beginning of the siege at the Libyan People's Bureau, St James' Square, London, 17 April 1984.

Photograph by Terence Wright.

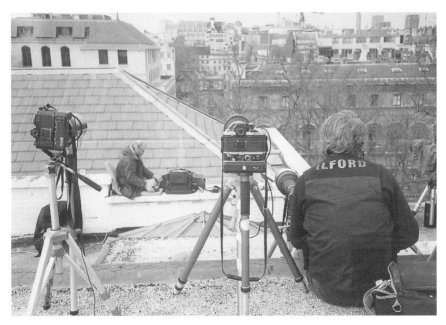

Figure 5.12 The press set-up at the siege.

Photograph by Terence Wright.

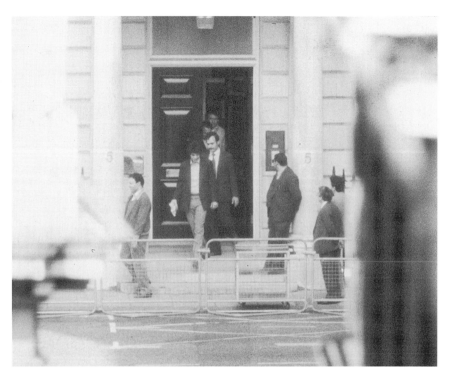

Figure 5.13 The end of the siege.

Photograph by Terence Wright.

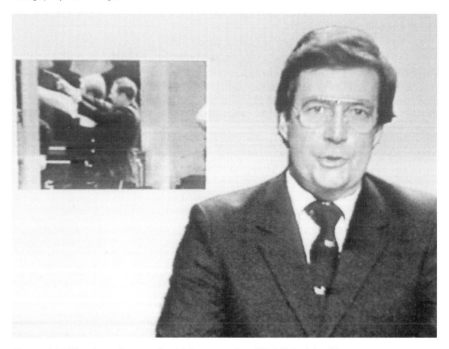

Figure 5.14 The siege photograph which was used on BBC Television News.

Photograph by Terence Wright.

Summary

- The chapter considered the term *documentary* and, within such practice, looked at the categories *observational*, *didactic* and *polemic*: photographs that aim to provide a transparent (realist) image of events; photographs that provide a record to inform or educate the viewer; and those that aim to convince the viewer of a particular point of view, respectively.

- The scene was thus set to consider the activity of photojournalism. This emphasised a familiarity with equipment so that use of the camera becomes 'second nature'.

- As an example the *Guardian* case study took a day-in-the-life approach to tracing the story of a newspaper photograph from the ideas stage at the editorial meeting to the photographic assignment and the picture's final appearance on the page of the newspaper.

- We then looked at the photographic assignment and examined some of the differences between news and feature story assignments. Not only does the news story require a quick response, but a photograph with 'impact'. In contrast, a photographic feature may include a number of images, and may allow for a more considered approach to produce photographs that invite the viewer to study or contemplation.

- The chapter concluded with the case study of the Libyan People's Bureau siege suggesting that with news stories patience, time and effort do not always produce their just rewards. Factors beyond the photographer's control must also be taken into consideration.

6 Photography as a cultural critique

From 'unconcerned' photographs to concerned photographers

One of Man Ray's experiments with photography involved taking what he termed 'unconcerned' photographs. He would use the camera to take pictures by chance, with little or no regard for subject or composition. By introducing this random element into his photography he allowed the camera to document whatever happened to be in front of the lens at the moment he happened to press the shutter. At another extreme of photographic practice, we can find photographers who have consciously used the camera not to reflect the world, but have made a conscious effort to produce images that will change it.

According to the *British Journal of Photography* (February 1992: 16), Tom Stoddard's picture of an 'emaciated, Belsen-like Romanian orphan' led to £40,000-worth of donations to relief charities within twenty-four hours of publication. Later, this figure was to rise to £70,000. This 'earning potential' for overseas aid seems to be true of images in general, though whether they have the ability to change opinions is another matter. In her comparison of the Mozambique floods (of February 2000) and India's Orissa cyclone (October 1999), Isabel Eaton, a former BBC *Newsnight* producer, notes that although Orissa suffered ten times the number of deaths of Mozambique, the disaster only raised £7 million in aid in comparison to Mozambique's £31 million (Eaton 2001). The unequal coverage can be put down to the fact that it was relatively easy for journalists to get to Mozambique and news people experienced less of a time difference than they would in India. This widened the possibilities for live broadcasts to coincide with the prime-time news slots of the European media. Also, in the Mozambique region there are not only better facilities and access to media technology, but also the availability of more comfortable hotels as well as R & R pursuits for off-duty news crews. Despite these considerations, Eaton believes it was the power of the visual images that was the overriding factor. The dramatic pictures from Mozambique had made the major contribution in generating donations to the disaster fund (Figure 6.1). It was a photogenic disaster featuring helicopter rescues, dramatic aerial shots of floods and sensational stories such as a baby born in a tree. This is in accord with the view of Mark Austin, reporter for UK's Independent Television News (ITN):

When our television footage was broadcast, it had an immediate impact. Finally, the world took notice of the scale of the disaster. Aid agencies issued appeals and western governments were forced to respond, albeit slowly. It is perhaps Mozambique's good fortune that this is a telegenic catastrophe. With no dramatic rescues, no riveting footage, would the world have noticed?

(Austin 2000)

As for the Orissa cyclone, the population suffered because their tragedy was not particularly photogenic. According to another ITN reporter, Mike Nicholson:

Pictures are everything, and it's well nigh impossible to convince the viewer of the scale of the disaster when the only pictures we can show are unsteady shots of people casually wading knee-deep through a flooded rice field.

(Nicholson 1999)

In Chapter 4 we considered Frith's mid-nineteenth-century standpoint where he had proposed that the truth of photography would, through its own intrinsic properties, have the power to change or influence people's moral standpoints and tastes. However, some photographers have made it their business to pursue the conscious use of photography with the aim of changing views and opinions – sometimes with the ultimate intention of changing the world in which we live. This is one step removed from Frith's notion of the replication of perfection, in that we are not necessarily looking for inherent characteristics of the medium as such which operate as agents of change. For example, in 1924, Moholy-Nagy had pointed out how the general cultural climate, combined with photographic representation, offered new viewpoints and consequently new ways of visualising and documenting the world:[1]

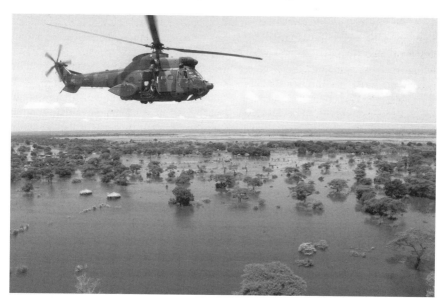

Figure 6.1 Helicopter Rescue, Mozambique, 2001.

Photograph by Pool – *Sunday Times*. Copyright Reuters.

In the age of balloons and airplanes, architecture can be viewed not only in front and from the sides, but also from above. So the bird's-eye view, and its opposites, the worm's- and the fish's-eye views become a daily experience.

(Moholy-Nagy 1924)

Similar notions were expressed in the work of Alexander Rodchenko, who believed he could find a new aesthetic through his photography that was appropriate to the new social order of post-revolutionary Russia (see p. 59 of this volume). This formalist version of Frith's approach relied on the photographer's ability to use the medium to show people what they would not normally be able to see – bringing issues to their attention through challenging their conventional perspectives of life. But we can move to consideration of another strategy: where the photographer is able to place him or herself in a privileged position and/or location to bring social or political issues to the attention of the viewer. The work of photographers Jacob Riis and Lewis Hine are particularly good examples in this context. Riis and Hine are considered to be the pioneers of social documentary photography. More recently, with the greater proliferation of photography, this approach has been developed by marginalised cultural groups (the Australian Aboriginal *After 200 Years* project, discussed on pp. 136–8) or social groups (the disabled, David Hevey (1992), for example). They have used the medium either to promote their own causes, or to challenge existing concepts and stereotypes in visual imagery. This said, there was the more unusual case of Amerindian photographer Martín Chambi who, in the 1930s, used his camera to explore his Inca heritage, to re-establish the lost history of his race as part of the Peruvian Indigenista movement. Chambi's photographs display a sympathy and understanding of those he has portrayed and do not objectify the subject.

Looking back in history, to 1868, we find the photographer Thomas Annan working in Glasgow compiling a documentary record of the slum districts. He published an album entitled *Old Closes and Streets of Glasgow* and, although such images were not necessarily operating in a self-conscious role of social criticism, the photographs did have the virtue of revealing the camera's potential to bring to a wider public evidence of social conditions and injustices. Similarly, John Thomson's series was published in monthly instalments in 1876–7: *Street Life in London*. He went to working-class areas with the writer Adolphe Smith, photographed the population and made a sympathetic record of the 'dangerous classes'. It is interesting to note that the cultural theories of social evolution, that were in vogue at the time of the Thomson and Smith project, viewed 'lower-class women' and criminals as sharing similar characteristics to 'savages' or 'primitive' man. This is perhaps most evident in the writings of Herbert Spencer (1870: II, 537–8). However, in the tradition of social documentation, Thomson and Smith were following a procedure initiated by Mayhew who, in 1851, had investigated *London Labour and the London Poor*. Mayhew was accompanied by daguerreotypist Richard Beard; however, the then technical limitations on photographic reproduction meant that the daguerreotypes had to be transcribed as woodcuts, and the originals no longer survive. Otherwise Mayhew and Beard might well have attained greater significance in the history of photography. They could have been seen as establishing the traditional approach of social documentary from the nineteenth century, through Agee and Evans of the 1930s, to contemporary collaborations between writers and photographers, Weisman and Dusard (1986) for example. But in Mayhew and Beard's case, as we shall see when we come to discuss the digital image,

an image manipulated by an artist, even though it may have been derived from a lens projection, does not seem to maintain the same degree of power of observation and authenticity as the unmediated photograph. We can summarise Thomson's use of the camera as being 'observational'. As far as the accompanying text reveals, he took a sympathetic standpoint.

However, there is a long tradition of photographer/writer partnerships. Classic examples of photographer and writer include (respectively) Thomson and Smith and Evans and Agee. In fact, the American photographer Walker Evans recognises the sharp distinction between the roles of the writer and the photographer which has a bearing on our reference to those who take on the combined tasks of reporter and photographer (p. 146 of this volume): 'I now perceive . . . that there are different methods and approaches in these two projects, the writing and the photographic project' (quoted in Newhall 1981: 318).

In the 1930s, Walker Evans had been employed on the *Farm Security Administration* project and began to work with journalist James Agee on an assignment for *Fortune* magazine (see Fleischhauer and Brannan, 1988). Although the magazine finally rejected the story resulting from the collaboration between photographer and writer, who had lived with the sharecropper families for two months during the summer of 1936, their work was later published in book form as *Let Us Now Praise Famous Men* (1941). According to Evans, it was the cooperation of the two men, their ability to gain the confidence of their subjects and their recognition of their individual skills that enabled them to achieve the assignment:

> It was largely due to Agee's tact and psychological gift that he made them understand and feel all right about what we were doing. . . . They were made to feel by both of us, I think, that they were participating in an interesting operation.
>
> (quoted in Newhall 1981: 318)

As mentioned in earlier chapters, it is important for the photographer to develop the ability to make the subject feel relaxed and to gain their cooperation as a joint participant in the picture-making process. In contrast, we can find the opposite extreme in the use of photography as propaganda. Dr Barnardo recruited the camera for his own social crusade. Barnardo photographed children in the 1870s to show their condition and appearance in order to aid his fund-raising enterprises for his children's homes. He used the diachronic technique of before and after pictures for this cause. These are held in the Barnardo photographic archive established in 1874 at Ilford in Essex. Not only was Barnardo accused of falsifying the information by making the children look worse than in actuality (which in itself opens up some moral and selection/editing issues), but he was taken to court and found guilty of 'artistic fiction'. This brought an abrupt end to this particular method, although he continued to fill the archive with some 50,000 more straightforward photographic portraits.

In contrast, on the other side of the Atlantic, in the United States Jacob Riis was photographing urban poverty from his point of view as a newspaper reporter in 1889. He benefited from the new technologies of dry plates and employed the early developments in the use of magnesium flash to make hitherto unrecorded scenes of interiors for his book *How the Other Half Lives* (1890) and his *Children of the Poor* (1898). It was Riis' central aim in his role as an investigative journalist to publicise the living conditions of his subjects. For the publication of *How the Other Half Lives*, Riis

worked closely with (President-to-be) Theodore Roosevelt to implement some actual social change.

The photographs brought about the closure of the lodging rooms (for example, as featured in Riis' photograph *Five Cents a Spot*) and later the slums of Mulberry Street which he had also documented. It is nonetheless rare for the camera to achieve this scale of social reform where the direct result of the camera's role between cause and effect concerning a single issue can be demonstrated, although in the broader media context we might look to the TV production *Cathy Come Home*, with regard to the UK housing crisis, and to the role of photography in the overall media coverage's contribution towards bringing about the cessation of the Vietnam War. However, Riis had established a style of photographic practice which set the scene for sociologist Lewis Hine to create his own brand of social documentation with his photographs of the arrival of the immigrants on Ellis Island, New York, in 1904.

Lewis Hine (1874–1940) chose to use his camera to promote the need for changes in society. He concentrated on child labour and his documentary photographs provided evidence for the Progressive and Reform movements in the United States. They were able to generate public concern and consequently appropriate changes in legislation. Hine's attitude to photography was not dissimilar to the didactic approach taken by Britain's Benjamin Stone (of an earlier generation): taking photographs as a form of evidence-gathering was a relatively uncomplicated realist approach but had the overall aim of educating the public. In this regard, both photographers probably intended to gather evidence of current conditions that would accrue additional value in its contribution to history in the future. As Alan Trachtenberg (1980: 111) has put it: 'to be "straight" for Hine meant more than purity of photographic means; it meant also a responsibility to the truth of his vision'. While Hine believed that realism was an inherent characteristic of the photograph 'not found in other forms of illustration', he also held the view that while the medium may be 'truthful', the hand releasing the shutter can often be deceitful: 'While photographs may not lie, liars may photograph' (Hine's 'Social Photography', in Trachtenberg 1980: 111).

In 1926 Hine returned to Ellis Island to continue photographing the new US immigrants and, in 1931, worked for the American Red Cross to photograph rural communities in Arkansas and Kentucky who were suffering from the drought. This helped to establish what we might term the humanitarian approach to social documentary photography. Hine referred to his style as 'social photography', which should be subject to a social conscience. It was not intended to be overtly critical: 'I wanted to show the things that had to be corrected. I wanted to show the things that had to be appreciated.'

In 1930, in Berlin, the Workers' International Relief established 'Workers' Camera Leagues' which spread through Europe and across to the United States. They aimed to supply photographs to the left-wing press.

The revolutionary approach to photography

In 1930s' Europe the revolutionary approach to photography was characterised by Max Dortu's poem (1930) 'Come Before the Camera' (reproduced in Mellor 1978: 45), which extols the use of the camera for its ability not only to photograph all strata of society, but also to unite all people in service of revolutionary victory. From another

perspective, Edwin Hoernle describes 'the working man's eye': the idea that the workers' world was invisible to the bourgeoisie. In his view, photographers must 'tear down' those representations that are set against the background of bourgeois culture:

> We must take photographs wherever proletarian life is at its hardest and the bourgeoisie at its most corrupt; and we shall increase the fighting power of our class in so far as our pictures show class consciousness, mass consciousness, discipline, solidarity, a spirit of aggression and revenge. Photography is a weapon; so is technology; so is art!
>
> (Hoernle 1930: 49)

It is clear here that Hoernle is not seeking for a well-rounded, balanced approach to the subject through employing the impartial camera. Rather, he sees an existing imbalance arising from a dominant culture which traditionally has maintained its control over the representations supplied to the masses. And, in his regard, the photographer's documentary role is one of confrontation: to show and actively to promote the alternative point of view, to the exclusion of all else. He goes on to propose that the 'worker photographers' are the 'eye' of the working class, but they also have the duty to teach the workers 'how to see': the role of photography in the service of revolutionary activity is both to promote a particular viewpoint and to educate. It was in the same era that Walter Benjamin in his *Short History of Photography* was discussing the work of Atget and the achievements of surrealist photography which creates an estrangement between human perception and our surroundings: 'It gives free play to the politically educated eye, under whose gaze all intimacies are sacrificed to the illumination of detail' (Mellor 1978: 69). This too suggests that photography can provide a new way of seeing.

In the United States, the Workers' Film and Photo League started to produce propaganda movies. Hine joined this group in 1940 and it was the League that looked after and protected the interests of Hine's work after his death. This branch of documentary practice, the social documentary, is not content simply to provide objective documentation; it also aims to use photography to influence opinions so as to change social conditions. Although news photography offers a type of documentation, its overall role is more concerned with recording events rather than with ongoing states or conditions. The notion of the 'concerned photographer' continues the humanitarian tradition. Cornell Capa organised two exhibitions entitled 'The Concerned Photographer': the first opened in 1967. Capa had consciously returned to the work of Hine with the aim of setting up the International Fund for Concerned Photography. The idea of this was that photographers could express and put forward a strong point of view from a variety of international perspectives. 'The Concerned Photographer 2' was held in 1973 and it perpetuated the humanitarian perspective. So, humanistic photography adopts a socially different role from that of revolutionary photography by adopting different means in its powers of persuasion.

The advent of colour

One of the expected characteristics of documentary photography is the stark, grainy, black and white image. Some photographers have maintained that the monochromatic

image enhances the viewer's imagination. The colours that are not present in the photograph can be somehow mentally filled in through the process of perception. In the mid-1970s photographers began to explore the artistic possibilities of the medium of colour photography in the documentary context. Until this time, serious photography had been associated with black and white, Ernst Haas being a notable exception. Photographing for *Life* magazine, he was one of the first photographers to explore the medium of colour photography, often to dramatic effect.

Apart from Haas' approach of formal experimentation, colour photography seemed to be regarded as being too real, leaving little room for artistic expression or imagination. Colour images were felt to be in a somewhat contradictory position – they did not embody the harsh actuality demanded by such documentary modes as the news photograph, established by photographers like Weegee (see p. 97). Moreover, the colour photograph seemed also to embody other contradictions in its usage. From the 1960s, colour photography had been associated with the amateur market and the snapshot was seen as either a brash and cheap photography for the masses or, on the serious side, was reserved for the glossy commercial image, offering glossy images for glossy subject matter (still-lifes, portraits, advertisements and plush architectural interiors). In addition to this, until recently colour images have had a reputation for instability and impermanence – colour photographs had a reputation for fading. Today, the new advances in photo-chemistry have gone a long way towards remedying the situation (see Meecham, p. 168 of this volume).[2]

However, colour photography has been in existence for a much longer period than most people realise. Colour images by Ducos du Houron were produced in 1877 and the Lumière brothers had introduced the autochrome process in 1907. In the mid-twentieth century, one of the few vehicles for the colour photograph was the *National Geographic Magazine*. Following this, in the 1960s there was an increased demand for colour photographs for such magazines as *Life*, *Paris-Match* and *Stern*. In the United Kingdom, the Sunday papers' colour supplements began to emerge, bringing about a new market for colour photography, closely followed by the use of colour in the mainstream tabloids and broadsheets. From today's viewpoint it may seem surprising that, only some twenty-five years ago, photographer David Duncan considered that colour was completely unsuitable for documenting war:

> In the photography of war I can in a way dominate you through control of black and white. I can take the mood down to something so terrible that you don't realise the work isn't in color. It is color in your heart, but not in your eye.
>
> (Schuneman 1972: 88)

Oddly reminiscent of Roger Fenton's approach to photographing the Crimean War in the 1850s, Duncan remarked 'I've never made a combat picture in color – ever. And I never will. It violates too many of the human decencies and the great privacy of the battlefield.' (Duncan also gained a certain notoriety for his claim that the Vietnam photographs of the My Lai massacre were a hoax – see Goldberg 1991: 230.)

The 'new color'

In the United States of the 1970s some younger photographers began to take a fresh look at colour. Photographers like Stephen Shore (see Figure 6.2) started using colour

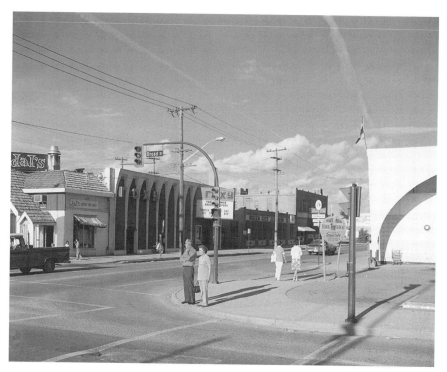

Figure 6.2 Broad Street, Regina, Saskatchewan, 1974.
Photograph by Stephen Shore. Courtesy of Stephen Shore.

as a mode of expression. He managed to escape the stigma of colour's amateurish or lavish reputation and, by using large format cameras (5 × 4 or 10 × 8), he evaded the association of colour with the snapshot. Having chosen minimal, austere subject matter and diminished the significance of the subject to emphasise the quality of the photograph, the viewer's interest is directed towards the colour of the image. In contrast, Joel Meyerowitz followed more in the tradition of Cartier-Bresson and in the style of Gary Winogrand, but using colour. Other US photographers began to use a fill-in flash in conjunction with larger format colour photography. This served the purpose of accentuating the colour present in the scene, sometimes enabling it to emerge from the dark or drab streets. In the United Kingdom photographers such as Paul Graham and Martin Parr began to use colour, influenced by the United States' *'new color'*, as it came to be called. In his introduction to Graham's *A1: The Great North Road*, Rupert Martin writes:

The bright, artificial colour of signs and buildings contradict but do not usurp the natural colour of the flat landscape which borders onto the road. Telegraph poles traverse a poppy field, a car dump focuses the eye as the fields stretch away. The interiors of cafés and hotels along the road with their vivid colours and old-fashioned décor become an expression of personality, humanising the road and alleviating its monotony.

(Martin, in Graham 1983)

Case study: independent photography – 'Outsiders Photography'

For those photographers whose lifestyle is more akin to that of the professional artist rather than that of the commercial photographer, there are particular difficulties in working with colour photography. Not the least of these is the expense. The photographer can use either a professional laboratory that makes available the time, sympathy and the dialogue to ensure the appropriate hand-printing, or they will need to set up the darkroom equipment that affords them their own control of the colour developing and printing processes.

Charlie Meecham and Kate Mellor are **independent photographers** based in West Yorkshire (see Figure 6.3). Their photographic practice involves pursuing their own photographic projects and interests, which in many respects evolved from their working practices established when they were students at Manchester Polytechnic (now Manchester Metropolitan University). They work in a similar framework to that of the painter or sculptor in that their work reaches its audience through exhibitions, publications, sales of prints to individuals (as well as commercial organisations) and commissioned projects. In addition they are studio-based and, unlike most photographers working in the mainstream commercial sector, they have developed the craft skills to see the entire process through from the conception of an idea to the production of the final exhibition print.

Kate Mellor's work (see Figure 6.4) is currently based upon the relationship between our environment and the beliefs we have about it. Her work aims to contrast the idea of landscape with the economic and physical realities, such as boundaries and

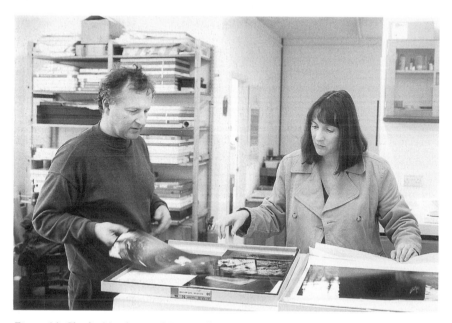

Figure 6.3 Charlie Meecham and Kate Mellor, Nanholm Studio, Yorkshire, 1997.
Photograph by Terence Wright.

Figure 6.4 From Kate
Mellor's series *Blue Shift*,
1997.

Photograph by Kate Mellor.
Courtesy of Kate Mellor.

ownership. One of her recent projects, *Island: The Sea Front* (1997), involved a discussion of a traditional concern of photography: objectivity and the gathering of evidence, and cartography's mathematical structuring of the terrain. Her latest project, *River*, takes a more formalist approach where she has used a panoramic camera to explore analogies between the qualities of water (e.g. transparency and fluidity) with the optical characteristics of the camera (e.g. the sampling of light, camera movement and duration of exposure). Working in this way has enabled her to make full use of the characteristics of the photographic medium to examine water's central role as a life-supporting element.

Charlie Meecham's work (see Figure 6.5) demonstrates a different engagement with the environment. His initial interest in producing romantic images has evolved into exploring the impact of social and technological change on the landscape. His current preoccupation is with the changing design of the landscape that results from the massive investment in road-building and redevelopment projects that have taken place in the late twentieth century (Meecham 1987). Throughout history, trade routes have shaped the landscape and acted as conduits for cultural influence and exchange, though now our perception of the environment is mediated by frames (such as the television screen and the car windscreen). Charlie uses the camera to document the proliferation of road signs and other street furniture, as well as to reveal the emergence of new environmental spaces (e.g. the undersides of flyovers).

An essential problem for the independent photographer is that of maintaining financial solvency. Traditionally, this sector was mostly supported by part-time lecturing

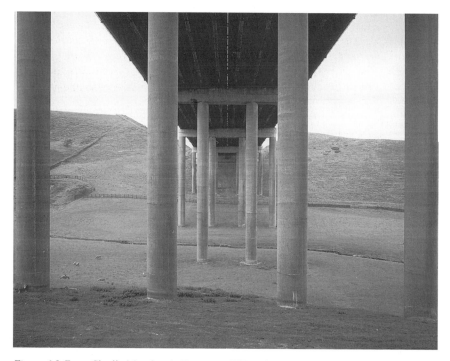

Figure 6.5 From Charlie Meecham's *Euroroute E20* project, 1997.

Photograph by Charlie Meecham. Courtesy of Charlie Meecham.

(this type of employment is now becoming increasingly difficult to find), by spending some time taking on commercial photographic work (lab work, for instance), gaining support from grant-giving bodies (for instance Regional Arts Boards) or through non-photographic employment (examples include working in a bar or driving a van). When Charlie and Kate first left college in the 1970s, there was a growth of interest in promoting independent photography and public funds were widely available.[3] Over the last twenty-five years or more there has been an increasing dependence on commercial sponsorship in the form of matched funding. While this can be relatively generous, covering most of the project costs and increasing the likelihood of the exhibition and publication of the work, it can mean that it is the funders who become the arbiters of photographic taste. These points aside, Meecham and Mellor have evolved a unique solution to this problem by establishing their own photographic printing business, 'Outsiders Photography'. They specialise in exhibition-quality colour hand-printing, a service they provide for other independent photographers (such as Fay Godwin) or for artists who find that photography forms an integral component in the production and exhibition of more ephemeral art activities (for example, Andy Goldsworthy's sculptures made from natural materials such as ice).

On the one hand, the advantages for their own photographic practice are that working in this way has enabled them to develop their printing skills to an exceptionally high standard. They have had the opportunity to obtain a unique insight into the practices and requirements of the art photography market – additional perspectives to the same market in which their own photographs feature. On the other hand, they have found that the specialised printing equipment for both colour negative and reversal processes requires a high capital outlay. And the setting up of a small business requires a considerable amount of time and energy that can detract from the pursuit of one's personal photographic ambitions. There is also the risk of gaining a higher reputation, in the art photography world, as a competent practitioner of a craft skill rather than as a creative artist in one's own right. As Meecham puts it, 'You need lots of patience.'

They have also found that their *modus operandi* demands the additional skill of achieving the correct balance between one's own work and that of others – in terms of time, income and commitment. At the same time, they are continuing to develop their practical and conceptual skills in the new technologies. For example, Kate has used the Internet as an additional exhibition site. While they find that the new technologies are redefining practice, they find it difficult to change radically and are sceptical about involving themselves in major reinvestment in technology which would need to be accompanied by the appropriate reskilling. Initially, they had feared that analogue photography would not survive the impact of digital imagery, but as yet there is no sign of diminished demand. In fact, according to Charlie, 'The new technologies expose the strengths and weaknesses of the old. Somehow, analogue photographs are beginning to look more honest, they do seem to demand a more sophisticated reading.' Also, traditional methods and early silver processes are being revived along with a wide range of workshops which are run both here and abroad. Photography as such appears to be separating itself from the digitised image as being a very different medium, and it is interesting to note that there have never been so many high-quality colour films and papers on the market, all with much improved performance, permanence and stability.

The life of an independent photographer can be financially precarious and potentially isolated, and many practitioners find it beneficial to belong to general independent photography groups. For example, in Oxford independent photographers set up Oxford Photography as a special-interest group to facilitate social interaction and exchange of ideas to arrange lectures, seminars, portfolio discussions, exhibitions and cultural exchanges to serve the locality. For some years the group had received funding from the Southern Arts Association. However, recently the budget was cut in favour of establishing a new organization (still based in Oxford) with a broader regional remit. FotoNet-South 'exists to encourage the creative practice of photography in the region, to provide up to date information and networking opportunities, to encourage the development of new work, to expand exhibition opportunities and to promote education and debate on all levels' (www.Fotonet-South.org.uk).

The aim of this chapter has been to show how attitudes have changed regarding photography's ability to document. The central issue of the documentary photograph hinges upon the relationship between the camera's ability to record and the selection of appropriate information by the photographer. Photographing in colour is not monochrome plus colour: it should be treated as a different system of representation. Different factors must be taken into account. Obviously, there have been technical restrictions in that colour film has been less stable and, until recently, much more expensive than monochrome. It also has a shorter shelf-life than black and white, as well as there being the additional problem that colour reversal has less exposure latitude so that taking an accurate light-reading becomes more critical. But colour creates different emphases within the picture, whereby new considerations regarding the indices and symbols have to be taken into account. It is not simply a matter of either mode being easier – each has its own characteristics.

The cultural chasm

The documentation of other cultures is a particularly important and sensitive aspect of documentary photography. In the practice of ethnographic photography all the ordinary issues of photographic documentation become exaggerated: for example, whether the subjects are being taken advantage of, whether the reason for photographing is understood, whether the subject is treated as an object, etc. It also provides a valuable example of the ways that photographs can betray the standpoint of the photographer. In short, ethnographic images say as much, if not more, about the culture of the photographer than about the subject.

In the nineteenth century the **anthropometric** approach attempted to use the camera as a scientific instrument, in a similar manner to today's use of it in forensic photography. Under the assumption that a camera could 'transparently' supply information, the image would yield exact mathematical data suitable for scientific investigation. Whether the subject was a human being or an object of material culture, in general they could be made quantifiable by the agency of the camera.

The evidence could be laid out on the table for comparison and classification. For the positivist approach, the realist view of photography seemed to provide an ideal medium for scientific documentation. It would provide an objective vision and collect facts which then could be organised and analysed in a systematic fashion. The

Figure 6.6 Anthropometric image of Malayan male, *c.*1868–9.
Photograph by J. Lamprey. Courtesy of the Royal Anthropological Institute.

photograph was viewed as a sort of container that could bring the subjects of anthropology directly into the academic's study (see Figure 6.6).

Photography itself could constitute a means of imposition on another culture. It can be regarded as a significant Western phenomenon. An area of controversy arises as to whether photographs are naturally perceived. This has involved experiments where psychologists have shown photographs to various tribespeople to see if they perceive them as representations or as physical objects. Photography in the cultural encounter has given rise to a number of myths regarding stolen spirits and images or, according to Carpenter (1972: 130), the 'terror of self-awareness'. Beloff (1985: 180) describes the use of photographs as 'ritual relics' throughout all cultures and quotes photographer Elliott Erwitt who suggests that in some cases it is photography that brings the event into existence. Whether this is true or not, the photograph is used to authenticate the event (such as a wedding for example), or it is a confirmation, saying 'I was here'.

Often an individual becomes representative of an entire race or culture, is considered to be a typical Australian Aborigine or a Trobriand youth, and thus must conform to certain racial stereotypes or preconceptions. Similarly, the chosen moments for photography can become representative of that culture's activities – 'These are the people who . . .'. Or should they be named as individuals? Historically, the approach was rigid, strictly determined and was spelled out to the colonial layman travelling abroad with a camera: 'to enable those who are not anthropologists themselves to supply the information which is wanted for the scientific study of anthropology at home' (BAAS 1874: iv).

Other issues of concern were the extent to which the subjects are objectified and the terms under which they can be said to be collaborating with the photographer. Do they understand the final outcome of the photograph? Or is it the situation of colonialism/tourism that may have forced them into collaboration? As Pinney (1992: 76) has pointed out, the colonial situation itself has exercised control over the subject: 'Photography fitted perfectly into such a framework and can be substituted for the idea of discipline/surveillance in almost all of Foucault's writing' (see also Green

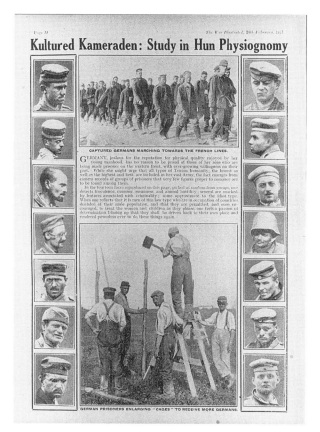

Figure 6.7 Kultured Kameraden: A Study of Hun Physiognomy, from *War Illustrated*, 27 February 1917, p. 33.

Photographer unknown. Courtesy of the Imperial War Museum.

1984). According to Foucault, as with the issue of voyeurism, observation is to be considered a one-way process. Disciplinary power is exercised 'invisibly':

> In discipline, it is the subjects who have to be seen. Their visibility assumes the hold of the power that is experienced over them. It is the fact of being constantly seen, of being able always to be seen, that maintains the disciplined individual in his subjection.
>
> (Foucault 1979: 87)

It should be added that photography was used not only to aid the pursuits of scientific rationalism in the context of nineteenth-century anthropology, but it also came to be employed for the pseudo-scientific pursuits of propaganda. The Study of Hun Physiognomy (Figure 6.7) has taken on the trappings of the prevailing comparative method of the study of 'physical specimens', maintaining that the camera's objectivity can, in itself, provide incontestable proof of racial development (Cowling 1989).

There are no set rules as to what makes a good documentary photograph. Which-
ever approach one takes there is the likelihood of infringing the rights of those
photographed and the compromising of the accuracy of the representation. The very
fact of being from another race, culture, nationality or class automatically poses a host
of issues and problems. The best that the photographer can do is to tread carefully
with an awareness of the broader issues arising from his or her undertaking:

> In societies which are not over familiar with the camera as a technical means . . .
> the ability to take photographs is often taken to be a special, occult faculty of the
> photographer, which extends to having power over the souls of the photographed,
> via the resulting pictures.

> (Gell 1992: 51)

Gell goes on to say that this so-called naive attitude to photography persists in
Western culture and is evident, for example, when an artist is commissioned to produce
a portrait of an absent leader as an icon bestowed with occult power 'to exercise a
benign influence over the collectivity which wishes to eternalise him' (ibid.).

The future of photojournalism?

Some photographers hold the view that the golden age of photojournalism has passed.
Magazines such as *Picture Post* or *Life* have either ceased to exist or no longer carry
the extensive photo-story. In many respects, the function of the highly visual, or spec-
tacular, story has been taken over by television. The photojournalist working for
today's newspaper colour supplements would be fortunate if three or four pictures
were printed as a piece of photojournalism. Often the picture story consists of just
one photograph, placing a greater requirement on the photographer to arrive at one
striking image and using the single decisive moment to tell the story, rather than having
the photographic narrative consisting of a number of possibly more sympathetic
images to convey a more subtle idea or interpretation of events. This is in contrast to
the pre-war peak of *Picture Post* in the day-in-the-life feature 'Unemployed' (vol. 2.
no. 3, 21 January 1939) whereby (adopting a Mass Observation style of 'random'
selection) 'from a group outside Peckham Labour Exchange we picked out one, Alfred
Smith, and followed him with the camera. On the following pages is the story of his
daily routine.' This picture story in total ran to nineteen photographs.

It was not only changes in house style or editorial approach that led to the demise
of traditional photojournalism and the rise of the new documentary era. In the new
documentary, rather than focusing on the world out there and making use of the
photographer's privileged position that enabled him or her to secure images which
would not be normally available to the general public, photographers came to make
use of their immediate environment – the family or their domestic sphere – to show
aspects of their own everyday life. The other impetus for this change was part of a
more general social move instigated by the 1970s' and 1980s' rise of the feminist
movement. Here one does not need to focus only on issues concerning equal rights,
and equality of opportunity and access to education, etc., but also on those of sexu-
ality. Issues of, say, birth control had been associated with feminism from the early
days. But the broader contemporary concerns of the woman's right to have control

over her body, the questioning of the traditional institutions of marriage and the family, the patterns of heterosexual behaviour, and the roles and attitudes that have been imposed by the dominant society have all influenced photographers, who have used the camera to explore such themes and provide the means to question and to redefine roles and values.

So one influence from the changes in the outlet of photography has arisen from the photographic institutions themselves, and another from the social and political concerns of contemporary society. A central topic has been how people's lives, as they are actually lived, conform or deviate from popular or dominant stereotypes of the nuclear family. These questions re-emerge in the case of the family snapshot. For example, Sally Mann's book *Immediate Family* (1992) provides a good example of this genre of photography. The images resulting from her work are very different from the *Picture Post* example of the outsider looking at a member of another community (exemplifying the power relations between photographer and subject discussed earlier, which were also characteristic of the Mass Observation projects of the 1930s). So in this kind of documentary we are moving away from a colonial style of photography to that of participant observer.[4]

According to *The New York Times Magazine* (27 September 1992: 36) it was debated whether Mann had exploited her own children in making the book: 'The photographs seem to accelerate the children's maturity, rather than to preserve their innocence.'

Further questions can arise with this style of work in the light of current concerns about child abuse, the invasion of privacy or the betrayal of trust. There is the problem of the insider making public the members and activities of their own social group, perhaps abusing or exploiting the intimacy of the subject. Naturally, the issue of the public and private domains is also encountered in mainstream journalism. In the media in general, on the one hand, we have the soap opera where fictional entertainment is made of the mundane aspects of everyday life; on the other, the amusing aspects of amateur family videos find their way onto prime-time television.

Most of the issues dealt with in this chapter have arisen from the so-called post-modern crisis, which consists of a blurring of traditional boundaries – arguably, the old polarisations and dualisms of the Cartesian influence on traditional Western culture. There is no longer any safe territory or a secure strategy that can be adopted in making a photographic documentation, and this uncertain state has been exacerbated by the advent of digital imaging, where we can no longer be sure that the image we see documents anything at all. At best, photographers need to be aware of the issues determining his or her approach to the subject as well as the ethical implications and the representational considerations. They can then at least make an informed choice with regard to their documentary strategy.

Summary

- The chapter considered the power of the photograph to instigate social and cultural change.
- We began by looking at a brief history of social documentation and how photography in this context could bring aspects of poverty, which would have normally

gone unseen, to the general public. The wider population may have known of the existence of those living in destitution, but photography (by making the subject a public issue) made it more difficult to ignore.

- We considered the new documentary approach to colour that took place in the 1970s and looked at the case study of 'Outsiders Photography' and their attempts to work as 'independent' photographic artists.

- The chapter concluded with a brief review of ethnographic photography and a consideration of the future role for photojournalism, which finds itself in a situation of realignment and reappraisal with the advent of digital imagining and the changing demands and roles in the magazine industry.

7 The ethics of photojournalism

I felt completely terrorized by the blasted lens. It was a helluva struggle. Finally, I decided 'Damn it, you're not going to do this to me, lady. I'm not going to be photographed like one of your grotesque freaks!' So I stiffened my face like a mask. Diane went right on merrily photographing – clickclickclickclick – cajoling me, teasing me, flattering me. This frail rose petal creature kept at me like a laser beam, clickclickclick. She'd jump off the bed periodically to load the camera. Just as I was breathing a sigh of relief, she'd be on top of me again! It was a battle between us. Who won? It was a draw. After that afternoon I never saw her again. I never saw the photographs either.

(Germaine Greer describing how she was photographed by Diane Arbus; quoted in Jussim 1989: 109)[1]

What is meant by ethics?

Ethics is a branch of philosophy that is concerned with issues of right or wrong. The ethical issues that are most often appropriate to media professionals come under the heading of 'applied ethics': What do I/we do in a particular situation? Should I take a photograph of this starving mother and child? Is my photograph going to help them and others like them? Am I taking advantage of their situation, exploiting them for my art or for my personal financial gain? Is my act of photographing them altruistic or voyeuristic? It is also the task of applied ethics to examine general social questions usually concerning controversial subjects: the rights and wrongs of abortion, collateral damage in war, nuclear power, etc. To help with these moral dilemmas, the philosopher might turn to the subjects of 'metaethics' and 'normative ethics'. Metaethics is concerned with the origins and meaning of ethical issues. It deals with more conceptual issues such as: Why should we treat others as we ourselves would like to be treated? Are moral codes of behaviour universal values or are they determined by their cultural and historical context? Normative ethics has a more practical task but one which aims to establish moral standards. These are often the subject of drama and are played out in the movies. For example one of many such

dilemmas occurs in Michael Curtiz's film *Angels with Dirty Faces* (1938). The film features two childhood friends: one who has grown up to be a gangster, one a priest. The priest is trying to keep a gang of teenage boys out of trouble and the gangster offers him money to aid him in his task. Should Father Connelly accept the cash, even though he knows it has come from a questionable source? Or would its use in helping the boys contribute to the greater good of the community? Does he take the practical route or does it compromise his own moral standpoint? However, like most systems of categorisation, the boundaries are blurred and issues in applied ethics will have metaethical and normative ramifications.

What does it mean for photography?

The By Laws (section XVIII) of the US National Press Photographers' Association (NPPA) acknowledge 'concern and respect for the public's natural-law, right to freedom in searching for the truth and the right to be informed truthfully and completely about public events and the world in which we live'. Taken in isolation, this statement is more concerned with metaethical concerns than applied ethics. Its focus is more to do with a universal human right and a practical aspiration rather than offering straightforward practical guidance.[2] Similarly we can find normative ethical concerns in the writings of the philosopher Richard Rorty:

> Th[e] process of coming to see other human beings as 'one of us' rather than as 'them' is a matter for detailed description of what unfamiliar people are like and a redescription of what we ourselves are like. This is a task not for theory but for genres such as ethnography, the journalist's report, the comic book, the docudrama, and . . . the novel.
>
> (Rorty 1989: xvi)

Here Rorty is assuming a metaethical standpoint – that we *should* see 'others' as one of 'us' – and then goes on to propose a very general (normative) solution that can be applied to the work of a variety of professions: anthropologists, journalists, cartoonists, playwrights, novelists and – we can assume – photographers. While we can recognise the importance of such a statement, for applied ethical guidance, we need to look elsewhere.

Some news organisations provide their employees with a code of ethics, which can be used to indicate the journal's moral boundaries to new and existing employees. This may be used by the journal as the 'big stick', if individuals infringe the code. Or, more cynically, it may merely exist to be waved at the public in the event of any complaint. However, here are two recommendations:

1 Respect the privacy and property rights of one's subjects.
2 Never use deceit in obtaining model or property releases.

These come from the section 'Responsibility to Subjects' taken from the American Society of Media Photographers' (ASMP) *Photographer's Code of Ethics*. One of the immediately noticeable things is that the extent to which these 'laws' can be applied in practice. Although they deal with specific issues, they are very much open

to interpretation. Rather than suggesting a preferred course of action, they seem to open up the subject to philosophical debate or point to an idealistic state of affairs. For example, was the photographer faced with the dilemma of whether to take photographs of people exiting from the World Trade Center after the terrorist attacks respecting their privacy or not? Is it appropriate/possible to ask permission before releasing the shutter?

The ASMP address ethical issues under the following headings:

- Responsibility to Colleagues
- Responsibility to Subjects
- Responsibility to Clients
- Responsibility to Employees and Suppliers
- Responsibilities of the Photojournalist.

And as for the closest we get to practical advice for photojournalists – the most immediate applied ethics are:

1 Photograph as honestly as possible, provide accurate captions, and never intentionally distort the truth in news photographs.
2 Never alter the content or meaning of a news photograph, and prohibit subsequent alteration.
3 Disclose any alteration and manipulation of content or meaning in editorial feature or illustrative photographs and require the publisher to disclose that distortion or any further alteration.

If we attempt to apply these codes to our World Trade Center example, we might not find them appropriate to that specific dilemma. For purposes of contrast the British NUJ issues a 'code of conduct' for journalists, which includes:

> A journalist shall obtain information, photographs and illustrations only by straightforward means. The use of other means can be justified only by over-riding considerations of the public interest. The journalist is entitled to exercise a personal conscientious objection to the use of such means.

Subject to the justification by overriding considerations of the public interest, a journalist shall do nothing which entails intrusion into private grief and distress

This may appear more specific in that 'a journalist shall do nothing which entails intrusion into private grief and distress', but then this instruction is 'subject to the justification by over-riding considerations of the public interest'. Again this leaves our ethical dilemma open to interpretation. One example might be the time constraints: are we considering the immediate public interest, interest in the foreseeable future, or the public interest as served by the historical dimension? Even so, the term 'public interest' may be difficult to pinpoint.

In short, ethical issues, whether conceptual or applied, can rarely be 'solved' by a list of 'dos' and 'don'ts'; they often involve questions, dilemmas and having to make

decisions in the best of intentions and according to information available at the time. Consequently, institutions (whether media, academic or medical) usually provide ethical 'codes' or 'guidelines' that indicate the appropriate factors to be taken into account. Whether and how the photographer presses the shutter, manipulates the image or adds a particular caption is often a choice that only he or she can make. They can be guided towards the pertinent ethical issues, but in the long run many of the significant decisions will be theirs alone. At best, all ethics can offer is a framework that can help people make moral decisions.

One area of concern for ethical issues is the manipulation of digital photographs. This is considered in Chapter 8. However the analogue image can be almost as manipulative, for example the photographer's ability to select a viewpoint, which may emphasise (or diminish) objects that will be seen to relate to the subject. Perhaps unknown to the subject, the object or person, which may be in the distance (now occupying the same flat pane of the picture surface) becomes associated with the subject – from the viewer's perspective. This was the cause of some speculation regarding a photograph of a group of Bosnian Muslims who had been photographed behind wire to result in an image that was similar to those we are used to of the Nazi concentration camps. It was later suggested that this was not an encircling or enclosing fence, but that the image had been created to give the appearance of a concentration camp. It is also within the photographer's power to choose the lighting, camera angle, moment, etc. that can dramatically alter the way the subject appears in the photograph. For example, in a portrait shot if the subject is lit from below they can take on a demonic demeanour. This happened in Arnold Newman's photograph of Alfried Krupp (1963), the German armaments manufacturer. According to Newman: 'I am not so much interested in documentation as in conveying my impressions of individuals by means of the ever-expanding language of my medium' (quoted in Ollman 1986: vi).

Newman's use of the symmetrical composition and lighting from beneath reveals Krupp as analogous to the statue of an evil deity, for example Moloch, to whom child sacrifices were made in the ancient Middle East.[3] This may be all well and good: the photographer has made the decision to not only give us his view of his subject, but has done so in a symbolic form that is also perhaps derived from the cinematic imagery of the science-fiction movie monster. Although Krupp's own activities may be questionable from an ethical point of view, we might still ask whether the photographer has the 'right' to represent the subject in this manner. For example, if Newman had photographed a member of a highland New Guinea tribe in this way to portray them as 'monsters', his actions would be clearly objectionable. We might ask to what extent the photographer is empowered to control the subject by means of the 'language of the medium' or to subscribe to the notion of the unique vision of the individual artist:

> the modernist aesthetic is in some way organically linked to the conception of a unique self and private identity, a unique personality which can be expected to generate its own unique vision of the world and to forge its own unique, unmistakeable style.
>
> (Jameson 1999)

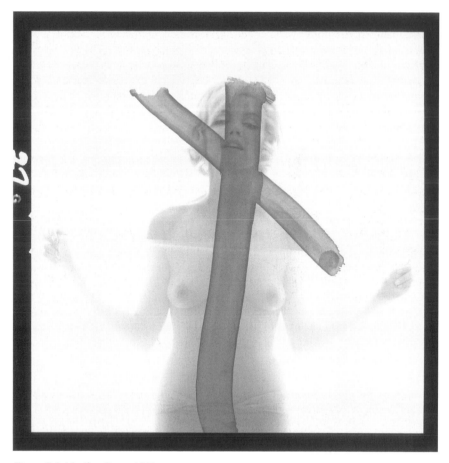

Figure 7.1 Marilyn Cross, 1962.
Copyright Bert Stern.

Monroe and Hitler

The use of photography as photojournalism raises a number of ethical issues with regard to how the subject should be treated and represented. In the instance of a photographer who is commissioned by the subject (to make a studio portrait or to photograph a wedding, for example), the photographer and subject usually negotiate control and possession of the subject's image. On the other hand, if a photojournalist has taken the photograph, it may be only a matter of trust that stands between the subject and the image that is presented to the general public. For example, in 1962 (the year of her death) Marilyn Monroe was photographed by *Vogue* fashion photographer Bert Stern. The shoot resulted in 2,571 prints and contact prints. On the contact prints, Monroe had crossed out the frames of which she did not approve. Since her death the photographs have been published, including those that Monroe had deleted.[4] At face value, this seems to be breaking an ethical code. Even though she is deceased, it would appear that abiding by Monroe's wishes is the right thing to do (see Figure 7.1).

Perhaps it is characteristic of their respective personalities that, where Marilyn Monroe had expressed preferences with regard to her photographs, Adolf Hitler had issued orders. Hitler was unhappy about his public seeing photographs of him wearing glasses – for him a physical necessity – as a bespectacled Führer was hardly commensurate with the propaganda image of the 'master race'. Where Monroe's wish to control her own image was perhaps a matter of self-esteem, perhaps Hitler's was more a matter of propaganda. But then dictators are not immune from vanity. According to Oechsner:

> Hitler is indeed vain, as I have said, and thinks of himself pictorially against the background of the mere world. . . . [H]e was always posed by his official photographer, Professor Hoffmann, to bring out the best points of his remodelled nose as well as of his other facial and physical features.
>
> Although he has worn glasses for several years, for reading, Hitler is very strict about not allowing anyone to photograph him with glasses on. Photographers, newsreelmen and others had stern instructions from Hitler's adjutant Brueckner to photograph Der Fuehrer only after he had removed his spectacles. Several rolls of film had to be destroyed on one occasion because this injunction was not observed, and one cameraman lost his permit to work because he tried to retain such a snapshot as a curiosity. Hitler wore glasses publicly for the first time for the signing of the Munich agreement with Daladier, Chamberlain and Mussolini. Whenever he is photographed at his headquarters now studying maps, reports and such, it is always with a magnifying glass only.

(1943: 21)

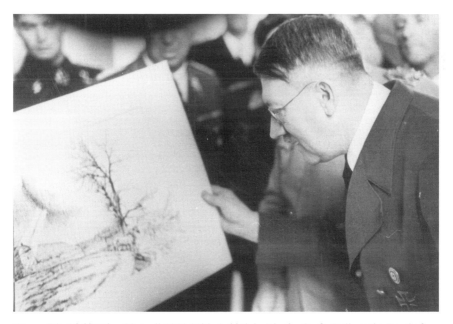

Figure 7.2 Adolf Hitler, 20 April 1944 (Hitler's birthday) in the Große Halle at the Berghof, Obersalzberg.

Photograph by Heinrich Hoffmann. Courtesy of the Heinrich Hoffmann Picture Archive.

Hitler ordered Hoffmann to destroy the negatives, an order that was disobeyed (see Figure 7.2). After Hitler's death, Hoffmann released the photographs against the subject's former wishes, as in the case of Monroe. Here we have a number of ethical dilemmas. Do ethical codes apply irrespective of who is the subject? Should a different rule apply to Hitler because of what we know of his actions during his lifetime? If so, in the less extreme cases of 'everyday folk', who is to decide whose lifestyle is such that their posthumous wishes should, or should not, be respected? And the larger ethical issue is: To what degree do we abide by the wishes of the dead? I can decide to leave all my worldly goods to a named charity, and most likely that wish would be carried out. On the other hand, if I request that on my death all photographs of me should be destroyed, I would probably have difficulty in receiving assurances that this would be the case. These instances may leave us reflecting upon a recurring issue for photojournalistic ethics: Do 'public' figures have the same 'privacy' rights as 'private' citizens'? And do private citizens have the same degree of power as the rich and famous to guard against the intrusions of the media?

> Some people, with more money and more power, are ... better able to inhibit access, maintain privacy, and take to task those photographers and publishers whom, for whatever reasons, they feel have trespassed. But this doesn't help the less-monied, less powerful person whose objections to being photographed are dismissed by the photographer working on assignment, or the person who might not object until some unanticipated consequence occurs after the picture is published.
>
> (Henderson 1988: 105)

The paparazzi

When it comes to photographing the rich and famous, the word 'paparazzi' is used most frequently for photographers who seek out and stalk celebrities in order to take their pictures. The term and the stereotype have their origins in the world of the movies. The character *Paparazzo*, played by Walter Santesso, features in Federico Fellini's film *La Dolce Vita* of 1959 and it was his name and activities that gave rise to the term. A paparazzo (singular) is a freelance photographer who has a reputation for aggressively pursuing and hounding celebrities: usually hunting in packs, they will intrude on all aspects of personal life with little respect for privacy. Originally concerned with the pursuit of Italian film stars, the targets for the paparazzi are anyone who might be considered newsworthy. In many respects the stereotype of the paparazzo has much in common with that of the bounty hunter of the Western film genre. Not only can catching the image of a celebrity, preferably in a compromising situation, offer substantial financial rewards for the supplier, but the paparazzo/hunter leads a marginal existence both as a freelance and on the borders of legality. At the same time, many press photographers themselves would not want to be identified with the paparazzi. Perhaps the most famous example concerning ethical issues, the paparazzi and press photography is that of the death of Diana Spencer, the Princess of Wales. Were photographers responsible for the car crash that killed Diana? Were they engaged in legitimate pursuit of their subject, or did they hound her to her death? Do photographers engaged in such activities merely act in our interests and supply

our demands as readers of the newspapers? Do we have a right to know what public figures get up to? Do we have the right to know what private citizens do?

Photographing in public

A.D. Coleman (1988) refers to an incident where a freelance photographer, Gianfranco Gorgoni, took a street photograph in New York. Sold by Gorgoni's agency, the photograph appeared later in *The New York Times* Sunday magazine section, entitled *The Black Middle Class: Making It*. The photograph featured a man called Clarence Arrington and his picture had been used without his knowledge or consent. Not only was Arrington's image used to symbolise a black middle-class experience but more than a million copies of his image were distributed throughout the United States. Arrington tried to initiate a lawsuit for the invasion of his privacy. Coleman indicates some of the factors that determined the outcome of the case which were not particularly satisfactory to the plaintiff, but in any case the ethical issue was not really considered to be a significant factor. It seems that as we walk the streets anybody can take a photograph of us and that it can be used in any context. Coleman continues by giving another example concerning his friend, a freelance photographer, who took a photograph of Coleman's son as the latter was going into the operating theatre, having suffered an accident. Some time later the photographer's agency wanted to use the photograph for a book cover on child abuse. There were, of course, a number of concerns. First, that the photograph showed an image of a boy in distress, yet child abuse was not the appropriate context. Second, the appearance of the picture could have had disastrous affects on the family both personally and professionally. Coleman goes on to say that it is only because the agency knew that he was a friend of the photographer that they had even bothered to check whether this was an acceptable use of the image or not. In Coleman's example the issues are not so much those of intrusion and invasion of privacy; they are more to do with exploitation, misrepresentation and stereotyping.

But the photographing of people in public is not a new phenomenon. In 1893, according to *The Weekly Times and Echo*, it was reported that 'Several decent young men are forming themselves as a Vigilance Association with the purpose of thrashing cads with cameras who go about at seaside places taking snapshots of ladies emerging from the deep. . . . I wish the new society stout cudgels and much success' (quoted in Macdonald 1980: 57). Now this was the period of the rise of amateur photography instigated by George Eastman's Kodak camera introduced in 1888. It meant that anybody who could afford a camera could take a photograph, removing photography from the exclusivity of the professional sphere and marking the arrival of the amateur photographer. As for the Victorian seaside photograph, whether it happened to be an invasion of privacy or not, the photographs taken by George Ruff in Brighton and George Wood in Hastings have left us with a valuable historical record of casually produced images which caught the spirit of their era.

The rights of the individual

This also opens up another aspect of ethical issues. As a photographer on coming across an accident or a terrorist attack, for example, do I have the right to take photographs of

...

the victims? In a particular situation it may not be appropriate to ask permission from them. Would my photographs be serving the public good, to use the recommendation of some of the photographers and journalists associations? It is possible that some of the photographs may be so horrific that my journal would not be able to publish them and, as far as serving the public good is concerned, the photographs may or may not serve the immediate public good but they would serve the public good 100 years in the future. By this time all those concerned would no longer be alive and the photographs would then be an historical record regarded in a similar way to the photographs of the dead bodies that were taken during the American Civil War.

During the 1860s photographs of dead bodies from the American Civil War were in great public demand, yet the public whose motivations were probably voyeuristic were not in accord with the intentions of the photographer. Alexander Gardener, one of the American Civil War photographers, had photographed the dead as part of his socialist crusade to reveal the horrors of war and one of his photographs of 1863, entitled *Home of a Rebel Sharpshooter*, was faked. A dead soldier was placed amongst some rocks with a rifle next to him, photographed and titled.

Another ethical issue is the matter of gaining consent of the subject before photographing them and during the 1980s this became a particular issue in documentary and portrait photography. It seemed that it was not just a matter of gaining the consent of the subject, but also that the photograph should itself demonstrate that this consent had been gained. This meant that photographs would be taken with the subjects gazing back at the viewer so that there could be little confusion that they were fully aware of the photograph being taken. This had the disadvantage of being almost formulaic. For example, it was often not enough to show by just one of the photographs that the subject was consenting but was necessary in every photograph. Unless the subject was staring at the camera you could not be fully sure that they were aware of the act of photography.

However, we could turn to another area to look for our ethical guidelines – that of scientific research – and this course has been taken by the documentary film critic, Calvin Pryluck, who looks at the issue of informed or uninformed consent. Pryluck has studied the scientific literature and has concluded that consent is not valid unless the conditions were free from coercion and deception, the subject has full knowledge of the procedure and anticipated effects and the person is competent to consent. Although there may be various arguments about what is informed consent, he concludes: 'consent is flawed when obtained by the omission of any facts that might influence the giving or withholding of permission' (Pryluck 1988). Here the general ethical guideline is that the photographers can photograph the subject as long as they have not coerced them or deceived them into what is going to take place. One way of avoiding such complications is to supply the subject with a model release form and in this case the subject is signing over the right for the photographer to take the photograph and for it to appear in subsequent publications, although it should be added that this is often more for the protection of the photographer than of the subject. This whole process may be fine for the developed Western society but if our subject, for the sake of argument, is a Saharan tribes person who may not be able to read or write or have any further awareness of the overall context in which the photograph is going to appear, can we truly say that this is free from coercion? In any case, the amount of time that people are usually allowed to make up their mind as to whether to sign a model release form is not necessarily long enough for them to make a considered

and informed decision and, if some of the language is obscure, they may not have the time or money to consult a lawyer.

Another matter may be that the presence of the camera may cause people to act or behave in a different way than they normally would. The presence of the camera may cause people to dramatise their actions, pose before the camera or just do things that they normally would not do. One example of this is Michael Laurent's photograph of the massacre in the Bangladesh polo field, where the acts were carried out with the perpetrators fully aware that the cameras were on them. Another of the problems that arises is that while the photographer may have a certain amount of control over the taking of the image, what happens to it afterwards when it may be sold by an agency to a news organisation where the editor may then control the image or decide how it is actually received by the final viewer? All these factors can be out of the photographer's command. As we have seen in the case of Gardener, although his intentions may have been to reveal the horrors of war, these were the very aspects of the images that the viewers were indulging in. Perhaps the final word on the ethical issue is to turn to Richard Rorty's quotation 'outseeing others as one of ourselves' and to assume that the subject in the photograph is not being paid by us, so we should respect the fact that they have contributed to helping us make our careers as photographers.

To publish or not to publish

A recent incident highlights some of the sensitivities of the photo-establishment and the ethical issues involved. In March 2002, the NPPA (America's National Press Photographers Association) awarded a photojournalism prize to Mike Urban of the *Seattle Post-Intelligencer* for his photograph of a sexual assault. Although the photograph had not been published, the NPPA not only released the image on their website, but they had digitally manipulated the image in such a way as to protect the woman's identity. The faces of the perpetrators were left unaltered. The journal for which the picture had been taken (*Seattle Post-Intelligencer*) had already taken the decision not to publish the photograph, but handed over the image (with others) to the police to help with their enquiries. The photograph had been taken during the Mardi Gras riots in Seattle in 2001. Apparently the photographer had climbed up a fire escape to get away from the crowds. Looking down he saw and photographed the crowd grabbing at the woman and tearing off her clothes. The arguments for giving the photograph the award were that it was a 'powerful picture', and that the public should be aware of 'the reality of this horrible act'. In general it was felt that publishing the picture would do some good and the decision had only been taken after a sexual abuse counsellor had been consulted. Apart from the woman's experience of the horrific incident, what rights should she have over the photograph? What protection is there for 'ordinary' individuals?

Such things considered, I have had to weigh up my approach to a similar ethical dilemma as to whether I should include the photograph as an illustration for this book. It could be argued that, in an educational context, reproducing the image could serve 'the greater good' in that it forcefully makes a point in alerting (potential) photographers to an important aspect of their profession. However, do I have the right to use someone's suffering for this purpose? Despite my 'good' intentions, you readers may

be taking a voyeuristic delight in viewing the image. Does this mean I am taking a moralist paternalistic standpoint? How would I feel if the woman, unidentified at the moment of writing, discovers her picture while browsing in a bookstore? But then I have already mentioned that the image is available on the Internet. Does this assuage my conscience, by assisting readers to gain access to the photograph without facing up to the responsibility of personally reproducing the image? Should I have even chosen to use this photograph as an example, in favour of a less controversial subject?

I chose not to publish the image because the woman remains unidentified (thus retaining her anonymity) and the incident took place fairly recently. (In contrast, I did not feel the same concerns in reproducing I. Russell Sorgi's photograph of the Buffalo suicide (p. 96), which is (almost) out of living memory.[5]) That the story about the image is controversial and is something of an 'ethical minefield' serves to show the complexity of ethical issues. I feel the fact that the photograph is available on the Internet in one sense does 'let me off the hook', but in another sense it provides a very real example of how editorial decisions can be circumvented by the new technologies. As in the case of the 'Bert is Evil' website (see pp. 211–13), its creator decided to close down his particular 'Frankenstein's monster', but could not stop Hydra-headed mirror sites springing up elsewhere.[6] Having made this decision, I nevertheless remain uncertain as to whether this is the best course of action. Whichever choice is made will have its pros and cons.

For the photographer and editor, the decision to take the photograph may have been taken in seconds; the decision whether or not to publish and in what context, minutes or hours. Yet it is a decision that may have to be defended under the scrutiny of a court of law.

Case study: James Nachtwey, war photographer

The US photographer James Nachtwey has made a reputation for himself by photographing war and humanitarian disasters (see Figures 7.3 and 7.4). While we might question his initial motivation for choosing this profession, 'To experience danger, to experience extremes and to tax myself in extreme situations. To go to war, but not to kill anyone' (quoted by Usborne 2002: 12), he maintains that his photographs have the power to raise awareness. This is through influencing public opinion in such a way that it undermines the intentions to control the agenda of society's political forces. For example, in recently released White House tape recordings of the Nixon-era of the 1970s, President Nixon had discussed the possibility that the photograph of the napalmed Vietnamese girl had been faked (see Figure 3.3). Such was the power of the image. 'That picture was a straightforward documentary of something that was happening. And it compromised his agenda. I mean that picture, in and of itself, changed history' (ibid.: 14).

In many senses, Nachtwey is subscribing to the stereotypical images of 'the war photographer': that of the macho independent observer with little respect for authority and unconcerned by danger. He was in New York, two blocks away, when the planes hit the World Trade Center. He ran towards the disaster with his cameras and began to photograph. Despite the collapse of the South Tower, he continued to take pictures until the North Tower collapsed. Then he escaped by hiding in the lift shaft of a nearby hotel and crawling through the dust, debris and darkness out onto the street again.

Figure 7.3 Photograph from *Inferno*, 2000.
Copyright James Nachtwey.

Figure 7.4 Photograph from *Inferno*, 2000.
Copyright James Nachtwey.

Apart from his conviction in the power of photographs to 'change history', does he maintain an ethical standpoint with regard to his subject? When in El Salvador in 1983 he stated:

> I saw the aftermath of a battle in which a soldier's body had been very badly mutilated and I began to walk away from it. I thought this is just too much for me to photograph. But I came to my senses and realised that I am not here to protect my own fragile sensibilities. I am here to report what's happening and it's my duty to do that. I returned to the scene and made the picture. I have tried to never turn my back on anything again.
>
> (ibid.: 14)

Summary

- We considered the meaning of ethics as a branch of philosophical enquiry, and looked at some of its practical applications for photography and some ethical guidelines supplied by photographic associations and trade unions.
- The ethical issues involved in providing a 'fair' representation of individuals was addressed and the contrasting cases of posthumous photographs of Marilyn Monroe and Adolf Hitler were considered.
- We looked at the role of the paparazzi and the ethical factors that need to be taken into account when photographing in public and consequently how this relates to the rights of the individual.
- We saw how the decision to photograph or not to photograph is one matter, to publish or not to publish is another. Ethical responsibilities are often shared between the photographers and editors.
- We concluded with a short case study of James Nachtwey to leave the reader to consider the ethical implications of his standpoint as a photographer.

8 Characteristics of digital photography

..

This chapter aims to address a relative newcomer in terms of technical development – that of digital photography. Over the past fifteen years or so, with the increased spread of computerisation, digital photography has totally transformed some aspects of photographic practice. As we saw in the *Guardian* case study, some photographic traditions continue. For the photographer to be sent out on an assignment equipped with a camera loaded with chemical film-stock has remained common practice. However, back at the picture-desk, the situation has changed from how it was a few years ago, even though some areas of the profession have been affected little by digital media. For example, while most studios will employ the use of a PC, the computer functions in a subservient role within mainstream photographic practice.

On the one hand, digital photography has its sinister aspects: for instance, George Orwell (1948) in his *Nineteen Eighty-Four* refers to 'elaborately equipped studios for the faking of photographs'. On the other hand, along with other technological developments, it has a charm of its own: 'The enchantment of technology is the power that technical processes have of casting a spell over us so that we see the real world in an enchanted form' (Gell 1992: 44). And we find in all areas that technological innovation has dramatic social and cultural repercussions:

> In all parts of the world the processes of modernization generally involve complex interactions of technology, commercial systems, government policies, population changes, and other factors. It is therefore practically impossible to assign a unique 'causal efficacy' to any *one* element such as a technological device.
>
> (Pelto 1973: 165)

However, as we saw in our consideration of the invention of the medium itself, photography was intrinsically bound to the cultural climate of the time. Whether we are considering the introduction of snowmobiles in the Arctic (Pelto 1973), or the integration of today's virtual reality systems in the mass media in our post-industrial culture (Loeffler and Anderson 1994), we can be sure that we shall not be encountering a simple relationship of cause and effect. We shall need to develop new 'survival strategies' (see Postman and Weingartner, p. 210 of this volume).

This chapter aims to address questions concerning the nature of digital photography:

- What is it?
- What does it mean?
- What are the scope and limitations of photographic manipulation?
- What are the theoretical implications for this new technology?

The chapter also questions the polarisation of new and conventional technologies. While the issue of digital photography lacking an original negative is addressed, the chapter aims to develop a model for approaching digital imagery through its attempt to condense concepts derived from different levels of analysis of existing practice. Although this will not enable the student of photography to predict the future, it may serve to indicate the potential options, wider scope and possibilities arising from the new technologies. Also examined is the convergence of camera representation and computer organisation: the gathering, processing and reception of information derived from the visual world.

What is digital photography?

In contrast to the chemical process of fixing a camera-produced image, based upon the processes of the industrial age and initially developed by such experimenters as Daguerre and Talbot, the digital photograph is captured and secured by recording the image as a *bit map*. The term 'bit' is derived from Binary digIT and these digits are stored in the computer's memory as switching an electrical current *on* (1) or *off* (0). So a digital image is made up of a series of bits amounting to a mosaic of informa-tion which is used to form the image on the computer screen. As far as the means of arriving at such an image are concerned, the digital image can be recorded directly – where a digital camera registers the image projected by the lens as a pattern of 1s and 0s; or indirectly – where a conventional photograph is scanned into the computer, transferring the tones and colours of the original image into the digital code of 1s and 0s. The digital camera operates on the same basic principles as the photographic camera (see Chapter 3) but without a film. In place of the film, present at the point of projection, there is a charge-coupled device (CCD) which records the pattern of light in the form of a digital code. There is no latent image recorded nor is there anything that corresponds to a film or negative. However, like the retina of the eye the CCD is reusable and, once an image has been recorded and stored at the opening of the shutter, the CCD is ready to record again. Apart from pressing the button to open the shutter, this process takes place with no moving parts; there is no need to replace the light-sensitive surface and no film to wind on. Once visual information has been converted into digital form there is no need for any physical carrier or base for the image.

Digital cameras[1] currently available can hold up to seventy-six picture frames stored on removable 105 MB (PC card) hard drives, though 256MB CompactFlash cards are now available. They can be instantly assimilated into the computer via an image-processing program (such as Adobe Photoshop) via a plug into a Macintosh computer. This eliminates the need for film, processing chemicals or prints. Once acquired, in as little as five seconds, the image can be transferred directly to a newspaper's comput-erised pagination system. The photograph can be cropped, captioned and edited, placed

on a page and published. During this process the 'computer allows modifications that appear virtually seamless to be made within seconds or minutes' (Ritchen 1990: 5). This has dramatically accelerated the operations of photojournalism, whereby a publication can receive images from remote locations – almost anywhere in the world – in a matter of seconds. The new technologies have created the possibility that photographs of up-to-the-minute news items can be published in the paper much closer to the deadline, and reach the reading public much sooner, than was hitherto possible.

Over the last few years there has been an increasing demand for a faster and faster turnaround in photographic processing. Polaroid had introduced a 35 mm colour slide film which had a processing time of approximately one minute, which can be done on the spot with a hand-held processor, requiring neither darkroom nor laboratory. Although hindered by a low film speed, it did prove very useful for taking stills of local news items for television news. However, this technology was restricted by its reliance upon analogue transmission: for example, it was subject to traffic hold-ups in the Central London rush-hour. In contrast, the digital cameras, having completely eliminated film, can be used to transmit images from a mobile phone. But not only do the digital cameras capture digital images, they can also capture soundbites, so that an audio-caption can be added by the photographer at the scene of the event, eliminating the need for notepad and pencil.

As far as the digital camera can be described as filmless, the flat-bed scanner can be said to resemble a paperless photocopier. The flat photograph, or artwork, is placed in the scanner where a light is passed over the image dissecting it into thin horizontal strips. This light is reflected, via a lens, onto a series of sensors which record the image as a modulated pattern of electric current. This pattern is transferred to the computer for storage and can be viewed on the computer monitor. There is also a hand scanner available which can be used in a variety of locations, on irregular surfaces and (with varying degrees of success) on three-dimensional objects.

Where the image is stored (as bits) in the computer as a bit map, the computer's monitor is made up of 'pixels' (picture elements): thousands of dots of light. Each pixel is composed of three rays of light – red, green and blue – which are balanced on-screen to display a particular colour. The achievement of this colour balance is not dissimilar to the way yellow, magenta and cyan are used when colour printing in 'traditional' photography. The number of bits needed to serve an individual pixel depends upon the monitor. However, to summarise: the digitally recorded image (whether obtained by camera or scanner) is stored in the computer's memory as a bit map. This is then decoded by the computer and displayed on the monitor as a mosaic of pixels. It is this mosaic which forms the digital image.

In popular estimation, a picture may be worth a thousand words. However, a reasonable quality digital image, size 8″ × 10″, would use a megabyte – equivalent to 500 double-spaced pages of text, i.e. approximately 100,000 words. The degree of quality of the digital image (its resolution) is registered as its *dpi* – the number of dots per inch – and the speed of transfer of digital information is measured in *bps* – bits per second:

8 bits = 1 byte 1,048,576 bytes = 1 megabyte (approximately 1 million)

In digital photography there is a change of emphasis in the role of the camera. Where the traditional camera had been referred to as a 'recording device', the digital camera (and scanner) is known as an 'input device'. Input devices are the means of

entering the data into the computer. This represents a theoretical shift from the primacy of the camera as the central apparatus in photography to its having a more subservient role: supplying information to the computer. We have discussed the dangers and theoretical pitfalls arising from the use of the (partly appropriate) analogy in relation to the eye and the camera, but it would seem that this change of role is more in keeping with Gibson's 'eye', considered as a constituent part integrated into a broader perceptual system.

What are the implications of digital photography?

At first glance there is very little difference between photographs whether derived through the digital or the analogue process. Unless viewed under magnification (see Figures 8.1, 8.2, 8.3), both digital and analogue images appear as photographs as we would normally expect them to appear, usually on a glossy, flat sheet of paper. And, in looking to the origins of the image, this is not surprising. We find that, at the beginning of the process, both have been taken through the lens and subjected to the same framing, focusing and focal criteria, therefore producing a similar visual array as a result. But, assuming an original conventional photograph has not been scanned into the computer, there will be no negative behind the digital photograph. Furthermore, the digital file can be copied endlessly.

An analogue image will lose its quality as it is copied whereby the processes of copying interfere with the information to be transmitted. In contrast, a digital image taken with a digital camera will have no original imprint. This means that the first image recorded will be identical in quality to a thousandth-generation copy, assuming no manipulation has taken place, without any deterioration of image.

If we make a comparison between an enlargement of an analogue and a digital image the digital image appears seamless. In the analogue photomontage, magnification can usually reveal the edges where the composite images have been stitched together. On the other hand, a carefully manipulated digital image will contain no evidence of the joins. This is assuming that the lighting of the constituent parts is uniform and consistent and the picture-planes do not present any spatial ambiguities, etc. Of course, images could always be manufactured, and photographic studios and film-sets have provided a complexity of ways of manufacturing fictional worlds for the camera. However, there is a distinct difference between manipulation *in front of the camera* and that *after the event*, even though both procedures may involve a distorting of actuality; for example, as in the work of Orlan who has photographed herself undergoing plastic surgery, changing her own body image by the means of analogue technology. This is determining the optical array specially for the camera's view: creating a picture by rearranging the subject in the tradition of the *tableau vivant*. 'The analogue technology of silver/gelatine photography has never *really* been a guarantee of the photograph's authenticity . . . has it?' (Cameron 1991: 4).

While the modern technologies of television, satellite and the Internet have displaced some areas of photographic practice, the visual images still have to be obtained from somewhere or other. They can sometimes be grabbed from video footage, which opens up the possibility of the armchair photographer, who sits at home contemplating an array of CCTV monitors, choosing whichever image takes his or her fancy, taking a snapshot and storing the image for later use. But the technology

Figures 8.1–8.3 Tube Theatre, London, 1983.

Photographs by Terence Wright.

Below left: Detail of analogue image.

Below: Detail of digital image.

begs further questions concerning the impact of the new media in relation to visual, verbal and critical skills. In this context, we might need to reassess the role of the realist, formalist and expressionist foundations established in Chapter 2. For example:

- In terms of realism, does the computer-manipulated photograph undermine the documentary status of the photograph?
- As for the formal aspects, do the special characteristics of digital photography constitute a new medium?
- And for the expressionist possibilities, are the new technologies rigidly mechanistic, or can they shape personal experience, imagination and perception?

The computer manipulation of photographic images has radically challenged our conception of photography. On the one hand, the purity of the photograph is undermined: its reliability as evidence is now highly questionable; on the other hand, a totally new range of possibilities for the display of images is beginning to emerge. We might also question whether digital processing simply modifies photographic images, or whether it would be more accurate to describe them as being reconstructed.

Changes to photography by digital imagery

In 1975 the artist Les Levine drew a distinction between the traditional art disciplines – painting and sculpture – and the more contemporary forms of representation produced by the camera. According to Levine:

> The painter and sculptor create images through a variety of physical-making processes, which are all an extension of the industrial world, by brushing, pouring, moulding, and shaping, etc. The camera artist creates . . . images merely by seeing through a series of post-industrial devices, such as still cameras, vidicons, etc. The painter often goes through a series of processes to create an image. The camera artist merely processes images.
>
> (Levine 1975: 52)

Over twenty years later, the distinction between – to use psychologist James Gibson's (1979: 272) term – the **chirographic** (drawing-based) arts and the photographic arts is not so clear-cut. The digitisation of photographic images has blurred the edges so that it is not out of the question to speak of brushing, moulding or shaping the photograph. In fact, computer programs such as Photoshop with a tool kit of brushes, airbrush, dropper, smudger and rubber stamp have been specifically designed to emulate these industrial processes. The use of such metaphors derived from existing graphic technologies aims to facilitate human agency in mechanical reproduction. For example, the digital photographic artist will find that using the smudger in conjunction with a touch pad does create a curious sensation of actual physical manipulation. No doubt, future advancements in the field of virtual reality will lead to an increase in tactile participation. Further developments of 'smart gloves' and 'smart skin' may well create the sensation of three-dimensional moulding and shaping of visual images. Nonetheless, at this point it may be useful to remind ourselves of Alvin Langdon Coburn's point of view regarding painting and photography, where

the essential difference is not so much a mechanical one of brushes and pigments as compared with a lens and dry plates, but rather a mental one of a slow, gradual, usual building up, as compared with an instantaneous concentrated mental impulse, followed by a longer period of fruition.

(Coburn 1911: 72)

(See p. 9 of this volume.) Digital photography provides the mechanical means to cut across such distinctions.

Metaphors are not new to photography. It is well known that the word 'photography' was derived from the analogy of 'drawing with light' and in the early years of the medium Talbot's 'photogenic drawing', Eastlake's 'solar pencil' and Holmes' 'mirror with a memory' employed familiar conceptual schemes to help in the understanding of a new technology.[2] As Margaret Boden (1981: 31–51) has pointed out, it is only with hindsight that one can determine the scope and limitations of such analogies. In the meantime, within photographic education they have been frequently invoked to play a central, yet rarely appropriate, role in providing the rationale for photography's status as art.

The possibilities of transforming photographs by digital processing have altered our theoretical perceptions of photography to the extent that we can no longer be certain that the photograph can provide, in any way at all, evidence of states of affairs in a real world. In part this stems from photography's subjection to two opposing theories of representation (Wright 1992a), discussed in Chapter 3. One of the central issues raised by digital photography is that it has the potential to undermine the documentary truth of the medium. Or, as some theorists would have it, it provides yet further evidence to undermine this truth. Not only can photographs be deliberately distorted so that their appearance radically departs from that of the scene as initially photographed but, with digital cameras, one cannot prove that the finished photograph actually corresponds to the latent image recorded by the light-sensitive surface in the camera. Even with conventional photography, where one may have recourse to an original negative, the transmission of images across the superhighway combined with the characteristic urgency of the news media leaves little time to verify the authenticity of any image that arrives at the picture-desk.

It is yet to be determined whether the combination of camera representation and computer organisation so departs from traditional photography that it can be considered a new medium. This largely depends upon whether digital photography offers anything new or simply provides greater ease with which traditional techniques can be performed – perhaps when it has been shown to free visual representation from the limitations of still photography.[3] Photographs have been subject to all sorts of physical manipulation since the time the medium was invented (see Mitchell 1992) and this practice has continuously haunted the history of photography: 'photographs have been subject to change, distortion, and misuse since the beginning of time' (Rosler 1991: 57).

This takes us straight back to the uncertainties of 1848 where image manipulation resulting from lithographic reproduction of the daguerreotype could be used to cheer up the sitter.[4] (See Figures 8.4 and 8.5.)

Edward Weston's purist approach to the photograph stemmed from a position that shuns any interference with the captured optic array. This might be considered an

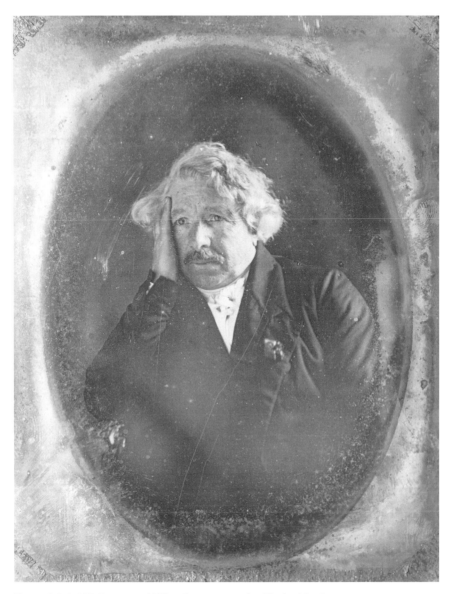

Figure 8.4 L.J.M. Daguerre, 1848: a daguerreotype by Charles Meade.
Courtesy of the Smithsonian Institution.

update on the theory of the perfection (or integrity) of the photographic image. It was based on the logic that the photographic image has an intrinsic tension dependent on the composite nature of the image being 'entirely made up of tiny particles. The extreme fineness of these particles gives a special tension to the image, and when that tension is destroyed – by the intrusion of hand work . . . the integrity of the photograph is destroyed' (Weston 1943: 16). At the very least, we can be certain that digital processing has motivated a significant shift of emphasis in the way that photography

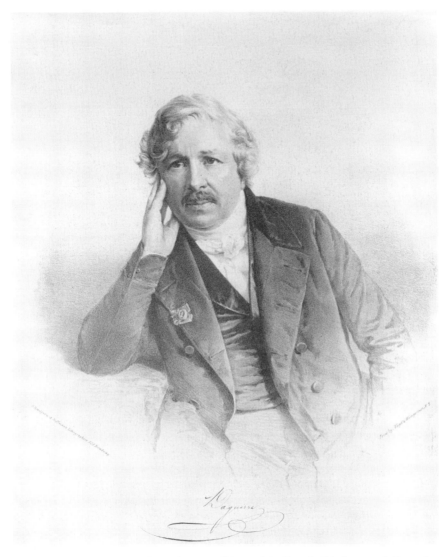

Figure 8.5 L.J.M. Daguerre, date unknown: a lithograph by Francis d'Avignon and Abram J. Hoffman from the daguerreotype by Charles Meade.

Courtesy of the Smithsonian Institution.

is generally regarded. This may necessitate a realignment in the history of photography whereby the contributions of hitherto marginal figures – such photographers as Oscar Rejlander and Henry Peach Robinson (see Figure 8.6) – are brought in from the cold and reinstated as playing a central role. They are moved from a somewhat reactionary position, characterised by their attempts to force photography into an aesthetic borrowed from painting, to becoming the ancestors of twenty-first-century image manipulation.

Figure 8.6 Carroling, 1887: a composite photograph.
Photograph by Henry Peach Robinson. Courtesy of the Royal Photographic Society, Bath.

New technologies provoke further retrospection resurrecting the 150-year-old debate concerning the familiar adage 'the camera never lies', and new questions are being asked as to whether the photograph remains faithful to its referent. Until recently, the viewer was most likely to be misinformed through the context of the photograph. The supporting caption, for instance, could determine the ways the image was to be viewed. In this context, Tirohl (1995: 18) has pointed out, 'the delivery of order in a web of information goes hand in hand with the manipulation of that information'. Here we need to distinguish between manipulation through context, emphasis and alteration. While the accompanying caption, for example, can create the context for a changed meaning of the image, in the darkroom the techniques of **dodging** and **burning-in** could add emphasis by diminishing or accentuating parts of the visual array. Now computer manipulation enables alterations to be made to the array itself. This widens the scope of photographic representation to include, for example, the characteristics that conform to Baldinucci's (1681) description of caricature whereby cartoonists 'disproportionately increase and emphasise the defects of the features they copy, so that the portrait as a whole appears to be the sitter . . . while its components are changed' (quoted in Gombrich 1960: 290). It is this changing of components that marks the significant mechanical difference between digital and analogue photography.

We look now at another closely related lens-based system: the cinema. The traditional divide in film theory between fiction and documentary hinges on the notion that fictional films are primarily made to entertain while documentaries aim to increase the viewer's understanding of some factual aspect of the world.[5] Indeed, if we look at a related mode of communication, the museum was held to be of a similar purpose which conformed to this definition of documentary. Nonetheless, this established categorisation is being eroded. The changing function of the museum exhibition involves increasing the viewer's understanding of some factual aspect of the world while employing the techniques of entertainment. It is in this area that the new

technologies are playing an increasingly significant role. But, ironically, the new technologies do not necessarily democratise art but actually restrict its appreciation to those who are computer-literate. And, as Anne Barclay Morgan (1994: 41) suggests, 'they also demand a precious commodity: time. Such works may create a new kind of elite audience – those who have the time for interactive art.'

Photographic manipulation

> Photography has been allied to technology since the moment it was invented. Then, it heralded a new industrial age and epitomised the new progressive spirit of its time. Today the industrial age has rusted shut, but the progressive spirit that fuelled it lives on; what has changed dramatically in the interim is not so much the spirit that motivates the photographs, or even the look of photographic images themselves, but what we make of them. They can no longer purport to be innocent witnesses devoid of intentions, and we can no longer pretend to be innocent bystanders in the path of their endless procession.
>
> (Andy Grundberg 1990: 222)

Photographic manipulation has a long history. As Martha Rosler (1991: 53) put it, 'any familiarity with photographic history shows that manipulation is integral to photography'. It may be remembered that because of the narrow band of exposure latitude of early photographic plates, landscape photographers would produce montages so as to introduce much lighter clouds into the sky of a relatively dark landscape:

> if [the photographer] be judicious in his arrangements, there is nothing whatever to prevent his having the satisfaction of seeing his conception perfectly realised by the camera, with such delicacy of finish as Nature's handling alone is capable of . . . for it suffices that a finger be disagreeably placed to spoil the whole as a perfect work.
>
> (William Lake Price 1858, in Haworth-Booth 1989: 96)

It would seem that the suggestion of manipulation was not out of place as long as it was considered to be acting in aid of enhancing photography's attribute of perfection, and this is evident in the traditional darkroom practices of dodging and burning-in – these aim to compensate for some of photography's technical limitations. And this returns us in many respects to the differences between seeing and knowing which were partly derived from Berkeley's visible and tangible ideas.

As expressed by Rosler, it is 'in the service of a *truer truth*, one closer to conceptual adequacy' (1991: 54). Certainly the computer, with its digital-processing program, is not the first piece of technical apparatus devoted to image manipulation. Aaron Scharf (1968: 234) cites Louis Ducos du Houron's invention which relied upon a series of fast-moving slits instead of a lens to make the sitter ugly or to 'correct and embellish' or, to use Rosler's term, to bring the image 'closer to conceptual adequacy'. Furthermore, it is Ritchen's point of view that photographers now have at their command a broader spectrum of expressionist possibilities:

Art photography . . . will no longer draw much of its strength and context from a perception that is inherently a comment on visible verifiable realities, but will come more easily to be seen like painting, as synthetic, the outcome of an act from the artist's imagination.

(Ritchen 1990: 5)

So many of the same sentiments regarding truth, art and the like may be similar to those of the nineteenth century about manipulation, retouching and montage. The computer allows the speed and detail quickly to produce images that would have taken photographers like Robinson weeks to achieve. Additionally, the older techniques were easily detected: one could 'see the joins'. However, if the contemporary image has been taken with a digital camera there is no negative to contradict the truth of what is seen.

Digital photojournalism?

photographs will not seem as real as they once did.

(*The New York Times*, 12 August 1990)

Andy Grundberg, photographic critic of *The New York Times*, suggests that in future photographs in the context of newspapers and magazines will assume the status of illustrations, rather than of documents. If we are to go by Grundberg's title of his article, 'Ask It No Questions, the Camera Can Lie', it seems to contest Suchar's (1989) and Harbutt's (1973) approach to the 'interrogatory principle'. The questions we should now ask of a photograph are very different and we must address the issue from different assumptions. We may consider a parallel with movie film, for in the high-control manipulation of the image in the feature film (in a costume drama, say, *Jane Eyre*) a set may be artificially constructed and the actors clothed to give viewers the impression that we are seeing a transparent rendering of eighteenth-century life. All that we see has been fabricated for the camera's point of view. Nonetheless, in practice we have little problem in distinguishing the difference between documentary or news footage from that of the fictional drama. For some reason, fiction in still photography poses a different set of representational uncertainties. There are issues of balance and bias but in general we automatically assume that the news image is, context aside, accurate:

the photograph still holds a descriptive power that remains convincing and lends strength to its various levels of meaning. The computer, allowing a new and bold conceptual approach to imaging, offering the easy exchange of visual and other elements, as well as ways of depicting the visible, is the portentous addition to the mix.

(Ritchen 1990: 7)

In the context of press and photojournalism the traditional mode of delivery, from the photographer to the picture-desk, is no longer appropriate. Images can come 'down the line', with little opportunity for the picture editor to check whether the image is genuine. In the urgency of producing a programme or publication, there is no time to

trace or check the originating negative. In many respects it depends upon the media agency relying on a tried and trusted supplier, rather than physical evidence. Even so, in the non-digital world, this trust is open to abuse, as illustrated by the recent case of Michael Born who did, literally, manufacture the television news. Born claimed to be the first television journalist to expose the activities of the Ku Klux Klan in Germany, apparently having secretly filmed closed Klan sessions. It was later revealed that the 'Klansmen' were in actuality Born's friends who had dressed in sheets to fabricate the story and help to supply the 'evidence'. In fact, twenty-two of Born's 'scoops' were set up with the help of friends and neighbours. Furthermore, he had achieved his deceptions through gaining the trust and confidence of a number of television stations where he was considered to be a reliable supplier of news footage.

Copyright

The practising digital photographer may encounter special problems with regard to copyright, with reference to the manufacture of digital composite images that may be derived from a number of sources and/or originals. The precise legal details with regard to copyright are beyond the scope of this book, but it remains important for the photographer to be aware of the legal position before using or incorporating any found images into a photographic composition.

In theory, the copyright issue should be little different from the situation of the designer who, in preparing a brochure, may use a variety of images from different sources, such as photo-libraries or archives. Each image will need to be cleared and (in consultation with the agent or institution) credited, where appropriate, and used in accordance with agreed terms. However, taking the other point of view, the photographer is less likely to encounter the issue of using other people's images, which may be less critical than facing the problem of keeping track of his or her own photographs. This may become increasingly difficult, particularly as digital manipulation could render them almost unrecognisable and, in the near future, there may be no original to prove the case either way. In such cases, could it be argued that the photograph is no longer the same image? Or the photographer may find it difficult to prove that a small part or detail of a larger composition actually belongs to him or her and, if it does, what percentage of the finished work any individual image constitutes. One of the advantages of the digital photograph – in that its image is coded as digital information – is that the information can be relatively easily transmitted via such electronic networks as telephone lines. A series of electronic pulses can be channelled from one location to another and the photographic image can be reconstituted at the receiving end without (in theory at least) experiencing any loss of quality.

Photography on the Internet

A group of computers can be linked to form a network so that they can share information or hardware. Programs, files or peripherals (such as printers) can be shown or transferred via a local area network (LAN)[6] to enable a number of people in a building or office to work on the same project and to consult or comment on information stored in someone else's computer. This can be achieved without printing out the

information or the physical exchange of disks. When connected to a network, files on my colleague's computer can be as accessible to me in my office as they are to her in hers. In addition, she can take photographs using a digital camera, plug the camera into a workstation in the main university building and I can access the images on my own computer screen in our faculty building half a mile away. In this case, the visual information is transmitted via wires and cables running between the buildings which form a wide area network (WAN).[7]

Having viewed the images I could copy them (with no loss of quality), crop them or digitally rework them. She might disagree with my suggested alterations and provide her own adjustments or add captions, etc. These processes of transfer can be achieved with no physical photographic image ever being made. The dialogue across this relatively small distance can take place simply through transferring and changing the pattern of 1s and 0s that comprise the digital image. Of course, it is possible that we cannot resolve our hypothetical dispute over the editing of the image(s) and decide that we need the opinion of the publisher who is based in Chicago. But, instead of making a print which we could send by airmail, we can e-mail the image so that it will appear and can be accessed on the publisher's computer in much the same way as it appeared on mine. And, in a similar way (international time zones permitting), the dialogue can continue across the Atlantic. In this instance the information would be transferred via telephone lines and communications satellites. This is done via the electronic information superhighway known as the Internet.

The Internet consists of the electronic connection of a number of computers situated all around the world. At the same time, all the computers in the office or the PC in your own home can be linked via the telephone line to a central computer called a server. Having connected to this local system, the individual user can use the server to get connected to any other server on the Web, whether it is located in Edinburgh, Chicago or Port Moresby. Not only does this give the user access to vast amounts of information across the world, but it is in the capability of almost any individual to set up their own website to offer any information they wish. For photography, this means that not only have a number of photographic archives and agencies displayed their wares on the Internet, but individual photographers (e.g. Kate Mellor, see p. 168 of this volume) have used this facility to showcase their work.

Despite the rapid expansion of the Internet over the last twenty years, the possibilities and potentials for the photographic image are in the very early stages of development. In fact, the Net has become so vast that it is becoming more difficult to explore and new systems of navigation are being developed. In 1995 the number of websites was estimated to be 23,500; by 1999 the figure had risen to 4.6 million. The *Online Computer Library Center* estimate the Web now contains 8.4 million unique sites, compared to 7.1 million in the year 2000. This actually means that the growth of the Internet is slowing down (from 1999 to 2000 the growth was 53 per cent, from 2000 to 2001 it was 18 per cent).

Nonetheless, for photography this means that images stored in photographic archives around the world potentially can be accessed by any individual with a computer and Internet connection. Similarly, any photographer can send his or her images to anywhere in the world or make available their own showcase of work to any interested parties. Indeed, it can be argued that it is the digital transmission of images, rather than the manipulation of the photograph, that will prove to have the greatest influence on photographic practice: images can be sent around the world

at such a rapid speed, with the potential (at least) of all photographs being available to all people. However, without the benefit of historical hindsight, one can at best hazard a guess as to the future importance of different characteristics of the medium. Paul Virilio in his *The Vision Machine* (1994) describes the changing role of transmission techniques in the context of military communications. During the First World War reconnaissance aircraft were used for aerial surveillance, a task now performed with greater precision by satellite observation's gathering of optical information. Over the decades, our visual perceptual processes have experienced increased separation from forms of physical representation. In the Gulf War the information from the battlefield was sent back by satellite to the United States, where strategies and directions could be drawn up and sent by armchair generals. As far as the press is concerned, we might cite the example of the European Network of Press Agencies, which has its editorial offices in Frankfurt while the technical centre is in Paris. In nearly all newspapers, digital image reception has increased dramatically over the last few years. As for photography, from the moment the shutter is pressed, assuming the photographer is using a digital camera, there is no need for any intervening physical object bearing a representation until the photograph appears on the newspaper page itself. The image can be transmitted down the line onto the screen where the page can be laid out and sent directly for printing, which could be the first time the image is made into a physical form.

Electronic transmission can give rise to new approaches/art-forms; for example, the *ArtAIDS* project (see Figure 8.7), which capitalises on transmission and manipulation. One of the problems with transmitting images is that they can be very large files in comparison to text. Therefore, a process of compression can be used to reduce the file size by coding redundant information and, in reversible systems, the image can be reconstituted at the receiving end. With irreversible compression, the reconstitution is approximate.

Case study: the Virtual Gallery

The *ArtAIDS* link was set up on World Aids Day (1 December 1994). It had the objective of forming a collaborative Internet art event open to all digital artists. It began by commissioning image files from twenty international artists. Operating in a similar manner to a chain letter, the project offered a worldwide interactive facility for accessing art and photographic images contributed by contemporary artists. Anyone with an Internet connection could view the images held on the *ArtAIDS* server, make a selection, download the image, manipulate it – perhaps adding their own images – and finally put the image back onto the server for others to view, download and make their own contributions. An additional feature of the project was that it aimed to create the computer (digital) equivalent of an (analogue) Aids quilt. This is the process in which contributors sew individual commemorative squares, for those who have died of the disease, which are then joined together to form a coherent whole.

The *ArtAIDS* project provided the necessary storage and the facility to transfer computer-based images between remote users, encouraging the process of collaboration to define and refine new art objects, to increase awareness and raise funds for AIDS research and related activities. Participation was open to anyone with access to the Internet, appropriate image-processing software and a basic understanding of file-transfer procedures.

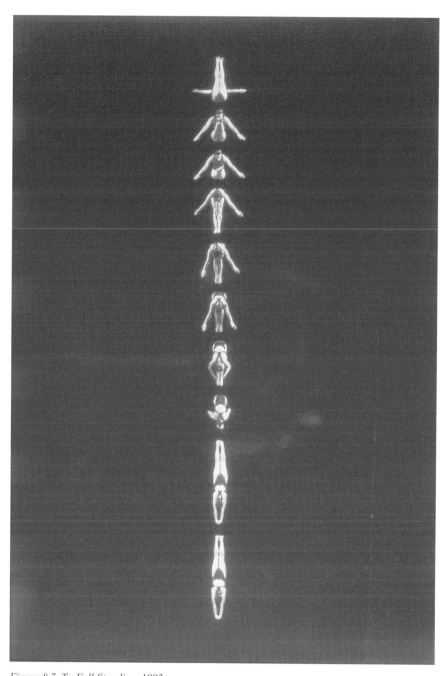

Figure 8.7 To Fall Standing, 1993.

Photograph by Rebecca Cummins. Courtesy of the artist and ArtAIDS, http://www.artaids.org.uk.

Apart from the use of the Internet for contemporary image-making, exciting developments have taken place in the photographic archive. One particularly innovative approach to the Virtual Gallery is that of the California Museum of Photography. The gallery not only provides access to the archive by remote users but it has made some interesting uses of the technology. For example, some nineteenth-century panoramic photographs have been displayed so that the viewer at home can pan round the 160 degrees or so of the photographed horizon. Some of the most notable exhibits in the gallery benefit from the use of the 'virtual magnifying glass':

> The photograph depicting a street in Nome, Alaska, *c.* 1905 is MAPPED. There is more to see deep in the image; pretend your mouse pointer is a magnifying glass. Move to an area of the photograph that looks interesting and just 'click'. A small detail will appear greatly enlarged. There is a lot to see and to speculate on deep in the recesses of photographic images nearly a century old. Use your virtual magnifying glass to take a close look down the streets of Nome, Alaska.
>
> (California Museum of Photography, http://www.cmp.ucr.edu/
> exhibitions/mapped_photos/alaska.html)

The Virtual Gallery is based upon transforming information from photography to digital media and disseminating the visual information via computer telecommunications.

JPEG: a note on the digital transfer of photographs

JPEG (pronounced 'jay-peg') is a standardised image-compression mechanism. JPEG stands for Joint Photographic Experts Group, the original name of the committee that wrote the standard. It has been designed to save on the relatively large amounts of computer memory that are required by photographs when compressing either full-colour or grey-scale images. It works well on photographs, naturalistic artwork and similar material but not so well on lettering, simple cartoons or line drawings. JPEG handles only still images, but there is a related standard called MPEG for motion pictures.

JPEG is 'lossy', meaning that the decompressed image is not quite the same as the one you started with. It is designed to exploit known limitations of the human eye, notably the fact that small colour changes are perceived less accurately than small changes in brightness. Thus, JPEG is intended for compressing images that will be looked at by humans. However, if for any reason the images are to be machine-analysed, the small errors in the picture information that have been introduced by the JPEG process may become a problem, despite the fact that they are invisible to the eye. A useful property of JPEG is that the degree of lossiness can be varied by adjusting compression parameters. This means that the image-maker can trade off file size against output image quality. So very small files can be made though predictably they will be of poor quality but, nonetheless, this is useful for applications like indexing image archives.

Another important aspect of JPEG is that decoders can trade off decoding speed against image quality by using fast but inaccurate approximations to the required

calculations. Until recently, most publicly available JPEG code has adopted a best-possible-quality philosophy, but we are now starting to see the appearance of viewers that give up some image quality in order to obtain significant speedups.

Digital theory

Apart from the technical or mechanical aspects of originality and image reproduction in particular, digital photography can be seen as part of a more general post-modernist concern:

> Just as execution of a brush stroke is a fundamental painting operation, and exposure is a fundamental photographic operation, so selection, transformation and assemblage of captured, synthesised, and drawn fragments to reconstitute the 'mise en image' are fundamental operations in the digital image.
>
> (Mitchell 1992: 164)

Digital photography is caught between the promise and excitement of expanding the photographer's repertoire and the scope of the photographic medium, while at the same time causing considerable concern regarding the potential for deception in the use of such images. John Long, the president of the US National Press Photographers' Association, wrote in a paper entitled 'Truth, Trust Meet New Technology':

> Photographers, editors and publishers need to speak out unequivocally and say 'NO!' to the abuses that can and will creep into newsrooms as the use of digital photo technology becomes widespread. . . . we cannot use this technology to create lies, no matter how tempting or easy.
>
> (*Electronic Times*, 6 October 1989)

Of course, it is not technology alone that can alter the image; as we have seen, the shot can be staged in the first instance. At the same time, the new technology requires a certain amount of mental adjustment on behalf of the viewer. We have a cultural conditioning regarding our knowledge of the relationship between photography's technical processes and our conceptions of human agency which is 'quite distinct from that in which we conceptualize the technical process of painting, carving, and so on' (Gell 1992: 50). Gell goes on to suggest that it is our familiarity with the process that accounts for the 'enchantment' of the representation; this is reminiscent of Aristotle's pleasure in others' imitations. He continues:

> the attitude of the spectator towards a work of art is fundamentally conditioned by his notion of the technical processes which gave rise to it, and the fact that it was created by the agency of another person, the artist.
>
> (Gell 1992: 51)

With digital imagery the distinctions between the mechanical representation and that brought about by human agency – the *photographic* and the *chirographic* (to use Gibson's terms) – melt away (or become blurred). In addition, we now find ourselves in a situation where the average spectator will most likely be unfamiliar with the

processing of digital imagery. So in Gell's proposal the spectator's attitude to the digital image would be indeterminate or undefined:

> Scholars can often trace back through a family tree of editions or manuscripts to recover an original, definitive version, but the lineage of an image file is usually untraceable, and there may be no way to determine whether it is a freshly captured, unmanipulated record or a mutation of a mutation that has passed through many unknown hands.
>
> (Mitchell 1992: 51)

The issue of the original art object regarding the manuscript has been discussed by Wollheim (1968: 22), who questions whether the original artwork is the production of the opera or, in the case of a novel, James Joyce's manuscript. He goes on to question how much we can change the production before it ceases to be the same opera or the original idea. Or should we assume that we base our judgement on the initial concept of the writer?

The new technologies seem to suggest that photography has been released from the constraints of its own characteristics – from those attributes that accounted for the sense of wonder and excitement that surrounded the medium's invention; for example, Frith's notion of the truth and perfection of the photographic image – that it automatically recorded reality. So digital manipulation, in releasing the photographer from those constraints, in some sense means that photography becomes like any other graphic art that might not *be* a lens-based image, but is *derived from* a lens-based image. In theoretical terms, it amounts to reinforcing the window-on-the-world view of photography.

Another possibility afforded by the new technologies is that they offer a new form of spatial exploration of the photograph. One can almost explore the depth of the photograph to find more things behind the photograph than may lie beneath the face value of the image: scratching the surface to find more information underneath. This can be seen in contrast to the usual spatial information that accompanies or surrounds the photograph (layout, caption, etc.) and the linear sequencing of the image (as in tape/slide presentation or film-still). The photographic information can be nested: contained at greater depths in the image so that further information can be accessed by a virtual peeling of the layers of the onion.

The widespread influence of digital media provokes a number of questions that inevitably arise. Is analogue photography due to be replaced by digital photography? Can we any longer consider a photograph as documentary? Is photography dead? It can be argued that any medium, whether photography, painting, poetry or literature, is in a perpetual state of redefinition. Just as the meaning of the term 'communication' has changed radically over the last century, so the photographic medium has been recontextualised and new elements have been incorporated into the field of practice. Photography may no longer be the medium it was thirty years ago; but thirty years ago it wasn't the same as it was sixty years ago.

Rather than considering pure digital photography in contrast to pure analogue photography, the most interesting area of innovation currently seems to be where the two practices converge. Looking back in photographic history, we can see that it is rarely the case that a new process has immediately supplanted another. A new process is introduced (or marketed) and taken up by a few individuals who see the potential

(or are prepared to take the risk). There can then follow a rapid expansion characterised by everyone jumping on the bandwagon, followed by a very gradual tailing-off, which may have been caused by the introduction of the next innovation. For example, the use of the daguerreotype, introduced in the early 1840s, spread rapidly over the next fifteen years or so, but then diminished towards 1860. In the meantime, the collodion (wet-plate) process had been introduced and was well established and in extensive use from around 1855 to the early 1880s, falling out of mainstream practice towards the turn of the century as it was becoming increasingly superseded by 1875's gelatin plate, and so on.

For example, in the United States, S. Rush Seibert recalled the introduction of collodion photography, in tandem with the simultaneous practice and gradual decline of the former daguerreotype process. Collodion 'was immediately made a success and Daguerreotypes were laid aside in many establishments, although I continued to make them at intervals between 1840 and 1874' (Busey 1900: 93). The process of technological change and innovation has been indicated by Kubler's 'battle-ship-shaped' curves (Kubler 1962), that is, how one social phenomenon runs concurrently with and then takes over from another.

Audio-visual work in conjunction with photography (tape-slide programming, for example) had been a sideline for the general practitioner in commercial photography, but it now has increased emphasis in the digital era. The presentation of photographs with text, music, sound and moving images is becoming more commonplace and increasingly important. It furthermore has the potential of supplanting mainstream photographic practice and presentation. The work of Pedro Meyer is one such example, as is the *From Silver to Silicon* CD-ROM. As far as the viewer is concerned this process can involve greater participation, as we have seen with the *ArtAIDS* project.

The photojournalist might ask if the new technologies pose a threat or present an opportunity. The photographer may take a particular angle on an event, yet the editor may not approve of his or her results and decide to 'correct' the image to conform or to suggest an alternative reading. From now on all images, whether photographic or not, may be judged as constructions or potential constructions and an air of suspicion hangs over all visual representation. So if a photograph is not considered a *realist* representation, attention may be directed to its *formalist* or *expressionist* characteristics: emphasising the *symbolic* over the *iconic* or the *indexical*. There is a change from the window on the world to the subjective imagination of the creator and, as all mediated communication becomes digital, the traditional categories of photography, film and the moving image become blurred. In considering the effects of technological change on society we might reflect that

> a change in an environment is rarely only additive or linear. You seldom, if ever, have an old environment *plus* a new element, such as a printing press or an electric plug. What you have is a totally new environment requiring a whole new repertoire of survival strategies.
>
> (Postman and Weingartner 1971: 20)

In the case of Benjamin Stone, his thorough approach and photographic method fuelled by a realist aesthetic unwittingly developed potential in the reuse of his images:

My method is to shoot successively, so as to show details and changes. If necessary, I take a dozen pictures of a ceremony or custom, recording the whole thing from beginning to end with a clearness that leaves little or nothing for the imagination to supply.

(Stone, press cutting, 1905)

This method, aided by his use of a tripod which had the result of standardising the background in the photographs of his 1905 shoot, resulted in his accumulation of images containing enough information so that digital processing makes it easy to create rudimentary animation of his subjects. They can be made to move slightly, giving an impression of their repositioning: posing before the camera. In looking to schools of ethnographic photography, the scientific anthropometric procedures yield precisely the information that would enable the construction of a 3D virtual-reality model of the anthropological subject. These early examples of ethnographic photography are ideally suited to manipulation by computer-aided design (CAD) systems, which 'allow the user to visualise and manipulate models directly in three dimensions' (Bolas 1994: 50). Aside from the likelihood that this Frankenstein-like method of reconstituting subjects of earlier study could result in a display that is both insensitive and tasteless, it also suggests new possibilities for (or warnings against) the restrictive procedures of anthropometric photography. The information to do so is contained within the images, although the visual reconstitution of the subject was never the intention of those who initially transcribed them.

At the extreme this may amount to dismissing photographic images altogether, and dealing with visual imagery in general. In addition, past evidence suggests that we might expect the vast cultural changes that have always accompanied technological change as photography developed alongside and itself emerged from the industrial revolution, together with its political changes and the adoption of new working practices.

Future developments might include the direct photographic input into the eye of the viewer itself, with no intervening material, artefact or medium (as we currently think of it) between the lens and the viewer. If this development takes place, the viewer will be put in the position of viewing the world through a telescope which can transcend distance and time, with the 'photographer', like Cratylus, pointing the camera-like device at events which we can view from the other side of the world.

Case study: 'Bert is Evil'

It is often the case that when a new technology appears the working practices of that new technology are based on the working methods of the technology that preceded it; for instance, early photography was based on the principles of painting. It is only now that the digital image is beginning to transform the traditional practices of photography. Already in photographic education the focus of students is shifting from the darkroom to the personal computer. On the one hand this has meant that acquiring photographic skills has become cheaper and easier, but on the other it means that traditional working practices may be lost. For example, in colour printing the student can mix the filtration of colours in the darkroom and may have to wait a number of minutes to actually find out the result of this colour mixing. On the computer it can be done

and the immediate effects of the magenta, yellow and cyan balance can be noticed. On the other hand the computer can alienate the photographer from the materiality of the photograph – the particular qualities of the medium, which have been considered so important in the creation of the 'fine print'. For example, some photographers find that, when editing on the computer monitor (rather than the light-table), subtleties within the image can go unnoticed. Whether this is an aspect of the learning-curve on their part, is a matter for conjecture. However, it is possible that chemical photography is 'on its way out' to join the other photo-processes of the past: the daguerreotype, calotype, etc. It is probable that chemical photography will find a niche as a process used in specialised markets (for example, as a fine art, perhaps not too dissimilar from the position currently occupied by silk-screen printing).

Perhaps in an ideal world we should consider not the analogue and digital technologies opposing each other but looking to how they can work together. In the earlier section we had looked at the notion of the pre-production choices the photographer makes as well as the post-production choices. With digital imaging to a certain extent these choices have been altered. Before, the optic array of the photograph which is captured by the camera at the opening of the shutter could not be altered. This provided the basic building block for the photographer's post-production manipulation of the image. Of course, this poses problems for photojournalism with the notion that one might, for example, certify a photograph as having chemical origins that would suggest that the image would have some element of authenticity. At the same time we can find that the digital image manipulation can actually aid people in their understanding of the way in which images operate and the way that photography works, as in the example mentioned earlier of colour mixing. In this context it may not only help people become better photographers in aiding their practical understanding of photography but may also help those writing about photography. It can provide them with an inside knowledge of the way the medium operates in order to give them greater critical awareness of how the photograph has come about. On the one hand the fact that images can be transferred rapidly from the photographer in the field to the picture-desk can be seen as a positive advantage for digital imaging. On the other hand, most unusual circumstances can come about and one example of this is from the 'Bert is Evil' website.

The website was set up in 1995 and featured the character Bert from the US children's television series *Sesame Street*. The author of the site, Dino Ignacio, collected pictures of Bert from storybooks and manipulated them, putting them into historical and contemporary settings. It was not long before the website started to get a cult following and other people started producing Bert images and posting them onto the website. In 1997 the 'Bert is Evil' website won an award in San Francisco for being the 'weirdest website' and the People's Voice Award. At the same time the authors were concerned that the Children's Television Workshop, which produced *Sesame Street*, might be likely to sue them for infringement of copyright. Reminiscent of the Woody Allen character Zelig, the images showed the puppet Bert amongst a crowd at the J.F. Kennedy shooting. There is also a photograph of him standing next to Adolf Hitler, but events took a different turn when Bert was digitally placed next to a photograph of Osama bin Laden (see Figure 8.8).

One of the aspects of photographs on the Internet is that they can be picked up by people anywhere in the world and taken off the Web and used for different purposes. After the World Trade Center attacks and the beginning of military action in

Figure 8.8 Poster of Osama bin Laden and Bert, in Bangladesh protest, 2001.
Photograph by Rafiqur Rahman. Copyright Reuters.

Afghanistan, various factions demonstrated in the streets in support of bin Laden. In Bangladesh, in Dakkha, a number of posters were made. The posters not only consisted of a multiple portrait of bin Laden but, by strange coincidence, the character Bert also appeared in the posters. It seems that the designer had downloaded images from the Internet and combined them into a poster without realising that the puppet character had crept into the picture. Photojournalists had covered the Bangladesh demonstrations. The photographer from Reuters took pictures of the angry crowd and his images were circulated down the wire to a number of publications (see Figure 8.8). At this point it seems that people began to notice Bert's presence in the image and questions arose: 'Were the images digitally manipulated?', 'How did Bert get there?', 'Was this some anarchic undermining of the support for bin Laden?' Reuters were quick to announce that all their photographs were unmanipulated (although it seems that the photographer had faithfully recorded a pre-existing photographic manipulation). Equally concerned were the members of the Children's Television Workshop; they were upset that one of their characters had been used in this context. The issue of Bert and bin Laden featured in *The Times* in a jokey article suggesting that bin Laden was linked to a 'US puppet regime'. In November 2001 the 'Bert is Evil' site was closed. Ignacio felt that after the events of September 11 the website had got too close to reality and that it was responsible for him to close the site, but this has not stopped further 'mirror' sites from appearing and carrying on the trend or reproducing images of Bert that continue to be in circulation.

Digital ethics

Although digital photography is rapidly overtaking analogue photography in the news media, there appears to be no significant change in the type of images that photographers take. There may be technological considerations, for instance the narrow latitude of exposure, but stylistically the images have remained fairly constant. Of course we must remember that technological change has always taken place in photography since the time of invention of the media. The introduction of the 35 mm camera, the invention of the portable flash – all these have contributed to changes in photojournalism and the type of images that we see today. For example, if we look at the case study of I. Russell Sorgi, we can see that even though he was using the old type of plate camera which prescribed a certain sort of response from the photojournalist, the image that resulted from the technology is probably little different from the sort of photograph that might have been taken with a contemporary 35 mm camera (or captured with a digital camera). In a study conducted by the Associated Press Managing Editors' Committee in conjunction with the Poynter Institute and the University of North Texas Department of Journalism, it was said: 'The basics of good journalism should remain in the forefront and not be overshadowed by new technological tools.' Also: 'The change to digital has occurred and the working roles of photo staffs have not only successfully adapted but have embraced the change without sacrificing content.'

Of course using digital images in newspapers raises a number of ethical issues. We have discussed ethical issues elsewhere but the fact that the image can be manipulated may demand a reappraisal of our early considerations. The fact that computer processes enable photographers or editors to alter the content of photographs (for example, colours can be manipulated and people can be added or removed from the picture) to such an extent, may lead one to question whether the photograph can offer any proof that anything occurred at all. On the other hand, many would argue that this has always been the case with photographs and even using analogue imagery photographers and editors have indulged in more or less successful attempts at manipulating the image.

Altered images: manipulation or enhancement?

In the media age, readers are becoming more sophisticated in their tastes for the visual image. Although it might not be so prevalent in the news media, magazines and newspaper colour supplements that occupy a position between news and advertising may feel more under pressure to bestow their photojournalism with the slickness of the advertising images that accompany them – contributing to the overall standard of the high-quality, glossy magazine commensurate with the mythic lifestyles promoted therein. So spots can be removed and wrinkles smoothed away, breasts can be enlarged and other operations of digital cosmetic surgery can be performed. For example, *Premiere*, the movie magazine, reputedly removed a scar from Harrison Ford's chin that many consider to be one of his most attractive characteristics. And more recently actress Kate Winslet came under criticism for being digitally 'slimmed' on the pages of the men's magazine *GQ* . The editor Dylan Jones admitted its cover photograph of actress Kate Winslet was digitally 'airbrushed' to improve the image. For Winslet

the matter was all the more embarrassing, as she had recently gained something of a reputation for championing the cause of the 'fuller-figure' woman.

It can be convincingly argued that there is little that is new in this. Indeed past examples of digital manipulation of photographs range from the Cottingley fairies of *c*.1917 to the photographic removal of Trotsky from a photograph of Lenin addressing a crowd (see Mitchell 1992: 196–218). But there are subtle differences: it is much quicker and easier to manipulate an image digitally and with relatively little skill. In addition the means to do so is already contained within the same program that is used for the 'legitimate adjustment' of images – as with (other) computer games, it is difficult to know when to stop!

Such issues undermine the traditional distinction between photography and design: the photograph as a document or as an illustration. The battleground for this debate is the magazine front cover. Between newspapers and magazines there is a subtle (not necessarily rational) distinction between the functions of the front page/cover. It is generally considered that the newspaper front page has the primary purpose of referring to the news (that also may appear on the front page) and that selling the newspaper is dealt with in an oblique manner. In contrast the magazine cover's primary function is to sell the magazine by tempting the prospective purchaser inside:

> If *The New York Times* alters a photo on its front page, it's much more of a statement to me because there's no imperative to do it. In a sense, altering a photo on the front page of a newspaper is much more of a content-based consideration, whereas altering images on the covers of magazines is almost always a purely graphic decision.
>
> (Robert Newman, Art Director, quoted in Irby 2001)

The cover photograph, while functioning to sell the magazine in a competitive market and to help it to stand out from the others on the news-stands, must also give an indication of the magazine's contents and this relies both on the photograph and the accompanying graphics and text. The necessity for the cover photograph to conform to the magazine layout is exemplified when shooting a cover shot – the picture editor may provide the photographer with a cover template. This piece of celluloid not only conforms to the format of the cover, but also indicates the main areas of text layout. The photographer places this on the ground-glass screen of the camera (usually 120 or 5 × 4 format) so that the photograph can be composed around the text and graphics (see Figure 8.9).

This can impose considerable restrictions on the photographer's choice of framing (up to 20 per cent of the photograph may become hidden by the magazine title alone), or it may not be possible to use the template if using a stock-shot or a 35 mm camera. To overcome the contortions demanded by conformity to the text, apart from cropping the image to fit the format, digital manipulation is used to darken parts of the photograph – perhaps if the magazine title is white in colour and is placed over areas of sky in the photograph: 'The image has become another graphic element, like type and color, to be altered at will to fit an editorial and graphic concept' (Robert Newman, quoted in Irby 2001). This means that the enhancement/manipulation boundary gets pushed further back. Colours may be made more vivid to give the cover greater visual impact, but a practice that may be more questionable is that of digitally extending a photograph – altering the picture format to create room for title and graphics. This

Figure 8.9 Cover of *Country Life* magazine, December 2001.

Courtesy of Terence Wright and *Country Life* Picture Library.

can be the case when the original photograph has been shot in landscape format and the magazine (most usually) is in portrait. A simple cropping of the photograph to fit the cover can remove important elements of the picture or destroy its visual impact.

The aforementioned debate introduces one of the consequences of the introduction of digital media manifested in a renewed emphasis on ethical issues in photojournalism. As we saw in Chapter 7 on ethics in photography, it is very difficult to establish a set of rules that can be applied to a set of circumstances that the photographer may encounter. The same applies to digital photography. It appears that the best we can aim for are guidelines on how to approach the subject, but the actual decision often remains to be taken by the photographer. However, it may be worth looking at the most prescriptive set of guidelines: that produced by the US Department of Defense (Swan 1995). According to the DOD, the following are permissible:

- Dodging, burning, color balancing, spotting and contrast adjustment to achieve accurate recording of an event or object.

- Photographic and video image enhancement, exploitation and simulation to support unique cartography, geodesy, intelligence, medical, research and development, scientific and training requirements, provided these techniques do not misrepresent the original image's subject.

- Obvious masking of parts of a photograph for specific security or criminal investigation requirements.

- Cropping, editing or enlarging to isolate, link or display part of a photograph or video image as long as the event or object's facts or circumstances are not misrepresented.

- Digitally converting and/or compressing photographic and video imagery without altering content.

- Post-production enhancement, including animation, digital simulation, graphics and special effects for education, recruiting, safety and training illustrations, publications or productions as long as the original image is not misrepresented. It must be clearly and readily apparent from the image's content or accompanying text that the enhanced image is not intended to be an accurate representation of any actual event.

They also state:

Unacceptable photographic or video imagery manipulation techniques include repositioning an element in an image; changing the size, shape or physical appearance of an element; merging two or more visual elements into one; adding an element to an image; changing spatial relationships or colors in an image; or removing a visual element from the image.

(Swan 1995)

This may be fine for the use of digital imaging for the military and the use of photography as evidence on the one hand, but if it were to be applied strictly to photojournalism, could it result in stifling the creative possibilities of the digital media on the other?

One solution, proposed among others by the UK's National Union of Journalists (NUJ), is to adopt a marking system that clearly states whether an image has been manipulated. The NUJ suggest a 'manipulated photo' symbol that appears within the area of the image, which may cause dismay to photographers and designers alike. The idea of the photograph being 'stamped' in this way could be seen by many as an unnecessary intrusion into the photographer's art. The NUJ's argument is that the caption already can easily become separated from the image in the contexts of newspapers, magazines and when used on television. In the latter case this is particularly so. But they consider that whatever recommendations they make should be able to adapt to the new electronic media and be able to predict future applications of photography. Nonetheless, in addition the NUJ propose that the accompanying text (or in the case of television – voice-over) should contain no suggestion that a manipulated image is to be taken as 'an accurate representation of any actual event'. The situation is by no means resolved. An article in the *Columbia Journalism Review* proposes a 'not-a-camera' symbol to be applied to manipulated photographs: the visual equivalent of 'quotation' of text. They propose a symbol consisting of an icon for a camera (a circle inscribed in a square), crossed out. In contrast they suggest an 'is-a-camera' symbol, which can be used to make it clear that the image is unmanipulated.

Summary

- The chapter began by defining digital photography by making an initial comparison with the 'traditional' recording of an image by means of photochemistry.

- We assessed the impact of technological change on photojournalism, taking into account the increased speeds of transmitting images afforded by digital technology.

- The chapter then took a sceptical view in order to assess whether the changes in photographic technology merely provide an easier way of recording and transmitting images or whether they amount to a much more radical social/cultural change.

- We considered some former attempts to manipulate photographic images and the impact of digital imagery on the field of photojournalism, paying special regard to some of the problems of copyright.

- We examined the *ArtAIDS* project and, in contrast, the case study of the 'Bert is Evil' website looked at the potential for unpredictable consequences from the distribution of photographs on the World Wide Web.

- The 'truth value' of the photographic image is again called into question with the proliferation of digital images. We had to consider where we establish the limits of enhancement (that has always been used by photographers – e.g. dodging and burning) in contrast to manipulation and, furthermore, deliberate distortion. We considered attempts to control digital manipulation and the contrasting 'regulations' applied to digital photography by the US Department of Defense and the British National Union of Journalists.

9 Conclusion

The future is very difficult to predict at the best of times, but even more so in this period of rapid technological change. In the last twenty years or so we have seen the introduction of the personal computer that has made possible the digital processing of images. Within that time the language of communication has shifted from a verbal linear mode to an iconic spatial character: from DOS to Windows. The end of the PC may now be in sight, with the Internet providing programs and information to a terminal that combines workstation and television. This may have the added benefit of placing greater emphasis on the broader areas of visual communication (in which photography has a significant role). Nonetheless, the traditional chemical analogue photographer may achieve enhanced status as the operator of a professional medium who is able to produce greater possibilities for authenticity and evidence than the photographer with a digital camera which may become the province of less serious journalism and of the amateur market. In this context, photography (as we knew it fifteen years ago) may become a specialist craft-based medium, as is print-making, yet with enhanced professional status as mentioned above.

We have so far encountered a variety of theoretical approaches which offer many perspectives through which to consider the photographic image. From the initial starting point we considered *realism*: that the camera directly transcribes what had appeared in front of the lens and the photograph shows us what we would have seen had we been there at the time. This was placed in the context of the photographer's intentions of *formalism* – concerned with the material nature of the photograph; photography as a process; and the photograph as an object – and *expressionism*, where the subject and the medium were used as a vehicle for expressing the photographer's ideas or feelings, or were an expression of the society or political context of the image and/or image-maker. It was concluded that a photograph cannot be produced to the exclusion of any of these concerns. It is up to the photographer to consider and select the proportions and the appropriate balance as to how these intentions come to achieve significance in his or her work.

In contrast to the *realist* view of photography, we encountered *conventionalism*. This proposed that photography, like language, is a product of a particular culture and that we, as its members, are required to learn to understand photographic codes as constituting accurate representations of the world. From the polarised viewpoints of

realism and *conventionalism*, we drew the conclusion that the photograph is able to record a limited selection of visual information derived from the environment. In most instances this information, in the form of a picture, can be immediately recognised and perceived. However, viewers must often resort to different social codes and cultural traditions in visual representation in order to optimise their understanding of the image. In order to understand how these processes might work, we considered the influence of *semiotics*.

Semiotics, as applied to photography, proposed that we might understand the 'photographic sign' through its function as an *icon*: looking like its referent; as an *index*: displaying a 'trace' of its referent's sometime presence; or as a *symbol*: standing for its referent in a similar manner to that espoused by *conventionalist* theory. It would appear from the evidence that our understanding of the photograph, or our deriving meaning from the image, may depend upon any combination of these three elements.

It is intended that these approaches may form a basic structure to make relatively secure excursions into the myriad of theories and 'isms' that are or have been applied to photography. As a generalisation, the primary preoccupations of the majority of theoretical standpoints concern *form* and *content*: the photograph (as a container) and the subject (the message). So, for example, we might expect a Marxist theoretician to look for the political determinants behind the production of the photograph. The Marxist photographer would not adopt a passive role in reflecting social conditions in his or her photography, but would aim to use the camera in an active manner 'that documents monopoly capitalism's inability to deliver the conditions of a fully human life' (Sekula 1978: 60), so as to promote political understanding and to stimulate social change. Behind the *realist* facade of the photograph is a political structure that has determined the form, content, production and consumption of the image. Similarly, a *feminist* approach, with regard to both theory and practice, would probably point out that, throughout its history, photography has displayed its limitations in showing the world predominantly from the viewpoint of only one half of the human population, that is, from the male perspective. Or it may be considered that the role of the theorist is to point out such limitations and draw attention to the subtext and/or alternative readings of the image; and that of the practitioner is not only to redress the balance but to create new visions and promote social change. Through the traditional approaches to education we have been encouraged to look at the world and its representations from a limited critical viewpoint, and to continue to emulate these traditions of practice. Similar moves have taken place with historical photographs, in the areas of colonial and ethnographic photography, to reappraise the photographs of 'others', taken as the agenda of 'scientific' study or as part of the broader regime of colonial control.

Who photographs/looks at whom? Having initially provided images of the masses for the masses, photography seemed rapidly to settle down to exemplify the social set-up. In the general sense, this tends to reflect the power relations of Western society. White people photograph/look at black people. Men photograph/look at women. Those who have photograph/look at those who have not. In contrast to this, the images of the famous are looked at by all, yet achieve special iconic status.

The photograph provides a series of framings – selections which become 'nested'. The initial spatial framing of the photograph itself, divorcing the image from its source, is superseded by the contextualising framing of the caption, the organ of communication and finally the overall socio-cultural context of the image.

In 1992 William Mitchell pronounced: 'from the moment of its sesquicentennial in 1989 photography was dead' (p. 20). This statement was no doubt intended to echo Delaroche's 1839 statement at the announcement of the invention of photography: 'from today painting is dead'. If there are any parallels to be drawn or lessons to be learned over the century and a half, the statement is incorrect. Painting did not die in 1839, and photography did not die in 1989. Nonetheless, painting was never to be quite the same again – and, like painting, we find that our whole conceptual outlook through the medium of photography has been irrevocably changed. And photography will no doubt seek new applications and a modified role. The encroachments made on professional practice by the digital image mean that photography can no longer be regarded as a window on the world. But then, it never really was.

Glossary

...

aesthetics Initially, aesthetics was concerned with the study of ideas about beauty or taste. More recently, it has been concerned with the principles (or 'rules') of art as well as the broader aspects of artistic practice.

analogue An image that is composed upon the principles of traditional technologies – of painting, drawing (see **chirographic**) or chemical photography.

anthropometric photography The use of the camera to record other cultures as a variety of types, concentrating on physical attributes – such as measurement – for scientific comparison.

aspect ratio The relationship between the width and height of the image produced by the camera that provides the proportions of the frame in which the photograph can be composed.

bracketing Having taken the correct light reading and made an exposure, the photographer makes two additional exposures, usually one stop below and one above the reading as a safety measure, especially in difficult lighting, or simply to give greater choice of selection and control of the subject.

burning-in When producing a photographic print in the darkroom, parts of the print can appear too light or too dark in relation to the whole image. Burning-in is a post-production printing technique where, under the enlarger, greater exposure is given to selected parts of the image in order to darken them.

camera obscura A forerunner of the photographic camera, where a hole at the end of a dark room projects an inverted image onto the opposite wall. This principle could be used as a drawing aid for draughtsmen.

camera lucida A similar device to the **camera obscura**, but one which allows the draughtsman a simultaneous view of both the picture surface and the scene, enabling an image of the scene to be traced onto the paper.

Cartesian co-ordinates The technique of plotting position, or mapping an image, by means of x and y axes. The use of the grid on the Ordnance Survey map is an example.

CCD Charge-coupled device: the light-sensitive surface of a digital camera which records the pattern of light in the form of a digital code.

chirographic An image produced by drawing, that is gradually built up from a trace made by a graphic tool such as a pencil.

cognitive A system of knowledge and how that knowledge is acquired.

Conceptual Art Art that evolved during the 1960s and 1970s which was more concerned with the idea of the artwork than with its material entity.

constructivism (In art) originally work produced by Russian artists in the 1920s; now the term can refer to any art with an obvious construction, for example, that is based on strong geometric principles. (In psychology) a theory of perception which proposes that the most important qualities for perception are individual sensations: for example, that might be produced on the retina of the eye.

contact prints Positive photographic images that are printed through bringing the negative(s) into contact with the photographic paper. Thus they do not involve any process of enlargement.

conventionalism A theory of pictorial perception which maintains that we can only make sense of pictorial images because we have learned how to read the language of pictures.

cropping Trimming or changing the **aspect ratio** of a photographic print, thus offering a different composition or emphasis from the photographer's initial selection.

daguerreotype The earliest practical photographic process which produced a one-off positive image on a metal plate, invented by L.J.M. Daguerre in 1839.

decisive moment The term coined by Henri Cartier-Bresson to indicate the precise, significant moment at which the shutter should be released which, combined with precise framing, captures the essence of the subject matter.

didactic Intending to inform or to instruct. A photograph that has a moral, educational or political message that predominates over its aesthetic concerns.

digital An image that has been coded by a computer into a series of 0s and 1s. This enables it to be digitally manipulated by image-processing programs and/or transmitted electronically, e.g. via a telephone line.

dodging While **burning-in** gives extra exposure to a selected part of the print (with the result of making the selected area appear darker in the developed print), dodging does the opposite by reducing the amount of light reaching a selected area (making the selection lighter). The technique of dodging is usually achieved by the use of a piece of plasticine mounted on a wire armature or some other opaque object.

door-stepping In press photography or investigative journalism, where the photographer lies in wait for a subject who usually does not wish to be photographed.

ecological perception The theory of perception proposed by J.J. Gibson which stated that, instead of testing the psychological subject in the laboratory, we should look at the broader context of an organism in its environment to provide the principles of visual perception.

ethnographic photography The use of the camera in the service of anthropological fieldwork, to provide visual means of recording and studying the activities of cultures and subcultures.

expressionism An emphasis on the expressive elements of a photograph: what does the photographer want it to say, or what do we see in it?

eye/camera analogy The proposition that the camera and the human eye function by the same basic mechanism and that either can be used to help explain the functioning principles of the other.

false attachment The photographic illusion that a distant object appears to be attached to an object in the foreground of the photographic print.

formalism A concentration on the formal aspects of the photograph, treating the photograph as an object or displaying a concern for the characteristics of the medium of photography.

Gestalt A German movement in psychology which proposed that the most important qualities for perception are not individual sensations but the organisation and structure of perceptual information. The overall pattern of stimulation is more important than the isolated stimulus: expressed in the phrase 'the whole is more than the sum of the parts'.

halides The light-sensitive salts within the film's emulsion. They react to light so that their overall pattern creates the latent image. See **latent image**.

house style The type of image expected by a particular journal that fits into the artistic layout, or the overall ethos, of the publication.

icon In **semiotics**, a sign which resembles or looks like its referent.

independent photographer Professional photographer who works more in the manner of artists than in that of mainstream commercial practice.

index In **semiotics**, a sign which is associated with, or has a causal link with, its referent.

interpretation The activity of proposing what a photograph means, or signifies, apart from that which appears, or is directly recorded, in the image. Looking for its broader historical, political or cultural significance.

Land Art A 1960s' art movement that moved away from the gallery as a site of display, and rejected the traditional materials of sculpture, in favour of producing artworks in the landscape, using natural materials that were found on location.

latent image The image recorded by causing chemical change on the emulsion of the photographic film which can be revealed by development (see also **halides**).

lateral message Details about the photograph that are evident from its material nature or are derived from the context in which the image appears.

modernism In painting, a self-conscious approach to the medium which highlights the formal characteristics and material nature of the art-object, over and above its representational function.

photo-elicitation The use of photographs to elicit a response from a subject which may reveal more information concerning his or her culture, lifestyle or own psychology.

pictorialism A photographic movement of the 1890s which displayed a concern for atmospheric and formal elements of the photograph. Rules of composition and precise control over the printing process were particularly significant.

positivism The philosophical standpoint, proposed by Auguste Comte, which stressed the importance of positive scientific evidence in the provision of all knowledge.

post-production The choices and options that are available to the photographer once the **latent image** has been recorded. These include decisions concerning the development and the **cropping** of the image.

pre-production The choices and options that are available to the photographer before the **latent image** has been recorded. These include choice of film-stock, selection of lens, camera angle, etc.

rationalism The philosophical standpoint which proposes that knowledge can be acquired by reason without necessarily having a basis in experience.

realism A theory of pictorial representation which proposes that the photograph provides a truthful record that conforms to the actuality of events that have been photographed.

self-reflexive photography Photography which has a primary concern for the photograph or the medium of photography, aiming to reveal or comment upon the scope and limitations of photography itself.

semiotics The science of signs, which has aimed to examine the constituent elements of any sign system, of which photography can be included. Accordingly, any sign can be summarised as an **icon**, **index** or **symbol**, or it may embody a combination of these elements.

spot news In terms of photography, a press photograph that is designed usually to appear only once. A sensational picture designed to have immediate dramatic effect.

stock-shots Photographs that are taken to form part of a library of images that can subsequently be retrieved and used in a variety of contexts.

structuralism As applied to photography, a method of understanding, interpreting and analysing photographs. Primarily espoused by the French critic Roland Barthes, it places special emphasis on the structure of the conceptual systematic relationships between images or the organisational principles by which images are used. It has its roots in the structural anthropology of Claude Lévi-Strauss that (in turn) was indebted to the structural linguistics of Ferdinand de Saussure.

symbol In **semiotics**, a sign which is only arbitrarily or conventionally linked with its referent.

tableau vivant A living picture: a pause (usually at a significant moment) at the end of a scene in a play where the characters freeze in their positions – a group posed motionless and silent.

third meaning The juxtaposition of image and text whereby the viewer derives the meaning from neither image nor caption: it is achieved by the combination of the two.

trompe l'œil A visual display that causes the eye to be mistaken in its perception. It presents the viewer with such a strong illusion that he or she is fooled into confusing a painting with an actual scene.

visualisation (or to pre-visualise) The ability of the photographer to make an accurate estimation of how the three-dimensional (perhaps moving) subject will appear in still, two-dimensional, pictorial form.

Notes

......................

Introduction

1 For example, Weitz (1956: 439) suggests that innovation in the arts depends upon invalidating 'closed' systems. It results from 'a decision on someone's part to extend or to close the old or invent a new concept. (For example, "It's not a sculpture, it's a mobile.")'.

2 These range from Langford (1978) *Basic Photography*, 4th edn and Adams (1981) *The Negative: The New Ansel Adams Photography Series*, to Vestal (1984) *The Art of Black and White Enlarging* and Miller (1981) *Building a Home Darkroom*.

1 Historical outline of photographic representation

1 Ross (1927) *The Works of Aristotle Translated into English, Volume VII – Problemata*. Also Eder (1945: 36).

2 Another example is stereo-photography.

3 Although, according to Minnaert (1993: 1–4) *Light and Colour in the Outdoors*, during an eclipse images of the sun can be cast onto the ground through the foliage of trees.

4 Expressing the alternative point of view, Kenneth Clark (1949: 29) describes mediaeval art as 'not a childish or irrational way of recording visual experience, for our eye does not dwell on a single point, but moves, and we move and a procession of objects passes before it'.

5 See Tylor (1873) *Primitive Culture: Researches into the Development of Mythology, Philosophy, Religion, Language, Art and Custom*, 2 vols.

6 This conforms to Berkeley's (1709) theory of vision.

7 *Trompe l'oeil*: French term meaning literally 'deception of the eye'.

8 According to Government census returns.

9 This was the view of perception held by the ancient Greeks. See Lindberg (1976: 2–3).

10 Later artists, such as Andy Goldsworthy, have produced ice sculptures sited in the frozen landscape – which has made the 'normal' viewing of such artworks impossible.

11 Even in the case of the Xerox machine, artist Ian Burn showed that this device has its own peculiar set of properties. See his *Xerox Book*, in Walker (1975) *Art Since Pop*.

12 The term was first employed by French writers in the nineteenth century.

13 See Baudelaire's introduction to his translation *Nouvelles histoires extraordinaires: Oeuvres complètes*, VII (1933: xiv) of Edgar Allan Poe.

2 Pre-production

1 For example, while Szarkowski adopts a two-category framework: 'Mirrors' and 'Windows' – photographs which 'reflect' the photographer's *expressionist* tendency, in contrast to those of *realist* intention – Barrett supports a fourfold scheme adding *instrumentalism* to *realism*, *formalism* and *expressionism*. In this scheme instrumentalism describes those photographs that aim to promote social change.

2 The phraseology adopted by Greenberg (1960) for painting: 'mastering' the medium, rather than 'acknowledging' it.

3 For instance, August Comte's *Philosophie Positive* (1830–42) in Comte (1983) spans the period of the invention of photography.

4 This can be seen as part of a general cultural shift paralleled, for example, by changes in the theory of visual perception and the move from the psychology laboratory into the environment.

5 Here Shklovsky was referring to literary works, but his remarks are equally applicable to photography.

6 On the relationship between technologies and their metaphors, see Boden (1981).

7 Kracauer (1947: 70) describes the expressionist elements of *The Cabinet of Dr Caligari* (1919, director Robert Wiene). Rotha in *The Film Till Now* (1930: 178) described Caligari as 'the first significant attempt at the expression of a creative mind in the medium of cinematography'.

8 This is not necessarily the case with instant (Polaroid) pictures, as has been demonstrated by Ken Josephson, for example.

9 For examples of this type of project compare the nineteenth-century work of Sir Benjamin Stone, *Customs and Faces*, with that of Homer Sykes, *Once a Year*, of the 1970s. Both photographers documented traditional British folk customs.

10 Ironically, on p. 62 of the same volume, Schneider recommends that if a bear comes into the campsite you should run towards the bear 'throwing things, and yelling or making other loud noises'.

11 Then West Surrey College of Art and Design.

3 The photographic image

1 Wollheim (1973), in his paper 'On Drawing an Object', reminds us that the process of drawing involves the gradual build-up of information on the two-dimensional surface and is as much to do with removing information as adding it. (This point is returned to in the section on digital photography.) '[T]he observer making a few strokes, scrutinising them, accepting them, or finding them unsatisfactory and correcting them, and so working his way forward to the finished product through erasures and *pentimenti*' (p. 7); 'the process of correcting the drawing is not essentially different from the process of constructing it' (p. 9).

2 According to Newhall (1964: 32) it was the scientist John Hershall who coined the term 'negative'. Furthermore, Eder (1945: 258) suggests that Hershall may also have been responsible for the term 'photography'.

3 Computer-aided design (CAD) programs which enable the viewer to 'fly through' a virtual building do little to aid the actual process of building; rather, their primary function is to give the client a three-dimensional, artist's impression of the completed architecture. For the purposes of producing a building, such systems are unlikely to supersede architectural drawing.

4 Post-production

1 Mentioned in his lecture at the Photographic Gallery, University of Southampton, 1978.

2 The Russian ultranationalist presidential candidate Vladimir Zhirinovsky, with his reputation for outspoken extremism, said that if he were elected, 'Our methods will be different. We will execute them right on the spot.' (Interview with Associated Press Television.)

3 The last similar case occurred in 1989 when eleven British journalists and foreign service employees were expelled from Moscow in retaliation for an equivalent expulsion of Russians from Britain. Nonetheless, these events were closely followed by an announcement from Presidents Bush and Gorbachev, during the so-called 'seasick summit' (held on a ship off Malta during gales and high seas) that the cold war was 'at an end'. 'Bush declared, "We stand at the threshold of a brand new era of U.S.–Soviet relations," and Gorbachev responded, "The world leaves one epoch of Cold War, and enters another epoch."' (*Washington Post*, Monday, 4 December 1989). Of course the best-known incident of Russo-British spy rivalry was in the 1950s and 1960s, when the Cambridge-educated ring led by Kim Philby was exposed; among other consequences it led finally to the art historian Anthony Blunt being exposed as 'The Fourth Man' of the spy-ring and stripped of his knighthood in the 1980s. Blunt had created for himself a unique blend of espionage and visual representation in being both a secret agent and the Keeper of the Queen's Pictures.

4 Quoted in E.D.R. Harrison (1993).

5 According to the double agent George Blake, 'I was given a Minox camera, and I carried that Minox camera with me whenever I went to work, like I carried my wallet with me, and the reason was that I never knew what important documents I might find on my desk which were worthwhile photographing.' Interviewed on *The Cold War* television series.

6 Hanson refers to the 'the Maori theory of mind; a theory which in philosophical parlance would be called Cartesian dualism' (1983: 86).

7 Indeed, Roger Fenton's photographs of the Crimean War proved to be a significant milestone in the history of photography and photojournalism.

8 This type of symmetrical reciprocity was to become an essential ingredient of the deescalation process that led to the end of the cold war. This was proposed by Mikhail Gorbachev in his speech to the British parliament on 18 December 1984: 'in limiting and reducing weapons, particularly nuclear arms, we are prepared to match whatever Western negotiating partners would do' (Gorbachev 1996: 161).

9 From 'The Sinews of Peace', Winston Churchill's speech of 5 March 1946, in Fulton, Missouri: 'From Stettin in the Baltic to Trieste in the Adriatic an iron curtain has descended across the Continent.'

10 It is interesting to note that Lewis Carroll in *Through the Looking-glass, and What Alice Found There* (1872) addresses some 'universal' political themes. J.B. Priestly (1957) proposed that the Walrus and the Carpenter were two archetypes of politicians. Indeed we find that the Walrus (in Tweedledee's poem *The Walrus and the Carpenter*) displays a type of 'imperialist nostalgia' in his mourning the oysters he is consuming:

"'I weep for you," the Walrus said,
"I deeply sympathise."
With sobs and tears he sorted out
Those of the largest size,
Holding his pocket-handkerchief
Before his streaming eyes.'

11 Interviewed on *The Cold War* television series.

12 For example, we can find the musical connotations to Geertz's map: we 'leave our hearts' in Tony Bennett's 'San Francisco' to arrive in Sinatra's 'New York, New York!'

13 In Carroll's book, the world becomes inverted and the text contains many references to left and right reversals, and in a representational style similar to the photograph in the *Guardian*, Carroll's ridiculous characters Tweedledum and Tweedledee are described as mirror images of each other. According to Gardner (1970: 10) this can be related to Carroll's own self-image: 'In appearance Carroll was handsome and asymmetric – two facets that may have contributed to his interest in mirror reflections. One shoulder was higher than the other, his smile was slightly askew, and the level of his blue eyes was not quite the same.' Not only did Carroll practise 'mirror writing' (p. 182), but it may be relevant that Carroll was a photographer. His writings may have been influenced by his first-hand experience of the formation

of the photographic image, the 'negative' of which is an inverted image on a glass plate which also displays left and right reversals. That 'the conceptual framework of photography would have appealed to Dodgson's fertile and surreal imagination' has been noted by Taylor (1998: 32): 'large things were reduced in scale. Adjust the camera and small things were enlarged.' In addition, one of Carroll's photographs titled *The Reflection* (1862) shows his sister Margaret posed next to a looking-glass. Furthermore Carroll's portrait of the actress Ellen Terry employs a compositional strategy that is very close to Dukor's photograph featured in the *Guardian*. On this matter our speculation may be curtailed as the portrait, with mirror, had become something of a fad during the latter part of the nineteenth century and such a compositional device was not especially unique to Carroll.

14 Another way in which the 'looking-glass game' is analogous to the cold war is in the permanent threat of imminent conflict: '"Let's fight till six, and then have dinner," said Tweedledum.' Threats rarely develop into action (the fight between the Tweedle brothers, and that of the Lion and the Unicorn). When conflict does break out, it does so by operating to absurd 'rules'; for example, in the combat between the White Knight and the Red Knight: 'Another Rule of Battle, that Alice had not noticed, seemed to be that they always fell on their heads; and the battle ended with their both falling off in this way, side by side. When they got up again they shook hands, and then the Red Knight mounted and galloped off' (p. 296). In the context of cold war espionage, Knightley (1999) maintains that intelligence communities have more in common with each other than they do with the governments they serve. This particular instance of the Lévi-Straussian scheme (of East–West ideological differences, while still maintaining qualities of sameness) manifested itself in the adoption of unwritten codes of conduct, delimiting the extent of conflict. For example the KGB, the CIA and the British SIS had agreed not to kill each other's agents. Some interpretations have regarded the 'looking-glass' contests as political allegories on Carroll's part, suggesting that the Lion and the Unicorn stand for the Victorian politicians Gladstone and Disraeli (ibid.: 243). This may, or may not, be so.

15 This has been outlined by Stołowicz (1988).

16 See Harrison (1993).

17 An example of cold war oversimplification can be found in President Reagan's use of the term 'evil empire' to describe the Soviet Union.

18 See Haslam (1998).

19 See Schwarz (1985) for an account of the range of mechanical devices that led up to photography and a culture looking for such a representational system.

5 The documentary photograph

1 It is ironic that although Fast News had been eager to embrace the new digital technologies, the company quickly went out of business shortly after this case study was conducted.

2 It is now important for some freelancers to have their own (negative) scanners and e-mail set-up.

6 Photography as a cultural critique

1 See also the effect of aerial photography on painting in Scharf (1968: 176).

2 See Wilhelm (1993) *The Permanence and Care of Color Photographs* for the most comprehensive discussion and details of this issue.

3 One such example resulted in the publication of Homer Sykes' (1977) *Once a Year: Some Traditional British Customs*, London: Gordon Fraser.

4 This is different from Malinowski's notion of the 'participant observer' who, although living with and joining in the activities of the subject, remains an outsider. Malinowski's methods had a profound influence over the MO project.

7 The ethics of photojournalism

1 In recounting this episode, Estelle Jussim understandably finds amusement that, in contrast to the diminutive Arbus, Greer is over six feet tall: 'why did the giant simply not punch out the pygmy?' or was it 'that once you have said yes to a photographer you cannot ask him or her to leave and kindly shut the door on the way out?' (1989: 109).
2 The difference is not too dissimilar from 'aims' and 'objectives' in research (see pp. 67–70).
3 In a poetic frame of mind, an extract from John Milton's (Paradise Lost) might provide a fitting caption for Newman's photograph:

> First Moloch, horrid King besmear'd with blood
> Of human sacrifice, and parents' tears,
> Though for the noise of Drums and Timbrels loud
> Thir children's cries unheard, that pass'd thru fire
> To his grim Idol.
>
> (Book I, lines 392–6)

4 For example, see Capote (1994).
5 In 1983 during a trip to the US I visited Buffalo to find the site of the incident, the Genessee Hotel. The entire area where the hotel had been had been redeveloped.
6 Frankenstein's monster took on a life that its creator had not predicted and he lost control of his creation. The Hydra is a monster from Greek mythology – if you try to kill it by cutting off its head, seven more heads will appear in its place.

8 Characteristics of digital photography

1 The 1998 price of a Nikon NC 2000 digital camera is £7,100 including lenses.
2 Another contemporary example of this metaphorical usage is 'genetic fingerprinting' – derived from a nineteenth-century invention which produced an imprint to provide evidence of a person's actions. Here the metaphor is based on the concept of a person's unique pattern of DNA, not on the technical process that achieves this aim.
3 According to André Malraux in Voices of Silence (1954: 124), 'the cinema acquired the status of an art only when the director . . . was liberated from the limitations of the theatre'.
4 As in the early years of photographic reproduction – when the technology did not exist to publish a photograph – an 'engraving after the photograph' would be used; thus the image became subject to some degree of artistic licence.
5 Nonetheless, it may be argued that documentaries are fictional: the pre- and post-production processes of selection, let alone the act of filming itself, create a screen-world that has little relation to the world we normally perceive (see Wright 1992b).
6 The LAN centres around a 'file server' – a computer which contains all the files and programs used by the network. This server can be dedicated, that is, it is not used by any individual but its sole purpose is that of maintaining the network; or it can be non-dedicated, that is, it maintains the network and operates an individual's workstation.
7 Both WANs and LANs require a network operating system to manage file-sharing and the sharing of programs, peripherals and the day-to-day communications links between computers.

Bibliography

Adams, A. (1973) 'The Zone System for 35 mm Photography' in D.O. Morgan, D. Vestal and W.L. Broecker (eds) *The Leica Handbook*, 15th edn, New York: Morgan & Morgan, pp. 228–34.
—— (1981) *The Negative: The New Ansel Adams Photography Series*, Boston, Mass.: New York Graphic Society.
Agee, J. and Evans, W. (1941) *Let Us Now Praise Famous Men*, Boston, Mass.: Houghton Mifflin.
Alberti, L.B. (1435) *Della Pittura*, ed. Janitschek, London: Routledge & Kegan Paul, 1956.
Annan, T. (1868) *Old Closes and Streets of Glasgow*. Published as *Thomas Annan: Photographs of the Old Closes and Streets of Glasgow, 1868–1877*, New York: Dover, 1977.
Arnheim, R. (1956) *Art and Visual Perception*, London: Faber & Faber.
—— (1986) 'On the Nature of Photography' in *New Essays on the Psychology of Art*, Berkeley, Calif.: University of California Press, pp. 102–14.
Auden, W.H. (1940) 'Musée de Beaux Arts' in *Another Time*, London: Faber & Faber.
Austin, J.L. (1962) *How To Do Things with Words*, Oxford: Oxford University Press.
Austin, M. (2000) 'Would We Care Without the Tide of TV Images?' *The Sunday Times*, London, 5 March.
BAAS (1874) *Notes and Queries on Anthropology, for the Use of Travellers and Residents in Uncivilized Lands*, London: Edward Stanford (British Association for the Advancement of Science).
Banks, M.S., Aslin, R.N. and Letson, R.D. (1975) 'Sensitive Period for the Development of Human Binocular Vision', *Science*, 190: 675–7.
Banville, J. (1997) *The Untouchable*, London: Picador.
Barrett, T. (1990) *Criticizing Photographs: An Introduction to Understanding Images*, Mountain View, Calif.: Mayfield.
Barthes, R. (1977) *Image – Music – Text*, trans. S. Heath, London: Fontana.
—— (1982) *Camera Lucida: Reflections on Photography*, trans. R. Howard, London: Jonathan Cape.
Baudelaire, C. (1859) *The Mirror of Art*, trans. J. Mayne, London: Phaidon, 1955.
—— (1933) *Nouvelles histoires extraordinaires: Oeuvres complètes VII*, Paris: Nelson.
Bazin, A. (1967) *What Is Cinema? Vol. I*, trans. H. Gray, Los Angeles, Calif.: University of California Press.
Beardsley, M.C. (1966) *Aesthetics from Classical Greece to the Present*, Tuscaloosa, Ala.: University of Alabama Press.
Becker, H.S. (1998) 'Visual Sociology, Documentary Photography, and Photojournalism' in J. Prosser (ed.) *Image-based Research: A Sourcebook for Qualitative Researchers*, London: Falmer Press.
Bell, C. (1914) *Art*, London: Chatto & Windus.

Bell, D. (1976) 'The Double Bind of Modernity' in *The Cultural Contradictions of Capitalism*, New York: Basic Books.

Beloff, H. (1985) *Camera Culture*, Oxford: Blackwell.

Benjamin, W. (1929) *Illuminations*, ed. H. Arendt, Glasgow: Fontana/Collins, 1973.

—— (1931) 'A Short History of Photography' in D. Mellor (ed.) *The New Photography: Germany 1927–33*, London: Arts Council of Great Britain, 1978.

—— (1934) 'Author as Producer' in *Understanding Brecht*, London: Verso, 1983.

Berger, J. (1972) *Ways of Seeing*, Harmondsworth: Penguin.

Berkeley, G. (1709) 'An Essay Towards a New Theory of Vision' in C.M. Turbayne (ed.) *Works on Vision: Berkeley*, Indianapolis: Bobbs-Merrill, 1963.

Bibby, C. (1959) 'Huxley and the Reception of the "Origin"', *Victorian Studies*, 3: 76–86.

Bloom, H. (1975) *The Anxiety of Influence: Theory of Poetry*, Oxford: Oxford University Press.

Boden, M.A. (1981) 'The Computational Metaphor in Psychology' in *Mind and Mechanisms: Philosophical Psychology and Computational Models*, Brighton: Harvester, pp. 31–51.

Bolas, M. (1994) 'Designing Virtual Environments' in G.E. Loeffler and T. Anderson (eds) *The Virtual Reality Casebook*, New York: Van Nostrand Reinhold, pp. 49–55.

Brassai, G.H. (1966) *Picasso and Company*, New York: Doubleday.

Broecker, W.L. (ed.) (1984) *ICP Encyclopedia of Photography*, New York: Crown Publishers.

Bronson, D.H. (1968) *Facets of the Enlightenment*, Berkeley and Los Angeles, Calif.: University of California Press.

Bullock, A. and Stallybrass, O. (eds) (1977) *The Fontana Dictionary of Modern Thought*, London: Fontana.

Burgin, V. (1975) 'Photographic Practice and Art Theory', *Studio International*, 190 (976): 39–51.

—— (1986a) 'Diderot, Barthes, *Vertigo*' in V. Burgin, J. Donald and C. Kaplan (eds) *Formations of Fantasy*, London: Methuen.

—— (1986b) 'Seeing Sense' in *The End of Art Theory: Criticism and Postmodernity*, London: Macmillan.

Busey, S.C. (1900) 'Early History of Photography in the City of Washington', *Columbia Historical Society Records*, 3.

Cameron, A. (1991) 'Introduction to Digital Dialogues', *Ten-8*, 2: 4–7.

Carpenter, E. (1972) *Oh, What a Blow that Phantom Gave Me!*, New York: Holt, Rinehart & Winston.

Capote, T. (1994) *Marilyn Monroe: Photographs 1945–1962*, New York: W.W. Norton & Co.

Carroll, L. (1872) *Through the Looking-glass, and What Alice Found There*, London: Macmillan.

Cartier-Bresson, H. (1952) in N. Lyons (ed.) *Photographers on Photography*, Englewood Cliffs, NJ: Prentice-Hall.

Clark, K. (1949) *Landscape into Art*, London: Penguin.

Clifford, J. (1988) *The Predicament of Culture: Twentieth Century Ethnography, Literature, and Art*, Cambridge, Mass.: Harvard University Press.

Coburn, A.L. (1911) 'The Relation of Time to Art', *Camera Work*, 36: 72.

Coleman, A.D. (1998) *Depth of Field: Essays on Photographs, Lens Culture, and Mass Media*, Albuquerque, N. Mex.: University of New Mexico Press.

Collier, J. and Collier, M. (1986) *Visual Anthropology: Photography as a Research Method*, New York: Holt, Rinehart & Winston.

Comte, A. (1983) *Auguste Comte and Positivism: The Essential Writings*, Chicago, Ill.: University of Chicago Press.

Cork, R. (1975) 'From Sculpture to Photography: John Hilliard and the Issue of Self-awareness in Medium Use', *Studio International*, 190: 60–8.

Cowling, M. (1989) *The Artist as Anthropologist: The Representation of Type and Character in Victorian Art*, Cambridge: Cambridge University Press.

Dante Alighieri (c.1314) *The Divine Comedy: 1 Hell*, trans. D.L. Sayers, London: Penguin, 1949.

Darwin, C. (1839) *Journal of Researches into the Natural History and Geology of the Countries Visited during the Voyage of H.M.S. Beagle*, London, 1891.

—— (1872) *The Expression of the Emotions in Man and Animals*, London: John Murray.

Demarchy, R. (1899) in *Camera Notes* III, 2: 45–8.

de Mare, E. (1972) *Photography*, Harmondsworth: Penguin.

de Maria, W. (1980) in *Pier and Ocean*, London: Arts Council of Great Britain.

Descartes, R. (1637) 'The Dioptrics' in E. Anscombe and P.T. Greach (eds) *Descartes: Philosophical Writings*, London: Nelson, 1954.

Doisneau, R. (1948) 'Photo Notes' in W. Manchester (ed.) *In Our Time: The World as Seen by Magnum Photographers*, London: André Deutsch, 1993.

Dolce, L. (1557) *Dialogo della Pittura Intitolato l'Aretino*, Firenze, 1735.

Dubrey, F. and Willats, J. (1972) *Drawing Systems*, London: Studio Vista.

Dzięgiel, L. (1998) *Paradise in a Concrete Cage: Daily Life in Communist Poland, an Ethnologist's View*, Cracow: Arcana.

Eagleton, T. (1983) *Literary Theory*, Oxford: Blackwell.

Eaton, I. (2001) *A Choice of Disasters: BBC Television News Coverage of Earthquakes, Storms and Floods*, Oxford: Reuters Foundation, Green College.

Eder, J.M. (1945) *History of Photography*, trans. E. Epstean, New York: Columbia University Press.

Edgerton, S.Y. (1980) 'The Renaissance Artist as Quantifier' in M.A. Hagen (ed.) *The Perception of Pictures*, New York: Academic Press, pp. 179–212.

Edwards, E. (ed.) (1992) *Anthropology and Photography 1860–1920*, New Haven, Conn., and London: Yale University Press.

Eisenstein, S. (1943) *The Film Sense*, London: Faber, 1968.

Else, G.F. (1957) *Aristotle's 'Poetics': The Argument*, Cambridge, Mass.: Harvard University Press.

Evans, D. and Gohl, S. (1986) *Photomontage: a Political Weapon*, London: Gordon Fraser.

Evans, F. (1900) in *The Photographic Journal*, 59 (30 April): 236–41.

Evans, H. (1978) *Pictures on a Page*, London: Heinemann.

—— (1981) *Eye Witness*, London: Quiller Press.

Export, V. (1977) 'Valie Export' in F.M. Neusüss (ed.) *Photography as Art – Art as Photography 2*, Kassel: Fotoforum.

Fahrmeier, E. (1973) 'The Validity of the Transactionalist's Assumed World: A Critical Reinterpretation of Experiments in Size Constancy', *Journal of Phenomenological Psychology*, 4: 261–70.

Fiske, J. (1990) *Introduction to Communication Studies*, London: Routledge.

Fleischhauer, C. and Brannan, B.W. (eds) (1988) *Documenting America: 1935–1943*, Berkeley, Calif.: University of California Press.

Foucault, M. (1979) *Discipline and Punish: The Birth of the Prison*, Harmondsworth: Penguin.

Freund, G. (1980) *Photography and Society*, trans. R. Dunn *et al.*, Boston, Mass.: Godine.

Frith, F. (1859) 'The Art of Photography', *The Art Journal*, 5: 71–2.

Gardner, M. (ed.) (1970) *The Annotated Alice: Alice's Adventures in Wonderland and Through the Looking Glass by Lewis Carroll*, Harmondsworth: Penguin.

Geertz, C. (1973) 'Thick Description: Toward an Interpretive Theory of Culture' in *The Interpretation of Cultures*, New York: Basic Books, pp. 3–30.

—— (1980) *Negara: The Theatre State in Nineteenth-century Bali*, Princeton, NJ: Princeton University Press.

Gell, A. (1992) 'The Technology of Enchantment and the Enchantment of Technology' in J. Coote and A. Shelton (eds) *Anthropology, Art and Aesthetics*, Oxford: Oxford University Press, pp. 40–66.

—— (1998) *Art and Agency: An Anthropological Theory*, Oxford: Oxford University Press.

Genette, G. (1980) *Narrative Discourse: An Essay in Method*, trans. J.E. Lewin. Ithaca, NY: Cornell University Press.

Gibson, J.J. (1954) 'A Theory of Pictorial Perception', *Audio Communications Review*, 1: 3–23.

—— (1966) *The Senses Considered as Perceptual Systems*, Boston, Mass.: Houghton Mifflin.

—— (1979) *The Ecological Approach to Visual Perception*, Boston, Mass.: Houghton Mifflin.

Gide, A. (1948) *Theseus*, trans. J. Russell, London: Horizon.

Goldberg, V. (1991) *The Power of Photography*, New York: Abbeville Press.

Gombrich, E.H. (1950) *The Story of Art*, London: Phaidon.

—— (1960) *Art and Illusion*, London: Phaidon.

—— (1975) 'Mirror and Map: Theories of Pictorial Representation', *Philosophical Transactions of the Royal Society of London, Series B*, 270 (903): 119–49.

Goody, J. (1976) *The Domestication of the Savage Mind*, Cambridge: Cambridge University Press.

Gorbachev, M. (1996) *Memoirs*, London: Doubleday.

Graham, P. (1983) *A1: The Great North Road*, Bristol: Grey Editions, unpaged.

Green, D. (1984) 'Classified Subjects – Photography and Anthropology: The Technology of Power', *Ten-8*, 14: 3–37.

Greenberg, C. (1946) 'The Camera's Glass Eye', *The Nation*, 162: 295.

—— (1960) 'Modernist Painting', *Arts Yearbook*, 4: 102–8.

Grundberg, A. (1990) *Crisis of the Real*, New York: Aperture.

Gunther, R. (1971) in D.W. Fokkema and E. Kunne-Ibsch, *Theories of Literature in the Twentieth Century: Structuralism, Marxism, Aesthetics of Reception*, London: Hurst.

Gutman, J.M. (1982) *Through Indian Eyes: 19th and Early 20th Century Photography from India*, New York: Oxford University Press.

Hagen, M.A. (1986) *Varieties of Realism: The Geometries of Representational Art*, Cambridge: Cambridge University Press.

Hanson, F.A. (1983) 'When the Map is the Territory: Art in Maori Culture' in D.K. Washburn (ed.) *Structure and Cognition in Art*, Cambridge: Cambridge University Press, pp. 74–89.

Harbutt, C. (1973) 'Epilogue' in *Travelog*, Cambridge, Mass.: MIT Press.

Harrison, E.D.R. (1993) 'Some Reflections on Kim Philby's *My Silent War* as an Historical Source', University of Salford.

Haslam, J. (1998) 'Russia's Seat at the Table: A Place Denied or a Place Delayed', *International Affairs*, 74, (1): 119–130.

Hawkes, T. (1977) *Structuralism and Semiotics*, London: Methuen.

Haworth-Booth, M. (ed.) (1989) *The Golden Age of British Photography 1839–1900*, New York: Aperture.

Heise, C.G. (1928) 'Preface to A. Renger-Patzsch, *Die Welt ist schön*' in D. Mellor (ed.) *The New Photography: Germany 1927–33*, London: Arts Council of Great Britain, 1978.

Helmholtz, H. von (1866) *Treatise of Physiological Optics*, trans. and ed. J.P.C. Southall, New York: Dover, 1962.

—— (1884) 'The Recent Progress in the Theory of Vision' in *Popular Lectures on Scientific Subjects*, London: Longmans, 1904.

Henderson, L. (1988) 'Access and Consent in Public Photography' in J. Ruby (ed.) *Image Ethics: The Moral Rights of Subjects in Photographs, Film and Television*, Oxford and New York: Oxford University Press, pp. 91–107.

Hevey, D. (1992) *The Creatures That Time Forgot*, London: Routledge.

Hicks, W. (1952) *Words and Pictures*, New York: Arno Press.

Hilliard, J. (1980) 'Triads' in *Pier and Ocean*, London: Arts Council of Great Britain.

Hoernle, E. (1930) 'The Working Man's Eye' in D. Mellor (ed.) *The New Photography: Germany 1927–33*, London: Arts Council of Great Britain, 1978.

Hughes, C.J. (1861) 'On Art Photography', *American Journal of Photography*, 3: 260–3.

Irby, K. (2001) 'Magazine Covers: Photojournalism or Illustration', Poynter Institute. Available online at http://www.poynter.org/centerpiece/021601.htm.

Iversen, M. (1986) 'Saussure versus Peirce: Models for a Semiotics of Visual Art' in F. Borzello (ed.) *The New Art History*, London: Camden Press, pp. 82–94.

Jameson, F. (1972) *The Prison-house of Language: A Critical Account of Structuralism and Russian Formalism*, Princeton, NJ, and London: Princeton University Press.

—— (1999) 'Postmodern and Consumer Society' in H. Foster (ed.) *Anti-aesthetic: Essays on Postmodern Culture*, Seattle: Bay Press, pp. 111–25.

Jones, R.V. (1989) *Reflections on Intelligence*, London: Heinemann.

Jussim, E. (1989) 'Trashing the Media: Taking on the World' in *The Eternal Moment: Essays on the Photographic Image*, New York: Aperture, pp. 93–111.

Keane, A.H. (1908) *The World's Peoples: A Popular Account of their Bodily & Mental Characters, Beliefs, Traditions, Political and Social Institutions*, London: Hutchinson.

Kember, S. (1995) 'Surveillance, Technology and Crime: The James Bulger Case' in M. Lister (ed.) *The Photographic Image in Digital Culture*, London: Routledge.

Kerouac, J. (1957) *On the Road*, Harmondsworth: Penguin, 1972.

Klein, W. (1981) *William Klein: Photographs*, New York: Aperture.

Klingender, F.D. (1935) *Five on Revolutionary Art*, London:

Knightley, P. (1999) Interviewed on Jeremy Issacs' 1999 *Cold War* television series, episode 21: 'Spies', Turner Original Productions.

Koffka, K. (1935) *The Principles of Gestalt Psychology*, New York: Harcourt Brace.

Köhler, W. (1929) *Gestalt Psychology*, London: Bell.

Kubler, G. (1962) *The Shape of Time: Remarks on the History of Things*, New Haven, Conn.: Yale University Press.

Kuhn, A. (1985) *The Power of the Image: Essays on Representation and Sexuality*, London: Routledge.

Kracauer, S. (1947) *From Caligari to Hitler: A Psychological History of the German Film*, New York: Princeton University Press.

Krauss, R. (1984) 'A Note on Photography and the Simulacral', *October*, 31: 21.

Langer, S. (1953) *Feeling and Form*, New York: Macmillan, 1977.

Langford, M.H. (1978) *Basic Photography*, 4th edn, London: Focal Press.

Lavrentiev, A. (1979) in D. Elliott (ed.) *Alexander Rodchenko*, Oxford: Museum of Modern Art.

le Carré, J. (1965) *The Looking Glass War*, London: Heinemann.

Lemon, L.T. and Reiss, M.J. (trans. and eds) (1965) *Russian Formalist Criticism: Four Essays*, Lincoln and London: University of Nebraska Press.

Levin, H. (1963) *The Gates of Horn: a Study of Five French Realists*, Oxford: Oxford University Press.

Levine, L. (1975) 'Camera Art', *Studio International*, 190 (976): 52–4.

Lévi-Strauss, C. (1968) *Structural Anthropology*, London: Allen Lane (London: Penguin, 1972).

—— (1969) *The Elementary Structures of Kinship*, Boston, Mass.: Beacon Press.

Lindberg, D.C. (1976) *Theories of Vision from Al-Kindi to Kepler*, Chicago, Ill.: University of Chicago Press.

Llosa, M.V. (ed.) (1989) *Martin Chambi*, Barcelona: Lunwerg.

Loeffler, C.E. and Anderson, T. (eds) (1994) *The Virtual Reality Casebook*, New York: Van Nostrand Reinhold.

Longinus (1953) *On the Sublime*, trans. W. Hamilton Fyfe, London: Loeb Library.

Macdonald, G. (1980) *Camera: Victorian Eyewitness – A History of Photography: 1826–1913*, New York: Viking Press.

Malinowski, B. (1922) *Argonauts of the Western Pacific: An Account of Native Enterprise and Adventure in the Archipelagoes of Melanesian New Guinea*, London: Routledge & Kegan Paul.

Malraux, A. (1954) *Voices of Silence*, London: Palladin.

Mann, S. (1992) *Immediate Family*, New York: Aperture.

Mathews, T.F. (1993) *The Clash of the Gods: A Reinterpretation of Early Christian Art*, Princeton, NJ: Princeton University Press.

Mayhew, H. (1851) *London Labour and the London Poor*, London: Griffin, Bohn & Co.

Meecham, C. (1987) *The Oldham Road*, London: Architectural Association.

Mellor, D. (ed.) (1978) *The New Photography: Germany 1927–33*, London: Arts Council of Great Britain.

Mellor, K. (1997) *Island*, Manchester: Dewi Lewis Publishing.

Meyer, U. (1972) *Conceptual Art*, New York: Dutton.

Michaels, C.F. and Carello, C. (1981) *Direct Perception*, Englewood Cliffs, NJ: Prentice Hall.

Miller, R. (1981) *Building a Home Darkroom*, Rochester, NY: Eastman Kodak.

Minnaert, M.G.J. (1993) *Light and Colour in the Outdoors*, trans. and revised L. Seymour, New York: Springer-Verlag.

Mirzoeff, N. (1999) *An Introduction to Visual Culture*, London: Routledge.

Mitchell, W.J. (1992) *The Reconfigured Eye: Visual Truth in the Post-Photographic Era*, Cambridge, Mass.: MIT Press.

Moeller, S.D. (1987) *Shooting War: Photography and the American Experience of Combat*, New York: Basic Books.

Moholy-Nagy, L. (1924) 'Space-Time and the Photographer' in J.B. Hall and B. Ulanov (eds) *Modern Culture and the Arts*, New York: McGraw-Hill, 1967.

Molderlings, H. (1978) 'Urbanism and Technological Utopianism: Thoughts on the Photography of Neue Sachlichkeit and The Bauhaus' in D. Mellor (ed.) *The New Photography: Germany 1927–33*, London: Arts Council of Great Britain.

Morgan, A.B. (1994) 'Tomorrow's Palette', *Art in America*, April: 37–41.

Morphy, H. (1992) 'From Dull to Brilliant: The Aesthetics of Spiritual Power among the Yolngu' in J. Coote and A. Shelton (eds) *Anthropology, Art and Aesthetics*, Oxford: Oxford University Press.

Newhall, B. (1964) *The History of Photography*, London: Secker & Warburg.

—— (ed.) (1981) *Photography: Essays and Images*, London: Secker & Warburg.

—— (1982) *The History of Photography*, 5th edn, New York: MOMA.

Newhall, N. (1952) 'The Caption, the Mutual Relation of Words/Photographs', *Aperture*, 1: 22–3.

Nichols, B. (1991) *Representing Reality: Issues and Concepts in Documentary*, Bloomington, Ind.: Indiana University Press.

Nicholson, M. (1999) 'Thousands Dead Not Many Interested', *The Evening Standard*, London.

Oechsner, F. (1943) *This is the Enemy*. London: William Heinemann.

Ollman, A. (1986) 'Introduction' in *Arnold Newman: Five Decades*, San Diego, Calif.: Harcourt Brace Jovanovich.

Orwell, G. (1948) *Nineteen Eighty-four: A Novel*, London: Secker & Warburg.

Panofsky, E. (1939) *Studies in Iconology: Humanistic Themes in the Art of the Renaissance*, New York: Oxford University Press.

Pelto, P.J. (1973) *The Snowmobile Revolution: Technological and Social Change in the Arctic*, Menlo Park, Calif.: Cummings.

Penny, S. (1994) 'Virtual Reality as the Completion of the Enlightenment' in C.E. Loeffler and T. Anderson (eds) *The Virtual Reality Casebook*, New York: Van Nostrand Reinhold.

Pinney, C. (1992) 'The Parallel Histories of Anthropology and Photography' in E. Edwards (ed.) *Anthropology and Photography, 1860–1920*, New Haven, Conn.: Yale University Press.

Pirenne, M.H. (1967) *Vision and the Eye*, 2nd edn, London: Chapman & Hall.

—— (1972) in 'Letters on Book Reviews', *Leonardo*, 5: 95.

—— (1974) *Optics, Painting and Photography*, Cambridge: Cambridge University Press.

Piven, J. and D. Borgenicht (1999) *The Worst-case Scenario Survival Handbook*, San Francisco, Calif.: Chronicle Books.

Poggioli, R. (1968) *The Theory of the Avant Garde*, Cambridge, Mass.: Harvard University Press.

Pollack, R. (2002) 'A Warning from Hollywood' *Panorama*, London: BBC, 24 March.

Postman, N. and Weingartner, C. (1971) *Teaching as a Subversive Activity*, Harmondsworth: Penguin.

Poulet, G. (1972) 'Criticism and the Experience of Interiority' in J.P. Tompkins (ed.) *Reader-Response Criticism*, Baltimore, Md., and London: Johns Hopkins University Press, 1980.

Priestly, J.B. (1957) 'The Walrus and the Carpenter', *New Statesman*, 10 August, p. 168.

Pryluck, Calvin (1988) 'The Ethics of Imagemaking' in A. Rosenthal (ed.) *New Challenges for Documentary*, Berkeley: University of California Press, pp. 308–18.

Raif, S. (1988) 'How I Fell for My Girl', *Sunday Magazine*, London: News Group Newspapers.

Ray, M. (1992) 'Man Ray' in P. Hill and T. Cooper (eds) *Dialogue with Photography*, Manchester: Cornerhouse, pp. 17–25.

Renger-Patzsch, A. (1929) 'Photography and Art' in D. Mellor (ed.) *The New Photography: Germany 1927–33*, London: Arts Council of Great Britain, 1978.

Riis, J. (1890) *How the Other Half Lives: Studies among the Tenements of New York*. Published in 1971 as an unabridged edition of the 1901 edition, New York: Dover.

—— (1898) *Children of the Poor*, New York: Ayer, 1971.

Ritchen, F. (1990) *In Our Own Image: The Coming Revolution in Photography*, New York: Aperture.

Robinson, H.P (1869) *Pictorial Effect in Photography: Being Hints on Composition and Chiaroscuro for Photographers*, London: Piper & Carter.

Rorty, R. (1989) *Contingency, Irony and Solidarity*, Cambridge: Cambridge University Press.

Rosaldo, R. (1989) 'Imperialist Nostalgia' in *Culture and Truth: The Remaking of Social Analysis*, Boston: Beacon Press, pp. 68–90.

Rosler, M. (1991) 'Image Simulations, Computer Manipulations, Some Considerations', *Ten-8: Digital Dialogues*, 2 (2): 52–63.

Ross, W.D. (1927) *The Works of Aristotle Translated into English, Volume VII – Problemata*, Oxford: Clarendon Press.

Rotha, P. (1930) *The Film Till Now*, London: Faber & Faber.

Ruskin, J. (1860) *Modern Painters*, Vol. 5, London.

Said, E. (1978) *Orientalism*, Harmondsworth: Penguin.

Sander, A. (1978) 'Photography as a Universal Language', trans. A. Halley, *Massachusetts Review*, XIX (4): 674–5.

Sartre, J.-P. (1940) *The Psychology of the Imagination*, London: Methuen, 1972.

Scharf, A. (1968) *Art and Photography*, Harmondsworth: Penguin.

Schneider, B. (1996) *Bear Aware: Hiking and Camping in Bear Country*, Helena, Mont.: Falcon.

Schuneman, R. Smith (ed.) (1972) *Photographic Communication: Principles, Problems and Challenges of Photojournalism*, New York: Hastings House.

Schwarz, H. (1985) *Art and Photography: Forerunners and Influences*, Layton, Ut.: Peregrine Smith Books.

Sekula, A. (1978) 'Dismantling Modernism, Reinventing Documentary' in J. Liebling (ed.) *Photography: Current Perspectives*, Rochester, NY: Light Impressions.

—— (1982) 'On the Invention of Photographic Meaning' in V. Burgin (ed.) *Thinking Photography*, London: Macmillan.

—— (1986) 'The Body and the Archive', *October*, 39: 3–64.

Seymour, C. (1964) 'Dark Chamber and Light-filled Room: Vermeer and the Camera Obscura', *The Art Bulletin*, XLVI (3): 323–31.

Sherman, C. (1982) in E. Barent (ed.) *Introduction to Cindy Sherman*, Amsterdam: Stedelijk Museum.

Sherrington, C.S. (1937–8) *Man on his Nature*, Cambridge: Cambridge University Press.

Shklovsky, V. (1917) 'Art as Technique' in L.T. Lemon and R.J. Reiss, *Russian Formalist Criticism: Four Essays*, Lincoln and London: University of Nebraska Press, 1965.

Shudakov, G. (1983) *Pioneers of Soviet Photography*, London: Thames & Hudson.

Siskind, A. (1956) 'Credo' in N. Lyons (ed.) *Photographers on Photography*, Englewood Cliffs, NJ: Prentice Hall, 1966.

Smith, H.H. (1961) 'Photography in Our Time' in N. Lyons (ed.) *Photographers on Photography*, Englewood Cliffs, NJ: Prentice Hall, 1966.

Sontag, S. (1977) *On Photography*, New York: Farrar, Straus & Giroux.

Sorgi, I.R. (1942) 'Graphic Story of Leap Told by Cameraman', *Courier Express*, Buffalo, 7 May.

Sowerby, A.L.M. (ed.) (1951) *Dictionary of Photography*, London: Fountain Press.

Spence, J. (1987) *Putting Myself in the Picture*, London: Camden Press.

—— (1995) *Cultural Sniping*, London: Routledge.

Spencer, H. (1870) *The Principles of Psychology*, 2 vols, 2nd edn, London.

Sprague, S.F. (1978) 'Yoruba Photography: How the Yoruba See Themselves', *African Arts*, 12 (1): 52–9, 107.

Squiers, C. (1990) 'Picturing Scandal' in *The Critical Image: Essays on Contemporary Photography*, Seattle, Wash.: Bay Press.

Stone, B. (1900) in B. Jay *Customs and Faces: Photographs by Sir Benjamin Stone 1838–1914*, London: Academy Editions, unpaged, 1972.

Stołowicz, L. (1988) 'Zwierciadło jako model semiotyczny, epistemologiczny I aksjologiczny' ('The Mirror as Semiotic, Epistemological and Axiological Model'), in *Konteksty*, Warsaw: Department of Art and the Anthropology of Culture, Polish Academy of Sciences, Nos. 3–4, 1998, pp. 124–7.

Suchar, C.S. (1989) 'The Sociological Imagination and Documentary Still Photography: The Interrogatory Stance' in R.M. Bonnzajer Flaes (ed.) *Eyes Across the Water*, Amsterdam: Het Spinhuis.

Swan, P.A. (1995) 'The Ethics of Photo Digital Manipulation', *Military Review*, LXXV (6).

Sykes, H. (1977) Once a Year: Some Traditional British Customs, London: Gordon Fraser.

Szarkowski, J. (1966) *The Photographer's Eye*, New York: Doubleday.

—— (1978) *Mirrors and Windows: American Photography since 1960*, New York: Little Brown & Co.

Tagg, J. (1988) *The Burden of Representation: Essays on Photographies and Histories*, London: Macmillan.

Talbot, W.H.F. (1839) *Some Account of the Art of Photogenic Drawing*, London: R. & J.E. Taylor, unpaged.

—— (1844) *The Pencil of Nature*, London, unpaged.

Taylor, B. (1811) *New Principles of Linear Perspective*, 4th edn, London: J. Taylor.

Taylor, P. (ed.) (1988) *After 200 Years: Photographic Essays of Aboriginal and Islander Australia Today*, Cambridge: Cambridge University Press.

Taylor, R. (1998) '"Some other occupation": Lewis Carroll and Photography' in *Lewis Carroll*, London: The British Council, pp. 27–38.

Thomson, J. (1876–7) *Street Life in London*, published in 11 parts, London: Sampson Low, Marston, Searle & Rivington.

Tirohl, B. (1995) 'The Art of Photofaction', *Second Sight*, 1: 18–19.

Trachtenberg, A. (ed.) (1980) *Classic Essays on Photography*, New Haven, Conn.: Leete's Island Books.

Turner, F.J. (1891) 'The Significance of History' in F. Stern (ed.) *Varieties of History, from Voltaire to the Present*, New York: Vintage.

Tylor, E.B. (1873) *Primitive Culture: Researches into the Development of Mythology, Philosophy, Religion, Language, Art and Custom*, 2 vols, London.

Ucko, P.J. and Rosenfeld, A. (1967) *Palaeolithic Cave Art*, London: Weidenfeld & Nicolson.

Usborne, D. (2002) 'The Man Who Saw Too Much', *The Sunday Review: The Independent on Sunday*, 17 March: 12–16.

van Leeuwen, T. and Jewit, C. (2001) *Handbook of Visual Analysis*, London: Sage.

Verrier, A. (1983) *Through the Looking-glass: British Foreign Policy in the 'Age of Illusions'*, London: Jonathan Cape.

Vestal, D. (1984) *The Art of Black and White Enlarging*, New York: Harper & Row.

Virilio, P. (1994) *The Vision Machine*, trans. J. Rose, London: BFI/Bloomington, Ind.: Indiana University Press.

Walker, J.A. (1975) *Art Since Pop*, London: Thames & Hudson.

Warburton, N. (1988) 'Photographic Communication', *British Journal of Aesthetics*, 28 (2): 173–81.

Ward, A. (2002) 'Koreans Set to Resume Family Reunions', *Financial Times*, London, 6 April: 2.

Weisman, A. and Dusard, J. (1986) *La Frontera: The United States Border with Mexico*, San Diego, Calif.: Harcourt Brace Jovanovich.

Weitz, M. (1956) 'The Role of Theory in Aesthetics', *Journal of Aesthetics and Art Criticism*, 15.

Weston, E. (1943) 'Seeing Photographically' in A. Trachtenberg (ed.) *Classic Essays on Photography*, New Haven, Conn.: Leete's Island Books, 1980.

White, J. (1957) *The Birth and Re-birth of Pictorial Space*, London: Faber & Faber.

Wilhelm, H. (1993) *The Permanence and Care of Color Photographs: Traditional and Digital Color Prints, Color Negatives, Slides, and Motion Pictures*, Grinnell, Ia.: Preservation Publishing.

Wittgenstein, L. (1953) *Philosophical Investigations*, trans. G.E.M. Anscombe, Oxford: Blackwell.

Wodehouse, P.G. (1930) 'Jeeves and the Impending Doom' in *Very Good, Jeeves*, Harmondsworth: Penguin, 1957.

Wollheim, R. (1968) *Art and its Objects*, Harmondsworth: Penguin.

—— (1973) 'On Drawing an Object' in *On Art and Mind*, Harmondsworth: Penguin.

Wombell, P. (ed.) (1991) *PhotoVideo: Photography in the Age of the Computer*, London: Rivers Oram Press.

Wright, T.V. (1983) 'Photography, Realism and "The Natives"', *British Journal of Photography*, 6400 (130): 340–2.

—— (1992a) 'Photography: Theories of Realism and Convention' in E. Edwards (ed.) *Anthropology and Photography, 1860–1920*, New Haven, Conn.: Yale University Press.

—— (1992b) 'Television Narrative and Ethnographic Film' in D. Turton and P.I. Crawford (eds) *Film as Ethnography*, Manchester: Manchester University Press.

Index

.............................

Note: main text entries are indicated by **emboldened** page numbers.